NATIONAL GALLERY OF ART

KRESS FOUNDATION STUDIES

IN THE HISTORY OF EUROPEAN ART

NUMBER THREE

FRENCH PAINTING IN THE TIME OF JEAN DE BERRY: THE BOUCICAUT MASTER

BY MILLARD MEISS

PHAIDON

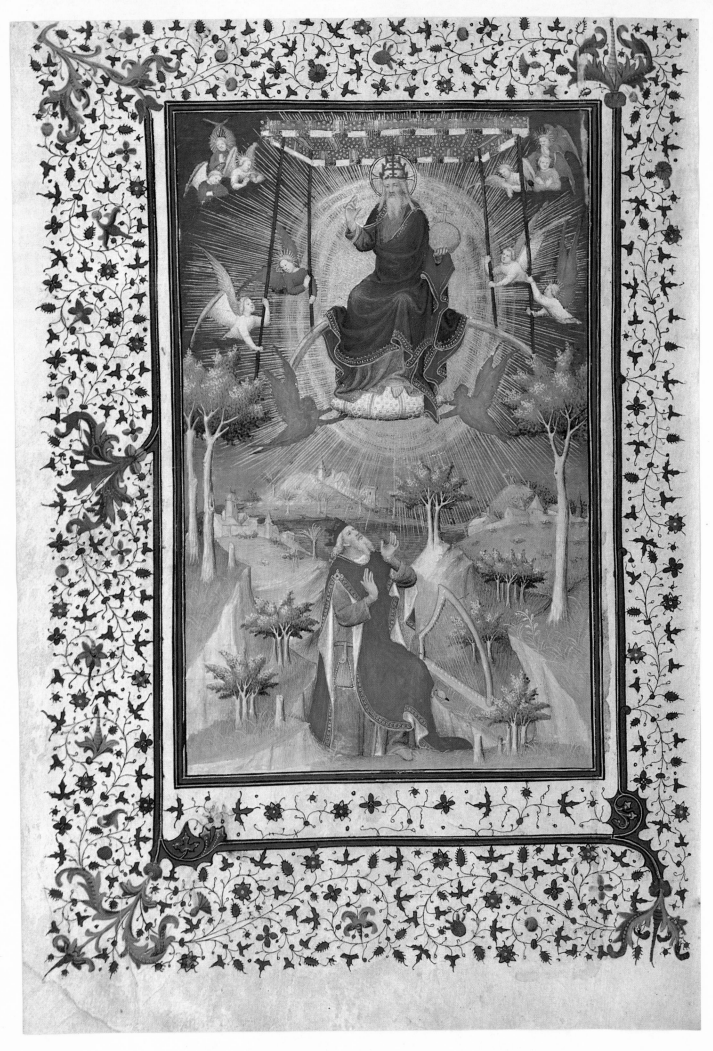

Boucicaut Master: *David's Vision of the Lord*. Paris, Musée Jacquemart-André, ms. 2, fol. 125v

NATIONAL GALLERY OF ART: KRESS FOUNDATION
STUDIES IN THE HISTORY OF EUROPEAN ART

FRENCH PAINTING IN THE TIME OF JEAN DE BERRY

THE BOUCICAUT MASTER

BY MILLARD MEISS

WITH THE ASSISTANCE OF KATHLEEN MORAND
AND EDITH W·KIRSCH

PHAIDON

ALL RIGHTS RESERVED BY PHAIDON PRESS LTD · 5 CROMWELL PLACE · LONDON SW7

1968

PHAIDON PUBLISHERS INC · NEW YORK

DISTRIBUTORS IN THE UNITED STATES: FREDERICK A. PRAEGER INC

111 FOURTH AVENUE · NEW YORK · NY 10003

LIBRARY OF CONGRESS CATALOG CARD NUMBER: 67–29885

SBN 7148 1346 X

MADE IN GREAT BRITAIN

PLATES PRINTED BY V. S. K. PRINTERS · BASLE

TEXT PRINTED BY R. & R. CLARK LTD · EDINBURGH

Contents

TO THE MEMORY OF
ERWIN PANOFSKY

Foreword

THE directors of many libraries and museums have continued to facilitate the preparation of this history. I should like to thank especially Marcel Thomas of the Bibliothèque nationale, Julien Cain of the Musée Jacquemart André, Jacques Guignard of the Bibliothèque de l'Arsenal, Jean Babelon of the Archives Nationales, Maria Teresa Gomes Ferreira of the Gulbenkian Foundation, Dorothy Miner of the Walters Art Gallery, William Wixom of the Cleveland Museum, Frederick Goff of the Library of Congress, John Plummer of the Morgan Library, Mrs. Henry Howell of the Frick Art Reference Library, Judith Sachs of the Institute for Advanced Study, and Elizabeth Usher of the library of the Metropolitan Museum. Private collectors, particularly Principessa Elena Corsini, Francis Kettaneh, Dr. Emil Ludwig, Philip Robinson, and Lessing Rosenwald have generously permitted me to study and to photograph some of their manuscripts and books. I am indebted for similar privileges to Martin Breslauer, Heinrich Eisemann, H. P. Kraus, and Otto Ronschburg.

For photographs and for valuable suggestions I am grateful to many friends and colleagues: Wart Arslan, Georges Bloch, Eve Borsook, André Chastel, William Forsyth, Samuel Y. Edgerton Jr., Marie-Madeleine Gauthier, Lech Kalinowski, G. I. Lieftinck, Nicky Mariano, Baron Meurgey de Tupigny, Florentine Mütterich, Carl Nordenfalk, and Francis Wormald. I feel very grateful also to Cara Dufour, Marthe Dulong, Mrs. Sharon Off Katić, Mrs. Jean Lillie, and Anne McCabe, who have contributed to the preparation of the text and the reproductions.

This volume, like its predecessors, has had the great advantage of the interest of Mrs. Elly Miller of the Phaidon Press, to whom I express my warmest thanks.

July, 1967 M. M.

Introduction

CHARLES V, a strong king with sustained intellectual interests, inevitably promoted the primacy of Paris as the artistic center of France. During his reign, from 1364 to 1380, most of the great commissions in all the arts were royal. After his death his young and uncertain son Charles VI, even before the beginning of his mental disturbances in 1392, was unable to maintain his father's control of the nation. Political power and still more patronage of the arts passed to his uncles, the Dukes of Anjou, Berry, and Burgundy. To judge from surviving works – we have lost or misplaced almost everything commissioned by Louis I d'Anjou[1] – the major artistic events occurred in Dijon, where Jean de Beaumetz, Malouel, and Sluter worked for Philippe le Hardi; and in Bourges and the Berry, brightened by André Beauneveu, the Passion Master (Jean le Noir?), the Master of the Parement de Narbonne, Jacquemart de Hesdin, and other painters and illuminators.

Just around 1400, however – for once a new century actually corresponded with something historically significant – we can observe a change. Jean de Berry began to reside more continuously in Paris. Philippe le Hardi, no longer in Dijon, placed important commissions there. Two of the Limbourg brothers, undertaking to illuminate a Bible for him, worked from 1402 to 1404 in the house of Philippe's physician, Jean Durand, near Notre-Dame.[2] Three other painters, among them perhaps the Boucicaut Master and the Bedford Master, were busy approximately at the same time, with a second Bible for which Durand represented the Duke also.[3] The Lucchese merchant Jacques Raponde was involved in both commissions. He, his brother Dino, and other members of the family had become the chief purveyors of works of art to Philippe le Hardi. After the death of Philippe in 1404, the firm continued to serve his son, Jean sans Peur, in this capacity. Though the House of Raponde had a branch in Bruges and representatives in Italy it seems to be true – though the published documents are not entirely clear – that headquarters was established in Paris. Certainly that is where practically all of the dealers of Jean de Berry were – his inventories leave no doubt.[4] The prominence of this swarm of Italian merchants in Paris is one of the striking phenomena of the time.

These patrons and dealers created in the royal capital a great demand for art. A combination of their stimulus, a rich artistic tradition, and I suppose the will of God, brought forth in Paris a group of illuminators rarely, if ever, equalled in her long and glorious past. Nevertheless, considering the quality of the results of the important commissions, the demand seems to have outrun the supply, or perhaps the going wages were not sufficiently high. Apart from the employees of the Duke of Berry, the illuminators spread themselves very thin. They also assigned work surprisingly often to men who were poorly trained and badly endowed. In the very period when illumination flourished as seldom before, something was clearly imperfect in its social and economic arrangements.

French culture and patronage concentrated in Paris tended often to impose a high degree of uniformity. The illumination of the first fifteen years of the century, however, was remarkably

varied. This variety must be in part attributed to the weakness of the King, the strong divisions in the Court, and the continued independence of the Dukes. The illuminators, furthermore, flocked to the capital from many parts of France and above all from the Netherlands. Indeed these regions, drained of their talents, accomplished very little of any consequence during this period. Diverse origins and early training, however, do not alone account for the diversity of styles in Paris. The Limbourgs, the Master of the Coronation, and the Master of Berry's Cleres Femmes all came from Guelders or the Low Countries, from towns no further apart than Nijmegen and probably Bruges. A continental divide, however, seems to separate their work in the metropolis.

In the end the marvelous flowering in Paris remains, like all such events, a mystery. This is true all the more because of the turmoil amidst which it occurred. The independence of the Dukes to which I referred is in a sense a vast understatement. The reigning princes of Burgundy and Orléans (the brother of Charles VI) were locked in a struggle to the death – a struggle that involved Berry, the King, and eventually the whole of France.[5] As the civil war became more intense English pressure increased. The tide of invasion in 1415 submerged the knights of France at Agincourt, and in 1420 swept over the capital itself. The occupation by Henry V finally snuffed out the great revival of the arts. One of the painters who disappeared around this time, after two decades of intense activity in Paris, was the Master of the Hours of the Maréchal de Boucicaut.

Often, though not always, artistic power and historical significance coincide. They indubitably did in the miniatures in the Marshal's book now in the Musée Jacquemart-André in Paris. On both counts these paintings were outstanding at the beginning of the fifteenth century not only in France but in the whole of Europe, Italy included. Their closest rivals for sheer beauty – panels by Lorenzo Monaco or the Master of Wittingau in Bohemia – are clearly not their equal in promise for the future. The Limbourgs, the only real peers of the Boucicaut Master in this period, struck their stride just a few years later. No further justification seems necessary, then, for the complete reproduction of the miniatures of this remarkable book and for a comprehensive consideration of the workshop that their painter founded, both undertaken here for the first time.

The exceptional quality of the *Boucicaut Hours* was recognized by the author of the first publication devoted to them, M. Guyot de Villeneuve. In his monograph of 1889 he identified the armorials and brought together instructive information about the Marshal of France who commissioned the codex. It was however the first real connoisseur of French illumination of the late Middle Ages, Paul Durrieu, who placed the manuscript in its stylistic context, recognizing it as the *chef-d'œuvre* of a master who was more or less personally responsible for miniatures in a couple of dozen outstanding manuscripts. In two fundamental articles of 1906 and 1913 Durrieu reconstructed the workshop of the Boucicaut Master with almost unerring judgment – an admirable accomplishment, especially in view of the prevailing ignorance of French painting of this period. His one great blunder, the inclusion in this œuvre of Jacquemart's cycles in the *Brussels Hours*, was an inexplicable lapse, but it did suggest the truth of the influence of Jacquemart upon the master.[6]

Very little escaped the eye of this extraordinary scholar in libraries from Seville to Berlin to

Oxford. Only about a dozen manuscripts can be added to his group, the most important of which are the *Grandes Chroniques* in the British Museum, Cotton Nero E II, the *Tite-Live* in the Ludwig Collection in Aachen, the Book of Hours in a private collection in New York, and the Boccaccio in the collection of Francis Kettaneh in the same city. Durrieu proposed that the Boucicaut Master, whom he first called the 'maître aux cygnes' because of the fondness of the painter for this bird, was identical with Jacques Coene, a master famous about 1400. For this hypothesis he offered some circumstantial evidence, but since no certain work by Coene is known, subsequent historians have either accepted or rejected the hypothesis without exploring the problem fully.

The painter whom Paul Durrieu recognized as pre-eminent in France has begun to attract more attention in recent years, and he emerged in Erwin Panofsky's account of 1953 as a major protagonist in European painting. In eight memorable pages Panofsky described the contributions of this 'great pioneer of naturalism' to the representation of landscape and the interior and to aerial perspective. Since then the Boucicaut Master has assumed a place alongside the Limbourgs in all accounts of the great renewal in the North.

I

The Boucicaut Hours

1 · THE MINIATURES AND THE PATRON

APART from the extraordinary quality of its miniatures, the manuscript in the Musée Jacquemart-André differs in three respects from the normal Book of Hours made for princes at the time. The display of mottoes, of emblems, and of coats of arms is unique, and the suffrages, here at the beginning, almost always appear elsewhere at or near the end of the book. Very rarely, furthermore, are the corresponding miniatures of the saints full-page.[1] The origins of these exceptional aspects of the manuscript are no doubt to be sought in the commission, and we must therefore give some consideration to Jean le Meingre II, the Marshal of France, for the armorials, now largely repainted, prove that the manuscript was originally made for him and his wife, Antoinette de Turenne.[2] The emblems of his family, an eagle with spread wings and a tablet checkered in green and white, are displayed in textiles or in the backgrounds of many miniatures, including the *Annunciation* (Figs. 26, 29). The 'carreaux échiquetés de blanc et de vert', as they are described in a contemporary document,[3] ornament even the tent of the Lord in which he crowns the Virgin (Fig. 36). The Marshal's motto, 'ce que vous voudres', which he adopted in 1388,[4] was no less omnipresent, though towards 1500 it was covered in most places by the 'sans nombre' of a later owner, Aymar de Poitiers. The richness of the original display of heraldry was responsible for the great damage to the miniatures, for it moved Aymar to emulation by clumsy, dull repainting.

We are unusually well informed about the public life of the Marshal by a remarkable contemporary biography, *Le livre des faicts du bon messire Jean le Maingre*. This text ends with the date of April 9, 1409, and it was presumably written in the preceding year or two.[5] It is certainly the work of a great admirer of the Marshal who was close to him during the first years of the century; the author may in fact have been Honorat Durand, the Marshal's chaplain at the time of his death and the heir, according to his will, of his diary.[6] Much of the text heaps praise on Boucicaut for his military prowess and for his sense of chivalric mission. He fought against the infidel as far afield as Prussia, with the Teutonic knights, and in search of him he went to Constantinople. He visited the Holy Land and the monastery of St. Catherine on Mount Sinai (Fig. 92). Like many knights of the time he wrote poetry.[7] In 1391 King Charles VI named him Marshal of France, and five years later he was a principal soldier in the crusade against the Turks led by the Duke of Nevers (from 1404 Duke Jean sans Peur of Burgundy). In the disastrous defeat at Nicopolis Boucicaut, who had been taken prisoner, was saved only by the intervention of the Duke with Bayazid, the leader of the Turkish army.

Many Italians had learned to respect the Marshal during the crusade and on his visits to their country, so that in 1401 when Genoa, torn by factional strife, put itself in the hands of France

Boucicaut was named governor. Though he succeeded in restoring peace to the city he soon became embroiled in the ceaseless conflicts of the city-states of the peninsula. Scarcely seven years after his entry into the city the Genoese rose against him, and he withdrew to Piedmont. There he waited with his men for a year, hoping in vain for help from the King of France to re-establish his position in Genoa. During this period *Le livre des faicts* was completed, and about the Marshal's later life we know very much less. He served as Governor of Guyenne and Languedoc until the great defeat of the French at Agincourt in 1415, after which he was taken to England as a prisoner. He died there in 1421, and his body was laid to rest in the family chapel in St. Martin, Tours.

The Marshal's biographer wrote of his unwavering piety. In addition to crusading he made pilgrimages to many shrines. On Friday he never ate anything 'qui prenne mort', and he wore only black, 'en l'honneur de la Passion de Nostre Seigneur'.[8] Important ideas were then commonly symbolized by color, and important events, particularly the great religious events, were made vivid by paintings, as in the pious Marshal's book for private devotion. A book of this kind he used daily; according to the *Livre des faicts* 'every day without fail he says his Hours and many prayers, and suffrages to the saints'.[9]

The biography says little about Boucicaut's wife, but she concerns us because she appears in the Book of Hours, and it is absolutely certain that the marriage was one of the great events of his life. This is true not simply because the Marshal and Antoinette de Turenne were happy together – all the evidence, including explicit declarations in their wills,[10] shows that they were – but because the union brought him social position and it promised to bring him wealth. The Marshal's family was of bourgeois origin; he possessed only 'noblesse de chevalerie'. Antoinette, on the other hand, belonged to one of the powerful old families of France and in 1391, when Boucicaut first met her at court, her suitor was Charles, son of the Duke of Anjou. Antoinette's proud father Raymond, however, owned territory in Provence and detested Anjou. He declared that he would rather see his daughter dead than married into that family, especially because his son-in-law would then be a *seigneur* before whom he would be obliged to kneel.[11] Raymond was scarcely more enthusiastic about Jean le Meingre, whom he scathingly described a few years later as of undistinguished lineage and in possession of less than 200 pounds a year: 'Boucicaut non era de gran linatge, quel non avia dos cens libres de randa'.[12] Whereas Raymond found Charles d'Anjou born too well, Boucicaut he judged too lowly. The marriage with the Marshal finally took place in 1393 only because King Charles VI and the Dukes of Berry and Burgundy insisted upon it. This we learn from Raymond himself: 'nous avions donné à Boucicaut sa femme à espouser à la requête du roy, de Monseigneur de Berry et Monseigneur de Bourgogne en plusieurs grandes promesses qu'ils nous firent'.[13]

As dowry Raymond gave properties that were either under lien or in the possession of others, hoping of course that Boucicaut would bring them back into his family. The Marshal soon failed him, and in 1399 his alliance with Provençal forces deprived Raymond of all possessions in this region. In July of this year the irate father-in-law disinherited his daughter and bequeathed his possessions to Louis d'Orléans.[14] The bitter conflict continued through the following years,[15] and in 1407 Raymond hurled insults at his son-in-law, who he said 'fait tant d'inhumanités que c'est merveille que Dieu soustient un tel homme sur la terre'.[16]

This decade of contemptuous treatment by a father-in-law who despised his birth might have been one of the motives that drove the Marshal to the unprecedented display of arms and devices in his Book of Hours. Armorials, it is true, not infrequently composed at that time the sole subjects of textiles; indeed fragments are preserved of a late fourteenth-century tapestry bearing the arms and devices of Guillaume Rogier, Comte de Beaufort and Vicomte de Turenne, and of his wife Cécile de Comminges (Fig. 466).[17] Religious objects are another matter. Not even kings were wont to inscribe their devices on the cope of St. Augustine (Fig. 17), to invoke angels as personal pages (Fig. 12), to dress them in their colors (Fig. 39), to inscribe their emblems on the tent of the Lord (Fig. 36).

Heraldry, in short, runs riot in the *Boucicaut Hours*, defying, as has been observed, 'all rules of probability and even ecclesiastical decorum'.[18] This defiance was not however the painter's – he did not exhibit it elsewhere. Nor did the lively imagination of the period and its delight in ceremony and symbolism produce anything else like it. The stubborn snobbishness of Raymond de Turenne must be accorded part at least of the responsibility, goading his son-in-law into a wholly immoderate parade of symbols.[19] And it is a grave responsibility, because the exceptional requirement hampered the painter and compromised his result.

On one earlier occasion the Marshal had taken a step that was probably not unrelated to the spectacular armorials in the manuscript and to the conflict with his father-in-law. In 1399, six years after his marriage to Antoinette, he founded a chivalric order. With twelve other knights including his brother Geoffroy, he established the *Ordre de la dame blanche à l'écu vert*, dedicated to the protection of noble women. New orders were frequently created during this period, but normally by kings and princes. The emblem that the members of Boucicaut's society were required to wear – a white lady on a small gold shield enamelled in green[20] – does not however appear on the representations of the Marshal in the Book of Hours.

The twenty-seven saints in the manuscript were chosen, of course, for their relationship with Boucicaut and his wife, and in several instances the nature of the connection is clear to us today. Leonard leads the procession (Fig. 1).[21] Boucicaut had good reason to commemorate this patron of prisoners, for he came close to decapitation after his capture by the Turks in 1396 at Nicopolis. The miniature vividly evokes that narrow escape by showing two prisoners kneeling before the saint. They are stripped to their shorts, and the *Livre des faicts* tells us that the Marshal was in similar abbreviated attire when brought before the victorious Bayazid.[22] The prisoner at the right, with his thick nose, even resembles the Marshal as we see him in the miniature of St. Catherine (Fig. 23), but not sufficiently to warrant an identification.

Leonard is followed by the militant Michael, conqueror of the devil (Fig. 2), and then appear the two great saints bearing the name of Jean (Figs. 3, 4). Another major patron of soldiers, George, is not lacking (Fig. 10), nor the rare St. William of the Desert, one of Charlemagne's captains and like Boucicaut a scourge of the Saracens (Fig. 27).[23] William, his helmet on his arm, appears at the very end of the series, after the female saints, probably because of a late decision to include him. The murder of St. Thomas of Canterbury stands as a reproach to the English, against whom Boucicaut had of course fought (Fig. 11). St. Martin was the patron of Boucicaut's church in Tours (Fig. 19) and Honoratus the patron of his confessor, Honorat Durand (Fig. 21).[24] Anthony

was venerated by Antoinette,[25] and Catherine by the Marshal (Figs. 20, 23). He visited her tomb on Mt. Sinai (Fig. 92), and he founded a hospital at Fierbois in her honor.[26]

Though the early Roman martyr Pancras was venerated in France and even in Tours, the birthplace of the Marshal, he does not appear once in the three hundred and thirteen Books of Hours in the Bibliothèque nationale studied by Leroquais (Fig. 14).[27] He was more popular in Italy, and a church in his honor stood in the Italian city governed by the Marshal, Genoa.[28] Much more clearly connected with the residence of Boucicaut in Genoa is St. Bridget of Sweden (Fig. 26). Carl Nordenfalk has pointed out that this city was a main center of the Brigittine cult, whereas the Swedish saint evoked little if any interest in Northern France.[29] Nordenfalk rightly claimed that the Marshal did not therefore commission the manuscript before his arrival in Genoa in 1401; but must we also conclude that the book was illuminated before he left that city? Might not a devotion to St. Bridget, formed in Genoa, have persisted? The nature of the image does not give us a decisive answer. As Nordenfalk observed, it departs in two respects from the Italian, and indeed all other, norms for the representation of the saint. Instead of the usual black monastic habit she wears a blue tunic and golden mantle; thus she is dressed in the national colors of Sweden. The hands of St. Bridget, joined in prayer, have become detached at the wrist and are held by an angel that has descended from heaven. This demonstration of divine approval of Bridget's prayer and of her acceptance in heaven was unprecedented. It remained unique, and the historian cannot readily decide whether such exceptional representations were executed within or outside a major center of the cult of the saint.

Consideration of the twenty-seven saints and their relationship to the Marshal has yielded evidence for the date of the manuscript: after 1401, but how much later? Hitherto opinion about date has favored either the period 1410–1415, or a couple of years within the first decade, or successive campaigns from 1400 to 1410–1411.[30] All the elements required for a decision will not be in hand until we have considered the entire group of manuscripts in the Boucicaut style. The iconography of another miniature offers us, nevertheless, weighty evidence for a precise date. In 1889 Guyot de Villeneuve drew attention to the unusual shape of the gold collar of the youngest Magus in the scene of the *Adoration* (Fig. 33). It bears a continuous series of small stubs, and Villeneuve therefore identified it with the *bâton noueux* adopted in 1403 by Louis d'Orléans as a symbol of the Armagnac or anti-Burgundian party. In reply the arch-enemy and in 1407 the assassin of Louis, Jean sans Peur, selected as his emblem the plane. Whereas several representations of Jean's plane survive (Fig. 473) no example of Louis' stubbed stick seems hitherto to have been cited. Partly for this reason historians have been sceptical about Villeneuve's identification of the collar in the miniature.[31] The *bâton noueux* served as an emblem, however, for other persons. Philip I of Spain, son of the Emperor Maximilian, employed two *bâtons* crossed one over the other (Fig. 47b). The emblem and a caricature of Jean sans Peur appear in the famous Hohenlohe necklace (Fig. 47a), if the attractive hypothesis of Carl Nordenfalk is right.[32]

Some observations not hitherto made lead me to reopen the question. Though in miniatures of the *Adoration of the Magi* painted by the workshop of the Boucicaut Master the youngest Magus commonly wears a gold collar and sometimes a stick-like pendant (Figs. 265, 286), as in the Jacquemart-André manuscript, not one of these collars shows the conspicuous stubs.[33] Nor do

they appear, to my knowledge, in any other representation of the subject. The figure of the youngest Magus in the *Boucicaut Hours* is wholly exceptional in another respect also. He is dressed in gray-black – a dark *houppelande* with fur collar and cuffs. Occasionally princes or courtiers of the time wear black (Bibliothèque nationale, fr. 23279, folio 5), but it is inappropriate to the Epiphany, the moment of the greatest joy of the Virgin,[34] and a sustained search has disclosed no other example. Black would, however, be quite suitable as a memorial allusion, and Louis was assassinated on November 23, 1407, at the age of thirty-five.

A third exceptional fact seems practically to prove the connection. Throughout the manuscript an initial normally introduces the text that begins on the folio opposite a miniature. Up to folio 44, all the initials are merely decorative, but from this folio on they bear the armorials of the Marshal. The golden eagle appears within a medallion (Fig. 45) or sometimes, as on folio 80, perched on the stump of a tree. In the initial on folio 143 the bird (redrawn in black by Aymar and given his motto) is unique (Fig. 46). Here it stands on a golden knotted stick glazed in rose – a *bâton noueux* (Fig. 48) similar to the collar of the Magus dressed in black in the *Adoration of the Magi* (Fig. 33). This unique initial begins the Office of the Dead.

Boucicaut and Louis d'Orléans had long been friends,[35] and Boucicaut's appointment as Governor of Genoa followed upon a decade of endeavor by Louis, son-in-law of Gian Galeazzo Visconti, to establish French power in Italy and to put a Frenchman on the throne of St. Peter.[36] As Governor Boucicaut launched an expansionist policy, acquiring Savona, Elba, and other territories, and for Louis he attempted to secure Pisa and Leghorn. These efforts ended when the Florentines captured Pisa on October 9, 1406.[37] To all these ties between the Marshal and the Duke should be added the fact that Boucicaut's brother Geoffroy, who had once been in the household of Philippe le Hardi, was by 1405 prominent in the Orléans party.[38] In the Marshal's late years his best friend was Charles d'Orléans, son of the murdered prince.[39]

Royalty does not on the whole have an attractive role in the story of Christ, and princes therefore found especially congenial one episode in which it does – the Adoration of the Kings. In an Epiphany play enacted in Paris in 1378 the king, attended by courtiers, identified himself with the Magi.[40] The Medici impersonated the Magi in Botticelli's well-known painting of the *Adoration* in the Uffizi. The association of one of the Magi with the Duke of Orléans would not be iconographically unusual. Three exceptional attributes and emblems all point to the identification, and we must therefore accept the probability that the illumination of the *Boucicaut Hours* was completed after the assassination of Louis d'Orléans on November 23, 1407. The part of the manuscript that precedes the *Adoration of the Magi*, which contains no evident reference to the prince, could well have been painted earlier. These historical indications correspond well enough – but not perfectly – with those provided by style. Study of the œuvre of the illuminator would lead us to place the *Boucicaut Hours* about 1405.

2·STYLE AND DATE

Accounts of the *Boucicaut Hours* have quite rightly stressed the enormous advances in naturalistic representation apparent in it. Less has been said about the limitation of this naturalism – to some extent a deliberate limitation by the painter, I believe, engendered in part by his sense of the peculiarities of painting in books and of qualities that are therefore appropriate to them.

The miniatures in the *Boucicaut Hours*, all full-page, are enclosed by borders of a generally uniform kind. During the course of the execution the design of these borders underwent no major change, such as occasionally occurred in the borders of large, richly illuminated manuscripts – the *Grandes Heures*, for example.[41] If we accept provisionally the date of *circa* 1405–1408 for the *Boucicaut Hours* the greatest novelty in the borders appears already on the folio bearing the very first miniature (Fig. 1). At the four corners and at the center of the outer border the more or less long established formalized 'ivy', gold 'paramecia', and small flowers have given way to large leaves that, unlike the other elements, curl conspicuously into space. Narrow, deeply indented, their main ribs prominently marked, these leaves were probably influenced by Bohemian manuscripts illuminated for King Wenzel or his predecessor Charles IV, examples of which were no doubt visible in Paris (Fig. 465).[42] The Boucicaut Master might well have been influenced also by the closely related forms employed from around 1400 to 1407 in Paris by the Master of the Brussels Initials (Fig. 467). The Limbourgs and their circle adopted 'pseudo-acanthus' leaves of this kind for initials in 1405 and 1406.[43]

Beginning on folio 29 verso of the *Boucicaut Hours* one group of pseudo-acanthus leaves is sometimes partly or wholly replaced by a pea-like vine and flower (Figs. 14, 32) or a plant growing from a pot (Fig. 21), naturalistic vignettes for which precedents existed as early as the work of Pucelle.[44] Whereas these freshly observed flowers may be considered advanced, the borders of the two beautifully painted miniatures at the very end of the cycle of the saints regress by abandoning one cluster of leaves for the older type of formalized gold corner unit (Figs. 26, 27). A sequence of this kind seems to indicate that the borders were painted within one span of time. The miniatures themselves, as we shall see, show a similar alternation between advanced and conservative designs, and thus also suggest one campaign of execution.

The filigree of the borders is unified and bounded along three inner limits by a gold bar. This bar resembles closely the one that serves as the frame of the miniature; between the two, at the sides, there is a narrow strip of quite bare parchment, and below, a somewhat wider strip with filigree. These three strips, partly like and partly unlike the main border, constitute what is perhaps best called a zone of detachment of the miniature. This kind of zone commonly separated miniatures of the later fourteenth century, with their increasing depth, from the relatively flat filigree and the script. It served as a bridge between two diverse spatial realms. It largely supplanted the broad bands that surrounded thirteenth-century miniatures, as in the *Psautier de St. Louis*.[45] These bands, common also in Trecento Italian illumination, succeeded in emphatically bounding the miniatures but only by no less emphatically emphasizing the flatness of the page.

From the time of Pucelle, French illuminators more than Italian sought to harmonize the tri-

dimensional miniature with the two-dimensional script and the thin resilient folio itself. As the impact of the recession of space increased, particularly in the representation of box-like interiors, the miniature seemed to require stronger boundaries – boundaries that would, however, be neither flat nor massive. These might have been provided by moldings simulating those around panel paintings or sculptured reliefs; this was the solution of the Parement Master in the *Très Belles Heures de Notre-Dame*.[46] The narrow, flat gold frame might on the other hand have been replaced by architecture; Gothic piers and arches, indeed, had been used for this purpose much earlier,[47] and the Limbourgs employed similar – but more voluminous – structures for their miniatures of 1402–1404 in the *Bible moralisée* (Fig. 471). Here the architectural frame is projected forward from the plane of the picture and of the parchment.[48]

The very first miniature in the *Boucicaut Hours* shows a related pavilion, but it all lies behind the picture plane (Fig. 1). Thus the architectural framing arch no longer obtrudes. It greatly reinforces the thin gold frame just in front of it but it is at the same time firmly fixed in the pictorial space. Inasmuch as it is the front face of the tabernacle under which Leonard stands it belongs to both the scene and the frame; it serves as a kind of architectural entrance arch. Structures of this kind first appeared in Trecento panel and mural painting, particularly in the works of Simone Martini and the Lorenzetti, and they were adopted in France by the Parement Master and Jacquemart de Hesdin (Fig. 136).[49] They fulfilled a special need in French illumination, where heavy frames simulating those of altarpieces or frescoes would not have been generally admissible.

In the miniatures we have cited by the Parement Master, Jacquemart, the Limbourgs, and the Boucicaut Master, the entrance arch is the nearest side of a tabernacle or a chamber that is parallel to the picture plane. In subsequent miniatures in the *Boucicaut Hours*, the *Martyrdom of St. Thomas* (Fig. 11), and more completely in *The Marshal praying to St. Catherine* (Fig. 23), the building behind is separated from the entrance arch. The two differ in character or position. Three-quarters of a century earlier the Lorenzetti had already partially accomplished this differentiation, chiefly by making buildings wider or higher than the aperture that framed them.[50] It seems to have been the Boucicaut Master who created the fully detached arch; it appears again in his miniature of St. Gregory in the *Grandes Heures*, finished in 1409 (Fig. 62).[51] The arches, or posts and lintel, compose a true intermediate form or diaphragm, though now they belong more to the frame than to the illusory space behind. Of course an entrance arch just inside the frame was employed earlier in French miniatures – in the *Psautier de St. Louis* for example – but then there was no building nor measured space behind it.

In the miniatures by the Boucicaut Master already cited the diaphragm is an arch that extends along the sides and along the frame at the top. In other instances it appears below as well. Sometimes we find a high sill, a diaphragmatic form used earlier by the Parement Master (Figs. 5, 16, 17).[52] At the lower frame of the *Trinity* two angels spread a curtain (Fig. 39). The unexpected garland of earth strung along the lower frame in the miniatures of St. Lawrence and of St. Pancras serves the same function (Figs. 8, 14). In these scenes and in an earlier composition, the *Annunciation to the Shepherds* in the *Brussels Hours*,[53] the lower diaphragm has an additional function. It promotes the effect of the floor or terrain passing below the frame. Related diaphragmatic hillocks

appear again in the *Boucicaut Hours* in the miniatures of St. Michael, St. Martin, and the Visitation (Figs. 2, 19, 30).

The Boucicaut Master employed the true diaphragm arch only in front of representations of interiors. Although he abandoned architectural continuity he wished to preserve a kind of representational consistency, and isolated arches rising in a landscape are a modern phenomenon, not medieval. Where the interior is open to the sky and does not rise to the upper frame, as in the *Nativity* and *Adoration of the Magi* (Figs. 31, 33), he set the nearer 'arch' a short distance behind the frame.[54] Here too the gold band is strengthened along the beholder's lower 'zone of entry' by small barriers: a strip of terrain, a couple of trees, or a low wattle fence (Figs. 2, 3, 31). The painter never introduced the complete diaphragm arch into these scenes. It was, furthermore, less needed because landscape, by its very nature, punctured the folio much less emphatically than did the interior; it retained or reasserted a relationship with the border, consisting as it did of innumerable small shapes and even of some of the same objects, such as leaves and flowers.

It is a striking fact, furthermore, that the most remote space, the sky, though radiant near the horizon, is always a dark blue above, and even this comparatively flat and formal color is some-times brought still more into the context of the page and the book by being strewn with stars (Figs. 30, 33, 37). Into the deepest spaces, moreover – astonishing panoramas, shimmering in a real Channel haze – the painter injected areas of gold. These metallic surfaces are radiant yet relatively flat, and inherently more related to the frames and the border than to the painted work. An enormous burnished gold sun, for example, looms over the horizon in the *Flight*, made vibrant by rays darting from its center, across its face and out over the blue sky (Fig. 35). Its face, furthermore, is encircled by three arcs of orange, which repeat a color prominent in the foreground but totally lacking in the distant hills. Around it, on the other hand, are two circles of nebulous white that partially restore a relationship of the sun to the adjacent landscape. Even the rays, though only symbols of natural phenomena, bear comparison with the painted forms nearby by virtue of their random widths and their scintillating, irregularly placed strokes.

These heavenly bodies are the most dazzling features of the *Boucicaut Hours*. Though associated with the sun in the *Flight*, they are usually visionary or supernatural forms. In the very second miniature one, with wavy rays, hovers over St. Michael to celebrate his conquest of the devil (Fig. 2). The cult image of St. John the Evangelist merits only a smaller orb (Fig. 4), whereas the Lord honoring St. Lawrence as he lies on the coals emits golden rays over a large quadrant (Fig. 8). Similar heavenly light appears over St. Bridget and St. William (Figs. 26, 27). In the deeper compositions of the *Visitation* (Fig. 30), the *Annunciation to the Shepherds* (Fig. 32), and *David before the Lord* (Fig. 40) the rays move down into the middle ground, so that the distant landscape near the horizon is perceived through them. This unnatural circumstance paradoxically enhances the naturalistic effect of the aerial perspective, breaking up the sketchy forms still more and contributing to their vibrant luminosity.

These celestial fireworks have other values in the paintings of the *Boucicaut Hours*. They are not only refulgent and translucent but they commonly compose large geometric shapes, exemplifying in heaven the kind of order visible in the world. Such forms are especially significant, as we have suggested, in the context of illumination, and in miniatures that contain so lavish a display of

heraldry. The radiances in the skies have, too, their terrestrial counterparts, though quieter and less prominent. Several floors are golden, at times glazed in red to form tiles (Fig. 1),[55] or lightly toward the rear to suggest shade (Figs. 14, 36). Often one area of a halo – usually the inner side – nearest a saint's head is covered with a patch of transparent red or green; at times these patches look like shadows, at others like foils between the gold and the light color of the flesh. The shadow on the halo of St. Francis is, however, black. Windows are shining silver, often partly glazed to simulate – very effectively – red and blue colored glass (Figs. 5, 23).[56] The shield and the wings of Michael are gold glazed with red (Fig. 2). The garments of figures often bear gilt highlights (Figs. 1, 4).

The burnished and glazed gold and silver constitute a fundamental category of color in the *Boucicaut Hours*. They are juxtaposed with surfaces in which color and light are produced by paint, or perhaps we should say by non-metallic pigments. The combination of the two luminary modes, present more or less in almost all pictorial styles beginning with the Byzantine, attained an unprecedented degree of subtlety and importance in the years 1390–1425. The orchestration of the two in the work of Giovannino dei Grassi, the Boucicaut Master, Gentile da Fabriano, and the early Fra Angelico was never equaled again. The later critical tradition, shaped by the Florentines of the Renaissance, found the combination logically contradictory, and at best only a necessary transitional stage on the way to the consistent painting of light. Already in 1435 Leon Battista Alberti, in an influential passage, condemned the use of gold and invited painters to simulate its effects with pigments.[57] The future certainly lay with the abstainers according to Alberti, but the disappearance of an art, or its lack of influence, is not necessarily a token of its weakness. On the best pages of Giovannino and the Boucicaut Master the two modes do not conflict but enhance each other. The interplay of painted and actual reflected light, of glazed metal and 'counterfeited' translucency, create effects of rare and exquisite beauty. They are reminiscent of the enamelled *joyaux* of the time with their glistening precious stones. *Orfèvrerie* was a highly developed and greatly esteemed art in this period of lavish princely patronage, and illuminators attempted to emulate it.[58] A generation later Jan van Eyck, when painting panels as well as miniatures, still felt its spell.

The Boucicaut Master's effectiveness with glazed metals certainly did not diminish his interest in the painting of light and color. He was the great pioneer, as we have seen, in aerial perspective, discerning and rendering with a marvelous touch the pallor of distant forms blurred by atmospheric haze. It is probably no accident that the discoverer of aerial perspective resided not in the Mediterranean but in Northern Europe, where the air is substantial so much more of the time. Not more surprising is the interest of a great French painter in clouds; they float near the horizon of the *Visitation* (Fig. 30) as well as in miniatures in other manuscripts by him (Figs. 104, 232). The Boucicaut Master is again one of the innovators. Clouds appear around the same time in the *Crucifixion*, much influenced by Jacquemart, in Yates Thompson 37,[59] in a *Martyrdom of St. Denis* in Douce 144 of 1407 (Fig. 59), in the *Pontifical of Luçon*,[60] and, inspired by the text, they fill the sky of *Aurora* by an associate of the Épître Master, again executed in these same years (Fig. 478).[61]

When rendering tiny distant objects the Boucicaut Master departed radically from the age-old

tradition of representing objects as they were understood to be and not as they were seen from a particular position and under particular conditions of light. The great painter perceived that distance and atmosphere partly 'destroyed' things. As he deftly laid his blue, gray, or pale green over the buff ground he allowed his brush strokes to be quite visible (Figs. 30, 35). An irregular spot of green is a tree, a few quick brown lines make a house, some wavy strokes compose a meadow. Here again, however, the painter proves not averse to some inconsistency, for a man or even an animal may be as large as a house, and more completely defined than a tree.

Prior to these miniatures by the Boucicaut Master receding forms in landscapes were differentiated, in both French and Italian painting, by varying color and hue, and the most distant object or hill, no less solid than its predecessors, was often also the darkest.[62] Though abandoning this convention for the background the Boucicaut Master retained it for the foreground, or at least for many forms in it. Especially the costumes of the figures normally bear the traditional saturated colors, quite unaffected by any atmospheric envelope. The painter may have wished to preserve intact the symbolic connotations of colors, such as the blue of the Virgin. He was concerned also with their expressive power, the black of the mourners and the violet and gray of the walls in the *Funeral Service*, or the bright sunny world of the shepherds to whom the angels bring the glad tidings of the birth (Figs. 32, 41). On the other hand, the strong local color in some buildings where it seems inexpressive and inharmonious – the vermilion vaults of the *Funeral Service*, for example (Fig. 41) – implies a limitation of artistic capacity.

The Boucicaut Master did, to be sure, significantly soften the color of the figures in the preceding miniature, which is the last, and presumably the latest, great outdoor scene in the book, *David before God* (Fig. 40). Intense, forward-moving vermilion has given way to red,[63] the tunics of David and of the Lord are violet, and the mantle of God is a paler blue. The light, furthermore, plays more prominently over these surfaces. It evokes the faces and the hands, but this it had done in the very first miniature in the manuscript (Fig. 1). The flesh surfaces of St. Leonard and of the two nude prisoners seem bathed in a soft light, the volumes evolved without any lines and by the subtlest variations of value. One might suppose that this impressive accomplishment was limited to very high values, near white, but the painter demonstrates that he can achieve similar effects with rose, brown, violet, and gray – as in the hamlet lying in the distance in the *Annunciation to the Shepherds* (Fig. 32).

The illuminator was sensitive to changes in color produced by the interrelation of surfaces. Thus the white, transparent loincloth of Christ in the *Crucifixion* turns blue when it hangs before the sky (Fig. 37). The halo of St. Denis is reddened by the reflection of the severed neck (Fig. 16). Some of the combinations of color are original and very beautiful: the *café-au-lait* mantle of Anthony, for instance, over a purplish tunic. St. Augustine wears a luminous blue cope over a scarcely less luminous black tunic, the whole crowned by a mitre of exquisitely modeled silky white, punctuated by small spots of color. In the magnificent *Trinity* God the Father, in crimson, rests his feet on a dull gold orb suspended before a deep blue stellated sky, while glorious violet angels bearing the pale green and white Boucicaut colors hold a soft red curtain (Fig. 39). Other compositions are less distinguished in color or sometimes even unpleasant, such as the unmodulated red vaults in the miniature of St. Denis (Fig. 16). Perhaps these areas were executed

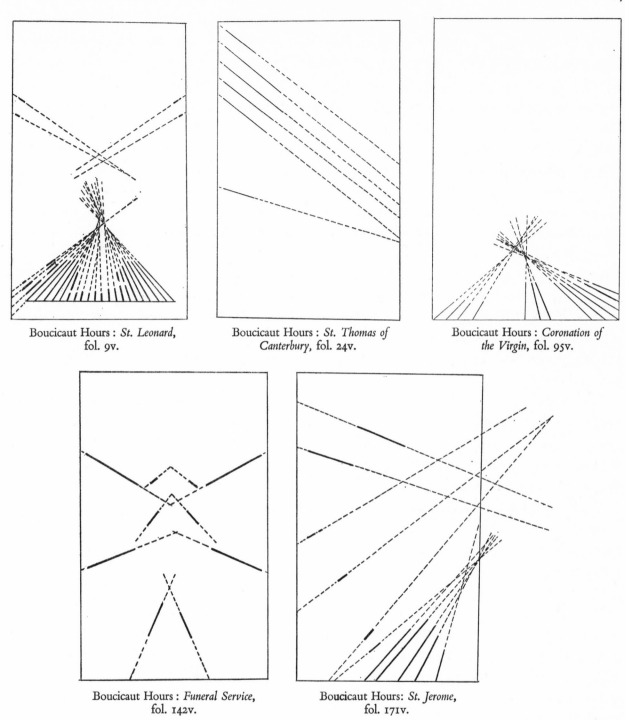

Boucicaut Hours : *St. Leonard,*
fol. 9v.

Boucicaut Hours : *St. Thomas of
Canterbury,* fol. 24v.

Boucicaut Hours : *Coronation of
the Virgin,* fol. 95v.

Boucicaut Hours : *Funeral Service,*
fol. 142v.

Boucicaut Hours: *St. Jerome,*
fol. 171v.

by an assistant; the quality of the miniatures varies conspicuously in other respects also, as we shall see.

The Boucicaut Master, the great discoverer of aerial perspective, acquired an unusual competence in linear perspective also. His structures fall into two main categories with regard to the viewpoint: centralized and asymmetrical. The first miniature, an example of the former, proves that he was thoroughly familiar with the great innovation of Jean Bondol, who, instructed by the Sienese, designed all the orthogonals in a tessellated floor to meet in one point (Text fig.).[64]

This principle the Boucicaut Master applied, with minor deviations, to his numerous tessellated stages. Not infrequently these stages alone define the space, even in the last miniature in the book (Fig. 42). Usually, as there, they signify an interior (Figs. 4, 15), but not in the *Coronation of the Virgin* (Fig. 36; text fig.). In other compositions they have superstructures that compose tabernacles (Figs. 1, 17). In the tessellated floors the tiles left and right of the point of sight grow progressively larger (Figs. 4, 42, 258, 444). This increase is somewhat irregular but it implies a principle, which may derive from the painter's visual experience of the fact that peripheral forms in fact do appear relatively large.

The illuminator was aware that orthogonals higher than the point or zone of sight descend as they recede; parallel lines meet (more or less) on a vertical axis above the vanishing point (Text fig.). Although he was unable to apply focus perspective to all the planes – no one did before Brunelleschi and Masaccio – he often approximated it sufficiently to create an impressive three-dimensional space. This is especially true, among centralized buildings, of the imposing, deep shed of the *Nativity* (Fig. 31) and only to a somewhat lesser degree of the *Adoration of the Magi* and the *Pentecost* (Figs. 33, 38). The control is poorest, surprisingly enough, in the next-to-last miniature, the *Funeral Service* (Fig. 41; text fig.). On the other hand the point of sight tends to be lowered in the latter part of the manuscript, and in folio 125 verso (Fig. 40) the horizon is both low and distant.

The painter was so confident of his mastery of linear perspective that he turned the long axis of the shed in the *Nativity* from its traditional position parallel or oblique to the picture plane to ninety degrees, so that the beholder looks into it through a narrow side (Fig. 31). This shift introduces an element of informality, which the painter counters, however, by increasing the shed to an unprecedented scale and by raising a large canopy over the Child.

A still greater informality distinguishes a second group of interiors. More sophisticated in their perspective, they show the vanishing axis (or the approximation to it) displaced toward the side (Text fig.). The beholder has the impression of witnessing the martyrdom of St. Thomas from a position opposite the left frame, or even a little outside it (Fig. 11; text fig.). The window jambs in the rear wall and the transverse arch of the chapel are designed for this position. In the miniature of St. Catherine the point of sight is moved to the far right, into the area of the beholder within the painting, the Marshal in prayer who looks at the saint (Fig. 23). The association of the viewpoint with spectators in the picture occurs again in the *Martyrdom of St. Pancras* (Fig. 14). In this composition the perspective system of the ceiling is conspicuously different from that of the floor, but both sets of orthogonals converge on the right-hand side, near the two men deep in space who watch the decapitation.

By this novel device the actual beholder finds a counterpart in the painting, and he shares with him not only spectatorship and the perspective 'region of sight' but also the fact of looking at a scene through a frame. The Boucicaut Master, fascinated by the phenomena of sight and perspective, exploited the motif of the window frame. A sort of window cut into the wall above the Virgin in the *Adoration of the Magi* permits an angel to witness the event from above (Fig. 33). An angel leaning through a similar opening adores Christ in the *Nativity*, and even the attentive ox and ass are similarly favored (Fig. 31). From various vantage points in the large building in

the scene of *Pentecost* tiny angels and other figures look out of windows; only one angel, however, is in a position to witness the event (Fig. 38).

The spectators in these miniatures forge a new kind of link between the picture and the beholder. The scenes, witnessed by a company of which the beholder is one, seem to gain in actuality. To the degree that the sacred stories are connected with observers, they are brought further within the realm of time. Certainly space is made more vivid by the glances that carry through it. The Boucicaut Master, indeed, won a greater control of the glance than any earlier Northern painter. Never before had the eyes of David been so firmly and so meaningfully fixed on the Lord (Fig. 40). The sad meditative look of St. William, abetted by the inclination of the head and the fall of the hand, becomes the engrossing central theme of this unforgettable picture (Fig. 27).

David and St. William are perhaps the most moving figures in the *Boucicaut Hours*. St. Bridget is deeply pious, the Virgin is touchingly humble in *Pentecost* and gravely distressed in the *Cruci-fixion*. Saints, such as the Baptist, possess a great dignity (Fig. 3) or, like St. Paul, a high seriousness (Fig. 5). The angel in the *Annunciation* presses fervently toward the Virgin (Fig. 29). In general, however, it is nobility rather than strong emotion that distinguishes the figures of the Boucicaut Master. Similarly the settings are designed to add scope rather than excitement to the narrative. We have already seen that the shed in the *Nativity* is not, as it had become, a conspicuously dilapidated, humble shelter but a soaring geometric pavilion, its roof leaky in only two com-paratively small spots (Fig. 31). The painter foregoes the picturesque for the monumental, the symmetrical, and the durable. The church in the *Annunciation* is loftier than any yet envisaged by a painter (Fig. 29). And of course the far-reaching landscapes give the 'exteriors' the same kind of grandeur. The huge burning sun in the *Flight* is an explicit cosmic phenomenon.

The deep commitment of the Boucicaut Master to scale and symmetry is announced in the very first miniature in the book (Fig. 1). It involves color as well as shape. The orange-red dalmatic of St. Leonard is trimmed with gold and blue whereas the vaults are blue framed by orange-red and gilt ribs, in other words the opposite. The balance is always dynamic, maintained by a counterpoint of diverse means. St. Augustine, for example, standing in a similarly centralized building, faces left but turns his eyes toward the right (Fig. 17). The glance, the inclination of the head, and the gesture of St. Peter Martyr open the figure toward the left, and here an order is imposed from above by the heraldic symmetry of the three angels (Fig. 15).

The largest consequences of the illuminator's fascination with geometry and scale are visible in the *Nativity* and in the *Adoration of the Magi* (Figs. 31, 33). He introduced the same shed, unprecedented in size, into both these remarkable miniatures, setting a different side in each toward the beholder. The *Adoration*, which anticipates the centralized representations of the same scene by Fra Angelico and Leonardo,[65] is deeply Italian also in its salient structure of triangles and balanced diagonals, including the rays from the star. The figures are shaped by similar concerns.[66] In the *Martyrdom of St. Pancras* the body of the commanding officer swells to a large oval (Fig. 14). The high hat of the spectator at the rear is a truncated cone. St. Pancras kneels in front of his executioner, the two composing a triangle along the main axis of the scene. The soldier faces left, the saint right; they join in a rich contrapposto. Such consolidation is exceptional in Northern art, and even earlier Tuscan paintings of this scene offer nothing similar.[67] Single figures commonly

possess a remarkable internal balance. St. Paul's body, for example, retains to a degree the Gothic spiral but within it a strong organic structure has emerged (Fig. 5). He stands reading, his head inclined toward the heavy book that he holds high on an arm while the counterposed shoulder is felt clearly through the mantle flung, in an opposing movement, across it. The *Boucicaut Hours* is evidently a momentous work.

Although the series of miniatures in the *Boucicaut Hours* is, as illumination goes, exceptionally uniform, the reader leafing through the book quickly becomes aware of some variations. A very few miniatures appear duller: the five female saints, though their faces are, to be sure, abraded (Fig. 24), the last two miniatures (Figs. 41, 42), and *St. Christopher* (Fig. 13). St. Christopher seems both inferior and unusually linear, with a flying mantle flapping over a tottering body and maladjusted legs. Tentatively one allows for the possibility that the Boucicaut Master employed an assistant, and that he gave him little instruction about even the general lines of his composition. Possibly, on the other hand, the difficulties arose from an attempt by the *chef* to set the figure in motion. The painter was not ever memorable for endeavors of this kind, but St. George, his horse, and the dragon or the men stoning Stephen are superior to our wobbly St. Christopher.

St. Michael, on folio 11 verso, is a similar but more impressive figure, the agitation of his mantle produced by his encounter with the devil (Fig. 2). His *standbein* too is in the right place. The elaborate calligraphy here seems bound up with the subject, whereas the landscape, inspired by Jacquemart, belongs to a different and more advanced mode. A similar subject a few folios further on evoked the same kind of florid linearity (Fig. 10). In the conquest of the dragon by another princely warrior, St. George, the flourish pervades the entire design. Much deeper in the book there are similar correlations. The Coronation of the Virgin on folio 95 verso is presented as an elegant courtly ceremony, the space shallow, apart from the floor, and the design two-dimensional (Fig. 36). On the other hand the brutal destruction of the saints, carried out by soldiers of a very different kind, occasioned from the beginning – except for the *Stoning of Stephen* (Fig. 7) – searching experiments in naturalism. We have already discussed the voluminous forms, the powerful gestures, and the vivid space of some of these scenes: the *Roasting of St. Lawrence*, 20 verso (Fig. 8), the *Shooting of St. Sebastian*, 21 verso (Fig. 9), the *Decapitation of St. Thomas*, 24 verso (Fig. 11), and of *St. Pancras*, 29 verso (Fig. 14).

These observations may be relevant to a puzzling aspect of the *Boucicaut Hours*. A male donor appears in two miniatures, on folio 26 verso in armor (repainted by Aymar), on folio 38 verso in a red *houppelande* (Figs. 12, 23). Near him are the green and white colors and the motto of the Marshal (repainted on 26 verso), and presumably originally his arms. What a difference, however, between the two heads! Though the second has been identified as the Marshal's brother, Geoffroy, the armorials and other evidence suggest that we do indeed have two representations of one man. This man could well be around forty in the second portrait, but much younger – perhaps ten years – in the first.[68] The difference between the two compositions as a whole is no less great than that between the portraits, and it has been an important factor in the hypothesis that the entire cycle was painted in three campaigns over a decade, with these two miniatures near the beginning and the end.[69]

It is, however, just the extraordinary degree of difference between the two compositions that

makes us a little uncertain how to understand them. The advanced space of the scene of the Marshal before St. Catherine requires no comment; the miniature appears near the end of the cycle of saints and the beginning of the Hours of the Virgin. The miniature of the Marshal and Antoinette before the Madonna falls about halfway through the series of saints; it follows immediately upon the vivid interior of *St. Thomas*, and it is followed by – after *St. Christopher* – the no less vivid interior of *St. Pancras* (Figs. 11, 12, 14). Yet the Marshal and his wife are given the shallowest space in the entire book. Is this simply a sign of early date? Even if the miniature is very early, why should the donors be given the most old-fashioned design of all?

These questions cannot of course be answered without considering the entire group of manu-scripts in the Boucicaut style, and even then no categorical reply could be given without inter-rogating the principals. We suspect that the subjects may have had much to do with the com-positions. On folio 38 verso St. Catherine stands close to the Marshal, occupying the same space as he. In answer to his prayer she seems to have come down to a prepared place – the famous shrine of St. Catherine at Fierbois, perhaps, where in 1408 the Marshal founded a hospital in her honor.[70] The Marshal looks intently at her, and she, a demure young woman, casts her eyes downward in his direction. In the other miniature the Madonna and Child loom in the heavens above the donors, a mystical apparition. She is the Apocalyptic Woman with her child, 'clothed' with the sun, the moon 'below her feet', but actually shown in a little more than half-length on a silver sickle, a new form developed in the fourteenth century, particularly in Germany.[71] Neither she nor the Child acknowledges the prayers of the two Boucicaut, and by her elevation in heaven above the curtain and her enclosure within gold and silver symbols she seems remote from them. True, the separation is lessened by the fall of the Child's cloth across the moon and the Marshal's upward glance, but it is still relatively vast, and it must deliberately have been sought.

In this miniature, as in no other in the book, half the pictorial field is filled with a large symbolic form. The exceptional design is surely related to the text that it illustrates, the Seven Celestial Joys of the Virgin. Distinct from the Terrestrial Joys, they were first revealed by Thomas of Canterbury after a vision of the Virgin, in which she promised him both deliverance from his enemies and 'gaudia paradisi perpetua'.[72] It seems quite possible then that the deliberate lack of realism of the composition as a whole may have extended to the conception of the donors. This difference of mode could account for the lack of portraiture. The more youthful, idealized repre-sentation is consistent with the spirit of the composition as a whole.

Inasmuch as the Boucicaut Master painted most of the forty-four miniatures himself he might well have devoted something like two years to the work. In general the book bears signs of an evolving art. The landscapes in the second part – *Visitation*, *Flight*, and *David* (Figs. 30, 35, 40) – reveal formal conquests only promised in *St. Michael* (Fig. 2). *St. George*, however, is from this point of view retrogressive, perhaps for reasons we have suggested (Fig. 10). The very first miniature, *St. Leonard*, is more unified, luminous, and imposing than the last, *St. Jerome* (Figs. 1, 42). The articulation of the third figure, the powerful Baptist, is hard to match further on in the book (Fig. 3), whereas the next to last miniature, the *Funeral Service*, though very ambitious, shows a more confused linear perspective than many of its predecessors (Fig. 41). Paintings that appear advanced in one respect are conservative in another.

There are, then, differences within the cycle of miniatures in the *Boucicaut Hours* that in a few instances may be ascribed to the intervention of an assistant but more often to the master's changing style over a rather short period of time. In some miniatures the Boucicaut Master also appears to have varied his mode to conform with his subject. He seems in addition more variable, more experimental than in any other work. This aspect of his style supports the early date of 1405–1408 that we have for other reasons proposed. All these interpretations depend in part of course upon the evidence provided by the other paintings in the Boucicaut style, which we shall proceed to consider. It should be said now that despite the variations to which we have pointed the miniatures in the *Boucicaut Hours* maintain an exceptionally high level. For consistent strength the cycle is approximated by only one other. The book is obviously the work of a major artist. We shall, in fact, have to try to disengage him from the sizable industry he established, in which he has, it seems to us, been to a very considerable degree lost.

II

The Master among his Associates

THOUGH Paul Durrieu proposed an œuvre for the principal illuminator of the *Boucicaut Hours* half a century ago and many historians have since studied his group, no agreement whatever has yet been reached about the development of this style nor even about the date of the principal work. For a time the task of achieving some order for the fifty or more related manuscripts that are known to us seemed utterly baffling. The origins of the difficulty are, we have concluded, deep, and the resolution of it radical.

The miniatures of the *Boucicaut Hours* vary in strength and in mode but the general level of execution is high and the controlling ideas remarkably consistent. To turn from this splendid work to the related manuscripts is like stepping off a high, bright plateau onto very uneven and generally lower terrain. The longer one wanders about in the attempt to produce a viable map the more one becomes aware that much of what looked quite familiar at first is really rather foreign. To begin with, just where, outside the *Boucicaut Hours, is* the Boucicaut Master? Before coming to grips with the niceties of chronology – always the art historian's hardest task – it is better to try to find the principal artist.

This master, who is nowadays judged great and whom we shall try to show is still greater, appears unmistakably again in a very surprising place: a Book of Hours, Add. 16997 in the British Museum, which is both very small and produced for a layman who is distinguished by no sign of high rank. Whereas the miniatures in the *Boucicaut Hours* measure about 18 cm. high those in the little book in London are only 6.2 cm. Yet almost everywhere in these tiny spaces we are confronted with the majestic designs of the master and also his touch. Here again is the great scale, the monumental simplification, the broad symmetry of shape and of color. In the *Vigils of the Dead* both the bier and the apsidal vault above it are red (Fig. 172). The antependia, the retables, and the corresponding vaults are blue. Many of the friars are brown with gilt lights, like the vaults in the aisles.

In *All Saints* the illuminator makes perfectly clear both his fascination with the representation of an innumerable congress of figures and his equally great fascination with the identity of each one of them (Fig. 293). He could not within so small a compass give them quite the variety of posture and gesture of the apostles in the Jacquemart-André *Pentecost* (Fig. 38), but the remarkable range of physiognomy and movement clearly discloses the same attitude toward the single figure and the same exceptional power of deft definition. In *Pentecost* in London each apostle acts with similar independence (Fig. 292). All twelve again conform, however, with basic principles of symmetry and logical balance, one of the foremost for instance reading, the other looking up. The frontal posture of the Virgin, the greater size of her throne, and the breadth of the group increase the formality of the occasion. Probably to give the figures a relatively large size the painter abandoned the imposing building of the *Boucicaut Hours* and enclosed them only within a high wall, of the kind visible outdoors in the earlier miniature (Fig. 38). The Holy Ghost, again

23

emitting golden rays, emerges from a layer of clouds. Behind the rays, which are geometric in general and random in particular, and visible through them, lies a glorious landscape. It resembles those in the *Boucicaut Hours*, but it is significantly different. At the horizon the hills and the buildings are conceived less as vertical planes; each is a complete volume, perfectly defined in relation to adjacent volumes. Though less sketchy than comparable forms in the *Boucicaut Hours*, they imply much more clearly the continuation of space beyond them.

This more advanced conception of a limitless space governs equally other landscapes in the manuscript in London, particularly the *Crucifixion* (Fig. 299). Here we see also a more developed form of another aspect of the *Pentecost*. Whereas the landscapes of the *Boucicaut Hours* consist of a series of overlapping units – hills and water – the *Crucifixion* in London shows a comparatively flat plane that extends continuously from the hillocks behind the figures to the distant city. The composition derives from the type of flat landscape developed about 1375 in the circle of Bondol[1] and exploited still, in more modern dress, in numerous miniatures by the Master of Cité des Dames in 1409 (Fig. 71). The Boucicaut Master transforms this type by decisively lowering the horizon and by applying to it more knowingly than any of his predecessors the laws of aerial perspective. Sympathetic to Italian principles as he was, he introduced indications of a tri-partite division of the landscape, creating thereby a flat middle ground that sweeps uninterruptedly into the distance.[2] Only the Limbourgs during these years made similar experiments, developing too both the Italian mountainous landscape and the indigenous flat one (*October* in the *Très Riches Heures*!).

On the great plain of the *Crucifixion* soldiers and a couple of men move about, some of them gazing in wonder at the event. In the landscape of the *Flight into Egypt* are enacted the Massacre of the Innocents and the Miracle of the Corn (Fig. 288). A frisky little dog follows Elizabeth in the *Visitation* (Fig. 283). One of the shepherds, watching the angels who bring the news of the birth of Christ, is accompanied by his family (Fig. 285). In *Pentecost* a shepherd with his dog and flock has moved forward, so to speak, from the distant hill of the *Flight* in the *Boucicaut Hours* to a nearby slope (Figs. 35, 292). He is quite unaware of the scene in the foreground, and in the *Nativity* a man with a pack over his shoulder walks conspicuously away from the event (Fig. 284). The painter, inspired perhaps by Jacquemart de Hesdin and the Master of the Brussels Initials, has thus begun to conceive of the great Christian events as historical.[3] They occur at one moment of time, along with other events and amidst people who do not always notice or understand them. In this respect as in many others the Boucicaut Master is a harbinger of Jan van Eyck and the later Netherlandish tradition.

Some forms in the miniatures of the *Boucicaut Hours* that had been continued from an earlier period have disappeared in Add. 16997. Scintillating diapered grounds, for instance, have yielded completely to graduated skies, often starry. On the other hand the painter's innovations tend to persist. There are diaphragm arches in the *Vigils of the Dead* and in the *Requiem Mass* (Figs. 172, 174). The *Elevation of the Host* has an entrance arch, the piers of which bear statues of the Baptist and St. John Evangelist (Fig. 294). St. Joseph looks through a 'window' in the *Nativity*, and angels may be said to do the same in *All Saints* (Figs. 284, 293). But more important is the evidence in the little book in London of the same touch – deft, sure, wonderfully expressive.

Though the haloes are minute compared with those in the *Boucicaut Hours* they are given the same rose shadows. In the *Requiem Mass* the brush evokes unerringly statues an eighth of an inch high, swirling gold arabesques on the tiny bier, reflected light on the central mourner, the flames of candles (Fig. 174). The canopy over the celebrant in the *Elevation of the Host*, like the hills and houses outdoors, is touched by a soft golden light at just the right place (Fig. 294). The whites melt into darker rose and yellow. In general the forms are softer and more luminous than in the *Boucicaut Hours*.

The manuscript in London was clearly painted much later than the one in Paris. The borders show a corresponding advance: large stems and curling acanthus leaves against a filigree of small flowers and stylized forms. Especially indicative are the large, serrated oak leaves of light green that lie flat on the page, as in the work of the Master of Walters 219, active around 1415–1420 (Fig. 479).[4] Nor would a date *circa* 1415–1417 be contradicted by the one miniature in the book not painted by the Boucicaut Master: the *Presentation in the Temple*, executed in the most refined manner of the Bedford workshop (Fig. 287). This style, which may be seen again in the *Death of the Virgin* in Châteauroux shortly before 1415 (Fig. 111), and later in the *Man of Sorrows* in Vienna 1855, may perhaps be identified with the *chef* himself.

The Book of Hours in London has been discussed at length because the Boucicaut Master himself painted most of it and also because it and the manuscript in the Musée Jacquemart-André represent the two poles of the painter's style. The *Boucicaut Hours* seems to me the earliest cycle we possess from his hand and Add. 16997 the latest. Among the hundreds of related miniatures only a few dozen may, I have finally concluded, be considered *eigenhändig*. Some of them appear, fortunately, in dated or datable manuscripts. First in time is the famous frontispiece to the 1412 copy of the dialogues between Charles VI and his counsellor Pierre Salmon, a manuscript preserved in Geneva (Fig. 72). The miniature is accompanied by beautiful marginal decoration, the exceptional nature of which is not to be ascribed to the intervention of an English illuminator but to its subject.[5] The border incorporates the motto of the King, 'James', and his emblems: peacocks bearing royal crowns and fine sprays of broom, heavy with golden pods and growing from roots placed within the initial.[6] The leaves are the green, red, and black proper for the King and the same colors together with gold and white brighten the canopy. Charles wears the same emblems around his shoulders below a richly jewelled collar; and inasmuch as his canopy and bedspread are covered with *fleurs-de-lys* and *France moderne* appears in the windows, the display of heraldry matches the *Boucicaut Hours*, though of course in a secular scene.

In many other respects too the painter has given the scene great immediacy. Charles has a homely but interesting face with a highly conspicuous Valois nose, and in this particular his counsellor even outdoes him. Jean sans Peur can be readily identified by his features, without the assistance of his hammer. One suspects that the other two princes are Berry, the oldest of the group, and Orléans or Anjou.[7] The King addresses Salmon, raising a finger to emphasize a point; perhaps he puts his first *demande*, asking his *magus* how mankind could have multiplied without committing the original sin.[8] Jean sans Peur points, it seems, toward two little animals at the foot of the royal bed. An ape appears to fondle a contented little white dog, possibly signifying, in this period of high tension between the Burgundians and Armagnacs, the hope of reconciliation.

The unstable position of the King on the bed and his lively outlines manifest the painter's interest in narrative actuality, to which he has in fact sacrificed spatial clarity. The canopy has been pushed to the left, out of the way of the King, and the rise of the floor is surprisingly steep. The interior has however an impressive scale, and the contrast between the comparatively high value of the diaphragm arch and the darker stone of the room helps to create a convincing depth. Windows and shutters stand open, permitting a view of a radiant sky, in which stars shine. A plant grows in a pot in the window, attracting the eye to the view.

Despite these glimpses of light and color the painting is less luminous than those in Add. 16997. The blues of the curtain and the canopy as well as the red, black, and gold of the floor are relatively unvaried. The painter cared more for the symmetry and balance of his large areas of blue, black, red, and green. In this respect the composition is not very different from those miniatures in the *Boucicaut Hours*, such as *St. Jerome* or *St. Francis*, in which volume and narrative count most (Figs. 22, 42). The same might be said of three or four of the small miniatures in a Breviary at Châteauroux that was very probably made shortly before 1415 for the Dauphin, Louis Duc de Guyenne, who died at the age of eighteen in that year. Here, indeed, the degree of participation of the Boucicaut Master himself might come into question. In the *Martyrdom of St. Lawrence* the figure of the victim is almost identical with that in the *Boucicaut Hours* (Figs. 8, 107), whereas the deeper space is defined by an elaborate building, which also provides windows for spectators of the event. The illuminator has rationalized both the space and the actors, allotting to each category of persons, so to speak, its own compartment. In the miniature of St. Martin a city towers over the saint as he shares his cloak with a beggar, replacing the diapered ground of the *Boucicaut Hours* (Figs. 19, 117).

The figures in these miniatures seem rather conventional, and this is true of two additional miniatures which are, however, very fresh and inventive in other respects. One represents a procession entering the portal of a cathedral, the bishops bearing a large golden cross that, given the entire context, is probably the 'Croix d'Anseau' possessed by the chapter of Notre-Dame, Paris, since 1109 (Fig. 106).[9] The procession passes through the central portal of the west façade, and the tympanum approximates the relief of the Last Judgment that actually fills this portal. In a simple but significant respect the Boucicaut Master did not, however, follow his model. He rounded the Gothic arches of the portals, perhaps simply because of his preference, more marked in his late works, for circular shapes. If true this would be a striking demonstration of adherence to an aesthetic rather than a naturalistic criterion. The illuminator, relying in general ever more on observed forms, no longer felt committed to the representation of complete buildings. He shows us only the lower part of Notre-Dame, in other words what we can see looking through a 'window' from a point nearby.

A second miniature in this group shows the interior of the Sainte-Chapelle in much reduced scale (Fig. 112); clerics cense the altar bearing the famous reliquary of the crown of thorns. Much more impressive is a remarkably accurate view of the Sainte-Chapelle from the south, the wall removed to show the exhibition of the important relics of the Passion that belonged to the church.[10] These portraits of specific buildings were executed around the same time as the famous *châteaux* of the Duke of Berry in the calendar of the *Très Riches Heures*.[11] They were preceded by

occasional single images in Trecento painting, such as the Cathedral of Florence by Andrea da Firenze in the fresco of the *Via Veritatis* in the Spanish Chapel of S. M. Novella in Florence.[12] The Limbourgs approximated such Italian precedents more closely, seeking to show the building as they knew it to be. They constructed in other words a sort of huge model. The Boucicaut Master on the other hand attempted to show the buildings more as he saw them from a distance.

The different and indeed radically new outlook of the Boucicaut Master is demonstrated in dramatic fashion by two remarkable views of the city of Paris in the Châteauroux Breviary, beyond doubt carried out by his own hand (Figs. 115, 116). In the instance of vistas as of the portrayals of single buildings the initial steps were taken by Trecento painters, above all by Ambrogio Lorenzetti in his famous representation – I hesitate to say view – of Siena, seen from a position within the town. Once again, too, the Limbourgs undertook a similar venture at the same time as the Boucicaut Master, introducing some Parisian buildings into the distant landscape of the *Meeting of the Magi* (Fig. 477). Each of these two leading French workshops learned quickly what was afoot in the other, and this fact strongly supports the proposal I have advanced earlier that the *Très Riches Heures* was painted in Paris,[13] where the headquarters of the Boucicaut Master was certainly established. The Limbourgs, again closer to Trecento precedents, presented exquisitely detailed little pictures of Notre-Dame and the Sainte-Chapelle, somewhat softened by the atmosphere but in a remarkably even light. These two buildings stand out in the miniatures of the Boucicaut Master also, but they lack sharpness and they are even distorted in perspective so as to be recognizable by familiar elements. They rise from a sea of buildings enclosed by the wall of the city. The whole marvelous panorama lies before the beholder, who stands near a distant hill, probably Montmartre.[14] The hill catches the light of the sun, its flank glowing with soft touches of gilt emulsion. In the *Martyrdom of St. Denis and his Companions* peasants and shepherds traverse the plain, which changes imperceptibly from light green near the hill to gray-green further away (Fig. 115). Many of the nearer roofs of Paris are blue, and they too catch the sunlight, shining with small irregular patches of gilt paint. The more distant buildings are much grayer, and the impression of dusk given by the relative darkness is enhanced by the starry sky behind.

Whereas the buildings of the Limbourgs, even in the distance, take shape more in accordance with what they know about them, the Boucicaut Master looks with unprecedented penetration, and relies more on his eye. It is he, not Jan van Eyck nor Masolino in S. Clemente or at Castiglion d'Olona, who had the honor of painting the first true *Häusermeer*.[15] Still, even in moments of tremendous discoveries he seems deliberately to control, limit, and revise his perceptions, just as he did earlier in the *Boucicaut Hours*. In the vistas of Paris he developed the tonal difference between nearer and further buildings to create effects of daytime and evening, corresponding to the simultaneous presence of the sun and a starry sky. This combination, far from striking us as contradictory, is so artfully achieved that it creates a rare and wonderful kind of cosmic poetry.

The production of the associates of the Boucicaut Master was so vast and the iconography so varied that the historian may more readily orient himself by surveying the representations of one or two subjects. The Annunciation offers advantages, because as the illustration of Matins

of the Hours of the Virgin it was normally painted by the best hand in the book, though this hand was not often therefore, as we shall see, that of the *chef* himself.

In the *Annunciation* in the Jacquemart-André Hours the Boucicaut Master developed the kind of ecclesiastical setting introduced by Jacquemart in the *Petites Heures*[16] into the first full-fledged church in representations of this scene (Fig. 29). Full-fledged, no doubt, in its high vaults above, but only semi-fledged below. The piers or columns of the great central arch come down into very different depths, and the lack of spatial clarity is compounded by the tapestry, which is suspended from hooks in the piers at the further side of the first bay but hangs down into the space just behind the feet of Gabriel and the cushion of the Virgin. The kneeling Virgin turns around from her prayer to greet the angel, as she had done in the *Brussels Hours*.[17] To the Brussels prie-dieu, however, the Boucicaut Master added an altar, a form that was in fact present already in the *Petites Heures*. In the *Boucicaut Hours* the majestic Virgin raises her hands in surprised acceptance of the angel's words, which seem to be spoken with a rare and beautiful urgency. Gabriel, pressing close to her, folds his hands in deference and at the same time delicately supports his scroll. One candle burns on the altar, near the luminous silver windows.

When we turn to other representations of the Annunciation in the Boucicaut style we encounter several types, and we soon recognize that the simplest is not always the earliest, even when appearing in a painting of relatively high quality. The miniature in the splendid Book of Hours in the Bibliothèque Mazarine, for instance, appears on what is perhaps the finest page in a fine book, but it shows only a floor moving back, and rather steeply up, to a tooled gold ground (Fig. 118). The only properties on the stage are a prie-dieu and a faldstool. On the former a tall lily is somewhat precariously balanced. The angel and the Virgin might be described as simplified versions of the figures in the *Boucicaut Hours*, but the flow of lines is smoother, and the scroll adds a strong flourish to the encounter. It leads the eye to God the Father and the swarm of angels around him, who spill into the framed area from above. This rich and beautiful border, surely designed by the Boucicaut Master, proves that the book belongs to the later phase of the workshop (Fig. 263).

A very similar composition of the Annunciation appears in a well painted miniature in Brussels 10767, sometimes regarded as the earliest work of the painter (Fig. 119).[18] It would not seem to be significantly earlier than the Mazarine *Annunciation*, and it was hardly painted by the Master himself. The border as well as the other inferior miniatures in the book imply a date no earlier than *circa* 1410.

Miniatures of the Annunciation in the Boucicaut style much more frequently place the Virgin at an altar than at a prie-dieu, though occasionally both appear side by side. In Books of Hours in the Zwemmer Collection and in the Walters Art Gallery (ms. 238) the altar occupies a small shrine that is represented in its entirety (Figs. 120, 121). In other miniatures the chapel rises above the upper frame so that only a segment of the vault is visible. In Books of Hours in Brussels (ms. 11051)[19] and in Turin the vault runs parallel to the picture plane (Figs. 122, 246), in a private collection and in Berlin diagonal (Figs. 123, 124). The church, two or three bays deep, is frontal in Paris, lat. 1161, and in the *Hours of Saint-Maur* (Figs. 125, 127). The latter borrows from the *Annunciation* by the Limbourgs in the *Belles Heures* the posture of the Virgin, the lectern, and the

arch in the picture plane; the vaults are lacking in the model (Fig. 126).

In most of the representations previously mentioned, including the *Boucicaut Hours*, God the Father hovers outside the main field or the building; in the *Hours of Saint-Maur*, however, he occupies a special little bay *à la Limbourg*, and in the miniature in Berlin he appears within an arch of the church (Fig. 123). This provision of a special compartment, analogous to what we have noticed in the Breviary in Châteauroux, becomes frequent in later Annunciations in the Boucicaut style. God appears in what is defined vaguely as a domical apse in Walters 260, and more explicitly in the rich miniature in the Charnacé Collection (Figs. 130, 131).

In both the preceding compositions the angel approaches from the right, and this is true also of two otherwise very different miniatures, one in a Book of Hours in the collection of Prince Corsini in Florence, the other in the Bibliothèque nationale, lat. 10538 (Figs. 128, 129). Compositions of this kind are not common earlier. Inasmuch as the scenes are on a right-hand page perhaps the painter preferred to show the angel moving toward the center of the book rather than out of it.[20] This hypothesis may be supported by the fact that the right-to-left movement does not occur in any Boucicaut *Annunciation* painted on a verso, though it may be seen in the *Adoration of the Magi* in the *Boucicaut Hours* which is in that position.

Below the *Annunciation* in the damaged Book of Hours lat. 10538 the Virgin weaving in the temple seems to be in a kind of crypt, and the angel here as well as in the chapel above flies horizontally toward her. The building occupies most of the folio, creating a deep space around the five lines of script (Fig. 129). This innovation, which may have been inspired by late Trecento Lombard or Neapolitan models,[21] is developed further on a subsequent folio that bears the illustration for the Penitential Psalms (Fig. 257). David, who kneels in prayer below, is seen from a high point of view, and the landscape extends effectively behind the script. The text is, in fact, framed by a gold border as though it were the illusory miniature. It appears in front of the space, suspended like a picture – or, rather, a billboard.

In the Corsini manuscript the frontal church with numerous stained glass windows resembles the representation of Sainte-Chapelle, Paris, in the Châteauroux Breviary (Fig. 112). In the beautiful borders angels glide or soar, making music or bringing food and flowers to the Virgin, who in the margin below works industriously at her loom. The parchment is strewn with stars, as in certain folios by Giovannino dei Grassi (Fig. 475).[22] This page is unique and enchanting in design, but the execution is not the master's.

The *Annunciations* in two manuscripts that are obviously late, toward 1420, restore some of the scale of the miniature in the *Boucicaut Hours*, and they likewise include the exterior of the church (Figs. 132, 133). The building is similar in both miniatures, and they no doubt reflect a composition by the Boucicaut Master himself, though they were painted by quite different illuminators. In the *Heures de Guise*, which is much the stronger of the two and close to the *chef*, God the Father occupies a roundel in a stained glass window. Neither these representations nor any of the others we have hitherto mentioned really approaches the Jacquemart-André *Annunciation* in the nobility of its figures and the grandeur of its church (Fig. 29). That kind of exalted design we may find only where we have found it before, in the little Book of Hours in London (Fig. 134).

As in other miniatures in this late manuscript we look through a diaphragm arch into a lofty

buliding. The shafts of the church, the tall windows, and the soaring vaults seem to draw the Virgin upward, in a kind of figurative Assumption. Both she and the angel, however, are less active now. She lowers her eyes, and even the scroll falls softly, without breaking the stillness. This tiny miniature is one of the most memorable scenes of Annunciation ever painted.

Of all the miniatures in our series only two bear throughout the marks of greatness, or more precisely, of one great artist. What are we to make of the others? It may be useful to propose tentative hypotheses at this point. The varying quality of the borders leaves no doubt whatever about the intervention of assistants; these men were often surprisingly inept. One wonders who hired the author of the borders of the manuscript in Berlin (Fig. 123). On the other hand the folio of the Mazarine *Annunciation*, rich in invention and beautifully painted, must have been produced under the eye of the Boucicaut Master and on his design (Fig. 263). Other Annunciation pages, such as those in lat. 10538 or the late *Heures de Guise*, though not excellently painted, disclose impressive pictorial ideas (Figs. 129, 132). They imply reliance on an imaginative artist, and we have every reason to assume that he was the Boucicaut Master. Some of the associates have sufficient individuality to be readily recognized; this is true of the chief illuminator of the *Hours of St. Maur*, who worked some five years earlier on Douce 144 (Figs. 58, 127). It is significant that he was sufficiently independent in certain miniatures in the former manuscript to abandon Boucicaut models for the *Belles Heures* of the Limbourgs, to which, we should note, he must have had access – or at least to corresponding drawings (Figs. 126, 127). We shall identify later a couple of lesser members of the *équipe*, and the profiles of still others will certainly be restored eventually by those students who wish to apply themselves to these useful but not now, it seems to us, very rewarding endeavors.

In view of our novel estimate of the role of the Boucicaut Master it may be appropriate to consolidate our hypotheses by reviewing briefly a second series of illustrations. For this purpose we shall choose Offices and Masses of the Dead. The miniature in the *Boucicaut Hours* for Vespers of the Office of the Dead takes the same place in the illustration of this subject as the *Annunciation* in this manuscript did in the history of its theme (Fig. 135). A glance at the compositions of the illuminators influenced by the Master of the Coronation and the Master of Berry's Cleres Femmes, showing small chambers filled with figures that nearly touch the ceiling (Fig. 137),[23] establishes quickly the debt of the Boucicaut Master to Jacquemart de Hesdin, particularly to his monumental miniature in the *Brussels Hours* (Fig. 136). The Boucicaut Master cut down Jacquemart's entrance arch and swung the long axis of the building perpendicular to the picture plane, precisely as he had done with the *Annunciation*, the *Nativity*, and the *Adoration of the Magi*.

The text of the Office of the Dead is not the Requiem Mass, which formed part of the Missal, nor the Burial Service, which was contained in a different volume called the Manual. The Office of the Dead, normally included in Books of Hours, was often said in choir over the dead body. The Boucicaut Master described more fully than any preceding painter this setting of the Office. He represented a complete apse and choir of a church. The choir reads from large Antiphonals, and numerous lay mourners in black bear candles. There is a close axial connection between bier and altar. These innovations had, as we shall see, a far-reaching effect on the iconography of the illustration, appearing as late as the great manuscripts by the Bedford Master

and assistants in the *Bedford Hours* and in Vienna 1855 (Fig. 150).[24] The unprecedented depth and height of the Boucicaut Master's composition was achieved in this instance, however, only at some sacrifice of spatial clarity, especially in the relationship of altar and *chapelle ardente*, and it is notable that this difficulty is diminished in later replicas in the Boucicaut style, such as Mazarine 469 (Fig. 149), as well as by the Bedford workshop. How shall we interpret these facts? Did the Boucicaut Master himself revise the composition shortly after the completion of the *Boucicaut Hours*, or did an assistant lay out the miniature in that manuscript?

Not far in time from the miniature in the *Boucicaut Hours* the Limbourgs, illustrating a mass for the dead in the *Belles Heures circa* 1409–1411, envisaged a large church with mourners seated in choir-stalls, but the building is seen from the outside and set at an angle, permitting only a limited though engaging view of the scene (Fig. 145). The seated mourners of this composition were moved into the long frontal church of the *Boucicaut Hours* by the Master of the Hours of St. Maur, who again effected, just as he had in the *Annunciation* in this manuscript (Fig. 127), a combination of Boucicaut and Limbourg forms (Fig. 147).[25] The Egerton workshop employed a more animated version of this composition in Egerton 1070, illuminated, like the *Hours of St. Maur*, around 1410–1412 (Fig. 148).[26]

Several comparatively small miniatures by assistants of the Boucicaut Master continue the fourteenth-century tradition for the illustration of the Office, showing only a floor, a bier, clerics at a lectern, and three mourners, sometimes standing behind a section of a choir-stall (Figs. 138-140). Around 1410–1412, however, two new compositions were introduced. One, the second illustration of the Office in the *Hours of St. Maur*, illustrates the unusual first Nocturn or Matins, and the iconography is novel (Fig. 142). As in a miniature by the Egerton Master in Madrid that shows mourners influenced by the Limbourgs (Fig. 141)[27] the setting is a private house, presumably of the deceased. Within a large room friars gather around the bier to read the service. Three mourners sit before the fireplace near a window and a sideboard that bears a vase and two bowls, perhaps a reference to a funeral repast. This highly developed domesticity is enhanced by the shift of the point of sight toward the left, giving the sense of a casual and informal look into an interior from outside. Light strikes onto the floor of the room through the frontal arch; it enters also through the window behind, brightening a little the top of the table and the wall nearest it. The vibrancy of the soft browns and blacks of the figures is increased by the open brush strokes of the floor and of the gray walls, the whole framed by the radiant white exterior. If to this impressive handling of color is added the individuality of the friars we cannot doubt that the miniature is beyond the capacity of the Master of St. Maur, who painted much of the book, and that it represents a very unusual intervention of the Boucicaut Master himself.

The *Hours of St. Maur*, which is exceptionally rich in illustrations of prayers for the dead, contains a third miniature (Fig. 151). Painted by the Master of St. Maur, it illustrates the normal Vespers Office but in a novel and surprising way. Instead of a reading in choir around the bier we see an interment in a cemetery. The officiating cleric asperges the corpse as it is lowered by two men into the grave.[28] The tools of the gravediggers and the earth they have dug lie in the foreground. This scene of burial illustrates the Vespers Office in two manuscripts that we have already for other reasons connected with the *Hours of St. Maur*, Paris, Bibliothèque nationale,

lat. 1161 and Berlin (Figs. 152, 153). In both these books the cemetery is given a more interesting environment, the roof-tops of a city and, in lat. 1161, a cloister also.

These three miniatures are interrelated in many ways, and they all probably derive from a model provided by the Boucicaut Master. The scene, not directly inspired by the text, springs from the confrontation of the late Middle Ages with the stark fact of the decay of the body. Together with the emaciated *transi* of the tombs, which first appeared in the late fourteenth century,[29] it is the most vivid early sign of the new, more problematic conception of death. Henceforth the interment was employed more often than any other subject for the illustration of the Office.[30]

The grim fact of death is presented around the same time in another, no less vivid manner. In a very beautiful *bas-de-page* illustrating the Office of the Dead in a Book of Hours of the Use of Rome in Turin two gravediggers shovel earth just behind a corpse that lies stretched out on the ground (Fig. 156). The naked body is a dramatic and unprecedented figure in this Office. With its crossed hands it resembles the two wasted corpses lying in a shallow grave in an illustration of the same text in the *Belles Heures* (Fig. 157). Here again we seem to witness an interchange between the Boucicaut Master and the Limbourgs, about three years before they showed an awareness of each other's landscapes.[31] That the resemblance is not fortuitous is proved by the presence at each side in both of a hermit reading a large tome.

The grinning bodies in the *Belles Heures*, surrounded by small mounds of earth, look as if they had been exhumed, a process that required a sizable set of tools. The scene is given an explicit didactic character by a strange bust of a prophet with a long black beard who appears behind a tablet fixed to a column below a crucifix. Looking at the nearby hermit he points towards the grave, and because of his gesture one almost expects to find a moral inscribed on the tablet. Indeed, when freely copying this composition in the *Heures d'Anjou* the Rohan workshop inserted a Crucifixion in this space and suppressed the Crucifix above (Fig. 158).[32] Perhaps some aspects of the novel scene by the Limbourgs were inspired by the immediately preceding cycle of the story of Diocrès. In one miniature this professor, according to the legend, cried out during the funeral service that he had been justly punished by God (Fig. 146). He did so again after it, during the interment (Fig. 155). Later an illuminator of this circle adapted the first scene for the illustration of the Vespers of the Dead (Fig. 144).[33] Surely, however, the illustration of Vespers in the *Belles Heures* reflects Lombard illustrations of a corresponding Office which, already in the later Trecento, commonly showed a skeleton and, still more relevant, the Three Living and the Three Dead (Fig. 161).[34]

We may safely infer that the Boucicaut Master took the hermits from the Limbourgs and probably also the nude corpse, though he eliminated all signs of decay. It is perhaps not accidental that, following a somewhat circuitous route, he should have introduced something resembling Lombard canons into a Book of Hours made, as the manuscript in Turin was, for the Visconti. The lone naked corpse caught the attention of later French illuminators, above all of that great observer of grief and death, the Rohan Master. In miniatures by his assistants the body lies exposed in mountainous terrain, alone except for golden symbols of God's presence (Fig. 159).[35] Around the same time the Bedford Master laid the corpse on a slab in the lower margin, just below a

curling scroll inscribed: 'O mort cruelle trop es dure et amere' (Fig. 160). Though the older medieval conviction of 'gloire pardurable' for the good is affirmed in the inscription at the bottom of the folio the corpse and the scroll demonstrate that it is not evil that is condemned nor punishment that is hard but simply death itself.

The initial at the beginning of the Office of the Dead in the Visconti Book of Hours serves as a frame for a Funeral Service (Fig. 143). The aperture of the initial is much smaller than the space that opens out from it, which is represented with great sophistication. The deceased, a king or a prince, appears in an exceptional manner. Wearing a crown and dressed in pink he or his effigy lies on a coffin or sarcophagus.[36] Another exceptional scene which illustrates the Penitential Psalms in the Seville *Horae* (Fig. 230), may have served as one of the sources of the famous miniature of the Rohan Master to be discussed immediately. A man (perhaps David), who is lying in bed and probably dying, prays to the Lord above him.

The beautiful naked corpse of the *bas-de-page* in Turin reappears, only a little altered, shortly afterward in the lower margin of the folio illustrating the Office of the Dead in the Mazarine Hours (Fig. 164). Nearby, in a thicket of flowers, angels and devils fight for his soul. The lone corpse and the contest served as the major illustration of the usual Vespers Office in a miniature by illuminators of the Boucicaut circle *circa* 1412–1414 (Fig. 163) and again some five years later (Fig. 165).[37] God the Father watches the struggle from above. Certainly a miniature of this kind inspired the famous illustration of the same text by the Rohan Master. This painter brought the Judge and the judged close together; otherwise he added only more skulls and bones, conversational scrolls, and a considerable measure of artistic power (Fig. 166).[38]

The miniature for the Office in the Mazarine Hours, above the *bas-de-page*, resembles the Vigils in the *Boucicaut Hours*, as we have observed. In some respects indeed it is identical, proving all the more clearly that the Mazarine folio, good as it is, was painted by an assistant of the master.

The illustrations of the Office in Books of Hours in the Boucicaut style painted in the period *circa* 1415–1420 assume one of two forms. Some, like the miniature in Cracow, follow the 'close-up' of the Turin initial, giving a view of only a small part of a church (Fig. 171). Others resemble the Mazarine manuscript in composition.[39] The most interesting of this latter group is the miniature in the Corsini Hours, which reduces the scale of the church and limits the number of clerics and mourners to two each (Fig. 167). The mourners kneel before a bench close to the bier, and the intimacy of the whole recalls scenes of the celebration of mass in contemporary Boucicaut manuscripts in which laymen kneel nearby (Figs. 168, 170, 200).

Many of the illustrations of the usual Vespers Office of the Dead in the Boucicaut manuscripts reflect the miniature in the *Boucicaut Hours*. The painting in the Mazarine Hours is especially close, but even it does not maintain the scale of the church in the model (Figs. 135, 149). That is not only restored but greatly increased in the wonderful illustrations of both Vespers and a Mass for the Dead in Add. 16997 (Figs. 172, 174). Again, as in the series of representations of the *Annunciation*, we recognize the brilliant revival and the astonishing development of the ideals of the *Boucicaut Hours*. These minute paintings, made near the fall of Paris and the end of its artistic primacy, had scarcely any following there. It was Jan van Eyck further north who took careful note (Fig. 173).

III

The Dated Manuscripts

THE reader is aware that discussion of the dated manuscripts in the Boucicaut style has been postponed because, Geneva and Châteauroux apart, they give us equivocal information about the development of the Master's art. They do offer, on the other hand, vivid proof of the existence of a large company of illuminators and also of durable agreements to collaborate with other companies. The *Grandes Heures*, completed for Jean de Berry in 1409, can be understood only by reference to one aspect of these arrangements. It contains two miniatures related in style to the *Boucicaut Hours*. *Limbo* is a compact composition, the souls manifesting great eagerness to leave the flames that lick them and rise up before a cloud-flecked sky (Fig. 61). Devils sporting two large satyr-like horns, as in the *Boucicaut Hours*, have retreated to the more distant rocks and the heights of the gate; watching the scene below – like the spectators in the *Boucicaut Hours* (Figs. 10, 38) – they gesticulate with frustration. The gate is massive and shaded, like the darkened interior of *St. Gregory* that is perceived through a fully developed diaphragm arch (Fig. 62). The space, however, recedes diagonally instead of straight inward from frontally placed structures, as in the *Boucicaut Hours*. This diagonal plan is, as we shall see, visible in many manuscripts in the Boucicaut style for the next several years.

Other innovations and refinements of the *Boucicaut Hours* are visible. The stones of the gate have a natural variety of color; the windows of the study of St. Gregory are silver, the walls pale green, the scribe mauve and dark blue. Christ's head throws a shadow on his halo, but his posture and the conventional flying fold attached to his back are not exhilarating. The ideas for the composition seem superior to the execution. The initials immediately below these miniatures are much weaker, and the manuscript contains other mediocre initials by illuminators influenced by the work of the Boucicaut Master.[1] Clearly the Master was surrounded at that time by numerous illuminators and, curiously, he did not choose to devote much of his own time even to a book that contained large miniatures by Jacquemart de Hesdin and that was destined for the most discriminating connoisseur in France. We cannot, however, exclude the possibility that he himself painted one or more of the now lost full-page miniatures.

The existence of what we have called Boucicaut Associates is proved also by the earliest dated manuscript in a related style, a Book of Hours, Douce 144 in the Bodleian Library. An inscription in the book stating that it was completed in 1407 in Paris seems to apply to the illumination as well as to the text.[2] St. Luke resembles such weighty, full-bodied figures in the *Boucicaut Hours* as St. Francis, Brother Leo, or St. Jerome (Figs. 22, 42, 49).[3] The tubular folds in his sleeve form a related pattern, but the attrition of the masses of the saint, of his ox, and even of the throne by strong linear movements is less like the *Boucicaut Hours* than the paintings of the Master of the Coronation (Fig. 458). The animation of the composition, or of another in the Boucicaut style representing the Virgin weaving in the Temple (Fig. 51)[4] – introduced for the Obsecro Te – may well have been promoted by the lively designs of followers of the Masters of the Coronation and

34

of Berry's Cleres Femmes who collaborated on the Douce manuscript (Figs. 53, 55). A very different, quieter version of the Boucicaut style appears in the miniature of the Madonna and the Child who receives cherries from an angel, an illustration of the prayer O Intemerata (Fig. 52). This illuminator, recognizable by such peculiarities as his drowsy eyes and squat figures, was chiefly responsible a few years later for the *Hours of St. Maur*, to which we have referred above (Figs. 127, 211, 221).

The Boucicaut Master apparently had little to do with the miniatures painted by his followers in the Douce Hours (Figs. 56, 57, 60). If on the other hand we were to assume that he had controlled the perspective of the floor of the *Virgin weaving* (Fig. 51), we would be led to wonder whether the far superior tiled floors of the *Boucicaut Hours* could possibly have been designed earlier or in the same period. Certain forms, however, on these folios of the Douce Hours – the borders and the frame lobed at the top – are important novelties. Many of the borders contain, furthermore, little nature studies; the potted flower below the *Visitation* is clearly more advanced than the one below *St. Honoratus* in the *Boucicaut Hours* (Fig. 21).

A new type of border appears throughout the manuscript, and it might be attributable to two or three masters working in closely related styles who undertook the lively illumination of the Hours of the Virgin and a few other miniatures (Figs. 50, 53-55). These masters, manifesting a bewildering number of inflections of one large stylistic trend, emerged from the circle of the Masters of the Coronation and of Berry's Cleres Femmes.[5] The trend defined by these masters may be followed shortly thereafter in one miniature of the *Grandes Heures* of 1409, in the *Boccace de Jean sans Peur* about 1410, in the *Livre de la chasse*, in the *Missal of St. Magloire* of 1412 (Fig. 481), in the illustration of the Adelphoe in the *Térence des ducs*, and in the *Merveilles du monde* before 1412 (Figs. 83, 84). These paintings, though closely related, were executed by more than one illuminator. Certain of them, for example in the *Livre de la chasse*, the Adelphoe of the Terence, and the Boccaccio, are especially close to one another. In some similar paintings soon after 1412 we may clearly recognize, I believe, the style of the later Hours in the British Museum and of the Breviary in Paris from which the Bedford Master takes his name (Figs. 150, 482). These works include a full-page folio in the Bible fr. 9 (fol. 283) and miniatures as well as initials in the Breviary at Châteauroux before 1415 (Figs. 108, 110, 111). These paintings show greater artistic strength than any of the paintings before 1412. On the other hand they do not show an equal measure of originality, and we may therefore ask whether the Master of the Bedford Hours simply emerged as a better illuminator from the earlier trend or whether he had also taken a part in shaping it. A solution of the question would require lengthy and close study of the manuscripts, which does not seem to me warranted by the importance of the historical issues involved.[6] I shall educe here only the striking fact that both the earlier paintings and the later, definite miniatures of the Bedford workshop combine stocky, bulbous-nosed figures derived from the Netherlandish tradition with the elegant, sinuously draped figures of Simone Martini (Figs. 111, 287, 481, 482).

The repetition of forms and figures in this series of paintings implies that the illuminators were in actuality associated and employed common models (Figs. 481, 482). For stylistic reasons and also documentary ones that will later be advanced it seems probable that the Master of the Bedford Hours was active in this group already near the beginning of the century. I cannot confidently

ascribe to his brush any of the paintings cited above, but approximations to his animated designs were established in Paris a decade before the execution of his first certain works. Curving mounds or flamboyant crags rise behind complex buildings and nimble, restless figures. The bent and twisted figures gesticulate emphatically, but the gestures seldom convey any specific meaning. The 'Bedford illuminators' abhor the poise, moderation, and propriety that are norms of the Boucicaut Master; they prefer an intense though generalized vitality and expressiveness. The stylistic trend, then, is quite distinctive, though the individual contributions to its early phase are not clear. Inasmuch as the name of the Bedford Master has frequently been attached to the entire group it seems right at present not to abandon it entirely. I shall therefore employ the term 'trend to Bedford' or, briefly, 'Bedford trend' for all paintings of the group earlier than the Missal of St. Magloire and the Châteauroux Breviary, in which the Master of the Bedford Hours and his workshop seem to me identifiable.

The origin of the new borders of the Douce *Horae* may be indicated by the fact that a closely related master collaborated in the illumination of the *Hours of Charles le Noble*, datable about 1405 (Fig. 467), for this manuscript too contains large 'acanthus' leaves that curl around medallions of gold. These borders, designed by the Italian Master of the Brussels Initials, no doubt served as prototypes for the illuminators of the Douce manuscript, just as they did *circa* 1409 for the Limbourgs when they undertook the *Belles Heures*.[7] In the *Hours of Charles le Noble* animated figures, nude putti, and animals take possession of the roundels, precisely as on the folios of Douce 144.

In the border of St. Luke in Douce 144 these humorous or satirical drolleries make way for an Old Testament prophet. In the vines around the Virgin an angel offers a pot of flowers and another, holding a lyre, glances up at her. Sometimes the subjects are secular commentaries on the main religious theme. Below the *Annunciation to the Shepherds* a fourth member of the profession lies asleep in the lap of his mistress, shaded by a tree and guarded by his dog (Fig. 54). At the left a more distant admirer culls flowers. The episode looks like the traditional 'occupation' in April.[8] Some pages of this book are given a unified religious iconography. In the Hours of the Virgin figures related to the miniature appear in all the medallions: the Magi travelling to the Christ Child or the shepherds hailing the birth (Fig. 54). The iconographically unified folio of the late fourteenth century, of, say the Parement Master in the *Très Belles Heures de Notre-Dame*,[9] has here re-emerged within the recently imported Italianate borders.

The Boucicaut Master himself gave the new design its most impressive character less than a decade later in the Mazarine Hours, where episodes preceding or following the main one fill the surrounding medallions (Figs. 262-268). The design soon was widely diffused in richly illuminated Books of Hours, especially by the Bedford Master, but the beauty of the Mazarine folios was never equalled.[10] Though some of the flowers and leaves are close to nature most of them possess a certain formality. In the *Return from the Flight into Egypt* they even invade the background of the miniature, giving the entire folio a unity of a special kind (Fig. 267).

Probably when the Boucicaut workshop was engaged with the *Grandes Heures* Jean de Berry commissioned it to paint a few miniatures in a Lectionary that he wished to present to his Sainte-Chapelle in Bourges. In one miniature he kneels at a prie-dieu before his patron, St. Andrew (Fig. 66). A pet dog reclines at his side. The appearance and dress of the Duke indicate a date

around 1410.[11] The oblique orthogonals of the tiled floor of this miniature and of the *Birth of the Virgin* (Fig. 64) resemble the diagonals of the miniatures in the *Grandes Heures* (Figs. 61, 62) and the triangular plan of *Limbo* is repeated in *All Saints* in the Lectionary (Fig. 65). The perspective view of the saints in the latter anticipates the corresponding illustration in Add. 16997 (Fig. 293), but how different the two miniatures are as works of art! The floor in the Lectionary is distracting and the saints comparatively conventional. The difficult question that all these miniatures of 1409–1410 raise is not whether the Boucicaut Master painted them but whether he had anything much to do with them at all. Indeed the spacious room in a miniature of *Pentecost* by Pseudo-Jacquemart in the Lectionary reflects the scale of the *Boucicaut Hours* more than do any of the paintings we have just considered (Fig. 63).

The figures in three miniatures in the Boucicaut style in a manuscript presented to Charles VI in 1409 resemble closely those in the *Grandes Heures* of the same year, but this fact is not immediately apparent because of the very dissimilar compositions (Figs. 67, 68, 70). The figures seem cast in the same mold; like those in the *Grandes Heures* most of them are simplified versions of the figures in the *Boucicaut Hours*. They give the impression of abbreviations, of an economical shorthand. There are exceptions, however, at least in design: notably Jean sans Peur on folio 1 verso (Fig. 70) and Jean de Berry on folio 53 (Fig. 67). Two of the compositions, furthermore, are novel and extremely interesting. The text was written for the King by Pierre Salmon, who was close at that time to the Duke of Burgundy, and it may not be accidental that in the first miniature Jean sans Peur, proudly displaying his ring of ducal investiture and still decorated with *rabots*, though he had already 'planed down' one Duke of Orléans, seems to have attracted far more of the painter's attention than poor Charles VI (Fig. 70). Jean sans Peur wears an elaborate and beautifully designed *houppelande*; he is furthermore a powerful figure, whereas the King hardly looks capable of holding the large tome that Salmon proffers him.

The main episode in the second miniature in the Boucicaut style is likewise a scene of presentation of the book to the King (Fig. 67). Again one of the Dukes is present, Jean de Berry, whose passion for jewelry leads him to turn his back disrespectfully on his sovereign to examine a neighbor's pendant.[12] For reasons not apparent from the text the designer held this scene to a fraction of the available space and surrounded it with a view of the palace, a courtyard, and a street outside the walls. A century earlier a Parisian illuminator had put together a view of familiar features of the capital (Fig. 490), but the designer of the palace of Charles VI would have had a perfect model in some miniatures in a *Bible moralisée*, such as the *Three Magi in Herod's Palace* (Fig. 489). He might well have known this manuscript, as the Rohan Master certainly did ten years later, for though it was illuminated by Neapolitan masters it probably belonged already in the fourteenth century to Louis I d'Anjou, and indeed might have been produced for him.[13] Herod's chamber, like that of Charles VI, occupies only a part of the space, the rest being devoted to the buildings and streets nearby, all bustling with activity. Both miniatures maintain the importance of the main episode by reducing somewhat the scale of the surroundings. Peculiar to the Boucicaut composition are the spectators, who look over the wall or pop their heads out of windows, as in the miniatures of *St. George* and *Pentecost* in the *Boucicaut Hours* (Figs. 10, 38).

The composition of the third and final Boucicaut miniature is very similar (Fig. 68). Pierre

gives news come from France to the King of England 'en sa chambre', but even here there are spectators of these comings and goings. On the tip of a conical roof at the right a stork stands on its nest, its head just barely within the frame, unlike other crowning statues and crosses that lap over it onto the parchment beyond. The fact that Pierre Salmon is represented in both these cityscapes suggests that it was he who inspired them. The elaborate architectural settings of these miniatures in the Boucicaut style become remarkable panoramas in several miniatures by the Cité des Dames Master in this manuscript (Fig. 71).[14] These deep flat landscapes are almost as exceptional in the work of this painter as the cityscapes are in the Boucicaut group, and thus we may infer that it was indeed the counsellor of the King who proposed them.

A miniature in a manuscript in the Archives nationales is interesting because it can be dated to early 1413 and because its subject is rare (Fig. 79). It shows Pierre Fortet, canon of Notre-Dame, Paris, and founder sometime after 1391 of a college, presenting the eight original scholars to the Trinity. Two other canons of the chapter, on which the college depended, kneel above. If they are, as has been suggested,[15] the uncles of the founder and the source of his fortune their larger size is rather droll. The slenderness of God the Father and the prominent loops in his mantle are symptoms of a trend that became manifest in numerous paintings in the Boucicaut style from this time on.

This trend is evident in many of the 265 miniatures in the *Merveilles du monde*, which Jean de Berry received from his nephew Jean sans Peur in January 1413, soon after the siege of Bourges and the reconciliation of these leading members of the Armagnac and Burgundian parties.[16] This splendid manuscript was the largest enterprise in the Boucicaut style, surpassing even the 225 miniatures in the *Trésor des histoires*, and the mode of painting was altered correspondingly. Apart from the frontispieces to each of the six books of travel (Figs. 80, 98), which were finished in the usual way, most of the miniatures were painted thinly. Fewer layers of paint are superimposed, and the brushwork is rapid and open (Figs. 94, 99). In the skies strokes of violet are intermixed with blue. The palette is restricted and the colors are pale, most frequently green, rose, tan, below the blue-violet sky.

The new canon of proportions of God the Father in the charter of the Collège de Fortet appears in many miniatures of the *Merveilles*. The dark-skinned Indian goddess and her blond votaries who join hands in a solemn dance are all very tall, with small heads (Fig. 85). Similarly proportioned are the nuns in the convent on Mt. Lebanon who reveal to Mandeville the Madonna painted by St. Luke (Fig. 96). The rectangular panel of the half-length Virgin with the nude Child hangs behind a curtain in a niche; it drips fluid into a huge chalice. The Virgin on her deathbed is very slender, and some of the apostles wear mantles with long flowing trains (Fig. 95).

The new, lively compositional rhythms emerge even in subjects that might at first seem less adapted to them. The Crucifixion is represented in an exceptionally low field, but the illuminator has held Christ somewhat above the throng and maintained the proportions of the figures by putting them on a ground plane below the lower frame (Fig. 93). Their extension downward is at once indicated and masked by the kind of curtain of earth that we first observed in several miniatures in the *Boucicaut Hours* (Figs. 2, 3). Again it implies a close point of sight. In most other respects the design recalls the *Crucifixion* in the *Boucicaut Hours*, though Christ and the Virgin are

now less broad and the greater animation introduced by the curving diaphragm and the hills behind is continued by the more vigorous flourish of the centurion's scroll (Figs. 37, 93).

In these respects the composition in the *Merveilles* conforms with an influential trend in Parisian painting represented by the work of the Apocalypse Master, the Rohan Master, and the Bedford trend. About 1412 the Bedford workshop painted a *Crucifixion* in the *Missal of St. Magloire* that exemplifies well the new linearity and the display of more overt emotion (Fig. 481). Thus stylistically it is more closely related to the painting of the same subject in the *Merveilles*, but several similar figures may be found in the *Crucifixion* in the *Boucicaut Hours*. With a knowledge of other sources of the Bedford style in mind we may safely say that the Magloire *Crucifixion* owes its monumentality also to the painting in the *Boucicaut Hours*. The latter, or a similar Boucicaut painting, was certainly familiar to Parisian painters by 1411. This fact supports our conclusion that the *Boucicaut Hours* was painted in the second lustrum of the century.

The Bedford Master and his associates, who collaborated regularly with the Boucicaut Master and his followers, had a secondary share of the miniatures in the *Merveilles* (Figs. 83, 84, 97). The manuscript shows different versions of the Boucicaut style itself. The weakest follower, much in evidence near the end in such miniatures as the *Prayers and Ablutions of Muslims*, had greater success imitating the perspective of the Boucicaut Master than his figures (Fig. 100). In one miniature we have an opportunity to see some forms that were not finished in the normal manner but only sketched (Fig. 99). The miniature represents the miraculous darkness in which Christ enveloped the King of Persia and his soldiers as they were hunting Christians to sacrifice them to their idols. In the area covered by wisps of pale blue and yellow fog the soldiers and the landscape are defined by quick, sure, lively strokes of the brush. The design of the two horses at the left appears again in the miniature that shows the Polo brothers at the gate of a very French Constantinople, taking leave of the Emperor Baldwin II on their way to the East (Fig. 80). The same pattern was used in both instances; the superiority of the sketchy forms is striking, and it is surprising in view of the fact that the *Departure* is the frontispiece of the *Voyage of Marco Polo* and the very first miniature in the book.

This comparison makes vivid the undeniable fact that the frontispieces of all six books, which one would expect to be superior to the rest, are on the contrary quite ordinary.[17] The one partial exception is the first miniature of the fifth section, showing the presentation of John Hayton's book of travels to Jean sans Peur (Fig. 98). The figure of the Duke is arresting. He sits on a cloth that bears *fleurs-de-lys* and the blue and gold stripes of Burgundy. He wears a black hat and collar, an enormous *balai* surrounded by five pearls, and a red mantle strewn with golden carpenter's planes and sprigs of oak. The courtiers around him are dressed in pale colors, and they stand or lean informally whereas Jean sans Peur sits stiffly upright, the fingers of his left hand arched, probably to hold his ducal ring as in the portrait in the Louvre[18] though the area in the miniature is damaged. His narrow yet fleshy face, cold glance, and remarkably prim mouth compose an unforgettable portrait. It is strikingly like the one transmitted by a later copy now in Antwerp (on p. 74), though the posture resembles more closely the copy in the Louvre.

The head of Jean sans Peur probably shows us the Boucicaut Master himself engaged in portraiture, though probably working from a pre-existing painting. He may also have touched

up the head of the dashing young courtier just behind the Duke. The rest of the miniature is not extraordinary. The design of the building does not strike us as inevitable, and the perspective of the door and the tympanum showing the Burgundian shield held by two lions is downright awkward. Even in this miniature the degree of personal commitment cannot have been high, and the same conclusion is forced upon us by the character of the borders – apart, of course, from the quatrefoils of the later fifteenth century. The scroll and oak leaves at the left, though not beautifully painted, are at least in a possible proportion to the miniature, but what are we to say of the coarse, loud, oversized arabesques elsewhere?

The answer must be sought in the conditions of production and the conventions of taste that permitted so variable a quality in illuminated manuscripts. The most discriminating patrons, such as the Duke of Berry, normally exacted more of illuminators in their employ. Even that consummate book, however, the *Très Riches Heures*, contains initials by a weaker hand.[19] When the Rohan Master undertook the *Grandes Heures de Rohan* for the Duchess of Anjou he struck a higher level than he had set earlier but in that extraordinary book nonetheless he permitted much slapdash and inferior painting. And do even the best miniatures in this superb manuscript equal the marvelous drawing in Braunschweig that is generally accepted as a work from his hand (Fig. 485)?[20] The miniatures are no less powerful but the forms in them are less sensitively rendered.

It is not surprising therefore that usually we have the art of the Boucicaut Master in diluted rather than concentrated form. Our impression that he was forever on the run may be correct. Without tenure he may have been constrained to watch constantly for commissions, to keep his wares marketable, to manage an atelier, and to meet deadlines set by less highly cultivated patrons. It is quite possible that the failure of the Boucicaut Master to win a salaried position with a sympathetic patron has deprived us of masterpieces even greater than the Boucicaut Hours and Add. 16997.

IV

Some Exceptional Cycles

IN the early fifteenth century a rising demand for richly illuminated manuscripts and an increasing variety of texts induced specialization among Parisian illuminators. The Cité des Dames Master, for instance, devoted himself for a time largely to the manuscripts of Christine de Pisan, and a little later to the illustration of texts of Boccaccio. He as well as the Virgil Master rarely illuminated Books of Hours. The Book of Hours, on the other hand, was a favorite of Boucicaut Associates, as we have seen. This workshop undertook also, however, a variety of other texts, more often secular than religious. Iconographically it was the most universal workshop in Paris.

We have discussed above the contributions of the Boucicaut Master to the illumination of the Book of Hours. He charged the borders with a new function, embedding in them successive episodes of the sacred stories, and he gave the entire folio a new rhythmical or architectural unity (Fig. 278). In the canonical cycle of miniatures he transformed the composition of the Annunciation and the Funeral Service. In the *Nativity* the Virgin herself rather than a midwife tests the temperature of the water of the Child's bath (Figs. 270, 272).[1] At Vespers in the Mazarine Hours the usual scene of the Flight into Egypt is replaced by the uncommon Return of the Holy Family from Egypt; they are greeted with reverence and affection by the citizens of Nazareth at the gate of the town (Fig. 267).[2] At Compline in the same Book of Hours the Virgin's crown, normally prominent and close to her head, is high in the sky, held by a pale bluish angel (Fig. 268). Below a canopy held by angels Christ blesses the kneeling Virgin and receives her clasped hands in his. This personal and touching gesture is rarely represented earlier, if indeed it has any precedents at all.[3]

Among the religious books of other kinds illuminated by Boucicaut Associates the *Cité de Dieu* in the Walters Art Gallery is by far the most impressive. The soft, luminous colors on resilient forms imply a late date. In the scene of Varro teaching small touches of bright red or vermilion rise out of broad areas of gray, tan, or violet (Fig. 340). In the gold field above God is touched with rose. Satan is a pale green monster with pink lips and a marvelously delicate red mouth (Fig. 338). The mandorla of Christ in the *Last Judgment* has become a golden haze (Fig. 341). The saints and prophets who venerate Christ and the Virgin have much of the individuality of posture and physiognomy of the apostles in *Pentecost* in Add. 16997 (Figs. 292, 342).[4] A similar variety distinguishes the audience of Varro, which is divided into men who listen thoughtfully, those who worship the true God (who appears in the window), and those who turn to idols (Fig. 340). Indeed, only the Boucicaut Master himself, and late in his career, could have envisaged the majestic Varro or Abraham, giants in European painting of the time (Figs. 336, 340).[5] David, too, is a powerful man, and he is given a huge throne and a noble chamber in which to compose the Psalms (Fig. 337).[6]

The predilection of the Boucicaut Master for circular designs is manifest in the apse-like

structure added to Varro's hall and in the great arcs formed by the figures in the *Fall of the Angels* and the *Last Judgment* (Figs. 334, 341). Geometry determines but does not absolutely fix shapes and movements, in the *Last Judgment* notably the symbols of the Passion and the angels holding them. Order is imposed even in Hell (Fig. 338). We look directly into the mouth of a monstrous but symmetrical head. The muzzle balances a column, a symbol of paganism employed as a fulcrum for the spits.[7] The damned are painted with great affection. The two bodies dangling beautifully from the gallows were inspired by a passage in the *Aeneid* quoted by Augustine:

> Some hang aloft in open view
> For winds to pierce them through and through,
> While others purge their guilt deep-dyed
> In burning fire or whelming tide.[8]

The Boucicaut workshop took only a relatively small part in the illumination of two Bibles, Bibl. nat., fr. 10, and Brit. Mus. Roy. 15 D III (Figs. 343-349, 351-353). In the former the four scenes of Solomon are framed by a handsome border executed probably by the same illuminator; the folio thus possesses an impressive consistency that is not common in the more routine products of the workshop. The motif of the angel holding the vine appears first in Douce 144 and then in manuscripts such as Egerton 1070 that were executed, like fr. 10, about 1411 (Fig. 209).

One miniature in the Bible in London is outstanding (Fig. 353). The Fool bites the tail of a dog, an action appropriate to a *monde renversé* that appears in a few Bibles of this time.[9] Earlier the Fool ate a loaf of bread, in accordance with the text of the Psalter: 'qui devorant plebem meam ut cibum panis'. It is tempting to believe that the new subject was suggested by a misreading of *panis* as *canis*.[10] In any event the surprising action evokes on the faces of two bystanders what is probably the earliest portrayal of a smile. The mobility of the features is extraordinary – the mouth curved upward and moved sideways, the pupils shifted into the corners of the eyes. The mood is carried into the spritely gestures of the two men, which are contrasted with the slow, downward curvature of the body of the Fool. A few other miniatures, such as Jacob's Dream or Nehemiah and the Jews, show a similar animation, but they are cruder (Figs. 346, 349). The stout man in the latter who grasps his belt seems to derive from a similar figure by Jacquemart in the *Brussels Hours*.[11]

Among the secular manuscripts illuminated by the Associates the *Merveilles du monde* is known best.[12] Indeed with the *Très Riches Heures* it enjoys a greater fame than any other manuscript of the late Middle Ages. Though the cycle is fascinating for its exotic and fanciful subjects the miniatures vary considerably in artistic strength. The Boucicaut Master did not give the book his continuous attention, the Bedford Master was not himself present at all, and many paintings, particularly from folio 227 to the end, are atrocious. Some miniatures, on the other hand, are delightful, a few excellent, and the cycle will never fail to fascinate us.

The *Merveilles* brings together several books of travel to the Holy Land and the Far East, all in French originally or in translation. It begins with the short, early fourteenth-century version of the most famous, Marco Polo's *Milione*, and includes the accounts of two predecessors, Friar Odoric and John Hayton, and contemporaries or successors, Ricold of Montecroce, John of

Cori, and William of Boldensele. To these is joined the fictitious but immensely popular text of John Mandeville, drawn from Odoric and other sources.[13] The *Merveilles* is the most richly illustrated compendium of this kind; some earlier manuscripts of these texts, including Italian ones, were embellished with miniatures but fewer in number.[14] It is notable that though most of the travellers were Italian the great cycle was produced in France. Like the Boccaccios to which we shall turn shortly, the *Merveilles* gives proof of the exceptional enthusiasm of metropolitan France for the illustrated book.[15] It implies also curiosity about history, exotic regions, and especially the fabulous East.

Fascination with the Near and Far East was of course not peculiar to the early fifteenth century. The Holy Land and the eastern Mediterranean had never failed to hold the attention of medieval Christians, and the attempt to reconquer or preserve these regions continued right into the period of the painting of the *Merveilles*. We should not forget that the patron of the book, as a young man, had led the crusade that in 1396 ended in the shocking defeat by the Turks at Nicopolis. His interest was not thereby diminished in representations of Constantinople, Jerusalem, and other holy places, as they were called forth by the texts of Hayton, William of Boldensele, and Mandeville. In his time the fate of Constantinople hung by a thread; the Emperor Manuel II had visited Paris for more than two years, from 1400 to 1402, hoping to rally massive support in the West.

It was, to be sure, not the travels around the Mediterranean that really earned the manuscript its title *Merveilles du monde* – a title given it already in the handsome inscription written on a flyleaf by Jean Flamel when the Duke of Berry received the book as a New Year's gift in January 1413. The greater marvels were in the lands beyond, practically unknown until the thirteenth century, when the domination and to a degree unification of Asia by the Tartars made voyages across the entire continent possible. A traveller needed only one single golden document of safe conduct.[16] Until that time the legend of Alexander the Great, disseminated in countless manuscripts, was the main source of Western ideas about the Orient. Inasmuch as silk, spices, and precious stones originated in those distant lands the wealthy purchasers of these objects had a special interest in them. The Duke of Berry, in fact, possessed six large tapestries with scenes of the Great Khan,[17] and a couple of months before receiving the *Merveilles* from Jean sans Peur he had acquired in Paris another illustrated compendium of Marco Polo and other books of travel.[18]

By presenting the *Merveilles* the Duke of Burgundy made a peculiarly appropriate gift to his uncle, the greatest living connoisseur of precious stones. In the miniatures Jean de Berry could see the mining of rubies in Badakhshan (folio 18 verso), the Queen of Mutfili searching for diamonds (folio 82), and pearl-fishing in Gaindu (folio 54). His eyes must have lingered – though the miniature was not what he would have wished – on the entire river of precious stones flowing from the Earthly Paradise, all according to the highly imaginative Mandeville (folio 213). The spectacle of the King of Maabar certainly diverted him, if it did not stir a measure of envy (Fig. 84). According to Marco Polo this Asian monarch adorned himself with almost nothing but jewels. Because of the temperate climate he and his subjects dispensed with clothes, and the illuminator seems to stress the point by introducing near the inhabitants some sheep still bearing their full coats of wool. From the King's neck dangles a long string of *joyaux*, 104 according to

Marco Polo.[19] These jewels, like those of a good Christian, had a religious significance. They served, in fact, as a sort of Asian rosary, employed in the King's daily prayer: *pauca, pauca, pacauca.*

Odoric of Pordenone describes a body of water in a mountain of Ceylon formed, he was told, by the tears of Adam and Eve, who wept for a hundred years after the expulsion from the Garden (Fig. 91). Odoric doubts this story of the origin of the water – 'ce n'est mie chose à croire' – and then continues with another extraordinary aspect of it. By a kind of compensation for the Fall, I suppose, it was filled with precious stones. Even these waters hallowed by grief, however, harbor serpents, in the form of leeches. When the King of the region permits his poor subjects to hunt for the stones they ward off the leeches by an ointment of lemon juice. The illuminator shows them thus anointed but riskily naked, searching in what has become a river.[20] Near it Odoric saw dangerous wild beasts, elephants and 'serpens', which the illuminator apparently took to be dragons.

This display of birds and animals no doubt fascinated the Valois princes, who were all passionate hunters, and such scenes are scattered through the manuscript. In Madagascar travellers, perhaps emissaries of the Great Khan, and two Orientals in one of the Boucicaut Master's characteristic 'box seats' watch elephants, an eagle with its prey, and a huge roc (Fig. 88). Marco Polo observed that the fabulous roc was entirely a bird, not half a lion like the griffin,[21] and the illuminator met him part way, giving the creature talons rather than paws but a rather unavian neck. The mountains of the kingdom of Eli shelter a lion that the illuminator obviously knew far better in art than in the flesh (Fig. 86). He had not brushed with a live unicorn either; the dashing creature took its shape and beautiful animation from the horse. The illuminator knew well, on the other hand, the handsome, alert fox, the swans, the rambling bear, the boar, and probably the partially concealed camel. Often in the *Merveilles*, as in the popular contemporary *livres de la chasse*, the animals are hunted. The Duke of Berry, a famous connoisseur of dogs, would have taken good note of the dogs in Afghanistan trained to hunt porcupines (Fig. 81). He could see the marvelous husbandry of a city on the southern coast of Arabia which, presumably lacking fodder, possessed horses and sheep that lived on fish (Fig. 89). A handsome prancing horse, much like the unicorn of Eli (Fig. 86), is put through its paces by Arabs of Qalhat, eager to sell it to visiting Indian merchants (Fig. 90).

Curiosity about imported articles for the table was touched by scenes such as the gathering of pepper in Quilon, South India (Fig. 87). The fruit is gathered, under the eye of an oversized white inspector, by Negroes in varied, freshly studied, lively postures, their dark gray bodies contrasting with the tan earth and luminous blue sky. One miniature describes music and dancing at the court of the Great Khan, one or two of the participants looking a little tipsy (Fig. 83).

The references of the travellers to the venerated sites in the Holy Land offered the illuminators an occasion to depict the great sacred events. The visit of William of Boldensele to Golgotha gave rise to the representation of the Crucifixion, which as we have seen differs from the traditional composition only in respects that were not inspired by the text (Fig. 93). Mandeville's description of Mt. Zion is accompanied by a miniature of the Death of the Virgin, which is one of the best paintings in the book (Fig. 95). The combination in it of widely dispersed figures and rhythmical

unity is impressive, and the varied actions of the large, majestic apostles implies a design by the Boucicaut Master himself. To conform with the open composition the celestial realm of Christ, represented by two-dimensional arcs or circles in earlier art, is transformed into a section of a cone – one more instance of the preference of these illuminators for circular shapes.[22]

Not long after visiting Zion Mandeville went to a convent near Damascus to see an image of the Madonna famous for its miraculous powers (Fig. 96). He wrote simply that the painting, which had become faint, exuded an oil that fell into a vessel below and could cure illness. The illuminator, drawing upon his experiences with venerated images of his own time, represented a chamber of the convent in which the image is installed in a niche behind a curtain. A nun unveils it for the traveller, who sees a Child quite nude in accordance with the newest French fashion.[23] Mandeville's vessel of unspecified shape has been transformed into a chalice that catches the brown fluid.

In the valley of Hebron near Jerusalem Mandeville saw the region where Adam and Eve lived after the expulsion from the Garden. The illuminator brought them back to life again, Adam delving and Eve spinning; alongside them he showed the famous Dry Tree, worshipped by the traveller (Fig. 94). This tree, which lost its leaves when Christ died, will, it is asserted, bear leaves and fruit when the Holy Land is won again for Christianity.

The church dedicated to St. Catherine on Mt. Sinai, where she was buried, drew many pilgrims in the Middle Ages, among then the Maréchal de Boucicaut, as we have seen. William of Boldensele, who made the journey also, wrote an account of his visit. In the miniature that illustrates his text he emerges from the Gothic church to witness Moses on his knees, addressed by the Lord (Fig. 92).[24] In characteristic medieval manner the illuminator is just as indifferent to anachronisms here as in the representation of Hebron (Fig. 94). When, however, not merely history but an eternal ideological difference is concerned – and is indeed the subject of the miniature – a painter would readily distinguish architectural types. In an illustration by the Orosius Master of a *City of God* about 1400, the Christian church is Gothic, the pagan or non-Christian a kind of blended mosque and Romanesque with a huge idol on the roof (Fig. 488).

An even more drastic telescoping of time occurs in the miniature of the baptism of Zagatai, the son of the great Tartar ruler Chinghiz (Fig. 82). This event occurs in the church that was built later to commemorate it. The illuminator ignored, however, an important part of the story as Marco Polo told it, though the design of the church suggests he was familiar with at least a part of it. The text says that the central column of the church rested on a square stone taken from a mosque, and when after the King's death the Mohammedans threatened to retrieve it the column miraculously stood without support and remained so to the time of Marco Polo's visit. John the Baptist, the patron of the church, stands on the altar. Probably the illuminator intended to represent a statue, but here as elsewhere in this manuscript and in miniatures in the Boucicaut style no distinction is made between an image and a miraculous appearance.[25]

The texts that the illuminators of the *Merveilles* undertook to illustrate had been received with great excitement. They related strange and startling facts, but they often also manifested a novel attitude toward these facts. It is true that what the travellers had read about the East, especially in

the legend of Alexander, affected what they found there. Even the most independent of them, Marco Polo, did not consistently distinguish between things seen or merely heard of. As a result we cannot always be certain even where he had gone.[26] Still, unfamiliar sights always tend to be peculiarly vivid, and Asian travel more than any other activity of the late Middle Ages confronted traditional ideas with fresh observations. Under its impact all the travellers and especially Marco Polo questioned conventional lore.[27]

None of the adventurers took a painter with him. Indeed, quite apart from practical considerations, it would hardly have occurred to an ambassador or a missionary to invite one to document his trip because the artist had only recently begun to assume the role of observer and recorder of the visible world. The illuminators of the *Merveilles* were not of course given the sights and sounds of Asia but only the more or less conventionalized record of them, and if they proceeded – as indeed they did – to alter and embellish this record with what the earlier pictorial tradition told them, they acted similarly to the travellers themselves.[28] The difference between travellers and illuminators is not in kind but in degree – though in the instance of Marco Polo this degree is considerable. Perhaps these texts provided a new climate; they stimulated the painters to more intensive observation not of exotic but of familiar things. Horses, for instance, had never been more attentively studied and more affectionately rendered than in several miniatures in this book devoted mostly to fantastic creatures (Figs. 90, 99).

The illuminators endeavored to make the subjects of their miniatures vivid for their clients by introducing well known emblems. As Rudolf Wittkower has shown, they added a unicorn, an animal certain to elude all normal hunters, where Marco Polo spoke only of wild beasts.[29] Like all medieval illuminators they felt no compulsion to translate the texts fully, and even if they had wished to, they would have found only poor clues to the appearance of exotic birds, plants, and cities. They gave Tartar women pigtails, and men long beards and hats something like those worn by the Byzantine emperors (Fig. 83). Curiously, the turbans and more fanciful headgear worn by Orientals in the *Très Riches Heures* are entirely lacking.[30] Just as the illuminators of the *Merveilles* showed little interest in chronology and history, they lacked much sense of cultural difference. They did seek to distinguish many Asian buildings by crowning them with barrel vaults or bulbous domes, but a Buddhist house could be entirely Gothic.[31]

A kind of curiosity related to the one that had made illustrated books of travel popular in early fifteenth-century France stimulated a sudden enthusiasm for certain texts of Boccaccio. In them this author journeyed through the past, especially the Greco-Roman past that then attracted the humanists and their circle. In *De casibus virorum illustrium* and a more or less parallel treatise on women, *De mulieribus claris*, Boccaccio presented pithy accounts of the destinies of famous men and women from Adam and Eve to his own day. A number of these figures were familiar from other historical texts, Roman as well as medieval, but Boccaccio's assessment of the life of each, fresh, comparatively open-minded, and extraordinarily personal, evoked their presence in a novel and peculiarly vivid way. In the somewhat earlier *De casibus* the men usually lost high position through pride or folly; the moral issue is primary. The illustrations of these grim events – the cremations, decapitations, mortal altercations – provided France in the early fifteenth century with a novel equivalent of the pictures of the martyrdom of saints common in an earlier age. In this

sense the *De casibus* is a sort of new *Menologion*. The cases of the women are more complex. A number of them were memorable for a heroic triumph, particularly over evil men, and their loss of life may even be ascribed to a wicked *Fortuna*.

Splendidly illustrated copies of the newly translated *Des cleres et nobles femmes* were acquired in 1403–1404 by the foremost bibliophiles, Philippe le Hardi and Jean de Berry (Figs. 368, 369). The full cycle of illustrations – one for each chapter – had no precedent in Italy. This treatise on women – the first ever written – appeared in French during the years when the indefatigable Christine de Pisan was attempting to improve the traditional low estimation of the weaker sex, and the two events were not unrelated.[32]

A literal translation of Boccaccio's *De casibus* completed by Laurent de Premierfait in 1400 did not prove popular but the same writer's second version, a sort of paraphrase that borrowed biographical data from Valerius Maximus, Livy, and other ancient writers, quickly became one of the most popular secular texts of the time.[33] It included biographies of a few women, such as Dido and Cleopatra. The text was completed in 1409 and it was dedicated to Jean de Berry. For New Year, 1411, this prince received the manuscript now in Geneva, which contains a miniature for almost every chapter (Figs. 380, 384, 389, 397, 399). About the same time – to judge from the interrelationship of the two cycles of illustrations[34] – Jean sans Peur received the manuscript now in the Arsenal (Figs. 381, 385, 393, 395).[35] Berry's copy was illuminated by the Master of Luçon and assistants, Burgundy's in small part in the same style and by other workshops, including that of the Cité des Dames Master and the Bedford group.

Boucicaut Associates produced handsome manuscripts of both texts. They executed almost all the miniatures in the *Cas des nobles hommes et femmes* in the collection of Francis Kettaneh in New York. For the *Cleres et nobles femmes* now in Lisbon they were joined by the Cité des Dames Master and other illuminators. A comparison of the miniature of Ceres in the Gulbenkian *Cleres femmes* with the corresponding miniature in either one of the two first copies of the translation[36] makes vivid the great contributions of the Boucicaut Master to perspective, space, and naturalistic scale (Figs. 366, 368). The massive figures, endowed with a new structure, work the fields effectively. The Italian source of these fundamental innovations is suggested also by the clear, balanced design, which entails, to be sure, a loss of the vivacious spontaneity of the figures painted a decade earlier.

The similar iconography of the two miniatures might seem to suggest a direct connection, but what is common to them is fully accounted for by the text. Boccaccio says that Ceres, perhaps an ancient Queen of Sicily, invented the plow, introduced grain, and taught men to turn it into flour for bread. Because of this great accomplishment Ceres, though a mortal, was exalted with divine honors. The earlier illuminator, in the workshop of the Master of the Coronation, simply gave Ceres a halo, and he added an adoring man, perhaps Triptolemus, who obeyed another Ceres (of Eleusis) mentioned in the text. The painter gave the goddess a posture especially common in Netherlandish painting in the early fifteenth century, seating her on the earth (*humus*), as though she were a Ceres of Humility. The Boucicaut Master crowned her with golden wheat and enthroned her under one of the large canopies common already in the *Boucicaut Hours* (Fig. 31). The miniature presents the rich fruitfulness of nature. Instead of the rather sparse, stunted

grain of the earlier representation it waves, high and lush, against the luminous blue sky, over the men who cut and bind it into big bundles.

The Boucicaut miniature celebrates highly productive agriculture, the necessary condition, Boccaccio says, of civilization. We see nothing of the consequences of it that the writer laments: fenced fields and the introduction of 'the words "mine" and "yours", which are certainly inimical to public and private peace'.[37] No painter would have readily found visual equivalents for such concepts, and neither the Boucicaut Master nor his predecessors made any attempt to communicate Boccaccio's wonderful meditation upon the gains and losses of social growth. They lacked also his sense of history, and they conceived of all the great worthies of the past as inhabitants of nearby *hôtels* or *châteaux*.

The doubts that Boccaccio expressed about the deification of Ceres become stronger in the instance of Isis. She did so much to civilize the Egyptians that they – encouraged by the devil – believed she had come to them from heaven rather than from Greece. All sources agree, however, Boccaccio says, that she appeared initially in their country because of the intervention of the gods. Jupiter loved her and, in accordance with some authors, she left Greece for fear of her father. She sailed to Egypt in a ship bearing a cow as an emblem, and it is her departure from an exclaiming father or more probably her arrival before surprised Egyptians that is represented in the early miniatures (Fig. 369).[38] Like the goddess Ceres she wears a halo.

In another version of the vicissitudes of Isis that Boccaccio records Jupiter transformed her into a heifer and gave her to Juno. When her guardian Argus was killed by Mercury Juno put a gadfly on her that drove her to Egypt, where she again became a woman. The rather enigmatic Boucicaut miniature seems to combine or rather to confuse this version with the other. A richly dressed and crowned woman, apparently Juno, points out to her companions (Jupiter among them?) a cow standing in a large barge (Fig. 367). This is not an isolated instance of novelty produced by error in Boucicaut miniatures.

Boccaccio introduced Arachne as an example of pride and ambition – 'those who fall prey to such madness are numberless'. Spurred on by the fame she had won at the loom, she dared to challenge even Athena. Unable to endure the inevitable defeat she hanged herself by a rope. The early miniatures show her hanging behind her loom, her instruments for weaving still in her hands, and nearby a large specimen of net or woven cloth, of which she was the inventor (Fig. 372).[39] The Boucicaut miniature replaces the suicide with a dramatic portrayal of defeat (Fig. 370). In a spacious loggia Arachne sits at her large loom, still at work. A majestic woman ennobled by a splendid drapery, she is even given an assistant, rather like the angel that attends the Virgin in the Boucicaut representations of the *Coronation* (Fig. 36). Into this industrious realm steps the 'golden-haired' Athena, beautiful but, as always in the Boucicaut manuscripts, without a halo. She strikes Arachne with a shuttle, symbol of their rivalry. This telling and dignified representation of Athena's triumph does not derive from Boccaccio's story, either in the Latin or French versions. It was inspired directly, it seems, by Ovid: '. . . as Pallas held a shuttle of Cytorian boxwood, thrice and again she struck Idmonian Arachne's head'. The medieval *Ovide moralisé* was briefer: 'Mais Palas, indignée . . . la batit, durement'.[40] It is notable that none of the miniatures illustrates an account of Arachne's fate that Boccaccio asserted was false: her metamorphosis into a spider.

Boccaccio felt far more sympathy for Thisbe's love than for Arachne's ambition, and he judged that Pyramus and Thisbe came to the tragic end that made them famous because 'wicked fortune sinned, as did perhaps their parents' by curbing their ardor too abruptly. The miniature, following the text, shows the lovers in a wood near the towering city of Babylon (Fig. 374). The blood-stained cloth lies near the spring, the villainous lion rests quietly among the trees. At the left Thisbe seems to be fleeing from him. At the center she returns behind a more distant hillock to discover that Pyramus has stabbed himself, and in despair she plunges a sword into her own bosom. In Boccaccio's story she employs the same sword as Pyramus after withdrawing it from his body; the illuminator, wishing to tell how Pyramus died, shows the weapon twice, just as he twice represents Thisbe.[41]

The Cité des Dames Master, who often collaborated with Boucicaut Associates, undertook some of the miniatures in the Gulbenkian manuscript, and it is interesting that one of them should have been for the chapter on Manto (Fig. 371). This famous Theban soothsayer appears at the left, finding signs of the future in the entrails of an animal. Flames, which she knew how to read also, rise behind. Only this scene of prophecy is represented in the two early manuscripts (Fig. 373);[42] perhaps the illuminators omitted the achievement of Manto's son because though Boccaccio described it he emphasized his preference for the tradition that she remained a virgin. But the Cité des Dames Master, who disposed of a wider pictorial field, added the representation of Ocnus directing the construction of Mantua above a swamp and around his mother's tomb, all in accordance with one version of her legend that Boccaccio records.[43] The scene is strikingly similar to the building of Christine's *Cité des Dames* that the illuminator had painted three times in 1405 or shortly thereafter,[44] and it is tempting to infer that it was he who chose to introduce the founding of, in this instance, Virgil's city.

It is true that the Gulbenkian cycle as a whole illustrates the text more fully and clearly than the earlier cycles. Only in the Gulbenkian manuscript does Nicostrata actually give to the Romans the alphabet she had created. She presents a scroll on which is written 'vers'. Similarly the Sibyl Amalthea, who simply writes in the earlier miniatures, burns her books in the Gulbenkian manuscript. In the earlier miniatures Hippo drowns herself to preserve her chastity, but the Gulbenkian scene includes the finding of her body by the Erythraeans and the shrine built in her honor (Fig. 376).

Among the collaborators of the Boucicaut and Cité des Dames groups one illuminator painted an interesting and animated representation of Sulpicia (Fig. 375). This Roman matron had achieved beyond doubt the virtue that may have eluded Manto; she was renowned for her chastity. As the purest woman in Rome, indeed, she was selected to consecrate a statue of Venus Verticordia. In the miniaturist's naïve conception of this ritual she stands on a bench near a high column, traditional symbol of paganism. She appears to stabilize a woman in white whose hands are demurely crossed in her lap. As in miniatures in the Boucicaut style the statue is scarcely distinguishable from a living person. The illuminator did not heed Boccaccio's warnings about the dangers of elaborate dress, for Sulpicia and one companion wear large jewelled hats of the type called *bourrelets*, and others sport hoods or high *cornettes*. The temple is a barrel-vaulted chamber, its walls penetrated by large glazed windows that meet the wish of the period for maximum radiance and luminosity.

Whereas the illuminators of the Gulbenkian *Cleres femmes* do not appear to have known the compositions of the cycles of 1403–1404, the painters responsible for the Kettaneh *Cas des nobles hommes et femmes* did utilize the preceding illustrations of this text completed by early 1411. In Book VIII, Chapter 1, for example, Boccaccio tells of falling from needed repose into a prolonged torpor. Suddenly the laurel-crowned Petrarch seemed to appear beside his bed, reproaching him for his idleness.[45] Boccaccio wept. Then his 'maistre françois' spoke more gently and soon disappeared, having inspired the writer to rouse himself. The long description of the encounter offered numerous possibilities to the illuminator, but the Kettaneh miniature as well as those in Geneva and in the Arsenal all show one action that is not described in the text: Boccaccio sits up in bed, his shirt slipped over both forearms (Figs. 388, 389).[46] In the two earlier miniatures he appears strangely inactive, both his arms caught in the cloth. In the Kettaneh miniature he seems to be donning the shirt, although the similar posture must derive from the earlier conception. Novel in the Boucicaut miniature, on the other hand, is the diaphragm arch, the 'dropped' floor that permits a more naturalistic scale, and the relocation of the bed perpendicular to the picture plane.

The composition in the medallion in the border of the folio devoted primarily to the *Siege of Jerusalem* and painted by a collaborator clearly depends upon the illustrations of the chapter *Contre les Juifs* in both the Geneva and Arsenal manuscripts (Figs. 384, 385, 387). The horrible scene shows a Jewess, starved during the siege, satisfying her hunger by eating her child. The drapery of the cannibalistic woman and the window are drawn from Geneva (Fig. 384), whereas the child on the spit and the tessellated floor resemble the Arsenal copy (Fig. 385). The medallion does not, however, adopt the earlier representation of the Jewess munching on a limb; that gruesome spectacle is revived, on the other hand, in the miniature in the Kettaneh manuscript for *Contre les Juifs* (Fig. 386). Once again in a Boucicaut miniature the long axis of a room is turned into depth, and the characteristic window motif introduced. The illuminator also provides equipment for the woman that had been lacking: a bellows and faggots for the fire, and an axe.

The touching if somewhat bewildering miniature for Anthony and Cleopatra derives from the earlier composition in the Geneva and Arsenal manuscripts (Fig. 392).[47] Without authorization by the text they show the famous lovers lying like statues in a Gothic tomb. Anthony, however, holds the sword plunged into his bosom and Cleopatra is attacked by serpents from both sides. These earlier illuminators wished to combine an account of the demise with funerary sculpture, and the Boucicaut Master responded enthusiastically to the latter conception. He painted the figures a stony white, opened their eyes, and set the tomb in an impressive Gothic church. At Anthony's feet crouches the symbol for fortitude, at Cleopatra's the symbol for faithfulness, all in accordance with conventional late medieval imagery. The Boucicaut workshop has, however, once again disavowed an intention to accept the canons of statuary by giving life to the lion and the dog. The dog is even distracted by the ecclesiastic who comes to look at the tomb. The viewer so dear to the Boucicaut Master is introduced again here. A small but significant correction of the earlier pictorial models reduces Cleopatra's two serpents to one.

The miniature of Hercules driven frantic by the intolerable pain of his shirt stained with the blood of Nessus resembles the two miniatures in the ducal manuscripts, which are in fact practi-

cally identical (Fig. 382).[48] The Boucicaut illuminator, modeling the shirt exquisitely in a soft gray, eliminated the emblem of fire but he conveyed better than his predecessors the utter frustration, not the fury, of Hercules. Uprooting trees and casting down rocks will not help; the great hero is apparently trapped by his anger as much as by the invisible poison of Nessus.

The miniature for Polycrates is by and large no exception to the principle just tentatively established. The composition of the Kettaneh miniature as a whole, the posture and even the gestures of the king, the two trees and the gibbet, are all undeniably related to the corresponding miniatures in the Arsenal and Geneva manuscripts (Fig. 401).[49] There are, however, two differences, one of them startling. Boccaccio tells that at an earlier period of Polycrates' life, before the hanging, a ring he threw into a river was swallowed by a fish, the fish was caught and yielded its ring to its owner. Laurent's words read: '. . . les pescheurs de lisle Samos prindrent le poison quil avoit recueilly laneau celuy mesme poison fut aporte et donne au tirant et lanneau fut trouve ou ventre du poison . . .' (ed. 1494, p. cim). In both the Arsenal and Geneva miniatures the king, standing by the water, holds a ring between his thumb and forefinger, and in the former the ring appears again close to the mouth of the fish. The associate of the Boucicaut Master, however, allowed his eyes to wander from his pictorial model to the text or to a note written to guide him. One or the other made the rather disastrous error of understanding *annel* – the form of the noun employed in the Kettaneh manuscript – to signify *anel* or *asnel*, a lamb.[50]

In other instances the illuminators of the Kettaneh manuscript abandoned pictorial precedent more completely and, at the same time, failed to conform with the text. The mediocre miniature in the Duke of Berry's copy correctly though clumsily represents Darius, wounded and bleeding, held prisoner in the stocks (Fig. 397). The corresponding miniature in Jean sans Peur's copy is almost identical.[51] These paintings follow Laurent's description: 'Daire blessie griefuement et bien lye en cepz dedens ung chariot'. In the Boucicaut miniature the *chariot* has given way to a massive prison in which three men, all uncrowned, are held in the stocks (Fig. 398). Here again the favorite Boucicaut window pierces the prison wall, and a guard peers intently through it.

Boccaccio's *Vision of Fortune* in Book VI, Chapter 1, of the Kettaneh manuscript is quite similar to the earlier miniatures of the subject, especially to the one in the Arsenal (Figs. 393, 394).[52] Once again we must conclude that the Boucicaut illuminators employed pictorial models, either one of the ducal manuscripts or a work closely related to them. This conclusion is inescapable when, looking at the pleasant face of Fortune in both miniatures (abraded in Kettaneh), we recall that Laurent, following Boccaccio, said that she had 'la face cruelle et horrible'.[53] The Boucicaut workshop, as one would expect, made Fortune more majestic by toning down the contrasts in her striped dress and by reducing the number of arms and hands that symbolize Boccaccio's hundred. The illuminator, however, kept the text in mind, and his awareness of it even led him to correct a basic error in both the earlier figures. Boccaccio (and after him Laurent) spoke of the burning eyes of Fortune, which seemed to threaten him and which she soon turned on him when she began to speak. Both the Cité des Dames Master (Fig. 393) and the Luçon Master had nevertheless shown her blindfolded, in accordance with an old tradition that was still strong in their time.[54] The Boucicaut illuminator, however, followed the text and took the band off her eyes. He refused on the other hand to let Fortune's hair hang loosely down her neck, as the text states

and Geneva shows. And it was almost certainly the same conception of the complete, dignified figure that led the illuminator to show the feet of the goddess when Boccaccio explicitly says he could not perceive them. The illustration is a fascinating example of the independence of a good early fifteenth-century painter who because of personal artistic ideals disregarded both authoritative models and a text he was illustrating.

It was indeed the painter rather than a hypothetical adviser who manifested independence; our examination of the relationship of several miniatures to the text has led us gradually to recognize that. This conclusion is strongly supported by the representation of the struggle of Poverty and Fortune (Fig. 396). It would certainly seem to be the Boucicaut illuminator rather than a scholar who decided to omit all the holes in Poverty's dress mentioned in the text, which specifies as many as a hundred. A few are apparent in the miniature in the manuscript of Jean sans Peur, to which the Kettaneh representation is once again in other respects related (Fig. 395).[55] Misfortune in the Kettaneh miniature is however pushed into the background, displaced by the figure of Boccaccio himself. The Boucicaut workshop has indeed given the figures such weight and poise that the writer seems to watch a greeting rather than a contest.

What the Boucicaut illuminators lacked in historical or geographical knowledge they compensated for by vivid 'local color'. As a punishment for the murder of his brothers Jugurtha, according to the text, was hurled into the River Tiber from 'la montaigne torpée ou fut le capitolle de romme'.[56] Both the Geneva and the Arsenal manuscripts show the brutally ambitious king thrown from a tower, and since a mountain, presumably the Tarpeian Rock, rises in the background of the Geneva miniature the tower may be the Capitol itself (Fig. 399).[57] The structure is preserved in the Kettaneh manuscript, but it becomes an integral part of a stirring view of a medieval city on a river – Paris on the Seine rather than Rome on the Tiber (Fig. 400).

Book I, Chapter 1, devoted to Adam and Eve, is marked in the Kettaneh manuscript by rich illumination and a uniquely large miniature (Fig. 379). Laurent does not speak of the Lord's acts of creation, which the Boucicaut Master, who must have had a share in the design and execution of this folio, spotted around the margins. These scenes were not introduced into the earlier manuscripts for the Dukes, and indeed the practice of distributing framed secondary scenes in the margins had not earlier been established in French illumination. There were models in earlier Italian and Bohemian illumination, and we have seen border medallions enclosed by pseudo-acanthus leaves in Douce 144, probably inspired by the work of the Master of the Brussels Initials (Figs. 53, 55). At about the same time as the Kettaneh Boccaccio the Boucicaut Master introduced similar marginal elements in the Mazarine Hours, employing there medallions enclosed by vines or framed squares or quatrefoils (Figs. 258-268). Quatrefoils he no doubt saw in the manuscripts of Jacquemart, though they were not filled with religious episodes. The relationship is significant, however, for like Jacquemart the Boucicaut Master distributed his smaller elements so as to give the entire folio a geometric pattern and a strong structure. This was very much less the intention of the illuminators, especially the Bedford Master, who adopted the new border design and exploited it for narrative enrichment.

The main miniature enclosed by the scenes of creation is likewise novel. In the Geneva representation Adam and Eve sit side by side on a curved bench, informal and even cozy (Fig. 380).

They are linked in a charming design of interrelated rhythms. In the Arsenal manuscript they stand beside the Fountain of Paradise, warmed by the rays of a 'Boucicaut' sun (Fig. 381). Eve addresses Adam as though before the Fall, but only the Boucicaut Master shows the tree, the apple, and the serpent. The miniature by the Boucicaut Master and his assistants, though painted only some five years later than the illustrations in the ducal manuscripts, seems to belong to a new era. In its perspective, spatial depth, and naturalistic scale – Adam and Eve stand almost under the Tree – it surpasses the contemporary painting of the Fall in the *Très Riches Heures* (Fig. 378). The Limbourgs, to be sure, gave this particular miniature of Paradise an idyllic character, tilting the chief plane, disregarding actual proportions, and endowing the sinners with a mood that even at the moment of their expulsion remains gentle and subdued. Alongside this episode the Boucicaut Master's angel flying at Adam and Eve with brandished sword looks extremely violent, and Adam does indeed seem to turn about to ward off a blow.

The Boucicaut Master employed his command of space and of the figure in the service of the narrative. First of all he developed the conception of a walled garden into a great octagon, including an exit gate and a second gate inserted, characteristically, for symmetry.[58] Within the garden there is ample room for angels, who turn to watch the scene of temptation and seem surprised by the serpent's success. Beyond the garden, in the rolling hills of a deep landscape, Adam and Eve toil, as Laurent said. In the shadow of the nearer wall they appear once more, aged and leaning heavily upon canes as they approach Boccaccio, who seems to hold open the book that describes this very vision.

Shortly after the illumination of the *Cas des nobles hommes et femmes* the Boucicaut workshop undertook a similar but much fuller *speculum historiale*. The famous *Trésor des histoires* presents the heroes and great villains of the past in 223 miniatures, the largest well illustrated historical cycle that has come down to us from this period. To ancient mythology it adds the history of the Greeks, Romans, and Persians; there are also Old Testament and Early Christian worthies, and the Middle Ages is represented through Pope John XXII. If, as is probable, so enormous a series was produced within a limited period of time collaborators would have been necessary, and indeed the Boucicaut Master himself apparently had little to do with the actual painting. He was fully occupied with general supervision and with the execution of the marginal drawings. Some of these excellent linear notations are still faintly visible.[59] Assistants who had been trained by the Boucicaut Master executed many of the miniatures (Figs. 405, 406, 408, 409) but other collaborators must have been engaged by the *chef* in a mood of desperation (Fig. 410).

The scribe often left a space somewhat longer than high for the miniature, perhaps by arrangement with the illuminator. When the text called for an event within a building the painter achieved a comparatively naturalistic scale without reducing the size of the figures by making visible only a section of the structure within a firmly established 'window' (Figs. 406, 408). In the scene of Isaac blessing Jacob the flower pots reposing on the lower frame prove that the illuminator associated it with an actual window that opens onto the light. (Fig. 406). The figures are near the window, whereas both floor and ceiling are no longer visible around them. The beholder, though held outside the pictorial space, has a sense of intimacy with the nearby action as he looks at it through the aperture. The Boucicaut Master employs this kind of close-up frequently in the

second decade of the century, usually for narrative scenes but sometimes, as in British Museum, Egerton 1070, for figures of saints also (Figs. 206-208).

In these and other miniatures the buildings are usually set oblique to the picture plane. They serve as usual not only to define the space but to sustain and clarify the narrative. Priam and Hecuba, weeping in symmetrical postures, stand close to the tomb of Hector but linked with a window that is in a different, specially constructed part of the building (Fig. 408).[60] The friar who leans towards the dying Augustine and is weighed down by a large open book is locked in place by the pattern of wall and windows behind him (Fig. 417). The geometry of the setting performs a similar function in *Isaac blessing Jacob* (Fig. 406), and it contributes to the rhythm and to the order underlying the turmoil in the scene of Roman officers murdered by followers of Jugurtha (Fig. 413). The same might be observed of the miniature of the destruction by Diocletian of a Christian church (Fig. 416). The figures themselves, massive and articulated, often assume the role of the architecture. The riders who bear the imposing and arrogant Pompey in triumph compose with his litter a sort of trabeated system (Fig. 414). Even a kneeling figure such as Herod paying homage to Augustus is given the precise verticality, balance, and broader base of an architectural member (Fig. 415). And Oedipus dangling, head downward, from a tree is as straight as a shaft and he is buttressed below – perfectly *all'italiana* – by the dogs of the hunters that strain up towards him (Fig. 407).

In deep landscapes with pale, vibrant distances the figures are often contained by a building: the three sons of Jugurtha, who look out at the realm that will be divided among them, stand in a sort of basilica (Fig. 411). When the figures occupy the landscape the trees, hills, and lakes (of which the illuminator is very fond) are carefully disposed to embrace them. King Arthur gains strength from the mountain that runs down toward his adversary, a Roman consul; the consul, backed partly by water, must conduct, as it were, an uphill struggle (Fig. 418). It is notable that the consul wears the appropriate cuirass. Occasionally the figures are reduced to small elements in a panorama; in the scene of Adherbal's fall the castle of Cirta in Numidia occupies most of the space (Fig. 412). The plain, highly burnished gold background is often reinstated as an equivalent of a luminous sky in this and other Boucicaut manuscripts of the second decade of the century.

One miniature, which belongs to the group painted by an execrable collaborator, is almost identical in design with a miniature in the *Boccace de Jean sans Peur* (Fig. 410). Henry Martin, who observed this resemblance many years ago, rightly stressed the great artistic inferiority of the painting in the *Trésor* and concluded that it must therefore be a copy of the other.[61] The *Trésor* is indeed, we believe, later than the *Boccace*, which was illuminated *circa* 1410, but the relationship between the two miniatures is more complex than Martin believed. The painting in the *Trésor*, which represents a triumphal journey of Scipio Africanus, lacks the yoke that connects the horses and the wagon and that is so carefully rendered in the *Boccace*. On the other hand the latter miniature, which was executed by a member of the Bedford group, lacks the *repoussoir* and is strange iconographically. It represents Emilius Paulus bringing prisoners to the capital, but the figure in the car looks less like a general than a lady! Probably both miniatures depend upon an earlier composition by the Boucicaut Master, and indeed the painting in the *Boccace* shows his pattern of color.

The third great historical cycle undertaken by the Boucicaut workshop has remained, like the Kettaneh Boccaccio, entirely unpublished, although many of its ninety miniatures are strikingly beautiful. Fortunately they were largely spared by a fire in the Cotton Library, though the borders were badly damaged. The cycle is the least universal of the three, consisting of illustrations of a *Chroniques de France* that ranges from the putative origins of the French in Troy to the coronation of Charles VI in 1380. As usual the Boucicaut group was joined by other illuminators working in diverse styles. The Egerton Master painted some refined miniatures (Fig. 426), but another practitioner was responsible for conspicuously mediocre productions, and it is notable that the execution of the first large miniature in the book was left to a competent but not greatly gifted member of the Boucicaut circle (Fig. 421). In this miniature King Priam, given an exotic high hat and the great beard that had long been out of fashion in France, is enthroned within a strange circular structure. It is enriched with dormers that are functionally meaningless in a building that consists of a roof and lantern resting on columns, but the lapidary and spatial effect is powerful. The Boucicaut Master may have provided the essential scheme.

The best miniatures are very beautiful in color. The variegated stones of the wall over which King Clothaire witnesses the punishment of Brunhilde compose a mosaic of hues (Fig. 419). King Hugh Capet, who dreams of the appearance of St. Valéry, lies in a building constructed of massive blocks, alternating irregularly between three shades of pink and a silver that is laid over a pink ground which now, and presumably to some extent originally, showed through the metal (Fig. 425). St. Valéry, bending over the King and gesturing pointedly, appears to be giving instructions, and indeed he is requesting the removal of his body from the church of St. Bertin to his own, St. Valéry. The poetic scene of Charlemagne's vision of a sign in heaven is represented on a terrace to permit a full view of the blue, starry sky (Fig. 422). The gestures of both an angel and St. James guarantee that neither the Emperor nor the beholder of the picture will fail to see what seems to be the white tail of a comet that has streaked by. St. James, standing before the lighter zone of the sky, wears a deep, slightly reddish blue dress, and the pot on the wall behind him that bears a green plant is red. The floor has transparent green triangles, the angel is pale orange, and the bed and canopy maroon, enlivened with spidery ornaments.

The convention of close views of diagonally placed structures was firmly established in the Boucicaut circle after 1409 (Figs. 113, 188, 191), and the *Chroniques*, painted around 1414, is no exception. We have seen one example in the miniature of St. Valéry (Fig. 425); another is the scene of the episcopal blessing of the body of St. Denis, which lies on the maroon and black floor of a pale green church (Fig. 424). The splendid but somewhat damaged miniature of King Charles V at table (in 1378) with his guest Emperor Charles IV conforms with this prevalent type (Fig. 429). Other miniatures show a recession straight inward, the space frequently viewed through an arcade such as we have seen in Books of Hours illuminated in the third lustrum of the century (Figs. 147, 253, 423). The triple arcade is ambiguously placed within the church of St. Peter's (Fig. 420). The building provides a Gothic setting for the coronation of Charlemagne as emperor. In the *Obsequies of Roland* the arcade lies in the picture plane, and is effectively combined with varying levels within the church to bring the observer above and close to the *chapelle ardente* (Fig. 423). The arcade has a similar function in the scene of the obsequies of Jean le Bon

in 1364 in the Abbey of St. Anthony (Fig. 428). The construction of the impressive space, which is parallel to the picture plane, resembles strikingly Ambrogio Lorenzetti's in his fresco of Boniface VIII and St. Louis in S. Francesco, Siena (Fig. 430). Ambrogio's architectural window, however, might be read as a member of the building itself, whereas the Boucicaut example is decisively differentiated both by color and by the clear implication of a much higher and much lower space behind it.

During the second decade of the fifteenth century the Boucicaut group participated in the illumination of three manuscripts of Pierre Bersuire's translation of Livy. One, the earliest, contains the text of all three Decades into which the history was divided, exclusive, of course, of the third chapter of the third, which was not discovered until the sixteenth century (Figs. 431, 432, 434, 435, 441). A second manuscript, in the Harvard College Library, contains now only the Second Decade (Figs. 433, 437), and a third, formerly in the great Phillipps Collection and now in the possession of Dr. Peter Ludwig, has only the Third Decade (Figs. 436, 439, 442-446). The one complete cycle (Bibliothèque nationale, fr. 259) is also the weakest; close followers of the Boucicaut Master painted only a very few miniatures, including the frontispiece for the prologue (Fig. 431) and for the Second Decade (Fig. 432). The former shows a fine broad landscape, in which Bersuire, a Benedictine monk, offers his translation to King Jean le Bon, while an angel hovers above holding the royal crown. At the right a herder of cows watches Romulus and Remus suckled by the wolf. A very solid yet incomplete Rome rises behind, an eagle perched over its gate. The frontispiece for the Second Decade seems to have been painted by the author of the large miniature of Priam at the beginning of the *Chroniques de France* (Fig. 421). This illuminator strove for a more showy effect, enlivening the outlines, creating fancy exotic hats, and turning the color toward yellow, vermilion, pink, and mauve.

From the period in the late fourteenth century after the translation of Livy into French we possess only one excellent cycle of illustrations, painted by Jean Bondol and his followers for Charles V.[62] When the leading illuminators after 1400 turned to the text they did not consistently follow earlier models, even with regard to the choice of subjects for illustration. The scenes in the Ludwig manuscript were regularly selected from the first three chapters of each book, whereas the illuminators of fr. 259, manifesting a predilection for exciting events, drew them from any part of the books.[63] For the fifth book (we shall follow Livy's original numeration) of the Third Decade, for instance, the illuminator seems to show the cavalry of Lucius Cornelius Merula riding into an ambush of the Boi (Fig. 434). In another miniature we see a responsive mason ordered to carry forward the rebuilding of Rome after the Gallic sack (Fig. 435). For Book II of the Third Decade fr. 259 illustrates a meeting between King Philip of Macedonia and a Roman consul from Chapter 33 whereas the Ludwig manuscript shows an assignment of consuls discussed in Chapter 1 (Fig. 439). For this same book an early fifteenth-century Livy illuminated in part by the Master of Berry's Cleres Femmes and originally in Berry's library, represents Romans praying after the appearance of alarming prodigies discussed in Chapter 1 (Fig. 438). Even the statues envisaged by this ebullient master engage in animated and – at least to us – prodigious discourse. This *Tite-Live* in Geneva shows, in medieval guise, the ordination of a new pontiff described in Chapter 2, Book V, Decade 2 (Fig. 440). Both fr. 259 and the

Harvard manuscript illustrate Chapter 1 of this book, representing Romans kneeling before a god (Mars?) distracted by growling dragons in the sky (Fig. 437).[64] These savage creatures apparently represent the foreign gods worshipped by many Romans, especially by rustics, Livy says, recently come to the city. In the Harvard manuscript a shepherd who remained on the land, warmed by a blazing sun, watches them.

Sometimes the same episodes are selected in two manuscripts but the compositions vary, even in miniatures painted within the Boucicaut circle. Thus Cato's defense of the Oppian law, described in Chapter 2, Book IV of the Third Decade, is illustrated in both fr. 259 and the Ludwig manuscript, but the compositions could hardly be more unlike (Figs. 441, 442). Only the latter bears the stamp of the Boucicaut Master himself, and it is fascinating to observe that he drew from the text – so it seems – the two tribunes who opposed Cato and sat them on either side of him to extend the dynamic symmetry begun by the placing of the women.

The appointment of Hannibal as general of the Carthaginians is the subject of the frontispiece of the Second Decade in both fr. 259 and Harvard (Figs. 432, 433). The compositions are generally similar, though the author of the miniature in the Harvard manuscript worked only occasionally with the Boucicaut group and never assimilated its style. In the Livy he painted only this one scene, the first in the manuscript, but he was responsible for a number in the Gulbenkian *Cleres femmes* (Fig. 375).[65] He may be called the Master of the Harvard Hannibal. Though not highly endowed he was a good storyteller, and he communicates the idea of the popular acclamation of Hannibal by creating ethnic variety, particularly Negroid and Semitic. He delights in fantastic headgear, and he was no doubt pleased to read Bersuire's statements that on this occasion Hannibal was acclaimed emperor.[66] He made doubly sure of the significance of the occasion by honoring the general with a sort of combined papal tiara and imperial crown. The comparatively sober author of the scene in fr. 259 used a fillet of laurel leaves.

Though the beautiful miniatures in the Ludwig manuscript show little sense of historical actuality they imply an awareness of passages in the text. The first chapter of Book V of the Third Decade tells of Scipio's encounter with the Lusitani after they had plundered a province and were laden with spoil. The movement of the column, Livy says, was 'hindered by the great number of its cattle', and this presumably the illuminator represented, adding out of his own repertory a magnificent sunset (Fig. 436). Amynander returning to Athanania is touchingly acclaimed as – apart from his pride – Christ entering Jerusalem (Fig. 445). Among the Macedonians who are driven from their 'ancestral homes' by King Philip, Mary and Joseph from the Flight into Egypt take an expressive place. The bent and sad people are not cheered by the brilliant light (Fig. 446).

In these late works the Boucicaut Master took advantage of the horizontal format to create broad and deep compositions. Whether interiors or landscapes they attain the grandeur of the paintings in Add. 16997. Though the miniatures in the Harvard copy are earlier and smaller they too have an impressive monumentality. The illuminator exploited the vertical format by piling up landscapes, buildings, or entire cities above the figures (Fig. 437). To increase the impression of lofty heights in both the Ludwig and Harvard cycles the ground plane on which the figures move is dropped below the lower frame. Just behind the frame the illuminator has stretched a

narrow strip of terrain across the space, and the beholder, who seems to stand on it, looks down on the main action and up at the heights of the buildings behind (Figs. 436, 446).

The Boucicaut workshop illuminated two copies of yet another of the great medieval treatises that were translated into French at the order of Charles V. The *Propriétés des choses* of Bartolomeus Anglicus is a general encyclopedia in which the entries appear in hierarchical succession, beginning with God and continuing through the angels and man to the animals and the qualities of earthly objects. With one or two exceptions the miniatures in the manuscript in the Fitzwilliam Museum are not as strong as those in the Bibliothèque nationale (fr. 9141), which compose in fact the most beautiful illustrations of this text that have come down to us.[67]

Though the two manuscripts were illuminated by painters who were certainly joined in some form of association, the pattern of illustration and the iconography vary, as so often in manuscripts in the Boucicaut style. Thus the first miniature – after the scene of the presentation of the translation to Charles V, which in fact is lacking in fr. 9141 – shows the seven days of Creation in that manuscript but the Lord introducing Eve to Adam in the Fitzwilliam copy (Figs. 447, 457).[68] The scenes of Creation in fr. 9141 resemble those in the border of the frontispiece of the Kettaneh *Cas des nobles hommes et femmes* (Fig. 379), though the Creator in fr. 9141 is far more powerful.

The fateful introduction of Eve to Adam in the Fitzwilliam miniature is watched with respect and curiosity by most of the newly created animals (Fig. 457). A unicorn, closest to *Eva pudica*, prances energetically. The first woman's power over it is to be entirely temporary. The presentation takes place in a garden very similar to the one in the Kettaneh Boccaccio (Fig. 379). The wall, to be sure, is more rustic in the Fitzwilliam miniature, and the octagon of the Boccaccio has been replaced by one of those impressive circular plans of which the Boucicaut Master was so fond (Figs. 34, 292). The space is deep and the horizon low.

Most of the following miniatures in the Fitzwilliam manuscript are by different illuminators than the frontispiece and they confine the illustrations to a shallow space, whereas fr. 9141 places several of them in a series of splendid landscapes. In the miniatures in both manuscripts for Book VIII, which deals with the properties of the world and the heavenly bodies, a professor holding a sphere talks to three or four men (Fig. 454). In fr. 9141 the speaker faces the sun, the moon, and the stars in the heavens; in the Fitzwilliam miniature he has the task of conjuring them for his audience, since there is only a diapered background bearing large lilies. In the miniature in Paris the swans, not to mention the rabbits, are present as favorite creatures of the Boucicaut Master and his associates, but the fine parade of fish in the miniature for Book XIII illustrates its contents, concerned as this section is with water and its inhabitants (Fig. 451). The corresponding Fitzwilliam miniature shows fish-less streams to illustrate 'leaue en general' (Fig. 453).

The audiences in the Fitzwilliam codex are less fashionable than those in fr. 9141 and certainly more serious. The illustrations manifest, furthermore, a special medical interest. Thus Book VII on human maladies, which remained unillustrated in fr. 9141, in the Fitzwilliam manuscript has a miniature containing some typical infirmities (Fig. 456).[69] Book IV, on the four elements and the four humors, is accompanied in the latter manuscript by a discourse in an interior that displays an array of medicinal jars (Fig. 452). The listeners seem, naturally, rather anxious. The correspond-

ing scene in fr. 9141 lacks all such therapeutic manifestations (Fig. 449). Only an emblem of the four elements hovers in a bright sky. The nobleman wearing a black *houppelande* and holding a mallet is probably Jean sans Peur.[70] Why he should be here is unclear, whereas the appropriateness of the presence of Jean de Berry in this same manuscript in the illustration of the chapter on precious stones needs no comment.[71] For Book V, on the parts of the body, the Fitzwilliam manuscript introduces a physician with his patients, whereas fr. 9141 offers a private anatomy lesson for the initial owner of the manuscript, Béraud III of Clermont, whose pet dog is curled up on a bench below the anatomical figure (Text fig. below).[72]

In fr. 9141 the illustration of Book VI describes the modes of life that are appropriate to different ages. Apart from children with their spinning tops and bows and arrows, young manhood rides off into the country to hunt with a falcon whereas middle age sits counting money. Moral or intellectual discourse is proper, finally, to old age. Although the landscape in this and other miniatures is fine, the one that accompanies the discussion of the regions of the world is the most studied (Fig. 450). It is studied, however, as a sun-struck vista but not as an illustration, for instead of the diversity with which the text deals the buildings are all French. Though somewhat confused in linear perspective and not the equal of the best miniatures of this kind in the Châteauroux Breviary and Add. 16997 (Figs. 115, 299), it is enchanting in color and atmospheric effects. In the rolling warm green and tan foreground nestles a small hamlet, its chimneys, tower, and cross reflecting back the light. The lake beyond is composed of strokes of blue, gray, and green. The dusky buildings of the distant town shimmer in a soft golden haze.

Miniatures of this kind show us one of the most engaging aspects of the Boucicaut style. God giving Adam a soul presents another (Fig. 448). To infuse the body the Lord bends over it, but not very far because Adam has been conveniently and gracefully propped up by a hillock. God and Adam are thus expressively set in parallel diagonals. In characteristic Boucicaut manner – derived from Tuscan painting – stable verticals are established all around this diagonal group, and especially just behind the tilted Lord.

Boucicaut Workshop: *Instructor giving an anatomy lesson, probably to Béraud III.*
Paris, Bibl. nat., fr. 9141, fol. 55.

V

The Boucicaut Master and Jacques Coene

I N 1905 Paul Durrieu proposed that the great anonymous artist who is the subject of this book might actually have been Jacques Coene, a painter of Bruges, who in July 1398 was living in Paris. In the following year Coene went to Milan to become an 'engineer' of the new Cathedral and to make a drawing of it. These facts fitted Durrieu's conception of the Boucicaut Master, who in his opinion painted the very Italianate main cycles of the *Brussels Hours* before 1402. For a time this hypothesis won much agreement, but it has been discarded by most recent historians because of the general recognition that he was wrong about the Brussels miniatures, and that they were painted by quite a different master.[1] His idea has continued, however, to tempt some scholars,[2] and for reasons already implicit in the preceding text and now to be summarized I believe that Durrieu's proposal was probably right after all.

Jacques Coene is documented from 1398 to 1404. In 1398, when we first hear of him, he was living in Paris and performed an interesting and unusual service for a certain Johannes Alcherius, himself an unusual man. Alcherius, very probably French and bearing the name Jean Aucher, was collecting information on materials and techniques of both writing and painting. We possess part of his compilation because in 1431 a French successor, Jean Lebègue, fortunately undertook a similar work and included parts of Alcherius' text in it. Lebègue's manuscript is preserved in the Bibliothèque nationale.[3] We know that Alcherius left Milan for Paris in 1382, taking with him a recipe for ink that Alberto Porzello, a master scribe, had given him. On July 28, 1398, in Paris Alcherius wrote out an account of pigments – 'de coloribus ad pingendum' – that the Flemish painter Jacques Coene, then living in Paris, dictated to him.[4] The recipes, which Coene said he had used throughout his career, refer primarily to illumination, but instructions are included for painting on panel and for drawing on parchment.

Alcherius frequented Milan as well as Paris. He transcribed technical data in the former city in 1409, in the latter in February 1410. In May 1410 he visited Venice, recorded extravagant praise of Michelino da Besozzo, and returned to Paris in 1411. He was, in other words, well known in circles concerned with art in Milan and Paris – circles that had been engaged in a lively exchange since about 1380.[5] He was admitted to the deliberations of the committee responsible for the construction of the vast new Cathedral; the records always refer to him as *francese*.[6] On his recommendation the painter Jacques Coene of Bruges, living in Paris, according to the record, received an appointment as 'engineer' (*inzignerius* or *ingegnere*) of the Cathedral. The council of the Fabbrica made the decision on April 13, 1399, appointing 'Cova . . . cum duobus discipulis suis', and fixing a monthly salary for the group.[7] The position of *ingegnere* was held earlier by another Frenchman, Nicolas de Bonaventure, and by the illuminator Giovannino dei Grassi.[8]

In the records Coene is always described as *pinctor* and sometimes *magister*; never *miniator*. He actually left Paris in July, with the painter Jean Mignot as companion, and arrived in Milan on

7 August.[9] Coene's salary was fixed at 24 (or 25) florins a month; that of Mignot and Companiosus at 20 florins each. The wages of the servant of each of the painters was included in the sum.[10] By contract Coene was charged with making a drawing of the church from bottom to top – 'designare ecclesiam a fundamento usque ad summitatem'.[11] Precisely what this phrase meant we do not know. Inasmuch as the construction of the Cathedral had not advanced beyond the raising of the piers[12] Coene may have been asked to draw a section, or a series of details of the entire superstructure. Possibly the committee was already thinking of the façade and wanted a drawing for public display. In any event the artist would not have been called from France to serve as 'engineer' unless he possessed a reputation for work of this kind. How much Coene accomplished we do not know. His name disappeared from the records after that date. Only Mignot remained on for a couple of troubled years, defended by Alcherius against charges by Lombard rivals that finally led to his dismissal.[13]

The Milanese records identify 'Cona' as a native of Bruges, and he was no doubt a member of the Coene family of painters in that city. We learn of them in records from 1363 on. Jean Coene, for example, was mentioned frequently until his death in 1408; he painted a *Last Judgment* for the Court Room in 1388, and he was twice dean of the guild of painters.[14]

After 1399 we lose sight of Jacques Coene until the spring of 1404, when he received 20 francs for painting miniatures in a Bible in Latin and French ordered by Philippe le Hardi, Duke of Burgundy.[15] He had two collaborators in the enterprise. The document is actually of 1407, when Jacques Raponde, the agent of Philippe and of Jean sans Peur, was reimbursed for sums he had laid out earlier for the Bible. The payment was ordered by Jean Durand, the physician and counsellor of Philippe who during this very period – 1402–1404 – had Paul and Jean Limbourg in his house near Notre-Dame. They too were working on a Bible, apparently unfinished at Philippe's death; it is very probably the famous *Bible moralisée*, fr. 166 in the Bibliothèque nationale.[16] 'Coene's Bible' may also have been a manuscript of the same text, for the document of 1407 states that – like fr. 166, and its Pucellesque model, fr. 167 – it was written in Latin and in French. Perhaps Philippe commissioned two copies of the *Bible moralisée* at the same time; in 1403 he ordered three copies of the *Fleur des histoires*, giving one to his brother Jean de Berry.[17] This is all the more interesting because Jean sans Peur, probably carrying out his father's wishes, gave the 'Coene Bible' to the Duke of Berry. It cannot, however, be connected with any item in Berry's inventories nor with any extant manuscript known to us. Its recovery, if it still lies in some library, would give us proof positive of the identity of three important masters.

The fact that Jacques Raponde as well as Jean Durand had a role in the commission for the 'Coene Bible' is significant. It was he who provided Philippe le Hardi with the *Fleur des histoires*, Bibliothèque nationale, fr. 12201, that was illuminated by assistants of the Master of the Coronation, and this master himself painted many of the miniatures in the *Cleres et nobles femmes* that Raponde gave Philippe on New Year's day, 1403 (Figs. 368, 372).[18] We have pointed above to the similarities of the style of this illuminator and of the Boucicaut Master, and we now find Coene working for the same employer.

Though for purposes of identification we have referred to the presumed *Bible moralisée* illuminated for Philippe le Hardi as 'Coene's Bible', he was only one of three masters engaged on the

work. He alone, it should be noted, is characterized as 'paintre', precisely as in the documents in Milan. The other two masters, described as 'enlumineurs', were 'Ymbert Stanier' and 'Hainsselin de Haguenot'. Stanier is otherwise unknown,[19] but his companion reappears in most interesting circumstances. Probably it was he who as 'peintre' carried out some minor work for the Queen in 1403.[20] One Haincelin served as 'enlumineur en titre' and *valet de chambre* of the Duc de Guyenne from 1409 till the latter's death in 1415.[21] The young Dauphin collected manuscripts and *joyaux* eagerly and with unusual discrimination, acquiring for instance the *Térence des ducs* and a good *Cité de Dieu*, Bibliothèque nationale, fr. 174. It was during the period 1409–1415 that, as we have seen, the Bedford Master acted as the *chef* of the Breviary now in Châteauroux that was made for this prince.[22] More interesting still, his chief collaborator was the Boucicaut Master, and indeed these two leading workshops may be found together from no later than 1407, the year of the Douce Book of Hours, till late in the second decade of the century, when the masters themselves illuminated Add. 16997, as we have remarked above.

Thus the identity of the Bedford Master as well as of the Boucicaut Master is at stake. About the former we can add that 'Jehan Haincelin, enlumineur demourant a Paris', received eleven pounds from the Duke of Orléans in 1409,[23] and that about 1415 the same man called on English visitors in Paris, offering them a steel mirror.[24] His workshop is generally recognized to have continued until the middle of the century, and in 1448 'Jean Haincelin enlumineur' (the same master?) received payments from the Duke of Orléans.[25] As for Coene and Boucicaut, the number of coincidences is striking. Coene was in Milan in 1399, and the early work of the Boucicaut Master (*circa* 1405) is deeply Italianate, reflecting the art of the Milanese Giovannino dei Grassi and still more the Tuscans. The *Boucicaut Hours* was commissioned, furthermore, by the Governor of Genoa, and it is quite possible that the Marshal, who went to Genoa in 1401, made the acquaintance of Coene–Boucicaut in that region.[26] Coene–Boucicaut could even have returned to Genoa after the death of Philippe le Hardi in 1404 to undertake the Book of Hours for the Marshal.

We must remember also that manuscripts illuminated by French masters for great Italian patrons are rare at this period, and that the Boucicaut Master's Book of Hours for the Visconti adds therefore a solid stone to our arch. Another is the fact that Lorenzo Trenta, the Lucchese merchant, found the Boucicaut Master's style congenial and acquired a Missal. The Boucicaut Master, moreover, maintained a surprising distance from the bulk of the manuscripts produced in his style; few miniatures from his own hand are extant. For this reason and still more because of the nature of his art we have suspected that he was not occupied with illumination alone. This conforms with the fact that Jacques Coene was a painter as well as a master of the book. Most impressive, finally, is Coene's concern with architecture at Milan in the light of the wholly extraordinary buildings in the Boucicaut Hours and in Add. 16997. In the earlier manuscript, for instance, the shed in the *Nativity* and the *Adoration of the Magi* (Figs. 31, 33) is conceived as an actual structure: it is rotated ninety degrees in the second miniature or, we might say, the point of sight has shifted from one side of the building to another. It cannot, furthermore, be doubted that the interiors of the Boucicaut Master have a measure and scale unprecedented in the history of painting.

VI

Inheritance and Legacy

ISTORIANS agree that the painting of the Boucicaut Master is related to several manuscripts datable from 1401 through 1403 and brought together by Bella Martens as the work of the 'Master of 1402'. She and subsequent writers have regarded as the nucleus of this group two very attractive copies of Boccaccio's *Des cleres femmes*, one received by the Duke of Burgundy in 1403, the other by Berry at the beginning of 1404.[1] Actually these manuscripts, though certainly connected, represent two diverse and distinguishable trends. Burgundy's cycle is more delicate in form and color, and the pantomime is elevated by reminiscences of the Mediterranean tradition (Fig. 368). Berry's miniatures are more pungent in color and livelier in narrative; they seem more purely Netherlandish (Fig. 369). These two styles are characteristic of illuminators whom I call the Master of Berry's Cleres Femmes and the Master of the Coronation.[2] Two works of the latter illuminator, who is the greater, concern us especially here. He was responsible for several miniatures in the beautiful *Bible historiale* owned by the Duke of Berry in 1402 (Figs. 459-463),[3] and a large miniature at the beginning of a *Légende dorée*, the text of which was written in 1402 (Fig. 458). This splendid painting, representing the *Coronation of the Virgin*, has been connected with the Limbourgs;[4] it is no doubt worthy of them but it surely must be considered a masterpiece of the chief painter of the Bible. It is, furthermore, especially close to the *Boucicaut Hours*.

Let us consider the Bible first because of its earlier date.[5] The choir singing the praises of the Lord stands on a platform that rises a little above a tiled floor (Fig. 462). As in other miniatures in this manuscript and again in the *Boucicaut Hours* it serves as a stage upon which many indoor events are enacted. In the Bible the platform projects forward further at the center, though, unlike the similar projection in *St. Leonard* in the *Boucicaut Hours*, it does not quite reach the picture plane (Fig. 1). Sometimes in the Bible as in the *Boucicaut Hours* the tiled floor alone measures the distance and serves to evoke a chamber (Figs. 4, 463). St. Mark in the Bible even turns his back somewhat on the beholder, promoting the recession of the space more than does the otherwise similar St. Jerome in the *Boucicaut Hours* (Figs. 42, 463). Though the Boucicaut Master avoided, at least in this Book of Hours, the informality of a major averted figure, he did achieve a more effective inward extension of the floor itself by his superior command of linear perspective.

The Bible, completed before 1402, contains other forms that recall the *Boucicaut Hours*. The halo of St. Mark, like many Boucicaut haloes, is decisively foreshortened (Fig. 463); the shadow on its more distant surface is matched in certain haloes of the *Horae* (Fig. 38). The tall, well-rounded David and St. Mark, wrapped in flowing mantles, resemble figures in the later manuscript (Figs. 461, 463). In facial type they recall such stalwart saints as Paul or Catherine (Figs. 5, 23). Even the domestic half-timber building appears in both manuscripts. Whereas it encumbers the side aisle of a church in the *Boucicaut Hours* it is turned to more appropriate uses in the Bible,

serving for instance as a cozy superstructure for Noah's ark (Figs. 29, 459).[6] These objects common to both manuscripts are symbols of a deep relationship that includes a fluid conception of paint and a comparatively open brushwork, especially conspicuous in the Bible in the waters of the Flood (Fig. 459).

The *Coronation of the Virgin* of 1402–1403 shows us the chief illuminator of the Bible working a couple of years later and on a larger scale (Fig. 458). The scene is viewed through an aperture in a thin layer of clouds that lies just behind the frame. This form fulfills a spatial function like that of the architectural or landscape diaphragms in the *Boucicaut Hours*. In miniatures of the *Coronation* it can be traced back to the Parement Master in the *Très Belles Heures de Notre-Dame* and to Jacquemart in the *Petites Heures*.[7] The illuminator of fr. 242 has, however, envisaged heaven more in terms of the world, giving Christ, who wears an emperor's crown, a massive, canopied throne. The throne stands on a far-reaching tiled floor that passes forward below the lower frame. On this floor a host of saints foregather, remaining discreetly at the sides of the thrones or even behind them. The Virgin kneels, assuming the posture introduced in the *Brussels Hours* and a few other representations around 1400.[8] She has not, however, descended from a place on his throne but from her own monumental faldstool that now stands empty at the left. Many corresponding scenes in Books of Hours in the Boucicaut style similarly show the Virgin's throne standing empty behind her, though its form is much more like Christ's (Figs. 180, 195).[9] In the *Boucicaut Hours* itself furniture is lacking (Fig. 36); the Virgin has stepped down from a cushion that, like Christ's, is miraculously suspended. The tent in this miniature is equally unusual; borrowed from military encampments or tournaments and bearing the colors and devices (mostly repainted) of Boucicaut, it celebrates the Marshal as much as Christ.

In the *Coronation* in the *Boucicaut Hours* and the earlier one in the *Légende* an angel holds the Virgin's train, tucking the end of it over folded arms in precisely the same way (Figs. 36, 458). The miniature in the *Légende* is in fact a very early instance of angelic support of the Virgin's train. It soon became popular in sculpture as well as in painting, appearing *circa* 1410 in the exquisite relief at La Ferté-Milon (Fig. 470). Though probably reflecting current court ceremonial the motif could have been found much earlier in that inexhaustible source of pictorial ideas, the painting of Siena. In a Lorenzettian fresco dated 1368 in S. Michele in Paganico angels raise the train of the Queen of Heaven as she mercifully bends to help sinners (Fig. 468).

Although the approximately one-point perspective of the tiles of the *Coronation* in the *Boucicaut Hours* creates a more vivid space than the unsystematically designed floor in the *Légende dorée*, the figures are less consistently disposed within it (Figs. 36, 458). Christ and the Virgin are incommensurate with the space measured by the floor. This dichotomy, deliberately magnified perhaps in a supernatural event, nevertheless reveals the painter's uncertainty before diverse possibilities – possibilities opened in part by his own basic researches. It suggests a comparatively early date for the *Boucicaut Hours*. The composition in the *Légende dorée*, on the other hand, is less advanced in perspective but more unified in design.

The figures in the miniature in the *Légende* are even closer than those in the Bible to the *Boucicaut Hours*. The ovoid heads and small features are evoked in both manuscripts by the most delicate gradations of value. Both painters frequently turn the eyes into the corners, so that the

glance moves in another direction than the head. Both masters, furthermore, like to stipple, and they bend their modeling strokes with the curvature of the plane, especially around the face and the neck. Foreshortened haloes, which the Master of the Coronation had introduced in the Bible, appear again in the *Légende* (Fig. 458). In the *Légende* as in the *Boucicaut Hours* they contain patches of red glazed shadow.

No paintings from the years around 1400 share so much with the *Boucicaut Hours* as the works of the Master of the Coronation, and indeed the connection suggested at one moment even the hypothesis that his miniatures might represent only an earlier phase of the Boucicaut Master. The fact that his works can all be dated before 1404 seemed to increase the plausibility of the hypothesis. After this year a few close approximations to the style may be found (Figs. 229, 464), but the style itself disappeared. On the other hand the latest manuscript of the group, Burgundy's *Des cleres femmes* of 1403, lacks any trend toward the forms of the Boucicaut Master; the opposite is in fact true. The Master of the Coronation, furthermore, shows very little of the Boucicaut Master's concern with the principles of Trecento painting. The differences of color and design between his works and the *Boucicaut Hours* are too great to have been encompassed by one master within less than a decade. The palette of the Master of the Coronation is brighter; it includes the Boucicaut Master's vermilion though not his red, and much white, which the Boucicaut Master employed more sparingly. The miniature in the *Légende dorée* contains many subtle hues, soft browns and violets over the olive green and pink tiles of the floor, but all of this exquisite spectrum is overwhelmed by the great scarlet patch of the hanging around Christ. This is the region of the strongest movement also. The angel streams in with the crown, and Christ and the Virgin bend toward each other more impulsively than in the miniature by the Boucicaut Master. It is clear that the Master of the Coronation preferred a more active pattern of forms as well as of color. His restless brush strokes in the circle of clouds would be quite foreign to the taste of the Boucicaut Master.

Despite the differences between them the Boucicaut Master and the Master of the Coronation must have been associated at some period before we have as yet been able to identify them. If the Boucicaut Master was Coene and a renowned painter by 1398 he must have begun his career as a master no later than 1390. Whether the Master of the Coronation was older or younger it is impossible to say. Coene went to Italy in 1399 and the Boucicaut Master was apparently separated from the Master of the Coronation about this time, for whereas the former must then have begun the apprenticeship to Italianate French painting and to Trecento painting itself that culminated in the forms of the *Boucicaut Hours* the Master of the Coronation continued with little or no relation to it. Most probably the two painters were in touch about 1395. Later, in 1402–1404, they had the same patrons if Coene was Boucicaut, because they were then both engaged by Jacques Raponde on illumination for Philippe le Hardi.

The Boucicaut Master began to move away from what seems to have been Netherlandish training by the study, first of all, of Jacquemart de Hesdin. Miniatures such as the *Flagellation* in the *Brussels Hours* served as models of centralized, balanced designs.[10] It showed the Boucicaut Master a mosaic of shape and color, imposing figures and telling gestures. Even the articulation of the 'free leg' of Christ seems to anticipate that of the Baptist (Fig. 3). The statue crowning the

church in the *Annunciation* in the *Boucicaut Hours* has prototypes in the *Brussels Hours* (Fig. 29).[11] More fundamental, the great building in the *Funeral Service* in the *Brussels Hours* is a harbinger of the church in which St. Thomas was murdered (Figs. 11, 136), and the background of *St. Michael* could not have been conceived without such precedents as Jacquemart's *Flight* (Figs. 2, 476). The two landscapes are so similar in form and content that the comparison immediately reveals the originality of the Boucicaut Master, striking even in one of the first miniatures in the *Boucicaut Hours*. Drawing on his earlier experience in the Netherlands – as we may infer from landscapes painted around 1400 by the Master of the Coronation (Fig. 460) – he juxtaposed large areas of high and lower value. He was then just about to enter the new realm of aerial perspective, leaving behind all his predecessors, both Northern and Italian.

The depth of the Boucicaut Master's conviction about a rational and measurable world has already led us to suppose a personal experience of major monuments in Italy, in Lombardy, and above all in Tuscany itself. Most historians have overlooked this aspect of the painter's art,[12] in part because it was not specific motifs of Tuscan painting to which he responded – indeed very few if any can be identified. It gave him rather an idea of pictorial style that he adopted as fundamental to his art. Studying Tuscan panels and Florentine embroideries in the North,[13] he could certainly have become familiar with their concepts of measure, geometry, and scale, but he would probably have felt the full impact of these qualities only in the presence of altarpieces and murals in the churches for which they were made. There he would have found also the most impressive paradigms of clear, rhythmical, restrained pantomime enacted by grave and majestic figures. Of course for all this a foreign visitor would have needed an uncommon perceptiveness. Appearing in Tuscany around 1400 he would have had to look beyond the new and widely diffused mode of Lorenzo Monaco or even Mariotto di Nardo in Florence, or of Taddeo di Bartolo and Fei in Siena, to the great masters of the first half of the century. Perhaps in Florence he looked beyond painting itself to the revolution in sculpture.

Though the Boucicaut Master's understanding of the foundations of Trecento painting was exceptional he was far from being a mere revivalist. His St. Martin, for example, turns on his horse toward the beggar with the dignity and the grace of Simone Martini's (Figs. 19, 486). The beggar lacks, to be sure, the beautiful expression of gratitude that Simone gave him. The saint's movement to cut his cloak, however, is far more credible, and it is accomplished without any sacrifice of compositional rhythm; indeed the extension of the movements of the figures into the environment is richer in the Boucicaut Master's miniature. The space of course runs deeper and plays a larger role in the design. It is striking that the illuminator buttressed the inclined saint and reasserted a vertical axis by juxtaposing the tower of the city gate. Though originally Simone's scene showed a figure near St. Martin the Boucicaut Master's principle of co-ordination is more Florentine than Sienese in character. Florentine too is the simultaneous interlocking in both the picture plane and in space of the main forms: the saint (abraded), the beggar, and the horse.

How deeply Tuscan the composition in the *Boucicaut Hours* is may be realized by comparing it with a *St. Martin* by the Limbourgs, who are generally considered the most Italianate masters of this period in Northern Europe (Fig. 487). Their miniature in the *Belles Heures* shows a greater adherence to single Tuscan forms than to the principles of Tuscan composition. Other miniatures

in the *Boucicaut Hours* show an even greater – one is tempted to say almost Leonardesque – consolidation. Behind the kneeling, prayerful St. Pancras stands his executioner, the two figures forming a compact triangle along the main axis of the scene (Fig. 14). The soldier faces left, the saint right, and their movements compose a rich contrapposto, difficult to parallel in earlier Italian painting, and certainly absent from scenes of the execution of St. Pancras.[14] The officer commanding the execution is remarkably robust, his volume boldly yet simply evoked in the manner of Giotto or the Lorenzetti.

Sometimes the Boucicaut Master gives a traditional French form a new character under the influence, apparently, of Italian models. This seems to be true of the Virgin in the *Visitation*, a high-waisted figure constructed as a spiral that has, however, a columnar base (Fig. 30). The lower half of the figure is amplified by the mantle, which winds around the body and serves as a sheath that is controlled by the Virgin's hand. The motif of a figure holding its drapery is old, passing from ancient art into Byzantine and Gothic, and appearing in the west façade of Reims (Angel Gabriel) or the north portal of Chartres.[15] The distance of the mantle from the body, however, and the turned edge that measures space, recalls Trecento developments of this motif in painting as well as in sculpture.[16] For the Boucicaut Master the columnar Virgin has a special value when juxtaposed with the stooping Elizabeth in a scene of reception and grave recognition.

The Boucicaut Master did not consistently explore all of the stylistic vistas opened by the early manuscript in the Musée Jacquemart-André. Having been the most perceptive student in Europe *circa* 1400 of Tuscan painting he turned away from it, so far as we can judge from the manuscripts that reflect his art. Much of what he had learned in Italy remained, of course, embedded in his style, but only his late Book of Hours in London shows a real re-emergence of his earlier ideals. There once more he became passionately concerned with symmetry, measure, and scale. In the preceding decade he devoted himself more to the analysis of the effect of light and atmosphere on form and on color. For these researches what suggestions he could find were mostly Flemish or Dutch. The miniatures of the Master of the Coronation (Fig. 458) and the illumination of the astrological treatise probably executed in Bruges and given to Jean de Berry in 1403 give us indications of the trend of painting in the southern Netherlands.[17] The miniature of Alexander in the enormous Bible in Brussels written in 1403 displays the concentration on a luminary mode in Holland.[18]

Surely the Boucicaut Master knew also the refulgent pages of Giovannino dei Grassi, the creator of one of the most original and beautiful styles ever to have appeared in a manuscript (Fig. 475).[19] Giovannino's folios glisten with gold, varied and softened by glazes of green or rose.[20] These areas, like dazzling lights, send out broken, vibrating gilt hazes, and the display culminates in great outbursts of centrifugal rays issuing from the main actor, be he God the Father, the archangel Gabriel, or Christ. Though transparent color was spread over comparatively small areas of metal by the Parement Master, Jacquemart, and other French masters it was Giovannino in the last two decades of the fourteenth century who saw the full possibilities of the technique. He utilized as no one else the rich potentiality of gold, giving it varying depth through pale glazes, breaking it into showers of unprecedented shapes, and surrounding it with marvelous vernal or autumnal

hues. In the eighties and nineties Giovannino exploited all the types of rays and radiances that appear in the *Boucicaut Hours*[21] except only the kind of large, partly glazed gold sun that appears over the horizon in the *Flight* (Fig. 35). It was probably his triumphs that inspired the Boucicaut Master's most spectacular *feux d'artifice*. One should not exclude the possibility, either, that Giovannino's luminous *painted* forms had their effects also.

During much of his career the Boucicaut Master was not free to devote himself to the most serious problems of his art. He supervised a large production, and though the variety of the tasks posed challenges it also exacted sacrifices. For reasons that remain obscure he seems not to have held a position at one of the great courts. Appointments as *peintre* or *enlumineur* were, to be sure, not numerous; they were offered by the king and by such courts as Berry, Anjou, and Guyenne. The paintings of Jacquemart, the Limbourgs, and the Rohan Master prove that such positions were valuable. Though the Boucicaut Master does not seem to have won such tenure his great distinction was widely recognized. Apparently he never lacked important commissions. If he was actually Jacques Coene he and two associates received a commission for a Bible for Philippe le Hardi.[22] Soon after the death of Philippe in 1404 he devoted himself to the Book of Hours commissioned by the Maréchal de Boucicaut, whose sensibility did not necessarily warrant such exceptional efforts. Around 1408 the illuminator's associates – by then he had at least three – undertook a small share of the execution of the *Grandes Heures* of the Duke of Berry (Figs. 61, 62). Then they went on to paint a few miniatures in this prince's Lectionary (Figs. 64-66). In 1409 they contributed three miniatures to the first copy of the *Dialogues de Pierre Salmon*, produced for King Charles VI (Figs. 67, 68, 70). In the second copy, finished in 1412, the Boucicaut Master himself painted a very beautiful miniature (Fig. 72). In this year, and probably already in 1411, he and his associates were occupied with the 265 miniatures in the *Merveilles du monde* for Jean sans Peur, and perhaps for someone at Jean's court they illuminated the splendid Mazarine Book of Hours. The Boucicaut Master himself painted some dazzling miniatures in a Breviary for the Dauphin around 1413 (Figs. 115, 116).

Two richly illuminated Boucicaut manuscripts, the *Trésor des histoires* and the *Cleres et nobles femmes* in Lisbon, belonged to the Admiral of France, Prigent de Coëtivy, and the former may have been made for him (Figs. 80-100, 366, 367, 370, 371, 374-377). Probably someone at the royal court commissioned the beautifully illustrated *Grandes Chroniques* (Figs. 419-429). Both the Book of Hours Add. 16997 and the Kettaneh *Cas des nobles hommes et femmes* were made for highly placed persons. The Boucicaut Master and his associates won, moreover, an unusual recognition. About 1411 they were commissioned to illuminate a Book of Hours for a member of the Visconti family – probably Filippo Maria (Figs. 122, 156, 183-187). The text of the manuscript was written by an Italian scribe. About four years later they illuminated a Missal for another Italian, Lorenzo Trenta, a Lucchese merchant who was, or who very recently had been, resident in Paris (Figs. 356-365). Shortly after its arrival in Lucca this Missal was probably studied by Jacopo della Quercia, who had an interest in French art and who in 1416 was carving the famous tombs of Lorenzo Trenta and his wife. The design of a part of the predella of the altarpiece that Quercia made for Trenta several years later may have been influenced by one of the miniatures in the Missal (Figs. 364, 469).

In addition to all these manuscripts that are connected with great patrons by records or armorials the Boucicaut Master and his associates illuminated dozens of books. It may, indeed, have been the very popularity of his product that made his own work so scarce. Though we speak of 'workshops' we do not know, of course, what the precise forms of association actually were. From the evidence of the codices we infer that the Boucicaut Master was an entrepreneur who produced manuscripts for the market and who accepted commissions that were to be executed mostly by associates. If this is true it is not immediately clear why the group collaborated so often with other 'workshops', or at least with illuminators who painted in a different style. Why did the Boucicaut Master not train more assistants in his own manner, to achieve a higher degree of homogeneity and control? Well-trained illuminators were, we have had sufficient opportunity to observe, in short supply. Were the craftsmen not adequately paid? Were there guild or legal restrictions of which we are ignorant? Perhaps the Boucicaut Master's great reputation and the apparently steady flow of orders were still not sufficient guarantees of security, and he entered into reciprocal arrangements with other masters as a form of insurance against expected times of reduced demand.[23]

On balance, the failure of the Boucicaut Master to win for a period of years a great, sympathetic patron such as Jean de Berry or Yolande d'Aragon, Duchess of Anjou, is an accident of history that very probably has deprived us of masterpieces even more deeply contemplated than the *Boucicaut Hours* and Add. 16997. Without tenure, the illuminator was constrained to keep his wares marketable, to manage an atelier, and to accept well-paid work from less highly cultivated patrons.

In a few instances Boucicaut Associates had a relatively small, unimportant share in the execution, and the commission was no doubt given to another master. This was eminently true of the *Grandes Heures* of Jean de Berry, for which, we are explicitly informed, Jacquemart de Hesdin served as the leading illuminator. The Bedford Master served as the principal illuminator of the Châteauroux Breviary and as the entrepreneur of the *Missal of St. Magloire* (Figs. 108, 110, 111, 481).[24] Illuminators belonging to the Bedford and Boucicaut groups worked together quite regularly. They joined forces for a very few miniatures in the *Grandes Heures* completed in 1409, and for the *Bible historiale*, fr. 9–10.[25] Numerous miniatures in the *Merveilles du monde*, finished by 1413, are related to the Bedford style (Figs. 83, 84, 97). It is curious that in each of three manuscripts for which the Boucicaut Master and his assistants had a greater or lesser responsibility the Bedford Master or an associate painted just one miniature or initial: the *Visconti Hours* (Fig. 186), the *Bible historiale*, fr. 9–10 (Fig. 343), and above all, Add. 16997 (Fig. 287). Does not the one Bedford miniature imply a minimal compliance of the Boucicaut Master with a contract to share the work?

Boucicaut Associates maintained over the years similar arrangements with several workshops. They collaborated with the Egerton group, in fact, more frequently than with the Bedford. Over the years they executed together many manuscripts, almost all of them, it is interesting to observe, religious. They worked together on Books of Hours or of prayers, early as well as late, such as those in Madrid (Fig. 141), Egerton 1070 (Fig. 148), and Victoria and Albert, Seville, Jean Durrieu, Corsini (Fig. 279), Chantilly (*Heures de Guise*). They joined forces also for two Bibles,

fr. 9–10 and Royal 15 D III (Fig. 354), and for one manuscript of the *Grandes Chroniques* (Fig. 426).[26] Boucicaut Associates collaborated with the workshop of the Cité des Dames Master on a *Bible historiale* (fr. 9–10) and on the Gulbenkian Boccaccio. This Boccaccio was painted in part also by the Master of the Harvard Hannibal (Fig. 375), who contributed to the Boucicaut Livy at Harvard (Fig. 433). The Master of the Breviary of Jean sans Peur collaborated on the tiny Book of Hours in Palermo, and his followers on Mazarine 469 (Fig. 269) and the *Grandes Chroniques*, Cotton Nero E 11. The Virgil Master had a share in Royal 15 D III, painting among other miniatures a lone, dejected Job that anticipates the famous *Baptist* of Geertgen (Fig. 350).

One of the interesting problems in the interpretation of the art of the Boucicaut Master is the extent of the effect upon it of the Parisian tradition of illumination. Certainly he shared to a degree the firmly implanted Parisian ideas of an appropriate relation of a miniature and a folio. These ideas curbed, as we have suggested, the naturalistic surge of his style. They were partly responsible no doubt for the insertion into the deepest spaces – the very areas that exhibited the most revolutionary innovations – of flat, sharp-edged shapes. In these combinations of partially transformed traditional forms with radically new ones the Boucicaut Master achieved rare and very beautiful effects. Historians of art, attentive to triumphs of naturalism, should nevertheless recognize that he was a great artist even when he was not consistently 'advanced'. Of course his more traditional elements conform with the taste of the time as well as with the tradition of the book; it is difficult to evaluate the relative importance of these factors. The few surviving panels from the great French centers do not resolve the question. Most of them are, for one thing, small devotional pictures. The one large *histoire* after 1400, *The Martyrdom of St. Denis* by Bellechose, is of 1416 and belongs to a very different stylistic phase.

Though we have suspected that the Boucicaut Master himself painted panels – if he was actually Coene he certainly did – attempts to link works of this sort with him have been very wide of the mark. Paintings have been invoked that are actually German or Spanish.[27] The French panels from the period that have survived show very little connection. The *Entombment* and the small *Lamentation* in the Louvre as well as the *Man of Sorrows* in Troyes are very Simonesque, and they would in any event be too early to correspond to the major phase of the Boucicaut Master's art. This is true also of the large tondo probably by Malouel in the Louvre. Furthermore this panel, the Berlin *Madonna*, a later work by Malouel, and the *Martyrdom of St. Denis* by Bellechose, are all linked with Dijon and with the tradition of Beaumetz.[28] In the art of the book they resemble most closely the Limbourgs. They share, too, the approach of these illuminators to Italian painting rather than that of their colleague, the Boucicaut Master.[29]

Among illuminators the miniatures of the Boucicaut Master were accepted as paradigmatic in Paris and Northern France, and he had many followers.[30] His greatest rivals, the Limbourgs, remained most independent, but even they learned much from his painting of light and landscape. The Boucicaut Master's frequent and extremely engaging collaborator, the Bedford Master, depended greatly upon him. He, like the other younger illuminators, the Apocalypse and Rohan Masters, gave currency to figures, groups, even entire compositions of the Boucicaut Master and his associates. The *Funeral Service* of the *Boucicaut Hours* served as the point of departure for the corresponding miniature in the *Bedford Hours* and in Vienna 1855 (Figs. 41, 150).[31] The

Annunciation of the type used in the *Heures de Guise* was employed by the Rohan workshop in the Book of Hours in the Fitzwilliam Museum (Fig. 483). The Apocalypse Master adopted the figural canon of the Boucicaut Master, and often also compositional designs (Fig. 480).

All these illuminators, however, while mining the work of the Boucicaut Master, subverted the principles of his art. Striving for verve and emotion they replaced his broad, deep spaces with a shallow, tangled design. Balanced figures and geometric groups yielded to agitation, and volume dissolved into line. Thus in a fundamental sense the art of the Boucicaut Master had no future in France. No immediate future, to be more precise, because a quarter of a century later the luminous miniatures of Jean Fouquet imply a deep sympathy. Fouquet's *Annunciation* in the *Hours of Étienne Chevalier* (Fig. 484) is a new, more spacious version of the miniature in Add. 16997 (Fig. 134). His panorama of Paris around Notre-Dame in the illustration of Vespers of the Holy Ghost seems to combine qualities of the miniatures of the Boucicaut Master in, for instance, the Châteauroux Breviary with those of the calendar pictures of the *Très Riches Heures*.[32]

The interest of Pisanello in the painting of the Limbourgs can be proved by specific forms that he took from them.[33] No such relation with the Boucicaut Master has yet been demonstrated, but it seems probable that without a knowledge of his work early fifteenth-century North Italian and Venetian painting would have been different (Figs. 491, 492). Shortly after 1400 the Boucicaut Master announced more forcefully than any other painter in Europe the great themes of the century: light, interaction of light and color, aerial perspective, landscape. Like the Renaissance masters he was deeply concerned with problems of representation as well as of form.

In some respects the art of the Boucicaut Master seems to move parallel to what was occurring simultaneously in early Renaissance sculpture in Florence and what was to happen somewhat later in Florentine painting. Where but in Florentine sculpture of the first years of the century are we to find figures with the power and majesty of the Baptist (Fig. 3)? His vitality is conveyed by his bearing, his gesture, and his bodily structure, especially his neck and shoulders. The painter no doubt wished to enhance it by the unusual exposure of the leg, though the analysis of its structure, we must admit, is not highly successful. St. Paul's figure, less vigorous and more rhythmical, rises through a spiral, but the sense of balance maintained through internal, organic effort is remarkable (Fig. 5). The head inclines toward the heavy book that he holds high on one arm while the firmly planted opposing shoulder is felt through the mantle flung deliberately across it.

The Boucicaut Master shares with the Renaissance artists a devotion to geometric design. He created conical groups of figures such as St. Pancras, charged with contrapuntal movement, and he favored circular spaces. The Baptist stands on a small round island (Fig. 3). The dome of the temple in the *Presentation*, the circular canopy, and the rounded apses are fulfilled, so to speak, by the very prominent though quite rare circular stones that serve both as steps and floor (Fig. 34).[34] The tapestry held by angels in the *Trinity* swings in an arc around the majestic God Father to form an imposing apsidal space (Fig. 39). It is suggestive to recall that such plans and spaces became characteristic of Renaissance painting in the second quarter of the Quattrocento. All these analogies are intriguing, and the qualities in the art of the early Boucicaut Master that make them possible merit full recognition. Like many aspects of Sluter's sculpture, they do not conform with the usual conception of the International Style. They remind us, too, that our current

ideas of Late Gothic and Renaissance do not refer to all aspects of European artistic evolution, not even to all important ones, and that there is some continuity between early fifteenth-century painting in France and what followed it in Italy.

The art of the Boucicaut Master radiated to Normandy and to England, and it was regarded as exemplary by illuminators in the Netherlands, where it influenced for example the Master of Zweder von Culemborg.[35] Some of his conceptions reappear in the work of the Master of Flémalle, but where motifs are concerned the accidents of losses and survival render an estimate of the nature of a relationship much more difficult. It suffices to point to the reappearance in the *Trinity* by the Master of Flémalle in Leningrad[36] of the sort of opened tent used in the *Coronation of the Virgin* in the *Boucicaut Hours*. In the panel by a follower of the Master of Flémalle in the Prado the Annunciation takes place in a church.[37] The standing Madonna with an angel in the Ambrosiana Book of Hours precedes the Master of Flémalle's composition, though the setting is a canopy rather than an apse (Figs. 177, 495). More basic is the resemblance of the composition of the Master of Flémalle's *Madonna* in Aix with miniatures such as *David before the Lord* in the *Boucicaut Hours*.[38] The Boucicaut Master was not, however, crucial to the Master of Flémalle's art. It was Malouel and painting in Dijon that had the greater effect on the formation of his style.[39]

The Boucicaut Master takes a place in the large design of European painting chiefly as a precursor of Jan van Eyck. So great is Jan's genius that the two funeral services in Add. 16997, probably executed close in time to the similar subject in Eyckian style in the *Très Belles Heures de Notre-Dame* in Turin, seem rather antiquated alongside it (Figs. 172-174). Still, no other rendering of an interior in Western painting approximates the miniature in Turin so closely, and indeed in one respect the Boucicaut miniatures are more advanced. Whereas the Eyckian church is represented as an incomplete structure terminating at the frame and also rising above it, the Boucicaut Master shows only a part of a larger building that seems to continue forward beyond the frame toward the observer, particularly in the illustration of Vespers (Fig. 172). The conception fundamental to the miniatures in Add. 16997 of representing only that part of the interior seen through a frame from a fixed point of sight is equalled by Jan only a little later, in his *Madonna in a Church* (Fig. 497).

In these two early Eyckian paintings and also in Jan's *Annunciation* in the National Gallery in Washington the church is placed oblique to the picture plane, partly because the pictures occupied one leaf of a book or a diptych. In any event it was only toward the mid-thirties that Jan van Eyck sought a stable, symmetrical space such as had appeared in Add. 16997. It may be seen in the Dresden, 'Lucca', and van der Paele *Madonnas* (Fig. 494). Jan's compositions create, however, a different effect than those of the Boucicaut Master. He wished to make vivid the forward extension of the space so as to seem to include the observers in it. He 'rolled out the carpets' for them, as we have said, and he restricted the size of the structure that is visible. To attain his effect he sacrificed the high building of his early *Madonna in the Church*. Indeed the quiet, broad, lofty spaces of the Boucicaut interiors were equalled only in Italy in the second quarter of the century. Alongside van Eyck the Boucicaut Master looks, in fact, almost Italian. His two funeral scenes are composed symmetrically; forms parallel to the picture plane nicely balance those

that recede. He emphatically bounded the pictorial space near the frame, especially below. His designs have much of the formality and sense of distance from the observer characteristic of Central Italian art.

The Boucicaut Master, passionately concerned like Jan van Eyck with the phenomena of vision and of light, created similar symbols for it. Whereas he frequently depicted observers gazing through a window, Jan employed a man entranced with the view (*Rolin Madonna*) or a reflective mirror (Arnolfini portrait in London). Since the Boucicaut Master as well as van Eyck was aware of the significant variation of shape even in slight alterations of light or of position he too could catch transient expressions. A man smiles at the Fool in his Bible in London (Fig. 353), just as later Jan gave to the face of St. George in the *Paele Madonna* a fleeting animation (Fig. 494). The Boucicaut Master was a herald also of Eyckian panoramas, the distant forms dissolved in a hazy atmosphere. He delighted in the portrayal of sources of light – a burning candle on the altar in the *Annunciation* (Fig. 29), or stars and a real or visionary sun in the sky. For these forms he employed metal and glazes whereas the Van Eycks created the illusion with paint alone. Both the illuminator and the painters were captivated by the transformation of light as it passed through stained glass. The Boucicaut Master represented it only in the red and blue glazed borders of a few silver windows but he was apparently the first painter to do even this.

When similar specific forms occur in the work of the Boucicaut Master and the van Eycks they may be the consequence of similar fundamental concerns. In representations of the Annunciation the Boucicaut Master placed God the Father in a tympanum of the church; Jan van Eyck, in his Washington painting, put him in a stained glass window. The preference of the Boucicaut Master for rounded forms, for circular buildings, canopies, and compositional plans (Figs. 3, 34, 457), for instance, emerges in the *Paele Madonna* of Jan van Eyck (Fig. 494). The structure over the Madonna and donor in Jan's unfinished *Ypres Madonna* performs a function similar to the tabernacles over the saints in the Boucicaut Hours (Figs. 1, 21).[40] It is harder, on the other hand, to avoid the hypothesis of a dependence of Jan van Eyck upon the Boucicaut Master when observing the colonnaded loggia in which a donatrix kneels before the enthroned Madonna in lat. 1161 and the similar building designed by Jan van Eyck for the same subject in the *Rolin Madonna* (Figs. 204, 493).[41] Most striking of all is the identical way in which both painters expressed the paradox of the earthly simplicity of the Madonna and Child and their spiritual greatness. Beneath the damaged shed of the *Nativity* the Boucicaut Master raised a majestic canopy, identical in purpose with the one in the domestic interior of Jan's *Lucca Madonna* (Figs. 31, 496).

To recognize the guidance the Boucicaut Master gave to Jan van Eyck does not imply neglect of the gulf between them. After everything has been said that needs to be said about the later date and greater stature of Jan, something distinctive and very impressive remains in the painting of the Boucicaut Master. Jan van Eyck did not of course surpass him in *every* respect. Even those tiny miniatures in the Book of Hours in London have a geometric order and grandeur that are not readily paralleled in Jan's work. They stand, in other words, more deeply in the Mediterranean tradition. The assimilation of it was, in the late Middle Ages, primarily the role of France. The Boucicaut Master belongs in the great historic succession that accomplished the

return of the North to the Mediterranean. He takes a place alongside Jean Pucelle, the Parement Master, Jacquemart, the Limbourgs, and Jean Fouquet. Though the dialogue of North and South that he conducted in the early fifteenth century was rather abruptly interrupted by disastrous circumstances, it was revived later; and what had been accomplished before the fall of Paris proved in the end not much less fateful than the brilliant successes of early Flemish panel painting.

Flemish: *Portrait of Jean sans Peur*. Antwerp, Museum of Fine Arts.

Catalogue of Manuscripts

The subjects of the miniatures that appear in all the following lists are not derived simply from titles, rubrics, or adjacent texts. They purport to present the most significant themes of the paintings themselves, which not infrequently differ considerably from what the context indicates.

Aachen

COLL. PETER LUDWIG

(formerly London, Robinson Trust, Phillipps ms. 2924)

(Figs. 436, 439, 442-446)

Titus Livius, *Histoire romaine, troisième décade*, translation by Pierre Bersuire
Ms. not foliated. 407 × 306 mm. 8 miniatures

HISTORY: Only the third decade of this copy of Livy's Roman History is known to survive, and there are no marks of original ownership. The beginning of Book I is missing.

STYLE AND DATE: The name of the scribe, Raoul Tainguy, is given in a quatrain at the end of the volume: '*Ci fine la tierce decade | De titus-livius memorable | Acomplie à Haubertvillier | Par Tainguy qui n'est pas givelier.*' Tainguy signed six other volumes; four of these are in the Bibliothèque nationale, Paris: Tite-Live (fr. 264-266), *Œuvres complètes de Eustache Deschamps* (fr. 824), *Livre des échecs moralisés* (fr. 1999), *Chroniques de Froissart* (fr. 6474-6475). One is in Leyden: *Chroniques de Froissart*, Vossius No. 9, and another in Turin, Nazionale, Végèce. From the *Chronicles* of Froissart it can be deduced that Tainguy was of Breton origin, probably from the area around Saint-Malo. There are good reasons for presuming that fr. 6474-6475 was written in 1413, but the miniatures which originally opened the last two volumes have been removed, and we have no clue as to whether Tainguy and the Boucicaut Master combined forces on any other occasion.

When Durrieu saw the present manuscript in 1889, some years before the publication of his studies on the Boucicaut Master, he ascribed it to Paul de Limbourg. It is, however, a beautiful cycle from the atelier of Paul's great rival, the Boucicaut Master, probably from the end of his career. It shows the more penetrating analysis of color and light characteristic of those late years, and also the majestic compositions.

BIBLIOGRAPHY: Deschamps, ed. Saint-Hilaire and Raynaud, II, 1880, p. VI ff. (Luce); Bradley, *Dictionary*,

III, 1889, p. 282; Durrieu, 1889, pp. 383, 394 f.; Camus, 'Notice d'une traduction française de Végèce', *Romania*, XXV, 1896, p. 393; London, Sotheby, November 30, 1965, lot 25.

MINIATURES:

 Third Decade
 Book I. Folio lost
Folio 25 Book II. Consuls chosen (by lot) for the command of the provinces
 Book III (Livy's text was not then known)
 44v Book IV (in ms. Book III). Porcius Cato speaks for the maintenance of the Oppian law against the Roman matrons. Two tribunes who favor abrogation at his side (?)
 72v Book V (in ms. Book IV). Scipio Africanus, praetor, conquers the Lusitani
 96v Book VI (in ms. Book V). The Romans propitiate the gods by offering sacrifices of full-grown animals
 116 Book VII (in ms. Book VI). The Aetolian ambassadors seek peace in Rome, probably appearing before Titus Quinctius and two consuls
 141v Book VIII (in ms. Book VII). The return of Amynander to Athanania welcomed by his partisans
 174 Book IX (in ms. Book VIII). Roman army moves out into the rugged terrain of Liguria
 201v Book X (in ms. Book IX). Macedonians leave their ancestral homes under order of Philip

Baltimore

WALTERS ART GALLERY, ms. 238

(Figs. 121, 248)

Book of Hours, Use of Paris. 170 fols.; 185 × 135 mm. (the ms. has been much trimmed). 13 miniatures

HISTORY: The early owners are unknown.

STYLE AND DATE: A rather routine product of the Boucicaut workshop around 1412.

BIBLIOGRAPHY: De Ricci, *Census*, I, 1935, p. 794 no. 183.

MINIATURES:

Folio 25 Annunciation
45 Visitation
54v Nativity
59v Annunciation to the Shepherds
65v Presentation in the Temple
69 Flight into Egypt
75 Coronation of the Virgin
79v Crucifixion
82v Pentecost
86 David with harp
104 Virgin enthroned
109 Last Judgment
112v Illustration of Office of the Dead

Baltimore

WALTERS ART GALLERY, ms. 260

(Figs. 130, 270, 271)

Book of Hours, Use of Paris. 298 fols. 197 × 141 mm. 13 miniatures and 24 calendar illustrations

HISTORY: There is no clue to the original owner.

STYLE AND DATE: The connection with the Boucicaut workshop and with the Book of Hours in Paris, Bibl. Nat., lat. 10538, was observed by Dorothy Miner when the book was exhibited in Baltimore in 1949. Panofsky remarked that the *Nativity* was nearly identical, but reversed. The *Flight into Egypt* is similar also. Both manuscripts should be assigned to a rather late phase in the development of the Boucicaut workshop, *ca.* 1415.

The main miniatures and the more elaborate border decoration are by an assistant (or assistants) following closely the Boucicaut Master's own manner. The marginal figures, many of which are unpainted, are by an inferior hand and they resemble those in the borders of the Book of Hours in London, Victoria and Albert Museum, ms. 1646-1902. This manuscript in London appears to be of about the same date and it too shows the *Nativity* with the maidservant and bath, but without St. Joseph.

BIBLIOGRAPHY: De Ricci, *Census*, I, 1935, p. 786 no 185; Baltimore, Walters (Miner), 1949, p. 33 no. 86; Panofsky, *Netherlandish Painting*, 1953, I, pp. 59 n. 2, 125 n. 2, 173 n. 1, 278 n. 1; Baltimore, Walters, *International Style* [1962], p. 59 f. no. 55.

MINIATURES:

Folio 27 Annunciation
51v Visitation
63v Preparing the bath after the Nativity
70 Annunciation to the Shepherds
75 Adoration of the Kings
80 Presentation in the Temple
84v Flight into Egypt
92 Death of the Virgin
116 Crucifixion
123 Pentecost
129 Illustration of Office of the Dead
217 Virgin and Child venerated by an angel
223v Man of Sorrows (Christ on rainbow and angels with instruments of passion)

Baltimore

WALTERS ART GALLERY, ms. 770

(Figs. 334-342)

Saint Augustine, *La Cité de Dieu* (translation and commentaries by Raoul de Praelles)

Second Volume, Books XI-XXII. 272 fols.; 433 × 315 mm. 11 miniatures

HISTORY: Only the second volume of this beautiful manuscript of the *Cité de Dieu* is known to survive, and of this the opening miniature (Book XI) has been removed. The one possible clue to original ownership is in the miniature on fol. 16v. If Laborde is correct in his somewhat dubious assumption that the silver shield with red cross borne by an angel on that folio should be regarded as a reference to the Baudricourt family, the manuscript was made for an earlier generation of the family that produced the celebrated *maréchal de France* under Charles VIII. The manuscript was formerly at Cheltenham, Thirlestaine House, ms. franc. 4417.

STYLE AND DATE: The connection with the Boucicaut Master was observed by Laborde and endorsed by Durrieu. The best miniatures (fols. 117, 179v, 227v) imply a considerable participation of the Master

himself. The soft richness of the colors, the fluidity of the painting, and the master's assurance in the representation of space (as in the *Teaching of Varro*) all indicate a late date, approximating the Book of Hours, Add. 16997. The breadth and majesty of the compositions recall that manuscript also.

BIBLIOGRAPHY: Laborde, *Cité de Dieu*, 1909, II, p. 323 ff.; Durrieu, 1914, p. 29; Baltimore, Walters, *International Style* [1962], p. 55 ff. no. 54.

MINIATURES:

Folio 16v Book XII. Fall of the Rebel Angels
28v Book XIII. Temptation
41v Book XIV. Expulsion from Paradise
60 Book XV. Cain kills Abel
87 Book XVI. Abraham visited by the three angels; Noah (but like Abraham wearing pink on green) in a boat with his wife and three sons and their wives.
117 Book XVII. King David writes the Psalms
139v Book XVIII. Adoration of the Child
179v Book XIX. Teaching of Varro
203 Book XX. Last Judgment
227v Book XXI. Mouth of Hell
252 Book XXII. Veneration of the Virgin and Child enthroned in Heaven

Berlin-Dahlem

STAATLICHE MUSEEN, KUPFERSTICH-KABINETT, ms. 78 C 4 (formerly H.S. 75)
(Figs. 123, 152, 231-234)

Book of Hours (in Latin and French). 225 fols.; 241 × 175 mm. 22 miniatures

HISTORY: There is no indication of original ownership.

STYLE AND DATE: The miniatures in the Book of Hours were painted by Boucicaut Associates probably not much after 1410. We do not agree with Martens' view that this manuscript represents an early work of the Boucicaut shop. The broad and lavish borders, some of which like Douce 144 incorporate supplementary subjects, are executed in a surprisingly crude hand. A similar kind of arabesque on a wide gold band, but more in the Boucicaut style, can be found in the Book of Hours in Seville (Bordona, no. 1717–see Fig. 230).

BIBLIOGRAPHY: Durrieu, *Arts anciens de Flandre*, II [1906?], p. 18; Durrieu, *Rev. de l'art a. et m.*, XX, 1906, p. 24; Durrieu, *Rev. de l'art chrét.*, 1913, p. 308; Berlin, Staatliche Museen, Winkler, 1928, p. 7; Martens, *Meister Francke*, 1929, pp. 92, 124, 173, 195; Berlin, Staatliche Museen (Wescher), 1931, p. 143 f.

MINIATURES:

Folio 25 Annunciation
48 Visitation
59 Nativity
65 Annunciation to the Shepherds
69v Adoration of the Magi
74 Presentation in the Temple
78v Flight into Egypt
85v Coronation of the Virgin
91 God the Father surrounded by angels and symbols of the evangelists; margin: half-figures of God the Father, King David, and angel playing the harp
108 Crucifixion
114v Pentecost
119v Madonna enthroned
125 Christ as Judge; angels bear cross and column
128v Burial service
199 Agony in the Garden; margin: sleeping apostles, kiss of Judas and Christ in prayer
205 Betrayal
209 Christ before the High Priest; margin: Mocking of Christ
211v Flagellation
214 Way to Calvary; margin: Caiaphas, Longinus and a soldier
216v Crucifixion showing Longinus wounding Christ
219 Lamentation beneath the cross; margin: Deposition, Virgin, St. John and Joseph of Arimathea
222v Entombment

Bourges

BIBL. MUNICIPALE, mss. 33-36 (Figs. 63-66)

Lectionary of the Sainte-Chapelle of Bourges. 4 volumes (183, 231, 221, and 225 fols.). 9 miniatures (4 in Boucicaut style). 505 × 305 mm.

This manuscript, which bears the arms and devices of the Duke of Berry and includes his portrait, has been fully catalogued in *Late XIV Century*. A date of *ca.* 1410 has there been proposed instead of the period before 1404, which has sometimes been assumed. The present manuscript shows the Boucicaut illuminators in collaboration with 'Pseudo-Jacquemart', with whom they worked on the *Grandes Heures*, completed in 1409 (see *Late XIV Century*). Only three of the four volumes contain miniatures, but the style of the Boucicaut workshop appears in each of these, as Durrieu recognized.

In a recent study ('Manuscrits hagiographiques de Bourges', *Analecta Bollandiana*, LXXXV, 1967, p. 75 ff.) J. van der Straeten has pointed to the considerable number of Parisian saints in this manuscript. He suggests the influence of the *Petites Heures* and the *Grandes Heures*, the calendars of which contain similar saints. An interest in Parisian saints might well be ascribed to the Duke's residence in Paris. After the death of Charles V in 1380 he lived there for ever longer periods of the year. After about 1400 it became his principal place of residence (see *Late XIV Century*, p. 291 f.).

BIBLIOGRAPHY (for the Boucicaut miniatures – for the manuscript see *Late XIV Century*, p. 320): Durrieu, *Rev. de l'art a. et m.*, XIX, 1906, p. 413 f.; Bourges, Musées, 1951, p. 37 nos. 14-16; Panofsky, *Netherlandish Painting*, 1953, I, pp. 59, 244; Paris, Bibl. nat. (Porcher), 1955, p. 94 f. no. 193.

MINIATURES (in the style of the Boucicaut workshop):

> Bourges ms. 33
> Folio 1 Four Prophets (very bad condition)
> Bourges ms. 34
> 46v Nativity of the Virgin
> 138v All Saints
> Bourges ms. 35
> 17v Duke of Berry adoring St. Andrew

Brussels

BIBL. ROYALE, ms. 10767 (Figs. 119, 139)

Book of Hours, Use of Paris. 247 fols.; 200 × 145 mm. 22 miniatures

HISTORY: The obliteration of the arms on fol. 30 deprives us of our only clue to the original ownership of this manuscript. What we know of its history is recorded on the guard leaves: it was given by Antoine de la Howarderie to the Jesuits of Tournai in 1598 and it presumably came into the possession of the State at the time of their suppression in 1773.

STYLE AND DATE: The attribution of the illumination to the Boucicaut Master, made by Durrieu in 1906, has not previously been contested. The *Annunciation* (Fig. 119) is fine but it nevertheless shows the conventionality of a workshop product, especially when compared with the design of the very similar *Annunciation* in the Book of Hours in Paris, Bibl. Mazarine, ms. 469 (Fig. 118). The execution of the other miniatures in Brussels 10767 is more routine. The elaborate acanthus borders would be improbable in a manuscript of this kind before *ca.* 1410. Delaissé has remarked that not long after the initial painting the workshop enriched some of the borders in the calendar with flowers and filigree.

BIBLIOGRAPHY: Monograph: Van den Gheyn, *Deux livres d'heures* [1911]; Brussels, Bibl. roy. (van den Gheyn), I, 1901, p. 455 no. 733; Durrieu, *Arts anciens de Flandre*, II [1906?], p. 16; Durrieu, *Rev. de l'art a. et m.*, XX, 1906, p. 24; Durrieu, *Rev. de l'art chrét.*, 1913, p. 308; Martens, *Meister Francke*, 1929, p. 195; Brussels, Bibl. roy., Gaspar and Lyna, pt. 1, 1937, p. 423 no. 176; Schaefer, 1937, p. 195; Delaissé, 1948, p. 78 ff.; Panofsky, *Netherlandish Painting*, 1953, I, p. 54 n. 1; Delaissé, *Medieval Illuminations*, 1958, p. 104 f.

MINIATURES:

> Folio 30 Annunciation
> 44 Visitation
> 59 Nativity
> 65 Annunciation to the Shepherds
> 71 Adoration of the Magi
> 76v Presentation in the Temple
> 82 Flight into Egypt
> 92 Coronation of the Virgin
> 121 King David prays to God
> 149 Crucifixion
> 158v Pentecost
> 166v Illustration of Office of the Dead
> 228 Betrayal
> 231v St. Michael triumphant over a demon
> 232v St. John the Baptist
> 233v St. Peter and St Paul
> 236 Martyrdom of St. Stephen
> 237v St. Christopher

239 St. George slaying the dragon
242v St. Mary Magdalene
243v St. Catherine
244v St. Margaret

Brussels

BIBL. ROYALE, ms. 11051 (Figs. 140, 245-247)

Book of Hours, Use of Paris. 232 fols.; 181 × 132 mm.
18 original miniatures and 2 later additions

HISTORY: There is no clue to the original owner of this manuscript. Although the text is Use of Paris, it appears to have been in Flanders in the first half of the fifteenth century, when additions on fols. 207-232 were made, including a commemoration of the Flemish archbishop and martyr Saint Livinus. It is to this phase that the miniature of St. Barbara on fol. 207 belongs. The miniature at the beginning of Christ blessing in a landscape was added also. This miniature was rather misleadingly referred to by Durrieu in his 1913 list as a 'Sainte Face', suggesting an analogy with those books in the library of the Dukes of Burgundy to which this image was added (cf. Brussels, Bibl. royale, ms. 11060-11061). In fact, there is no indication that this book was ever in that library.

STYLE AND DATE: Both this manuscript and the other Book of Hours in the Bibliothèque royale (ms. 10767) were regarded by Martens as earlier than the Boucicaut Hours itself. We have, however, already given reasons for the later dating of 10767. The present work offers fewer indications of the time when it was made. It is too weak to have been executed even under close supervision by the Boucicaut Master himself. As a derivative work it was very probably made in the second decade of the fifteenth century. The abundant use of birds in the margins is rare in the workshop, but some can be matched exactly in the very late Book of Hours in London, British Museum, Add. 16997. The illuminator was clearly employing patterns available in the workshop. The birds are indeed repeated exactly *within* the manuscript: compare fols. 10v and 11 with 47v and 48. The birds fly, raise their wings or turn their heads. They thus resemble the birds in the *Grandes Heures* of 1409 rather than those in the earlier *Brussels Hours* (see *Late XIV Century*, p. 259).

BIBLIOGRAPHY: Monograph: Van den Gheyn, *Deux livres d'heures* [1911]. Brussels, Bibl. roy. (van den Gheyn), I, 1901, p. 483 f. no. 771; Durrieu, *Arts anciens de Flandre*, II [1906?], p. 16; Durrieu, *Rev. de l'art a. et m.*, XX, 1906, p. 24; Durrieu, *Rev. de l'art chrét.*, 1913, p. 308; Martens, *Meister Francke*, 1929, p. 195; Brussels, Bibl. roy., Gaspar and Lyna, pt. 1, 1937, p. 426 no. 177; Panofsky, *Netherlandish Painting*, 1953, I, p. 54 n. 1.

MINIATURES:

Christ blessing in landscape (late fifteenth-century addition)

Folio 17 St. John the Evangelist
19 St. Luke
21 St. Mark
22v St. Matthew
33 Annunciation
57 Visitation
69 Nativity
75 Annunciation to the Shepherds
79 Adoration of the Magi
84 Presentation in the Temple
88v Flight into Egypt
96 Coronation of the Virgin
103 King David prays to God
123v Crucifixion
131v Pentecost
138 Illustration of Office of the Dead
185v Virgin and Child with angel
191 Christ as sovereign judge
207 St. Barbara (added *ca.* 1430-1435)

Cambridge, England

FITZWILLIAM MUSEUM, ms. 251
(Figs. 452-457)

Barthélemy l'Anglais, *Le livre de la propriété des choses.* 363 fols.; 405 × 285 mm. 19 miniatures

HISTORY: Lilies in the miniatures on fols. 106, 135, 169v, 251v, and 344v may be the emblem of the original owner. *Fleurs-de-lys* are prominent on fol. 166.

STYLE AND DATE: Though the Boucicaut Master himself may have designed the large and impressive miniature for Book I, the miniatures were all executed by his associates. Wormald and Giles have distinguished three illuminators, the best being the author of the above-mentioned miniature and also those on

fols. 16, 21v, 24v, and 32. Though many of the miniatures appear conservative, especially because of the partial or symbolic interiors, the landscape on fol. 16 is advanced, and the illumination was probably carried out around 1415.

BIBLIOGRAPHY: Cambridge, Fitzwilliam Museum (Wormald and Giles), 1966, p. 31 no. 70.

MINIATURES:

Folio 14 Jean Corbichon presenting his translation to Charles V (VI?) in the presence, perhaps, of the Dukes of Burgundy and Berry
Book I. God
 16 God presenting Eve to Adam (large miniature)
Book II. The Angels
 21v Fall of the rebel angels
 24v Hierarchy of archangels, three orders
 28 Hierarchy of archangels, three orders
Book III. The Human Soul
 32 Creation of Eve
Book IV. The Four Elements and the Four Humors of Man
 45 A doctor expounding the elements and the four humors of man
Book V. The Parts of the Human Body
 54v Physician with his patients
Book VII. Maladies
 106 Physician addressing men suffering from maladies
Book VIII. The World and the Celestial Bodies
 135 Professor discoursing on the world and the celestial bodies
Book X. Matter and the Elements
 166 Cleric writing and others discoursing on the nature of matter
Book XI. Air and Atmospheric Phenomena
 169v Philosopher discoursing on the properties of air: fire and hail falling
Book XII. The Ornaments of the Air (i.e. the birds)
 177 Birds
Book XIII. Water and Fish
 190v Philosopher in landscape with rivers addressing group on the properties of water
Book XIV. The Earth and the Mountains
 200v Philosopher in landscape addressing group on the earth and its parts

Book XV. Provinces of the Earth
 210v Philosopher and disciples discuss the provinces of the earth
Book XVII. Trees and Plants
 251v Scholars discussing trees and plants
Book XVIII. Animals
 300v Animals
Book XIX. On Color
 344v Scholar addresses audience on color; he points to a rainbow

Note: Illustration for Book VI missing
 Opening of Book IX missing
 Opening of Book XVI removed

Cambridge, U.S.A.

HARVARD COLLEGE (HOUGHTON) LIBRARY, Richardson ms. 32 (Figs. 433, 437)

Titus Livius, *Histoire romaine, deuxième décade,* translation by Pierre Bersuire, Vol. II, 192 fols.; 417 × 316 mm. (for Richardson ms. 32, Vol. I, see below). 10 miniatures

HISTORY: These volumes, which were formerly in the collection of the Marquess of Lothian (sale, New York, 1932), bear no marks of original ownership.

STYLE AND DATE: The two volumes that compose Richardson ms. 32 contain the first and second decades of the same translation of Livy and they are generally similar, so that it is not surprising that they have been connected with one another at least since the time they were in the library of the Marquess of Lothian. In our opinion, however, they did not belong together originally. The script of the two volumes is different, the sizes vary somewhat (Volume I is 427 × 291 mm.), the 'running heads' in Volume II that give the numbers of the books are lacking in Volume I, and the initials are far finer in II than in I. Most indicative of all, the miniatures in I, related to the work of the Bedford Master, are significantly later than the miniatures in Volume II.

The frontispiece of Volume II was painted by an artist who was responsible also for a few miniatures in the Gulbenkian *Cleres Femmes* (Fig. 375) and for the *Horae*, New York, Morgan ms. 455. The nine smaller miniatures in this volume were executed by the Boucicaut Master and his workshop. The spaciousness of the compositions and the luminosity of the color indicate a rather late phase of the artist's development, *ca.* 1415 or the following years. The date

suggested in previous catalogues for both volumes (*ca.* 1425–1430) is approximately correct for the miniatures in Volume I.

BIBLIOGRAPHY: New York, American Art Association – Anderson Galleries, *Lothian*, 1932, lot 12; Baltimore, Walters (Miner), 1949, p. 35 no. 93; Cambridge, Harvard University, 1955, p. 22 no. 65; de Ricci, *Census, Supplement*, 1962, p. 247.

MINIATURES:

Volume II – Second Decade
Folio 263 Book I. Coronation of Hannibal as 'empereur' of Carthage
 280 Book II. Battle Scene
 299 Book III. Hannibal receiving tribute (probably from the Compsans)
 317 Book IV. The Carthaginians judge Locrian prisoners. Five women burned at the stake
 332v Book V. Romans worshipping foreign gods
 350 Book VI. Roman soldiers assigned to the provinces
 373 Book VII. Hannibal defeating a Roman proconsul, probably Gnaeus Fulvius
 396v Book VIII. The Carthaginians Hanno and Mago
 419 Book IX. Arrival of Scipio by ship in Sicily
 435 Book X. King Syphax of Numidia brought before Scipio

Chantilly

MUSÉE CONDÉ, ms. 64 (ex 1671) (Fig. 132)

Hours of François de Guise. 204 fols.; 240 × 175 mm. 29 miniatures

HISTORY: There are no indications of original ownership, but the manuscript was in the possession of François de Lorraine, duc de Guise, in the sixteenth century when it was rebound, and his arms appear on both cover and opening folio.

STYLE AND DATE: Only one miniature, the *Annunciation* on fol. 25, is by a close follower of the Boucicaut Master. Several other artists, who will be discussed briefly in a subsequent volume, completed the illumination. One of them learned much from the later style of the Egerton Master.

The borders as well as the exaggerated ogee arches projecting from the frames of some of the miniatures are improbable before the middle of the second decade of the fifteenth century. Indeed, a date of about 1420 is indicated by the composition of the miniature of the *Annunciation*. On many folios the drolleries correspond in outline on both recto and verso. This peculiarity, the consequence of a time-saving device, can be seen when the book is held up to the light.

BIBLIOGRAPHY: London, Sotheby, May 23, 1889, p. 65 f. lot 70; Chantilly, Musée Condé, *Cabinet*, I, 1900, p. 58 f. no. 64; Durrieu, *Arts anciens de Flandre*, II [1906?], p. 17; Durrieu, *Rev. de l'art a. et m.*, XX, 1906, pp. 24, 25; Durrieu, *Rev. de l'art chrét.*, 1913, p. 309; Chantilly (Meurgey), 1930, p. 52 ff. no. 25; Schilling, 1954, p. 274; Meiss, *Art Bull.*, 1956, p. 194 n. 29.

MINIATURES:

Since only the *Annunciation* on fol. 25 is in the Boucicaut style the list of the miniatures in this manuscript will appear in *Paris, 1400–1420*.

Châteauroux

BIBL. MUNICIPALE, ms. 2 (Figs. 101–117, 162)

Breviary, Use of Paris (Summer section only). 454 fols.; 280 × 195 mm. 3 half-page miniatures, 44 framed miniatures, numerous historiated and illuminated initials, and 36 calendar miniatures

HISTORY: Only the first half of this lavishly illustrated Breviary is known to survive, and the arms of the Dauphin on fol. 430 indicate that it was made for the eldest son of the King of France. Since the mortality rate among the sons of Charles VI was rather high we have three Dauphins to choose from in the period possible for the execution of the manuscript: Louis de France, duc de Guyenne, and dauphin de Viennois (b. January 1397, d. December 1415); Jean de France (b. 1398), who succeeded his brother as heir to the throne in 1415 for a few months before dying of poison in April 1416; and, finally, the future Charles VII, who enjoyed this title from 1416 until his succession to the throne in 1422. The speedy decease of Jean de France would seem to rule him out as the patron of a work that calls for a prolonged period of execution. Of the remaining two candidates the

future Charles VII was favored by Hubert and Porcher. Louis, duc de Guyenne, would, however, seem to be by far the more likely possibility. Burdened with affairs of state while still a child, this prince proved ineffective in the face of the diplomatic intrigues and civil war that came to a climax as Charles VI grew increasingly insane. Instead, he became a connoisseur of objets d'art, and had he lived longer he might have rivalled his great-uncle, the Duke of Berry. Less is known of his library than of his collection of jewels, but in 1409, when he was only twelve years old, he became the possessor of several manuscripts confiscated from Jean de Montaigu, and he was the owner of a superbly illustrated copy of the plays of Terence (now Paris, Bibl. de l'Arsenal, ms. 664), which the Duke of Berry must have coveted, since he obtained it from the Dauphin's confessor very soon after the young prince's death. From 1409 until his death in 1415 the 'enlumineur et valet de chambre' attached to Louis, duc de Guyenne, was Haincelin de Haguenau. Haincelin may very probably be identified, as we have argued above (Chap. v), with the Bedford Master, who had the primary responsibility for this Missal.

STYLE AND DATE: The volume shows three distinct main styles; the inferior smaller initials are the work of assistants. Scholars have attributed the miniatures to both the Bedford and Boucicaut Masters, or have hesitated to choose one or the other. In fact, both are involved, as Porcher recognized in the Bibl. nat. catalogue of 1955, though the Boucicaut Master himself rather than 'une main de l'atelier' certainly painted a few excellent miniatures in his style. The third main illuminator is the Orosius Master, a name derived from his extensive participation some years earlier in the Histoires d'Orose (Bibl. nat., fr. 301). The contribution of each of these three workshops is indicated in the list of miniatures. The major part of the illustration, including the three large miniatures and the initials in the Psalter at the beginning, is by the Bedford Master and his assistants. He no doubt received the commission. The calendar, which is not included in the list of miniatures, is by the Bedford and Orosius Masters. The manuscript was probably illuminated shortly before the Dauphin's death in 1415.

Breviaries as extensively illustrated as this one are not common, and an iconographic connection between this book and the so-called Breviary of Charles V was observed by Leroquais (Bibl. nat., lat. 1052). The latter manuscript was in the Duke of Berry's possession from 1408 until his death in 1416. A miniature in another of Berry's manuscripts, the Belles Heures, illuminated ca. 1408–1410, influenced fol. 395v. in the Châteauroux Breviary (Figs. 157, 162). Jean de Berry and the Duke of Guyenne were in close touch and frequently exchanged gifts.

BIBLIOGRAPHY: La Vallière, Catalogue, I, 1783, p. 79 no. 251; Durrieu, Arts anciens de Flandre, II [1906?], p. 17; Martin, Térence, 1907, pp. 4 ff., 30 ff., 31 notes 1, 2, 3; Durrieu, Rev. de l'art chrét., 1913, p. 309; Hubert, 1924–1927, pp. 25–42; Leroquais, Bréviaires, I, 1934, pp. 315-322 no. 187; Panofsky, Netherlandish Painting, 1953, I, p. 61 n. 3; Porcher, Belles Heures, 1953, p. 29; Paris, Bibl. nat. (Porcher), 1955, p. 86 f. no. 179; Porcher, Medieval Miniatures [1959], p. 69; Spencer, 1966, p. 612.

MINIATURES (the initials with drollery are not listed):

Psalter

Folio 8 *Beatus vir* . . .: King David playing the harp (Bedford workshop)

19 *Dominus illuminatio* . . .: David pointing to his eyes (Bedford workshop)

26v *Dixi custodiam* . . .: David pointing to his tongue (Bedford workshop)

32v King David praying (Bedford workshop)

33 *Dixit insipiens* . . .: Fool (Bedford workshop)

40 *Salvum me fac* . . .: David half-submerged in water (Bedford workshop)

47v Moses (Bedford workshop)

48v *Exultate deo* . . .: David playing bells (Bedford Master and workshop)

56v *Cantate domino* . . .: Clerics singing (Bedford Master and workshop)

64 Moses (Bedford workshop)

65v *Dixit dominus domino meo* . . .: Trinity (Bedford Master and workshop)

67 Trinity (Bedford workshop)

69 Man praying (Bedford workshop)

74v Holy Ghost above three praying figures (Bedford workshop)

76v Monk (Bedford workshop)

91 Zacharias with censer (Orosius workshop)

91v Virgin reciting the *Magnificat*; Simeon reciting the *Nunc dimittis* (Orosius workshop)

98 Office of the Virgin: Full-length Virgin

with Child as Apocalyptic Woman (Bedford workshop)

100v Censing of relics (Bedford workshop)

103 David in prayer (Orosius workshop)

Temporale

106 Trinity (Bedford Master)

112v Elcana between two women (Bedford workshop)

113v Institution of the Eucharist (Bedford workshop)

119 Head (Bedford workshop)

130 Hannah nursing Samuel (Bedford workshop)

131v Child Samuel asleep (Bedford workshop)

136v Solomon writing Proverbs (Bedford workshop)

141 Job on his dunghill (Bedford workshop)

143v Tobias (Bedford workshop)

145 Judith with the head of Holofernes (Bedford workshop)

148 Feast of Ahasuerus (Bedford workshop)

149v Maccabees (Bedford workshop)

152v Ezechiel in prayer (Bedford workshop)

171 Dedication of a church (Bedford workshop)

172v Solomon in prayer (Bedford workshop)

Sanctorale (Summer)

181 St. Germain (Bedford workshop)

184v St. Cantius, St. Cantianus, and St. Cantianilla (Bedford workshop)

185 St. Nicomedes; St. Marcellin and St. Peter (Bedford workshop)

185v St. Medard and St. Gildard (Bedford workshop)

186 St. Primus and St. Felician (Bedford workshop)

186v St. Landry (Bedford workshop)

188v St. Barnabas (Bedford workshop)

190v St. Basilides and his companions (Bedford workshop)

191v St. Basil (Bedford workshop)

193 St. Vitus and St. Modestus (Bedford workshop)

193v St. Cyr and St. Julitta; St. Ferreolus and St. Ferjeux (Bedford workshop)

195v St. Avit, St. Marcellianus, and St. Marcus (Bedford workshop)

196 St. Gervase and St. Protasius (Bedford workshop)

198 St. Leufroy (Bedford workshop)

199 St. Paulin and the widow (Bedford workshop)

199v Zacharias and Elizabeth praying (Bedford workshop)

201 Birth of St. John the Baptist (Assistant of Bedford Master)

204v St. Eligius (Bedford workshop)

206 St. John and St. Paul (Bedford workshop)

208 St. Leo Pope (Bedford workshop)

208 Young St. John the Baptist in landscape (Bedford workshop)

211v Fall of Simon Magus (Bedford workshop)

215 St. Paul preaching (Assistant of Bedford Master)

218v St. Processus and St. Martinian (Orosius workshop)

218v St. Martial exorcising a demon from the daughter of Arnoul, Seigneur of Tulle (Orosius Master)

223v St. Martin Bishop (Orosius workshop)

226v Martyrdom of St. Thomas of Canterbury (Bedford workshop)

227v St. Claude and St. Nicostratus and companions (Bedford workshop)

228 St. Thibaud and three other saints (Bedford workshop)

229v Three of the Seven Brothers (Bedford workshop)

230 St. Benedict (Bedford workshop)

233 St. Turianus (Boucicaut workshop)

234 St. Arnoulphus (Boucicaut workshop)

235v St. Margaret (Boucicaut workshop)

236v St. Praxedis (Boucicaut workshop)

237 St. Victor bearing arms of the abbey of St. Victor (Boucicaut workshop)

238 Noli me tangere (Boucicaut workshop)

242 St. Apollinaire (Orosius workshop)

242v Martyrdom of St. Christina (Orosius workshop)

243 St. Christopher (Orosius workshop)

243v Demons leading the bound Hermogenes before St. James the Major (Orosius Master)

246 St. Marcellus and the dragon (Orosius Master)

249 Transfiguration (Bedford Master and Assistant)

250v St. Anne teaching the Virgin to read (Orosius Master)

254v St. Martha and the mythical monster of Tarascon (Bedford workshop)

255 St. Felix, Pope and Martyr; Sts. Simplicius, Faustinus, and Beatrix (Orosius workshop)

256v Sts. Abdo and Sennen (Orosius workshop)

257 St. Germain, Bishop of Auxerre (Orosius workshop)

258v Maccabees (Bedford workshop)

259 Angel awaking St. Peter in prison (Orosius Master)

260 St. Stephen, Pope and Martyr (Orosius workshop)

261v Finding of the relics of St. Stephen and his companions (Bedford Master and Assistant)

265 Arrival of the Croix d'Anseau at Notre-Dame, Paris; marginal angel carries banner with arms of France (Boucicaut Master and workshop)

266v Sts. Felicissime, Sixte, and Agapit (Orosius workshop)

267v St. Donat holding a chalice (Orosius workshop)

268 Infant St. Justin carrying his head in his tunic; Sts. Cyriaque, Large, and Smaragde (Orosius workshop)

269v St. Romain (Orosius workshop)

270v Martyrdom of St. Lawrence (Boucicaut Master and workshop)

274 Veneration of the Crown of Thorns in the Sainte-Chapelle (Boucicaut workshop)

277 St. Tiburtius (Boucicaut workshop)

277v St. Hippolytus (Boucicaut workshop)

280 St. Eusebius (Bedford workshop)

282v Death, Assumption, and Coronation of the Virgin (Bedford Master)

288v Solomon writing the Song of Songs (Assistant of Bedford Master)

294 Sts. Timothy and Symphorian (Bedford workshop)

295v St. Timothy and St. Apollinaire (Bedford workshop)

296 Martyrdom of St. Bartholomew (Bedford Master and Assistant)

298v St. Louis, King of France (Orosius Master)

304 St. Bernard Abbot (Orosius workshop)

305v Sts. George and Aurelian; St. Rufus Martyr (Orosius workshop)

307v St. Hermes and St. Julian; St. Augustine (Orosius workshop)

310v St. Sabina (Orosius workshop)

311 Martyrdom of St. John the Baptist and presentation of his head to Salome; dance of Salome (background of gold *fleurs-de-lys* on azure) (Orosius Master)

313v St. Fiacre digging; Sts. Felix and Adauctus (Orosius workshop)

316 St. Priscus, Bishop and Martyr (Boucicaut workshop)

316v St. Giles and the wounded doe (Boucicaut workshop)

318v St. Antoninus (Orosius workshop)

319 St. Loup (Orosius workshop)

321 St. Victorinus, Bishop and Martyr (Orosius workshop)

321v St. Cloud dressed as a prince of the royal house of France (Orosius workshop)

323v St. Adrian; Birth of the Virgin (Boucicaut workshop)

326v St. Gorgonius (Boucicaut workshop)

327 St. Protus and St. Hyacinthus (Boucicaut workshop)

330v Cross held by angels (Orosius Master)

330v Sts. Cornelius and Cyprianus (Orosius workshop)

333v St. Nicomedes (Orosius workshop)

335 St. Euphemia; St. Lucy and St. Geminianus (Orosius workshop)

335v St. Omer (Orosius workshop)

337v St. Matthew putting dragons to flight before exotic audience (Orosius Master)

340v St. Maurice and his companions (Bedford workshop)

342v St. Tecla (Orosius workshop)

343 St. Firmin, Bishop (Orosius workshop)

343v St. Cosmas and St. Damian (Orosius workshop)

345v St. Michael: episode of the bull on Mount Gargano (Boucicaut Master and workshop)

350 Ostentation of the relics of Ste-Chapelle (Boucicaut workshop)

357v St. Jerome and the wounded lion in the

saint's study (Bedford Master and Assistant)

359 St. Remigius (Bedford workshop)
360 St. Leodegarus (Bedford workshop)
361 St. Francis of Assisi (Orosius workshop)
362 St. Aurea (Boucicaut workshop)
363 St. Mark, Pope (Orosius workshop)
363v St. Demetrius (Orosius workshop)
364 Martydom of St. Denis and his companions at Montmartre with Paris in the background (Boucicaut Master and workshop)
367v Preaching of St. Denis against a background of Paris (Boucicaut Master and workshop)
370 St. Gerald (Orosius workshop)
371 St. Calixtus, Pope (Boucicaut workshop)
372v St. Cerbonius (Bedford workshop)
373v St. Luke writing; St. Luke painting the Virgin (Bedford workshop)
374v Sts. Savinian and Potentian (Boucicaut workshop)
376 St. Ursula and her companions; St. Ursula and a queen (Bedford workshop)
378v St. Mellonus (Orosius workshop)
379v St. Severinus, Bishop of Cologne; St. Magloire (Bedford workshop)
381 Sts. Crispin and Crispinian (Orosius workshop)
382v St. Genevieve; St. Simon and St. Jude (Assistant of Bedford Master)
384 St. Lucan (Orosius workshop)
385 St. Quentin (Orosius workshop)
387v Coronation of Virgin (Bedford workshop)
395v Monk praying on a tomb in a cemetery; below, a dead or dying man (Orosius Master)
400v St. Marcel, Bishop of Paris (Orosius workshop)
401 St. Clair (Orosius workshop)
402 Quattuor Coronati; St. Theodore (Boucicaut workshop)
402v St. Mathurin exorcizing a devil from a young girl (Boucicaut workshop)
403 St. Martin, Pope (Boucicaut workshop)
404v St. Martin sharing his cloak with a beggar (Boucicaut Master and workshop)

410 St. Gendulphus (Orosius workshop)
413 St. Aignan (Orosius workshop)
414v St. Martin (Orosius workshop)
415v St. Elizabeth (Orosius workshop)
417 St. Cecilia (Orosius workshop)
420v St. Felicity (Orosius workshop)
421 St. Clement, Pope (Orosius workshop)
422v St. Chrysogonus (Orosius workshop)
423v St. Catherine (Orosius workshop)
427 St. Genevieve (Orosius workshop)
429v St. Saturnin (Orosius workshop)

Common of Saints

430 Two apostles; Angel holding shield of the dauphin of France (Orosius Master)
433v Martyr (Orosius workshop)
439 Scene of martyrdom (Orosius workshop)
443 Bishop blessing (Orosius workshop)
449v Female saint (Orosius workshop)
452v Holy woman (Orosius workshop)

Cracow

MUZEUM NARODOWE (formerly Czartoryski), ms. Czart. 2032 (Figs. 171, 316-319)

Book of Hours, Use of Paris. 233 pages. 200 × 145 mm. 15 miniatures, two historiated initials, and border medallion

HISTORY: The original owner of this Book of Hours may have been Agnes de Kiquemberg, who is portrayed twice in the manuscript. The first portrait is in the form of a border medallion at the opening of the Hours of the Virgin, and her identity is stated by an inscription which, though written after the Humanist revival, is considered by Gąsiorowska to be a copy of an early fifteenth-century original. It reads: Agnes de Kiquemberg dit Loen en Genoux. The second portrait is in one of the main miniatures (p. 363), and shows a fashionably dressed lady in reverence before the Virgin and Child at the beginning of the Fifteen Joys of the Virgin. Once again an inscription, crude but still Gothic, tells us that this is 'une pourtrait de dame Agnes de Kiquemberg dit Loen'. The book apparently remained in this family until it was handed over to a Piret des Odes (or 'de Sainte Odes') 'ex donatione domini de loen', as is recorded on p. 1.

The name of Agnes de Kiquemberg is not French

and may possibly be Flemish, but it has not been possible to trace the lady. However, the fact that the book is for the Use of Paris and is partially in French suggests, in any case, that it was acquired in Paris. The existence of a number of manuscripts in which initials or border medallions have remained blank would seem to point to a common workshop practice of producing books for stock. When a buyer arrived his arms could readily be inserted. The portrait on p. 363 differs considerably from the small figure on p. 49 and the fashion would suggest a date in the mid-1420's. Professor Lech Kalinowski has kindly inspected the figure and concluded that it has not been repainted.

STYLE AND DATE: Though the compositions are monumental and interesting the Master himself had little if anything to do with the illumination. The date, certainly late, may be after 1420, and the costume of the owner suggests *ca.* 1425.

BIBLIOGRAPHY: Cracow, Muzeum Narodowe, Gąsiorowska, 1935, pp. 59-68 no. 10.

MINIATURES:

Page 49	Annunciation; Initial: Virgin and Child; Border medallion: Agnes de Kiquemberg (?) kneeling at a prie-dieu
73	Visitation
99	Adoration of the Child
109	Annunciation to the Shepherds
119	Adoration of the Magi
129	Presentation in the Temple
138	Flight into Egypt
153	Coronation of the Virgin
202	God the Father in Majesty
203	Initial: King David prays to God
247	Crucifixion
263	Pentecost
275	Illustration of Office of the Dead
363	Agnes de Kiquemberg (?) adoring the Virgin and Child
373	Christ as Sovereign Judge
449	Man of Sorrows

Florence

COLL. PRINCE TOMMASO CORSINI
(Figs. 128, 167-170, 278-282)

Book of Hours, in Latin and French. Not foliated. 220 × 160 mm. 48 miniatures

HISTORY: Miniatures by the Boucicaut Master illustrating Masses of the Holy Ghost, of Our Lady, and of the Cross, include various numbers of lay participants, who probably represent the family of the original owner, but there is no means of identifying them. Saints in the calendar point to northern France.

STYLE AND DATE: The manuscript was first associated with the Boucicaut Master in 1917 by Toesca, who recognized the presence of collaborators. One of these was identified by Schilling in 1954 as the Egerton Master.

The oustanding illumination in the style of the Boucicaut Master is on the two folios which introduce the Hours of the Virgin and the Penitential Psalms. On each of these folios the main figures, the borders, and the *bas-de-page* are given a high degree of rhythmical and iconographic unity. Two folios in Bibl. nat., lat. 10538 (painted *ca.* 1415) are unified architecturally, and although these represent a more advanced application of a principle the Corsini Hours may be later.

Five other miniatures are in the Boucicaut style. These particular miniatures were apparently chosen by the Boucicaut Master because the subjects were especially meaningful for the family of the donor, who may in fact be represented in some of them. The borders on these folios, like almost all the borders in the manuscript, are coarse, large-figured, and insistent; they impinge disagreeably on the miniatures. They were executed by a hand related to the Egerton Master, whose workshop had a large part in the illumination of the manuscript. They painted the miniatures through the *Madonna Enthroned*, except for those executed in the Boucicaut style. The calendar has quiet borders and quatrefoils by followers of the Boucicaut Master. It was the latter who received the commission for the book.

Beginning with the miniature of the *Last Judgment* assistants played a predominant role. Some miniatures are closer to the Egerton Master (*St. Christopher*), others assimilate Boucicaut elements (*St. Nicholas*), and still others introduce new forms, of a Netherlandish or Lower Rhenish nature (*SS. Peter and Paul*).

BIBLIOGRAPHY: Toesca, 1917, p. 118 f.; Heimann, 1932, p. 15; Panofsky, *Netherlandish Painting*, 1953, I, pp. 59 n. 3, 193 n. 4; Schilling, 1954, p. 274; Meiss, *Art Bull.*, 1956, p. 194 n. 29.

MINIATURES (manuscript is not foliated):

St. John on Patmos (Egerton workshop)

St. Luke (Egerton workshop)

St. Matthew (Egerton workshop)

St. Mark (no symbol) (Egerton workshop)

Virgin at the loom (Egerton workshop)

Virgin of Humility in *hortus conclusus*; angels with baskets gather flowers (Egerton workshop)

Annunciation; *bas-de-page*: Virgin at the loom (Boucicaut Master and workshop)

Nativity (Egerton workshop)

Annunciation to the shepherds (Egerton workshop)

Adoration of the Magi (Egerton workshop)

Presentation in the Temple (Egerton workshop)

Flight into Egypt (Egerton Workshop)

Coronation of the Virgin (Egerton workshop)

God the Father with Evangelists and their symbols; *bas-de-page*: King David (Boucicaut Master and workshop)

Crucifixion (Egerton workshop)

Pentecost (Egerton workshop)

Illustration of Office of the Dead (Boucicaut Master and workshop)

Virgin and Child enthroned (Egerton workshop)

Last Judgment with Virgin and St. John the Baptist interceding

Mass of the Holy Ghost (Boucicaut workshop)

Mass (Kissing the Pax) (Boucicaut workshop)

Mass of the Cross (Elevation of the Host) (Boucicaut workshop)

Mass for the Dead (Boucicaut workshop)

Trinity (God Father enthroned, Crucifix, dove, and angel)

Trinity (rays descend on Two Persons enthroned and dove)

St. Michael the Archangel triumphant over a demon

Baptism of Christ by St. John the Baptist

St. Peter and St. Paul [Netherlandish (?) illuminator]

St. Andrew

St. James the Major

St. Simon and St. Jude

Stoning of St. Stephen

Martyrdom of St. Lawrence

St. Christopher

Holy Martyrs

St. Nicholas raising three youths

St. Martin sharing his cloak with a beggar

St. Maur

St. Fiacre

St. Anne and the Virgin

St. Catherine of Alexandria and the miracle of the wheel

Noli me tangere

St. Margaret

Holy Virgins

All Saints

Martyrdom of St. Denis

St. John the Evangelist

Virgin with Child playing on the psaltery

(The sequence of these last three miniatures is undetermined.)

Geneva

BIBL. PUBLIQUE ET UNIVERSITAIRE, fr. 165 (Figs. 69, 72-78)

Pierre Salmon, *Les demandes faites par le roi Charles VI touchant son état et le gouvernement de son royaume, avec les réponses de Salmon* (second version). 260 fols.; 265 × 195 mm. 23 miniatures (6 missing)

HISTORY: The manuscript contains a revised version of the text that appears in the Paris manuscript of 1409 (Bibl. nat., fr. 23279); its elaborateness suggests that it too was intended as a presentation copy. In the revision of the original three parts of the text sympathies with the Duke of Burgundy were suppressed. To these revised parts Salmon added a long moralizing fourth section. Letters dated 1410 and 1411, respectively, appear on fols. 95 and 100v, and the composition of the manuscript can hardly be earlier than *ca.* 1412. The preamble, which is now missing, may have given a more precise date. The complete text is preserved in a copy on paper, possibly in Salmon's own hand (Paris, Bibl. nat., fr. 5032). In the preamble to this manuscript (Salmon, ed. Crapelet, facsimile opposite p. xx) blanks are left for the month and year of presentation, but the year of the king's reign is given as his thirtieth (i.e. 1409). Since the preamble is clearly written for the revised version and mentions its four parts, this repetition of the presentation date of the first version must be a mistake. The dated letters, in any event, provide a *terminus post quem* of 1411 for the illustration. Both of these letters are illustrated by Boucicaut miniatures.

In attempting to fill in lacunae in the present manuscript, Aubert (1911) referred to other versions of the same text, but he erroneously identified as two manuscripts (Paris, Bibl. nat., fr. 5032 and 9672)

what are, in fact, the new and old numbers for the single copy on paper mentioned above. His claim that Bibl. nat., fr. 5070 incorporates the same text does not agree with the *Catalogue général*, which lists only three relevant texts: fr. 5032, fr. 9610, and fr. 23279. Fr. 9610, which bears the arms of the Rochechouart family, is there mistakenly given the date of 1409. The text is that of the present manuscript, but the execution clearly belongs to the second half of the fifteenth century.

STYLE AND DATE: The miniature of Charles VI with Salmon and three nobles (his uncles?) on fol. 4 is universally regarded as a major work by the Boucicaut Master himself, and it becomes all the more precious as a witness to his development because it is probably datable in 1412. No other miniature in the manuscript equals this in quality; indeed the second representation of the same subject shows a startling inferiority. It is noteworthy that in a manuscript illuminated for the king the *chef* did not scruple to employ such mediocre assistants as were responsible for fols. 34, 44, 95. Some of the initials, however, are beautiful, notably fol. 78 for its majestic space and structure, and fols. 54 and 100v for their luminosity. The beautiful border on fol. 4, in our opinion by the Boucicaut Master himself rather than an English illuminator (to whom Panofsky ascribed it), is exceptional in its motifs because the elements are all badges, mottoes, and emblems of Charles VI and his order of the Broom-pod (see above, p. 25).

Beginning on fol. 109v some miniatures were left blank in the original campaign of illustration and painted only towards 1450.

BIBLIOGRAPHY: Salmon, ed. Crapelet; Levesque [1798–99], p. 415 ff.; Aubert, 1911, p. 295 ff.; Aubert, 1912, p. 74 no. 1; Durrieu, *Rev. de l'art chrét.*, 1913, p. 309; Panofsky, *Netherlandish Painting*, 1953, I, pp. 55 n. 2, 59; Baldass, *Jan van Eyck* [1952], pp. 10, 19, 21, 66, 81.

MINIATURES:

(Only fols. 4 and perhaps 54 are by the Boucicaut Master himself; the workshop painted the rest)

Folio	4	Charles VI in conference with Salmon in his bedchamber; Duke of Burgundy is among three nobles present
	7	The same subject, but Burgundy not identified
	34	Creation of Adam
	44	Nativity
	51	Last Supper (Institution of the Eucharist)
	54	Hell
	61v	Kings, bishops, and the poor
	66v	King David kneels to God
	72	King David kneels to God
	78	Salmon at his desk
	95	Salmon with the king
	100v	Salmon writing
	110	Salmon with Reason, Faith, and Hope
	114v	Salmon with Reason, Faith, and Hope
	119	Salmon with Reason, Faith, and Hope
	145v	Reason, Faith, and Hope visit Salmon in his study and present him with a picture inscribed with the names of the vices; architecture opens on to a landscape. Only the border is by the Boucicaut workshop; the miniature is *ca.* 1450. Miniatures on fols. 109v, 117, 128v, 138, 143v, 144, 144v were added *ca.* 1450.

Lisbon

GULBENKIAN FOUNDATION, ms. L.A. 143 (formerly Yates Thompson)

(Figs. 366, 367, 370, 371, 374-377)

Boccaccio, *Des cleres et nobles femmes.* 190 fols. (originally 270 fols.); 409 × 292 mm. 48 miniatures. Originally there were 105. Many folios are missing, and a few have been misplaced.

HISTORY: There are early monograms at the bottom of folio 53v and the top of 190, deciphered by Cockerell as 'AG'. Furthermore on folio 4v, at the end of the table of contents, appears the signature, 'Ladmiral', and on the final leaf in the same large hand: 'dame sans per. a prigent'. Both refer to Prigent de Coëtivy, who also possessed the *Trésor des histoires* (see Paris, Bibl. de l'Arsenal, ms. 5077).

STYLE AND DATE: Though in 1912 Cockerell disagreed, the manuscript was rightly included by Durrieu in his initial list of works in the Boucicaut style. The Boucicaut Master himself certainly designed the best compositions, such as Ceres, Arachne, or Europa. In these miniatures the color too is luminous and telling. The miniatures were probably painted between about 1410 and 1415.

The Boucicaut Master and his assistants collaborated

with illuminators with whom they worked on several occasions. We may identify one as the Master of the Harvard Hannibal (see the Harvard Livy), and another belonged to the circle of the Bedford Master. A third, the Master of the Cité des Dames, was reintegrated by Meiss in 1956. His shop worked on other manuscripts of Boccaccio; he was, indeed, a specialist in secular texts.

Sketches for the guidance of the illuminator are still faintly visible in the lower margins of folios 155, 178v, and 180v.

BIBLIOGRAPHY: Durrieu, *Arts anciens de Flandre*, II [1906?], p. 18; Durrieu, *Rev. de l'art a. et m.*, XX, 1906, p. 22; London, Burl. Fine Arts Club, *Exhibition*, 1908, p. 79 no. 159; London, Thompson Coll., *Fourteen Mss.* (Thompson), 1912, pp. 27-40 no. XCVII (Cockerell); Durrieu, 1914, p. 29; London, Thompson Coll., *Illustrations*, 1915, p. vi, pls. XXVII-XLI; Meiss, *Art Bull.*, 1956, p. 193.

MINIATURES:

(The folio numbers are those in the upper right which, unlike the older numbers below, take account of the losses. Many folios are out of sequence)

Folio 5 Prologue: Boccaccio presents his book to Joanna, Queen of Jerusalem and Sicily (circle of the Bedford Master). Boccaccio's prologue in the early manuscripts expresses his hesitation whether to dedicate his text to 'Jehanne la tresnoble royne de iherusalem et de secile' or to 'Andrée de Accioroles de Florence comtesse de Haulteville'. The latter did, in fact, receive Boccaccio's manuscript. The first rubric of the Duke of Berry's copy of the text (Bibl. nat., fr. 598) speaks of its presentation to Joanna. The rubric in the present manuscript speaks correctly of Andrée de Accioroles, but the illustration shows Queen Joanna, who is clearly identified by her armorial dress.

(Juno and Venus missing)

19 Europa is approached by an old woman into whose lap gold pieces are falling from the hand of Jupiter above. Perhaps the illuminator confused Danaus, King of Argos, who is mentioned in

the chapter, with Danäe. (Boucicaut workshop)

13v Ceres: Ceres and the cultivation of wheat (Boucicaut workshop). The rubric erroneously reads 'Cerce' (Circe?).

17 Isis, Queen of the Egyptians: Juno points out to Jupiter the boat containing Io transformed into a cow (Boucicaut workshop)

21v Thisbe escapes from the lion, leaving her cloak. At the right she stabs herself near the body of Pyramus (Boucicaut workshop)

28v Medea: Jason approaches Medea (Boucicaut workshop)

31v Arachne: Arachne weaving while Athena strikes her with a shuttle (Boucicaut workshop)

34 Deianira watches combat between Hercules and Achelous. Hercules shoots poisoned arrow at Nessus as he carries Deianira across the river (circle of the Bedford Master)

35v Oedipus blinds himself, his sons lie dead, and his daughters stand nearby. On right, Jocasta stabs herself with a sword (circle of the Bedford Master)

37 Amalthaea: Amalthaea attempts to sell King Tarquin the nine Sibylline books and then throws them in fire (circle of the Bedford Master)

39 Nicostrata: Nicostrata, inventor of the Roman alphabet, gives to the Romans a scroll marked *a b c d* and another inscribed *vers*.

44 Argia, holding her baby son Thersander, begs her father Adrastus to take up the cause of her husband Polynices against his brother Eteocles. On right, Argia and three companions prepare to bury the body of Polynices by night against the command of Creon (Cité des Dames workshop)

47 Manto divining by means of the entrails of animals. Her son Ocnus superintends the building of Mantua round her tomb (Cité des Dames workshop)

48v The Minyans, who were condemned to

death for conspiring against Lace-
daemon, are saved by their wives, who
change clothes with them in prison
and remain in their stead (Cité des
Dames workshop)

51v Polyxena looks down from the battle-
ments of Troy on a group of Greek
warriors. At right she kneels to receive
her death-blow from the sword
of Neoptolemus near the tomb of
Achilles (Cité des Dames work-
shop)

53 At the left Neoptolemus slays Priam
before the altar of Zeus and in the
presence of Hecuba. On right, Hecuba
made mad by grief (Cité des Dames
workshop)

71 Tarquinius Sextus by the bedside of
Lucretia threatens her with drawn
sword; on right, Lucretia stabs herself
in the presence of her father and
husband (Cité des Dames workshop)

74 On left, soldiers in drunken sleep; on
right, Queen Thomyris orders a man
to throw the head of the vanquished
Cyrus into a tub of human blood
(Cité des Dames workshop)

77 The prostitute Leaena receives the con-
spirators Harmodius and Aristogeiton
in her bedroom and swears not to
betray them. When threatened she
bites out her tongue so as to be be-
yond the power of speech (Cité des
Dames workshop)

80 In Jerusalem Queen Athaliah directs the
murder of members of the house of
Judah; on right, two men drag the
queen by her hair through the gate to
kill her (Cité des Dames workshop)

86 Hippo throws herself from a pirate ship,
preferring death to dishonor. Her
corpse is lifted from the water by two
Erythraeans (Cité des Dames work-
shop)

87v Megulia is presented to her future hus-
band, who stands at the door of a
bedroom holding her dowry (Cité des
Dames workshop)

89 Veturia, mother of Coriolanus, holds the
hand of a bearded man (according to

text her daughter-in-law Volumnia)
and is accompanied by her son's three
children; on right, Coriolanus listens
to his mother's entreaties to abandon
the attack on Rome (Cité des Dames
workshop)

97v Virginia kneels before Appius Claudius,
enthroned as judge, while Marcus
Claudius holds her arm and claims her
as an escaped slave in order to betray
her to the embraces of the judge. Her
father Virginius intercedes; and on
right he cuts his daughter's throat
to save her from dishonor (French
illuminator)

101 Leontium, woman of letters; at the
right as a courtesan (Master of the
Harvard Hannibal)

102v Queen Olympia, mother of Alexander
the Great, awaits the arrival of two
men sent by Cassander to assassinate
her (Master of the Harvard Hanni-
bal)

105 Claudia, dressed as a nun, seizes a tribune
who has attempted through envy to
arrest the progress of her father's
triumphal car on its way to the Roman
Capitol (workshop of Master of the
Harvard Hannibal)

107v Flora and a youth embrace; at the right,
men and women dance around the
statue of Flora, dressed as before and
raised on a pedestal (Master of the
Harvard Hannibal)

110v Roman charity: on left, a praetor and
a jailer; on right, a young woman
suckles her mother through prison
bars, and the jailer realizes why his
charge has not died of starvation
(workshop of Master of the Harvard
Hannibal)

113 Sulpitia, the most chaste woman of
Rome, dedicates the temple of Venus
Verticordia (workshop of Master of
the Harvard Hannibal)

115 Harmonia, of the royal house of Syra-
cuse, hearing that a young woman
has willingly died in her stead, pro-
claims her identity, refuses to escape
the insurgents, and prepares to die by

her side (workshop of Master of the Harvard Hannibal)

116v Busa gives food and clothing to fugitive Roman soldiers after the battle of Cannae (workshop of Master of the Harvard Hannibal)

119 Sophonisba, Queen of the Numidians, marries Masinissa, the conqueror of her husband Syphax; on right, Sophonisba drinks the cup of poison sent to her by Masinissa to avoid falling into Roman hands (workshop of Master of the Harvard Hannibal)

122 Theoxena, fleeing with her family from Philip of Macedon, is driven by contrary winds into the hands of the enemy. After urging her companions to kill themselves she leaps into sea (Cité des Dames workshop)

125 Queen Berenice, better known as Laodice, kills Ceneus with a stone after he has slain her son Ariarathes by order of Mithridates (Cité des Dames workshop)

128 The widowed Aemilia wearing black conceals her husband's intrigue with a young slave by freeing her and marrying her to a freedman (Cité des Dames workshop)

131v Claudia proves her chastity by pulling with her girdle a boat containing an image of the mother of the gods, which the combined strength of many youths had failed to move (Cité des Dames workshop)

133 Hypsicratea, wife of Mithridates, rides in full armor by her husband's side into battle and is slain with him (Cité des Dames workshop)

136 Sempronia stands behind a table on which men have placed a girdle, purse, and a heap of coins; on right she sits between two armored warriors (one probably intended for Catiline) (Cité des Dames workshop)

138 The troops of Caius Marius, after routing the Sicambrian soldiery, face the resistance of the Sicambrian women (Cité des Dames workshop)

141 Portia, wife of Brutus, wounds herself to prove her courage if the attack of Brutus on Caesar should fail; on right, Portia swallows burning coals on hearing of her husband's death (Master of the Harvard Hannibal)

143 Curia hides her husband Quintus Lucretius, who has been proscribed by the Triumviri; on right, Curia and the maid pretend to bewail the disappearance of Lucretius (Master of the Harvard Hannibal)

144v Hortensia, daughter of the orator Quintus Hortensius, pleads before the Triumviri, who are seated together under a picture of the Crucifixion, on behalf of Roman women whose property was being heavily taxed (workshop of Master of the Harvard Hannibal)

153v The sun shines on Antonia, wife of Drusis, who exemplifies virtuous widowhood. She appears with her daughter Livia and her three sons Germanicus, Caligula, and Augustus. On right she rejects the offer of two suitors (workshop of Master of the Harvard Hannibal)

155 Agrippina, mother of Nero. After her husband Germanicus has been poisoned with the connivance of his adoptive father Tiberius she attempts to starve herself to death, but Tiberius orders that she be fed by force (workshop of Master of the Harvard Hannibal)

161v Epitaris is tortured for details of a conspiracy against Nero; on right, she kills herself on the third trip to the torture chamber in the fear that her courage may fail her (workshop of Master of the Harvard Hannibal)

178v Emperor Otto IV, impressed by the beauty and virtue of Engeldruda, gives her a rich dowry (workshop of Master of the Harvard Hannibal)

180v Constance, Queen of Sicily, marries Henry, Emperor of the Romans; on right, birth of the Emperor Frederick II (workshop of Master of the Harvard Hannibal)

London

BRIT. MUS., Add. 16997

(Figs. 134, 172, 174, 283-295, 299)

Book of Hours, Use of Paris. 226 fols.; 159 × 114 mm.
17 miniatures

HISTORY: The initials of two prayers at the end
contain pictures of a layman in a red robe with furred
cuffs before the Virgin. The arms still visible on fol.
90 (per fess indented), presumably those of the
original owner, were repainted and the monogram
of Étienne Chevalier substituted sometime before
1474, when the book must have been in the possession
of this well-known patron of Fouquet. It has been
suggested that the name of St. George in gold in the
calendar might indicate a date after 1420, when the
English entered Paris.

STYLE: With the exception of the *Presentation* (fol.
72v), which is by the Bedford Master, all the minia-
tures in this exceedingly beautiful book were designed
and to a large extent executed by the Boucicaut
Master himself. Despite their small size they are
wonderfully monumental in conception. They show
the late style of the Boucicaut Master at its best: deep,
lofty spaces and soft, freshly harmonized, luminous
colors. The grandeur of the buildings is unrivalled in
European painting of the period.

The borders too, unlike those in many manuscripts
produced by the workshop, are of the highest quality
(except, strangely, on fol. 21). Each one was designed
to match the miniature it encloses, especially in color
(Figs. 174, 299). The principle of harmony, initiated
in the *Boucicaut Hours*, is more subtly and extensively
applied here.

The presence of naturalistic oak leaves in the borders,
spread out as though pressed, is not paralleled else-
where in the Boucicaut workshop and suggests that
he may have known the work of an artist active in
France *ca.* 1420, the Master of Walters 219 (see *Late
XIV Century*, p. 360, Pächt, 1950, p. 44 n. 1, and Meiss,
1956, p. 195). The style of the Bedford Master's
miniature in the present manuscript would hardly
seem to be datable later than *ca.* 1418.

BIBLIOGRAPHY: Monograph: London, Brit. Mus.,
French Horae, 1927. London, Brit. Mus. (Warner),
1903, text and pl. 49; Durrieu, *Arts anciens de Flandre*,
II [1906?], p. 18; Durrieu, *Rev. de l'art a. et m.*, XX,
1906, p. 24 f.; Durrieu, *Rev. de l'art chrét.*, 1913, p.
310; London, Brit. Mus., Millar, 1933, p. 36, pl. LI;

Pächt, 1950, p. 44 n. 1; Pächt, *Burl. Mag.*, 1956, p.
150; Meiss, *Gaz. B.-A.*, 1961, p. 293 f., fig. 38.

MINIATURES:

Folio 21	Annunciation (the border by a crude assistant)
45v	Visitation
57	Nativity
63	Annunciation to the Shepherds
68	Adoration of the Kings
72v	Presentation in the Temple (Bedford Master)
77	Flight into Egypt (Massacre of Innocents and Miracle of Corn in distance)
84v	Coronation of the Virgin
90	King David in penitence before God the Father
111	Trinity
119v	Requiem Mass
129	Pentecost
137	All Saints (St. John the Evangelist, St. Catherine, and St. John the Baptist prominent)
145	Elevation of the Host (statues of St. John the Evangelist and of the Baptist)
153v	Crucifixion
163	Assumption of the Virgin
171v	Monks saying the Vigils of the Dead
219	Initial. Madonna above green curtain; layman wearing orange *houppelande* in prayer
223	Initial. Half-length Madonna; layman wearing orange *houppelande* in prayer

London

BRIT. MUS., Cotton Nero E. II (Figs. 419-429)

Grandes Chroniques de France. 487 fols.; 395 × 251 mm.
(but losses around all the margins). Frontispiece and 89
miniatures. 2 vols.

HISTORY: This manuscript, originally in one volume
of large format, was damaged by fire while in the
Cotton Library. Each folio is now mounted in a
paper frame, and the whole is bound in two volumes.
The arms of France, which occur several times on
fol. 2 of Vol. I, are the only clue to the original owner,
but it has not been possible to identify the book in
any of the royal inventories. The chronicle ends with
the accession to the throne of Charles VI.

STYLE AND DATE: As pointed out by Meiss, the extensively illustrated manuscript is a product of the cooperation of the Boucicaut and Egerton workshops, with a few miniatures (Vol. I, fols. 54v, 175-182; Vol. II, fols. 1, 20v, 24, 181, 183, 224v) by a very weak, conservative practitioner. The shop of the Boucicaut Master had the largest part, and he no doubt assumed the primary responsibility, designing the presentation miniature and perhaps also the large scene of King Priam on fol. 2 of Vol. I, but he left the painting of this miniature to an undistinguished assistant. Though as usual the Master relied heavily on his workshop, many miniatures are very beautiful in color and design.

The style as well as the formalized scrolls and the flowers they enclose on fol. 2 of Vol. I indicate a date ca. 1415. The miniatures in the Egerton manner point to these years also, for they approximate the style of this workshop that appears in the *Bréviaire de Jean sans Peur*, which was illuminated around 1416. The miniature on fol. 173v of Vol. I, for instance, shows a similar atmospheric perspective.

Numerous sketches in red pencil and written instructions for the composition of the miniatures in the margins have escaped erasure or trimming. They have been discussed in *Late XIV Century*, p. 11 f., figs. 304, 307, 309, 311, 312. The sketches appear only on those folios that contain miniatures in the Boucicaut style. The draughtsmanship is very good, but the compositions are generally more conservative than those of the corresponding miniatures. Perhaps this difference is simply functional. The drawings may be the work of a specialist in the group of illuminators.

BIBLIOGRAPHY: Delisle, *Notes sur quelques manuscrits du Musée britannique*, Paris, 1878, p. 33 f; Meiss, *Art Bull.*, 1956, p. 195.

MINIATURES:

(All by the Boucicaut Master and assistants except those otherwise classified)

Vol. I

Folio 1 Presentation miniature (badly rubbed).

2 King Priam of Troy. Angels in margin carry royal shields or banner; one clad in gown adorned with *fleurs-de-lys* holds helmet surmounted by crown and *fleurs-de-lys*; damaged red pennant in lower margin. (Executed by an assistant; border figures closer to Boucicaut Master)

8v Clovis and St. Rémy with the 'sainte ampoule'

11v Clovis receives a sign of victory from heaven

15v Queen Clotilde divides the realm among the four sons of Clovis

31 The division of the realm among the four sons of Clothaire

44v A nimbed monk overcome by the devil during the reign of Chilperic

48v The murder of King Chilperic by order of Fredegunda

54v King Guntram committing the realm to his nephew Childebert (weak French illuminator)

59v The two sons of Childeric, before Brunhilda, divide the realm

64v Brunhilde punished for her misdeeds by King Clothaire

67 King Clothaire holds council; Dagobert cuts the beard of his tutor

72v King Dagobert receiving a bishop

73 The building of St. Denis by Dagobert

87v The sons of Charles Martel; griffon thrown into dungeon

90v Charlemagne as King of France blessed by Pope Leo III

103 The coronation of Charlemagne as Emperor in St. Peter's, Rome

118 The vision of Charlemagne. An angel and St. James show him the celestial sign.

124 Roland wounds the giant Ferragus (weak French illuminator)

127 Ganelon delivers his message to King Marsile

129v At mass Archbishop Turpin learns from demons of the death of Roland

130 The army headed by Charlemagne discovers the dead Roland or Oliver

131 The obsequies of Roland in the Church of St. Rommain de Blaye

131v Charlemagne returning to France

135 Coronation of Louis le Débonaire

156v Dream of Charles the Bald

169v King Louis le Bègue (ms. has *Barbe*) receives his father's sword and sceptre from Empress Richilda

172v Coronation of the two sons of Louis le

Bègue (ms. has *Barbe*) (Egerton work-
shop)

173v The siege of Vienne; Carloman in his
tent (Egerton workshop)

174v The coronation of King Eude (Egerton
workshop)

175 Robert of Normandy received by the
archbishop of Rouen (weak French
illuminator)

176 Robert of Normandy is baptized (weak
French illuminator)

178 Bishop of Sens brings letter to King of
England (weak French illuminator)

182 Coronation of Lothaire (weak French
illuminator)

184v King Robert, son of Hugh Capet, writ-
ing the music of a religious book

188 Veneration of body claimed to be that
of St. Denis

192v Philip I received by the Pope

202 Murder of Guy de Sire de la Roche-
Guyon

222 Battle of Louis VII and his father Louis
le Gros

233v An angel addresses Louis VII and
his queen, who conceives Philippe-
Auguste

241 Rollo the Tyrant sets out to capture
Normandy

Vol. II

Folio 1 Capture of Tours [or Le Mans?] (weak
French illuminator)

4v The young, ailing Louis VII, carried in a
cart, praying to the reliquary of St.
Denis

8 Richard of England pays homage to
Philippe-Auguste

10v King Philip orders the despoiling of
Normandy

14 King Philip receives the key to the city
of Rouen

16v Punishment of heretics by King Philip

20v Albigensian prisoners led naked from
Carcassonne (weak French illumi-
nator)

24 The battle of Bouvines (weak French
illuminator)

29 St. Valéry appearing to King Hugh
Capet in a dream

36 Louis IX venerates a reliquary, probably
near St. Denis

40v Battle between Louis IX and Henry III

45 Louis IX addressing messengers from the
great Khan

48v French and Saracen armies in Egypt

53 Battle between the Counts of Flanders
and of Holland

56v Louis IX gives provisions

61 Battle between Conradin and Charles of
Anjou

64 Louis IX sailing to Tunis

67v Charles of Anjou fighting the Saracens
in Tunis

72v The tomb of St. Louis

73 Coronation procession of Philip III

80v Philip III listening to Cardinal Collet

85 Edward I (or II) pays homage to Philip
IV of France

88v Guy, Count of Flanders, in secret meet-
ing with Edward I of England

93v Papal messengers before Philippe le Bel

95v Charles de Valois in the presence of Pope
Boniface

100v Knights Templar before Pope and King

105 Philip the Fair watching the burning of
Master Templar

109 Calamities in the reign of Louis X

110v Burning of Jews under Philip V

115 Dissolution of marriage of Charles IV
and of Blanche (Egerton Master and
workshop)

124v Council after the death of Charles le Bel
(Egerton workshop)

137 Encounter of French and English armies

152v The Battle of Crécy

154v Charles de Blois battling the English

160v The coronation of Jean le Bon (1350)

166 Battle of Poitiers

173v The King of Navarre following the bier
of those decapitated at Rouen

175v Murder of the Marshals of Clermont
and Champagne

181 Meeting of the Regent and the King of
Navarre near Vincennes (weak French
illuminator)

183 Murder of Étienne Marcel and com-
panions (weak French illuminator)

200v The obsequies of King John in the Abbey
of St. Anthony (1364)

202v Coronation of Charles V at Rheims

205 Du Guesclin taken prisoner (assistant)

217 Marriage of Philippe le Hardi and Margaret of Flanders

220v Charles V makes du Guesclin constable of France

224v Charles V holds council (weak French illuminator)

229v King Charles V entertains the Emperor Charles IV

238v Charles V receives the cardinal of Limoges

242v Coronation of Charles VI (badly mutilated); angel in margin bears royal shield

London

BRIT. MUS., Egerton 1070 (Figs. 148, 205–209)

Book of Hours, Use of Paris. 154 fols.; 220 × 162 mm.

HISTORY: The Egerton Master and his assistants illuminated most of this manuscript; their work will be considered in *Paris, 1400–1420*. A much smaller share in this campaign was allocated to the Boucicaut workshop and to followers of the Parement Master, of Jacquemart and of Pseudo-Jacquemart, whose somewhat mysterious appearance here suggests a connection with the Duke of Berry and with his *Grandes Heures*, finished in 1409. This first campaign has left no clues to the original owner. The later additions, which include arms, devices, and five miniatures, one of which is a portrait, were made for King René of Anjou. The book was in England in the late fifteenth or early sixteenth century, when a note on a guard folio says that it was given to Henry VII by his chaplain, and it may have reached England in the first place through René's daughter, Margaret of Anjou, who was the wife of Henry VI.

STYLE AND DATE: All the full-page miniatures, which illustrate the Hours of the Virgin, the Penitential Psalms and the Mass for the Dead, are by the Egerton Master and his workshop; they are, in fact, the works from which he takes his name. Illumination by assistants of the Boucicaut Master is confined to the smaller miniatures and their borders. Probably this work was done *ca.* 1409–1410, when the Boucicaut workshop was in touch with artists of the Duke of Berry. The Egerton Master himself seems to show a renewed responsiveness to the Duke's painters, especially to the Limbourg brothers.

The Boucicaut Master painted nothing himself. The interesting contribution of his workshop discloses some tendency to conform with the style of the Egerton Master, who apparently directed the work. The miniature on folio 140, for instance, shows Egerton's characteristic flecked sky, and his large gilt arabesque appears in a miniature on folio 92. On the other hand Boucicaut models influenced not only the main miniatures by the Egerton Master but probably also the borders that show angels bearing vines. Though such angels appear first in the manuscript on folios illuminated entirely by the Egerton workshop, those in the Boucicaut style are much superior in structure and variety of posture. The Boucicaut workshop used similar angels slightly later in the *Bible historiale*, Bibl. nat., fr. 10 (Fig. 343). Related figures appeared in the borders of the *Grandes Heures*, finished in 1409.

The Boucicaut Master was no doubt responsible also for the innovation of representing sacred figures in half-length within tabernacles. For such 'close-up' representations he preferred an architectural member or a strip of terrain along the lower frame. In many of his later miniatures, beginning with the *Merveilles du monde* (Figs. 93, 446) the scale of the figure is similarly increased by showing only a part of it. Thus these miniatures anticipate to a degree (more than Ringbom recently allowed) 'the close-up' on panel and canvas that became popular in the second half of the century. Most of the miniatures, however, do not exploit the psychological and dramatic possibilities of the design.

The use at the lower frame of a drapery may have been initiated by the follower of the Parement Master who painted the miniature on fol. 97 (at the beginning of a new gathering – Fig. 208). The curtain was adopted by the followers of Jacquemart and of Pseudo-Jacquemart who worked on this gathering (Fig. 207), and also by the Egerton Master.

BIBLIOGRAPHY: Durrieu, *Arts anciens de Flandre*, II [1906?], p. 18; Durrieu, *Rev. de l'art a. et m.*, XX, 1906, pp. 24, 25; Durrieu, in *Florilegium, Melchior de Vogüé*, 1909, p. 197 ff.; Durrieu, *Rev. de l'art chrét.*, 1913, p. 310; London, Brit. Mus., Millar, 1933, pp. 34–35, pl. XLVII; Schilling, 1954, p. 272 ff.; Meiss, *Art Bull.*, 1956, p. 190; Ringbom, 1965, p. 192 f.

MINIATURES IN THE BOUCICAUT STYLE:

Folio 91 St. Mark; Stoning of St. Peter Martyr

91v St. James and St. Philip; Invention of
the Cross

92 St. Quiriacus; St. John the Evangelist
being boiled in oil

92v St. Ives; Ascension

93 St. Germain; Pentecost

93v Trinity; Mass

94 St. Barnabas; St. John the Baptist

94v St. Peter

. . . .

111 Standing Virgin and Child; St. John the
Evangelist

112 Trinity

113 Last Supper

115 Virgin enthroned

116 Crucifixion

117 Illustration of Office of the Dead

118v Betrayal

124v Way to Calvary

129v Flagellation

134v Crucifixion

140 Creation of Adam, Creation of Eve, and
Cain killing Abel – three incidents
combined in one miniature

London

BRIT. MUS., Harley 2940 (Figs. 322, 323)

Book of Hours, Use of Paris. 183 fols.; 192 × 137 mm. 6
miniatures

HISTORY: There is no indication of original owner-
ship.

STYLE AND DATE: The manuscript would seem to
be a very late and rather mediocre product of the
Boucicaut workshop, or rather of a follower. The
Rohan Master painted the miniature on fol. 175. So
far as we know these two workshops joined forces in
only one other manuscript: an earlier Book of Hours
in the Zwemmer collection in London.
In his miniature the Rohan Master was influenced by
the Boucicaut style. On the other hand this style –
see especially the architecture in the *Annunciation* –
has in turn responded to the general trend around
1420, shaped especially by the Rohan Master and the
Master of the Berry Apocalypse. The borders of this
manuscript also indicate a date around 1420.

BIBLIOGRAPHY: London, Brit. Mus., *Harleian Manu-
scripts*, II, 1808, p. 721 no. 2940; Durrieu, *Arts anciens*

de Flandre, II [1906?], p. 18; Durrieu, *Rev. de l'art a. et
m.*, XX, 1906, p. 24; Durrieu, *Rev. de l'art chrét.*, 1913,
p. 310; London, Brit. Mus., *French Horae*, 1927, n.p.

MINIATURES:

Folio 38 Annunciation; Lamb of God and Sym-
bols of the Evangelists in margin

90 King David kneels in landscape to God
the Father in lunette above

110 Cruxifixion

118 Pentecost

126 Illustration of Office of the Dead. In
margin digging of grave, censing of
corpse, and skull and cross

175 Virgin and Child attended by angels
(Rohan workshop); golden boar in
initial

London

BRIT. MUS., Royal 15 D III (Figs. 344-354)

Guiart des Moulins, *Bible historiale.* 532 fols.; 460 × 330
mm. 3 large and 103 smaller miniatures

HISTORY: Original ownership is undetermined, but
the manuscript was already in England in the fifteenth
century, when fol. IIIv was inscribed: 'My lady
Powys, I yow pray / raymambayre me wayn yow
may'.

STYLE AND DATE: The texts of this manuscript and
of the other *Bible historiale* in which the Boucicaut
Master participated (Paris, Bibl. nat., fr. 9-10) have
been grouped by Berger in the same family. An
iconographic misunderstanding common to both
books, whereby the traditional illustration for the
Book of Isaiah is instead applied to Jeremiah, indicates
a connection between the workshops that were
responsible for the illumination, those of the Master
of the Cité des Dames in fr. 9-10 and of the Boucicaut
Master in the present Bible.
The Boucicaut Master himself did not participate in
the execution of this manuscript; even most of the
compositional sketches in the margins are by assistants,
who likewise painted the miniatures. The styles of
the Boucicaut and Egerton workshops predominate,
but other illuminators played a part. Some miniatures
were painted by a follower of the Master of the
Breviary of Jean sans Peur (see *Late XIV Century*, p.
355), and others by the Virgil Master and assistants

(*Late XIV Century*, p. 360). The miniatures show the Virgil Master in a late phase, and a date *ca.* 1415 is suggested also by the fact that an assistant of the Breviary Master painted a miniature in Paris, Mazarine, ms. 469 (fol. 83), a manuscript executed around that time.

The Egerton Master probably received the commission for Royal 15 D III, because his workshop executed the presentation miniature, the larger miniatures, and indeed more of the illumination than the other workshops. Sometimes two or three styles appear within one gathering, as in fols. 405-412. The contribution of the assistant of the Master of the Breviary of Jean sans Peur was not limited to a few miniatures. Animals and figures in the borders around miniatures painted by the Egerton shop are in that style (see fols. 297v, 299, 305, 321, 520v, 526).

An inscription: '*Petrus gilberti me fecit*' appears in a line-ending on fol. 15v immediately after the rubric, beneath a miniature in the style of the Boucicaut workshop. Since the same inscription may be seen in the *De Lévis Hours*, where the main illustration is by the Bedford Master, on pages where there are no miniatures at all (London, Sotheby, May 9, 1933, Lot 53), and in a *Bible historiale* in Brussels (Bibl. royale ms. 9001-9002) in conjunction with illustration by a different hand, it seems clear that 'Petrus Gilbertus' did decorative work rather than miniatures.

Numerous drawings and notes for the illuminators, giving instructions for the miniatures, are still legible in the margins. They are discussed in *Late XIV Century*, p. 11.

BIBLIOGRAPHY: Berger, *Bible française*, 1884, pp. 206, 218, 387; Durrieu, *Arts anciens de Flandre*, II [1906?], p. 18; Durrieu, *Rev. de l'art a. et m.*, XX, 1906, p. 22; Vollmer, 1910, p. 235 f.; Mély, *Signatures*, 1913, p. 177; Durrieu, *Rev. de l'art chrét.*, 1913, p. 310; London, Brit. Mus., Warner and Gilson, 1921, II, p. 172; Schilling, 1954, p. 274 f.; Meiss, *Art Bull.*, 1956, pp. 193 n. 24, 194 n. 29, 195 (on p. 193 n. 24, owing to a slip, the Master of Christine de Pisan is given a share in the work).

MINIATURES:

Folio 1 Petrus Comestor gives his book to the Archbishop of Sens (Egerton workshop)

3 Garden of Eden (large) (Egerton workshop)

3v-6 Seven scenes of creation (Egerton workshop)

9v Expulsion from Paradise (Boucicaut workshop)

12 Building of the Ark (Boucicaut workshop)

15v Building of Babel (Boucicaut workshop)

27 Jacob's ladder (Boucicaut workshop)

31v Joseph put in the well (Boucicaut workshop)

40 Pharaoh gives tasks to the Israelites (Boucicaut workshop)

48 The Exodus (Boucicaut workshop)

62 Offerings at the altar (Egerton workshop)

69v God speaks to Moses (Egerton workshop)

78 Israelites at the Red Sea (Egerton workshop)

82v Offerings at the altar (Egerton workshop)

85 Moses with the tables of the law (Egerton workshop)

97 Joshua leads the Israelites (Egerton workshop)

103 Capture of Adonibezek (Egerton workshop)

112 Hannah's prayer (Egerton workshop)

115 Anointing of Saul (Egerton workshop)

124 The Amalekite relates Saul's death (Egerton workshop)

130v Death of Absalom (Egerton workshop)

134v Anointing of Solomon (Egerton workshop)

138v Building of the Temple (Egerton workshop)

152 Elijah taken up (Egerton workshop)

170 Tree of Jesse (Egerton workshop)

180 Prayer of Solomon (Egerton workshop)

193v Edict of Cyrus (Boucicaut workshop)

197 Nehemiah enquires of the Jews (Boucicaut workshop)

202v Sacrifice of Josiah (Boucicaut workshop)

209 God, Satan, and Job (Virgil Master)

219v Job and his friends; above, God and angels (Boucicaut workshop)

220v Raphael, Tobias, and Tobit (Virgil Master)

225 Gedaliah receives Ishmael (Boucicaut workshop)

232 Susanna accused by the elders (Boucicaut workshop)

236 Rebuilding of Jerusalem (Virgil Master)

239 Judith kills Holofernes (Boucicaut workshop)

243v Ahasuerus and Esther (Boucicaut workshop)

244v Artaxerxes sends letters (Boucicaut workshop)

245v Ahasuerus and Esther (Boucicaut workshop)

248v Ochus sends Vagosus (Boucicaut workshop)

252 David plays on a harp (Boucicaut workshop)

256v Dominus illuminatio (follower of Master of the Breviary of Jean sans Peur)

259 Dixi custodiam (Boucicaut workshop)

262 Dixit insipiens (Boucicaut Master and workshop)

265 Salvum me fac (Boucicaut workshop)

268 David playing on bells (Boucicaut workshop)

271 Cantate domino (Boucicaut workshop)

274v Dixit dominus domino meo. God and Christ (on His left) (Boucicaut workshop)

285 Solomon dictating proverbs; Solomon receiving the Queen of Sheba (large) (Egerton workshop)

294v Ecclesiastes pointing to the sun (Egerton workshop)

297v The Bride and Bridegroom (Egerton workshop)

299 Justice enthroned: the teacher and disciple (Egerton workshop)

305 The teacher introduces the disciple to Wisdom (Egerton workshop)

321 Isaiah prophesies to the Jews (Egerton workshop)

340v Jeremiah and two men with saw (as noted by Warner and Gilson, this iconography normally applies to Isaiah) (Egerton workshop)

361v Jeremiah lamenting beneath the walls of Jerusalem (Egerton workshop)

363v Baruch reading the book (Egerton workshop)

366v Ezechiel and the four wheels (Egerton workshop)

383v Daniel receives a book from God (Egerton workshop)

391 Birth of Jezreel (Egerton workshop)

394 Joel and trumpeters (Egerton workshop)

395v Amos and Damascus (Egerton workshop)

398 Obadiah with orb (Egerton workshop)

398v Jonah in the mouth of the whale (Egerton workshop)

399v Micah propping the falling walls of Jerusalem (Egerton workshop)

401v Nahum and two figures: Christ upon the mountains (Egerton workshop)

402v Habakkuk crying to God (Egerton workshop)

403v Zephaniah and the destruction of man and beast (minor follower of the Master of the Breviary of Jean sans Peur)

405 Haggai and Zerubbabel (Egerton workshop)

406 Vision of Zechariah (same hand as 403v)

409v Polluted offerings (Boucicaut workshop)

410v Wars of the Maccabees (same hand as 403v)

422v The letter delivered (Boucicaut workshop)

432 St. Matthew: tree of Jesse (large) (Egerton workshop)

445v St. Mark (Boucicaut workshop)

455 St. Luke (Boucicaut workshop)

470v St. John (Boucicaut workshop)

481v St. Paul writing; Romans receiving the epistle (Virgil Master)

486v St. Paul sending letter (follower of Virgil Master)

491 St. Paul reproving the Corinthians (Virgil Master)

494 St. Paul accompanied by three men (follower of Master of the Breviary of Jean sans Peur)

496 St. Paul speaking to children (follower of Master of the Breviary of Jean sans Peur)

497v St. Paul expounding to the Philippians (follower of Master of the Breviary of Jean sans Peur)

498v St. Paul speaking to kneeling Colossians (follower of Master of the Breviary of Jean sans Peur)

500 St. Paul, with Thessalonians (follower of Master of the Breviary of Jean sans Peur)

501 St. Paul indicating God to the Thessalonians (Boucicaut workshop)

501v St. Paul sending book to Timothy (Boucicaut workshop)

504 St. Paul speaking to a child and pointing to five men (Virgil Master)

503 (Misbound) St. Paul addressing an audience (Virgil Master)

506 St. Paul speaking to Philemon, Apphia, and Archippus (Virgil Master)

509 Descent of the Holy Ghost (Virgil Master)

520v St. James sending letter (Egerton Master)

526 St. John in Patmos: candlesticks and the beast (Egerton workshop)

527 The Lamb, with the book, between the four beasts; elders (Egerton Master)

528 Seven angels before the throne (Egerton Master)

529 St. John; the woman clothed with the sun; the dragon; St. John and the beast (Egerton Master)

530 The whore; one of the angels with the vials and St. John (Egerton Master)

531 St. John; the angel binding the serpent (Egerton Master)

531v St. John; the new Jerusalem (Egerton Master)

532 The river of crystal; the angel and St. John (Egerton Master)

assigned a date *ca.* 1415: Baltimore, Walters ms. 260, and Paris, Collection Charnacé, from both of which Joseph likewise is absent, and Paris, Bibl. nat., lat. 10538, where Joseph appears. The beginning of this domestic action of the Virgin is discussed in *Late XIV Century*, p. 18.

Though the execution of the present manuscript is more perfunctory than that of Walters 260, the two are linked also by the participation of the same very inferior assistant in the borders.

St. Matthew, which was ascribed to the Egerton Master by Schilling in 1954, an attribution which I accepted in 1956, now seems to me only the work of a follower.

BIBLIOGRAPHY: (Anonymous), *Burl. Mag.*, I, 1903, p. 389; Schilling, 1952, p. 169; Schilling, 1954, p. 274; Meiss, *Art Bull.*, 1956, p. 194 n. 29.

MINIATURES:

Folio 13 St. John
15 St. Luke
16 St. Matthew (related to Egerton Master)
43v Visitation
56v Nativity
66 Flight into Egypt
81v Coronation of the Virgin
172 Clerics singing to standing Madonna
178v Illustration of Office of the Dead
184v Christ as Judge displays his wounds

London

VICTORIA AND ALBERT MUSEUM, ms. A. L. 1646–1902 (Reid ms. 4) (Figs. 276, 277)

Book of Hours, Use of Paris. 190 fols.; 179 × 130 mm. 10 full-page miniatures

HISTORY: There are no indications of original ownership.

STYLE AND DATE: The manuscript was referred to the Boucicaut workshop by Schilling in 1952. The book is a routine product. In the *Nativity* the Virgin tests the water of the Child's bath, which is poured by a servant into a tub. The Virgin acts similarly in a miniature by a follower of the Boucicaut Master in Arsenal 623, fol. 15, painted in 1412, and the full group of the Victoria and Albert manuscript appears in somewhat later manuscripts, which should be

London

COLL. D. AND J. ZWEMMER
(Figs. 120, 138, 239-244)

Book of Hours, Use of Paris. 281 fols.; 210 × 153 mm. 17 miniatures

HISTORY: In 1947 the manuscript belonged to Heinrich Eisemann in London, and shortly before then to Major J. C. Balfour, Balbirnie, Markinch, Fife.

STYLE AND DATE: The Rohan workshop illuminated the Calendar (Figs. 242, 243). The rest of the manuscript was carefully executed by the Boucicaut workshop towards 1415. Many of the miniatures are impressive in design and delicate in color.

BIBLIOGRAPHY: London, National Book League, *A Thousand Years of French Books*, London, 1948, p. 12 f.

MINIATURES:

Folio 21 Annunciation
 48 Visitation
 60v Nativity
 67 Annunciation to the Shepherds
 72 Adoration of the Magi
 76v Presentation in the Temple
 81 Flight into Egypt
 88v Coronation of the Virgin
 95 Crucifixion
 104v Pentecost
 113 David before the Lord
 137 Virgin enthroned and lady donor
 143 Christ in majesty
 147 Illustration of Office of the Dead
 212v Trinity
 257 All Saints
 274v Mary Magdalene

Lucca

BIBL. GOVERNATIVA, ms. 3122 (formerly Parma, Bibl. Palatina, Cod. pal. 3) (Figs. 356-365)

Missal for the Use of Rome. 354 fols.; 336 × 256 mm. 2 full-page miniatures and 17 smaller miniatures

HISTORY: Fol. 7 bears the arms of the Trenta family of Lucca (Fig. 357). The lay figures at Mass in the miniature on this folio are no doubt members of this family. Carta, Cipolla, and Frati identified the chief donor as Stefano Trenta, Bishop of Lucca (1448–1477) and Papal Legate to the Duke of Burgundy (1467–1477), but the date entailed by this assumption is of course much too late. That the Missal was commissioned by an Italian is indicated by the Use. Actually around 1400 four members of the Trenta family, like their fellow-citizens the Rapondi, were living near the great courts and trading centers in northern Europe, Paris, Dijon, and Bruges (cf. Mirot and Lazzareschi, *Boll. stor. lucchese*, I, 1929). The four Trenta brothers – Galvano, Lorenzo, Banduccio di Nese, Federigo di Matteo – were purveyors of Lucchese silks, goldsmiths' work of all kinds, and Netherlandish panels. They served Philippe le Hardi, Jean sans Peur, and Louis d'Orléans. Of these brothers Lorenzo was almost certainly the commissioner of the Missal. His saint, Lawrence, is honored by a miniature in the Missal, but not, so far as one can judge, the patrons of any of the other brothers.

We know that in 1401, 1407, and 1409 Lorenzo Trenta sold textiles and gold objects to the Dukes of Burgundy. In 1416 Jacopo della Quercia carved tomb-slabs of Trenta and his wife Caterina for S. Frediano, and several years later he completed an altarpiece for his chapel. St. Lawrence is on the Madonna's right, and the Martyrdom is represented in the predella. In the predella St. Jerome is singled out for representation, as in the Missal (for Jacopo's altarpiece see A. Venturi, *Storia dell'arte italiana*, Milan, VI, 1908, fig. 34). It is indeed not unlikely that Quercia's composition of the Martyrdom owes something to the representation of the same scene in the beautiful book recently acquired in Paris by the donor (Figs. 364, 469). The contrapposto of the saint is rare in earlier representations of the Martyrdom, and the movements of the executioners have much in common.

STYLE AND DATE: The folio containing the Trenta arms and, presumably, the family of Lorenzo Trenta at mass is the most beautiful in the Missal, and probably owes much to the Boucicaut Master himself. The figure style and the spatial breadth indicate a date towards 1415. The broad, rich borders point to the same period; especially significant are the vines on fol. 7, which originate in a sort of tuber below and spread up through the three margins. Flowers and naturalistic leaves sprout from the more formal tendrils and pseudo-acanthus.

BIBLIOGRAPHY: Carta, Cipolla, and Frati, 1899, p. 44; Durrieu, *Arts anciens de Flandre*, II [1906?], p. 18; Durrieu, *Rev. de l'art chrét.*, 1913, p. 313 f.; Toesca, 1917, p. 117; Rome, Pal. Venezia, *Mostra della miniatura* [1953], p. 285 f.

MINIATURES:

Folio 7 Celebration of the Mass with donors present. Arms of the Trenta family in lower border
 17v Nativity
 25 Adoration of the Magi
 95 Entry into Jerusalem
 151v Crucifixion ⎫
 ⎬ Canon Pages
 152 Majesty ⎭
 160 Resurrection
 173v Ascension
 178 Pentecost
 187 Trinity
 188v Corpus Christi procession
 219 St. Andrew

246v Birth of the Baptist
261 Martyrdom of St. Lawrence
263 Death of the Virgin
275v St. Michael killing the dragon
276v St. Jerome
281v All Saints
285v Apostles

Madrid

BIBL. NACIONAL, Vit. 25 no. 1

(Figs. 141, 176, 178)

Book of Hours. 8 miniatures

HISTORY: There are no clues to the original owner of this manuscript, which has been deprived of its calendar and many of its miniatures, and now survives in a very mutilated condition.

STYLE AND DATE: In 1913 Durrieu included the manuscript in his list of paintings by the Boucicaut Master, relying on a communication from F. Winkler. Actually only one miniature, *St. Matthew*, is in his style. It is, as the text above states, an important and problematic painting because it is linked more closely than any other miniature in the Boucicaut manner to the great illuminator of the *Coronation* in the *Légende dorée* (Fig. 458) and of certain miniatures in the *Bible historiale*, Bib. nat., fr. 159 (Figs. 459-463). Though its connections are all with the art of the very first years of the century its value as evidence of the art of the Boucicaut Master at this time is rendered questionable by the modesty of the execution, which implies perhaps the intervention of an assistant.

All the other miniatures are early works of the Egerton Master and his shop, as observed by Meiss in 1956, and they support an early dating of the *St. Matthew*. The borders, without acanthus leaves and with *bas-de-page* of a late fourteenth-century kind, point to the same period. The designs of the vertical bands resemble, in fact, a manuscript dated 1402 (New York, Morgan Library, ms. 515 – see *Late XIV Century*, Fig. 823). The mourners in the *Office of the Dead* and some other figures reflect the early style of the Limbourgs, and a date for the Madrid manuscript before the *Boucicaut Hours* must therefore be seriously entertained.

BIBLIOGRAPHY: Durrieu, *Rev. de l'art chrét.*, 1913, p. 311; Domínguez Bordona, *Manuscritos*, I, 1933, p. 418 no. 979; Meiss, *Art Bull.*, 1956, p. 194 f.

MINIATURES:

Folio 1 St. Matthew (Boucicaut workshop)
3 Virgin and Child in Hortus Conclusus (Egerton Master)
12 Visitation (Egerton Master)
22 Nativity (Egerton workshop)
31v Presentation in the Temple (Egerton Master)
35v Flight into Egypt (Egerton workshop)
272 Illustration of Office of the Dead (Egerton workshop)
312v Christ before Pilate (Egerton Master)

Milan

BIBL. AMBROSIANA, S. P. 56 (Libro d'ore 5)

(Figs. 175, 177, 179-182)

Book of Hours, Use of Paris. 275 fols.; 170 × 130 mm. 16 miniatures

HISTORY: There are no clues to original ownership.

STYLE AND DATE: A product of the workshop, though the *Man of Sorrows* on fol. 21v and the *Madonna* on fol. 22 are in a distinctive and better style, and their borders differ from those of the other miniatures. The illustration of the Mass for the Dead by the *Raising of Lazarus* is unusual. It appears again in an Italianate cycle of miniatures in a Book of Hours (Walters Art Gallery, ms. 219) produced in France and with a Paris calendar, but the subject is rather common for this Office only in the Netherlands. The position of the sarcophagus in the miniatures on fols. 21v and 205, parallel to the picture plane instead of diagonal as is usual among contemporary artists north of the Alps, probably implies an affinity with Italian principles of composition.

The manuscript would seem to belong to the second lustrum of the fifteenth century and to reflect an early phase of the Boucicaut Master's style.

BIBLIOGRAPHY: Durrieu, *Rev. de l'art chrét.*, 1913, p. 311.

MINIATURES:

Folio 21v Man of sorrows held by angel
22 Standing Virgin adored by angel with harp
28 Birth of the Virgin

56	Annunciation
89	Nativity
98	Annunciation to the Shepherds
104	Adoration of the Magi
111	Presentation in the Temple
118	Flight into Egypt
129	Coronation of the Virgin
139	Christ as Judge
167	Crucifixion
179v	Pentecost
191	Virgin and Child enthroned
199	Trinity
205	Raising of Lazarus (Office of the Dead)

New York

COLL. FRANCIS KETTANEH

(Figs. 379, 382, 383, 386-388, 390-392, 394, 396, 398, 400-404)

Boccaccio, *Des cas des nobles hommes et femmes*, translation by Laurent de Premierfait. 318 fols.; 425 × 298 mm. 2 large and 50 smaller miniatures. Traces of red, abbreviated sketches of the compositions on several folios, especially on III, 15; V, 7

HISTORY: There are no indications of original ownership.

STYLE AND DATE: Laurent de Premierfait, who translated Boccaccio's *De casibus virorum illustrium* in 1400, later wrote a free paraphrase, drawing biographical information from other writers. This second version was completed on April 15, 1409, and was dedicated to the Duke of Berry. Laurent's prologue for him appears in the first two copies of the text, given at the beginning of 1411 to the Dukes of Berry and Burgundy (Geneva, Bibl. publique et universitaire, fr. 190 and Paris, Bibl. de l'Arsenal, ms. 5193). This prologue is not always included in later copies of the text, including the Kettaneh manuscript, which is probably the earliest. In the miniature at the head of the Prologue the identity of the recipient of the book is not clear.

The miniatures in the Kettaneh manuscript are on the whole more impressive than those in the ducal copies; they are strong in design and soft, fresh, and constantly varied in color. Though the cycle is smaller it is clearly related to the earlier ones. The subjects and compositions are often similar, and some of them presuppose knowledge of the Geneva and/or Arsenal

paintings. The scene in the medallion in the border of the folio devoted primarily to the *Siege of Jerusalem*, for instance, depends upon the illustrations of *Contre les Juifs* in both the Geneva and Arsenal manuscripts (Figs. 384-386). The drapery of the cannibalistic Jewess, the two men at the right, the window are all drawn from Geneva (Fig. 384), while the child on the spit and the tessellated floor resemble the Arsenal copy. The Kettaneh Boccaccio must be later than the two copies for the dukes, which can be dated 1410-1411. Its style resembles the *Chroniques de France* of *ca.* 1415 (London, British Museum, Cotton Nero E II), and the borders of the frontispieces are similar. One large miniature (VII, 8) is in a style less close to that of the Boucicaut Master.

BIBLIOGRAPHY: Martin, *Boccace*, 1911, p. 6 ff.; New York, American Art Association – Anderson Galleries, *Lothian*, 1932, no. 11.

MINIATURES (manuscript is not foliated):

Prologue: The book presented to a king, presumably by the translator, Laurent de Premierfait, but long white beards were not then worn at the French court and therefore neither Charles VI nor any of the great dukes is represented. On the verso of this folio Laurent speaks of Boccaccio's dedication of the book 'a ung sien compere chevalier appelle monseigneur agart des chevalchans de flourence seneschal de sicille'. This is Mainardo Cavalcanti, chamberlain of the kingdom of Naples. Could the illuminator have represented him receiving the book from Boccaccio? A 'seneschal' is not a king, and Boccaccio's gown in two miniatures (I, 1 and III, 1) contains the lappets of the *houce* which are lacking here.

I, 1	Garden of Eden with Temptation and Expulsion from Paradise; Adam and Eve delve and spin; grown old they approach Boccaccio. Border: 6 scenes of Creation
I, 7	Medea sending dismembered children and jewels to Glauce (?)
I, 12	Althea and Meleager
I, 12	Hercules
I, 17	Samson

II, Prologue: Four men in humility before God

II, 8 Althaliah, Queen of Jerusalem, dragged from the Temple

II, 11 Suicide of Queen Dido

II, 18 Cyrus, grandson of Astyages, King of the Medes, is nurtured by a wild animal

II, 22 Cyrus the Great, founder of the Persian Empire, put to death by Thamyris, Queen of Scythia

III, 1 Debate between Fortune and Poverty; Misfortune condemned by Poverty to be tied to a column

III, 3 Death of the elder King Tarquin (described at end of III, 2)

III, 3 Lucretia dies by her own hand

III, 6 Xerxes, King of the Persians, crosses a bridge with his army

III, 9 Virginia killed by her father to save her from the attentions of Appius Claudius

III, 15 Carthalon hanged by order of his father

III, 19 The sons of Artaxerxes, King of the Persians, killed for conspiring against their father

IV, 1 Manlius Capitolinus driving the French from the Capitol?

IV, 7 Polycrates hanged. The lamb instead of a ring in the mouth of the large fish probably derives from a reading of *annel* as *anel* or *asnel*, both of which may mean a lamb.

IV, 10 Imprisonment of Darius, King of the Persians, and companions

IV, 14 The dying Agathocles, King of Sicily, orders his Egyptian wife and their two children to abandon him and flee to Egypt

IV, 16 The sons of Lysimachus, King of Macedonia, massacred before the eyes of their mother, Arsinoe, by order of her second husband

IV, 18 Pyrrhus, King of Epirus, dead beneath the walls of Argos

V, 1 Murder of Antiochus III

V, 3 Death by torture of the Roman Consul, Marcus Regulus

V, 7 Prisoners being led from a defeated city (Text is diffuse; a similar subject illustrates this chapter in Arsenal ms. 5193 – see Martin, *Boccace*, no. LXXX.)

V, 9 Massacre of Hieronymus, King of Syracuse

V, 11 Prusias II, King of Bithynia, reduced to begging

V, 14 Death of Philip, false claimant to the throne of Macedonia

V, 17 Demetrius Nicator, King of Syria, killed as he attempts to land at Tyre

V, 19 Cleopatra served with the head and limbs of her own child through the vengeance of her husband

V, 20 Jugurtha, King of Numidia, thrown from his Roman prison into the Tiber

VI, 1 Boccaccio and Fortune

VI, 2 Head of Telesinus exposed after death pact with Caius Marius; Marius killed by a slave

VI, 5 Mithridates triumphs at a tournament

VI, 9 Pompey beheaded

VI, 11 Julius Caesar, escaping from the island of Pharos, swims to a boat with a letter

VI, 15 Tomb of Mark Antony and Cleopatra

VII, 1 Herod presiding over the Massacre of the Innocents

VII, 3 Tiberius, Messalina and Caligula reproach one another while flames devour them

VII, 4 Nero drinks after the murder and mutilation of his mother

VII, 6 Assassination of the Roman Emperor Vitellius

VII, 8 The army of Titus destroys the city of Jerusalem and captures the Jews (large; distinctive style)

VII, 9 Jewish woman devours her child during siege of Jerusalem

VIII, 1 Boccaccio's vision of the laurel-crowned Petrarch

VIII, 4 Humiliation of Sapor, King of Persia, by the Roman Emperor Valerian

VIII, 9 Putrefaction of the flesh of the dying Emperor Galerius

VIII, 14 Romans feast in an encampment before Florence, while the Goths under Radagasus starve

IX, 1 Death of Brunhilda, Queen of France

IX, 4 Mutilation of Justinian II, Emperor of the East, and Philippicus, Emperor of Constantinople

IX, 21 The Knights Templar condemned to the flames in the presence of Philippe le Bel

New York

PRIVATE COLL. (Figs. 133, 300-315)

Book of Hours, Use of Paris. 238 fols.; 180 × 130 mm. 51 large miniatures and 24 calendar illustrations

HISTORY: The presence of English and even Irish saints (Patrick and Columbanus) in the calendar of this manuscript points to a special commission, although veneration of the same saints in various parts of northern France and even into the Rhineland means that its destination cannot automatically be assumed to have been England. The book was, however, in England in the nineteenth century, when it was noted by Waagen. The suggestion, which was made in 1895 and has since been repeated, that the donor who appears on one of the folios is Margaret of Anjou, wife of Henry VI of England, is hardly tenable in view of the fact that Margaret was not born until 1430. Scrolls in the borders of fols. 17 and 19 bear inscriptions, or cryptic letters, that I have been unable to read.

STYLE AND DATE: The miniatures in the Boucicaut style, with their deep landscapes, distant shimmering cities, and complex interiors, are late. The borders too belong to the period around 1415. Compositions, however, from as early a period as the *Boucicaut Hours* are still used. A second major style in the manuscript does not appear in other products of the Boucicaut shop, and the manuscript may have been completed outside of Paris. An illuminator responsible for many miniatures, especially the cycles illustrating the Hours of the Cross and the Hours of the Holy Ghost, shows strong Netherlandish affinities. Occasionally, as in the *Adoration of the Magi*, he adopted Boucicaut compositions. His *Flight into Egypt* takes the well-known figure of St. Joseph from Broederlam's panel, sent from Ypres to Dijon in 1398.

BIBLIOGRAPHY: Waagen, *Treasures*, 1854, III, p. 113; New York, Hoe Library (Bierstadt), 1895, p. 34 f.; de Ricci, *Census*, II, 1937, p. 1655 no. 4; New York, American Art Association, *Bishop*, 1938, p. 468 ff.; Meiss and Eisler, 1960, p. 235, fig. 6.

MINIATURES:

Folios 1-12v Calendar

13 St. John the Evangelist on Patmos (Boucicaut workshop)

15 St. Luke (Boucicaut workshop)

17 St. Matthew (Boucicaut Master and workshop)

19 St. Mark (Boucicaut Master and workshop)

20v Christ before Pilate (Boucicaut follower)

23 Madonna and Child with angel and basket of cherries (Boucicaut follower)

27v Madonna and Child with two musician angels (Boucicaut follower)

33 Annunciation (Boucicaut follower)

60 Visitation (Boucicaut follower)

72v Nativity (Boucicaut follower)

79 Annunciation to the Shepherds (weak painter)

84 Adoration of the Magi (Netherlandish [?] master completing a Boucicaut painting)

89 Presentation in the Temple (weak painter)

94 Flight into Egypt (Netherlandish [?] master)

102 Coronation of the Virgin (Netherlandish [?] master)

109 King David (Boucicaut follower)

132v Agony in the Garden (Netherlandish [?] master)

134v Mocking of Christ (Netherlandish [?] master)

136v Flagellation (Netherlandish [?] master)

138v Christ bearing the Cross (Netherlandish [?] master)

140v Crucifixion (Netherlandish [?] master)

142v Descent from the Cross (Netherlandish [?] master)

144v Entombment (Netherlandish [?] master)

146v Pentecost (Netherlandish [?] master)

148v Angels ringing the bells above, nine men below (Netherlandish [?] master)

150 Baptism of Christ (Netherlandish [?] master)

151v Apostle baptizing four men (Netherlandish [?] master)

153 St. Peter preaching (Netherlandish [?] master)

154v Holy Ghost descending on two apostles (Netherlandish [?] master)

156 Holy Ghost descending among the faithful (Netherlandish [?] master)

158 Illustration of Office of the Dead (Boucicaut follower)

209 Trinity (Boucicaut follower)

210v Assumption of the Virgin (Boucicaut follower)

211v Archangel Michael and devil (Boucicaut follower)

212v St. John the Evangelist (Netherlandish [?] master)

213v Sts. Simon and Jude

215 St. Andrew (Boucicaut workshop)

216 St. Thomas (Boucicaut workshop)

217 St. Stephen (Boucicaut workshop)

218 St. Denis (Boucicaut workshop)

219v St. Lawrence (Boucicaut workshop)

220v St. John the Baptist (Boucicaut workshop)

221v St. Martin and the beggar (Boucicaut workshop)

222v St. Nicholas (Boucicaut follower)

223v St. Anthony Abbot (Boucicaut follower)

224v Virgin and St. Anne (Boucicaut follower)

226 St. Mary Magdalene (Boucicaut follower)

227 St. Catherine of Alexandria (Boucicaut follower)

228 St. Margaret (Boucicaut follower)

230 Virgin and Child, with lady in prayer (Boucicaut follower)

235v Last Judgment (Netherlandish [?] master)

Orange (Texas)

STARK COLL. (Figs. 163, 222-226)

Book of Hours, Use of Paris. 192 fols.; 175 × 125 mm. 18 miniatures plus 2 miniatures of the late fifteenth century

HISTORY: There are no marks of original ownership. The manuscript came to light a few years ago when it entered the possession of Lathrop C. Harper, Inc.

STYLE AND DATE: The Harper *Catalogue* recognized that some miniatures were related to the Boucicaut Master and others to the Bedford Master (fols. 66, 72v, 77v, 86v). Miniatures on fols. 191 and 191v were rightly judged to be additions of the late fif-

teenth century. I believe that the Egerton workshop and followers of the Boucicaut and Bedford Masters joined to illuminate the manuscript. The border style develops that of the Book of Hours, Oxford, Bodleian Library, Douce 144, dated 1407. A date *ca.* 1410–1415 seems probable.

BIBLIOGRAPHY: New York, Harper, *Catalogue No. 10*, 1960, p. 1 no. 1.

MINIATURES:

(The unclassified miniatures are in the style that I designate as 'trend to Bedford'.)

Folio 13 St. John the Evangelist (face damaged)

15 St. Luke (face damaged)

17 St. Matthew

19 St. Mark

29 Annunciation

54 Visitation (follower of Boucicaut Master)

66 Nativity (retouched)

72v Annunciation to the Shepherds (retouched)

77v Adoration of the Magi (faces retouched)

82 Presentation in the Temple

86v Flight into Egypt

94 Coronation of the Virgin (Egerton workshop)

100 God the Father enthroned

115 Crucifixion

123 Pentecost (follower of Boucicaut Master)

130 Cemetery and salvation of a soul (follower of Boucicaut Master – damaged)

179 Enthroned Virgin and Child (follower of Boucicaut Master)

184v Last Judgment

191 Standing emperor (late fifteenth century)

191v Imago Pietatis with lady kneeling (late fifteenth century)

Oxford

BODLEIAN LIBRARY, Canon. Liturg. 75
(Figs. 227-229)

Book of Hours, Use of Paris. 193 fols.; 183 × 131 mm. 14 miniatures.

HISTORY: 'De peu assez recourt. 1500' appears on the inside of the cover.

STYLE AND DATE: Pächt and Alexander have pointed in the right direction by attributing the miniatures in this manuscript to the Boucicaut and Egerton Masters. However, the miniatures in the Boucicaut style are not outstanding, and they do not seem to me to have been touched by the Master himself.

The manuscript contains a third, very interesting style. The painter of the *Presentation in the Temple* was certainly close to the Master of the Coronation, and he perhaps painted also, or at least supervised, the *Visitation* and the *Nativity*. A related but less subtle style appeared in several illustrations of the Hours of the Virgin in Douce 144, dated 1407 (Figs. 53, 55). The borders of Douce 144, furthermore, resemble those around the *Annunciation* of Canon. Liturg. 75, but the large *rinceaux* on gold of this *Annunciation* are still closer to those surrounding some miniatures in the *Horae* in Berlin and Seville (Figs. 123, 227). They all probably derive from the borders of the Brussels Initials Master (Fig. 467). The large *rinceaux* in the lower corners of folio 116 are handsome and unusual.

This manuscript should be dated around 1410.

BIBLIOGRAPHY: Pächt and Alexander, *Bodleian Library*, 1966, p. 50 no. 642.

MINIATURES (many folios damaged by water):

Folio 25 Annunciation (Boucicaut workshop)
 50 Visitation (follower of the Master of the Coronation)
 62 Nativity (follower of the Master of the Coronation)
 68v Annunciation to the Shepherds (Egerton workshop)
 73v Adoration of the Magi (Boucicaut workshop)
 78 Presentation in the Temple (follower of the Master of the Coronation)
 82v Flight into Egypt (Egerton workshop)
 89v Coronation of the Virgin (Boucicaut workshop)
 97 David before the Lord (Egerton Master)
 116 Crucifixion (Boucicaut workshop)
 124v Pentecost (Boucicaut workshop)
 131 Madonna enthroned in walled *hortus conclusus* (Egerton workshop)
 137 Last Judgment (Egerton workshop)
 140v Funeral Service (Egerton workshop)

Oxford

BODLEIAN LIBRARY, Douce 80

(Figs. 326-332)

Book of Hours, Use of Paris. 233 fols.; 198 × 143 mm. 10 miniatures

HISTORY: The original owner, an unidentified woman, is represented on folio 196.

STYLE AND DATE: The miniatures, in the Boucicaut style, were painted towards 1420 by associates who ranged in ability from the weak author of the *Last Judgment* to the impressive masters of the *Annunciation to the Shepherds* and the *Way to Calvary*. The *Way to Calvary* resembles closely the best miniatures in the equally late Hours in a private collection in New York. The church in the *Annunciation* is unusual and interesting. It consists of two elements, the more distant of which frames the angel. They weave around the figures a rich interplay in space.

The calendar and many of the borders were completed in the second half of the fifteenth century, as Pächt and Alexander observed. I cannot follow these historians, however, in giving the miniatures to the Boucicaut Master himself (though they are no doubt based on his designs) or to the Bedford Master.

BIBLIOGRAPHY: Pächt and Alexander, *Bodleian Library*, 1966, p. 50 no. 643.

MINIATURES:

Folio 18 Way to Calvary (Boucicaut workshop)
 36 Annunciation (Boucicaut workshop)
 72 Adoration of the Child (Boucicaut workshop)
 78v Annunciation to the Shepherds (Boucicaut workshop)
 101 David before the Lord (Boucicaut follower)
 127 Pentecost (Boucicaut workshop)
 134 Funeral Service (Boucicaut workshop)
 185v Virgin and Child (Boucicaut workshop)
 192 Last Judgment (Boucicaut workshop)
 196 Madonna and female donor (Boucicaut follower)

Oxford

BODLEIAN LIBRARY, Douce 144 (Figs. 49-60)

Book of Hours, Use of Paris. 144 fols.; 215 × 160 mm.

27 miniatures, border illustration, and drawings in margin of 4 fols.

HISTORY: There is no evidence of original ownership, but an inscription on fol. 27 tells us that the work (the entire manuscript?) was completed in 1407: 'factum et completum est anno. m°. cccc°. vij°. quo ceciderunt pontes paℝ. [Parisius]'. This inscription was written by the same scribe as the text, in slightly paler ink and in smaller letters so as to fit the words into two lines. These lines follow the end of the prayer O Intemerata, and they come at the end of a gathering. This gathering originally appeared much further on in the book. The present sequence of folios is not what it was, and at certain points there are gaps.

STYLE AND DATE: Scholars have paid less attention to the original illumination of 1407 than to the drawings added perhaps a decade later on fols. 105, 108v, 109, and 110 by a follower of the Limbourgs whom I have called the Master of St. Jerome. Pächt ascribes these drawings to one of the three famous Limbourgs themselves, and he and Alexander give the main miniatures to the Boucicaut and Bedford Masters. To me some of the miniatures seem by a painter close to the Boucicaut Master. The better miniatures related to his work, as for example on fols. 2v, 19, 129, resemble a version of Boucicaut style that appears in the *Grandes Heures* of 1409 and in Paris, Bibl. nat., nouv. acq. lat. 3107, illuminated shortly afterward. The other illuminators who worked on the book are not yet clearly defined. One, who painted much of the Hours of the Virgin, had studied the illumination of the Master of Berry's Cleres Femmes and, still more intently, the Master of the Coronation.

This is the earliest manuscript in metropolitan French illumination that shows an abundant use of the acanthus leaf; in many of the borders it forms a rounded field for lively putti or supplementary religious episodes. This important innovation, widely adopted in the second decade of the century, had precedents in Italy and Bohemia. Its adoption in France was probably inspired by the Master of the Brussels Initials, an Italian artist active in Paris (Fig. 467). On this illuminator and the appearance of the acanthus in North France see *Late XIV Century*, p. 246.

BIBLIOGRAPHY: Champeaux and Gauchery, *Travaux*, 1894, p. 148; Oxford, Bodl. Lib., Madan, IV, 1897, pp. 536-537 no. 21718; Fry, 1905, p. 435; Durrieu, *Arts anciens de Flandre*, II [1906?], p. 18; Durrieu, *Rev. de l'art a. et m.*, XX, 1906, p. 24; Durrieu, *Rev. de l'art chrét.*, 1913, p. 311; Delaissé, 1948, p. 80; Panofsky, *Netherlandish Painting*, 1953, I, p. 56 n. 2; Porcher, *Belles Heures*, 1953, pp. 7 n. 10, 26 f., 41 f.; Pächt, *Pantheon*, 1963, p. 137 f.; Meiss, *Gaz. B.-A.*, 1963, p. 149 ff.; Pächt and Alexander, *Bodleian Manuscripts*, 1966, p. 50 no. 637.

MINIATURES:

Folio 1 St. John on Patmos
2v St. Luke (Boucicaut workshop)
5v St. Mark (Bedford trend?)
19 Virgin at the loom (Boucicaut workshop)
23 Virgin and Child enthroned with angel offering Christ Child cherries (associate of Boucicaut Master)
28 Annunciation
52 Visitation (figures partly repainted at later date)
63 Nativity
68v Annunciation to the Shepherds
72v Adoration of the Magi
76v Presentation in the Temple
80v Flight into Egypt; border: Massacre of the Innocents
105 Drawing in border: Procession of Pope Gregory during the plague in Rome (Master of St. Jerome)
108v Drawing in border: Procession (Master of St. Jerome)
109 Drawing in border: Procession (Master of St. Jerome)
110 Drawing in border: Flagellants (Master of St. Jerome)
111v Crucifixion; bas-de-page: Discovery of the True Cross (French illuminator)
123v Virgin and Child (French illuminator)
128v Last Judgment (French illuminator)
129 St. Michael (Boucicaut workshop)
130 St. Peter (Boucicaut circle)
131 St. Paul (Boucicaut circle)
132 St. Andrew (Netherlandish illuminator?)
133 St. John the Evangelist (Boucicaut workshop)
134 Martyrdom of St. Stephen (associate of Boucicaut Master)
135 Martyrdom of St. Denis and his companions (Boucicaut circle)

136 St. Nicholas (Boucicaut circle)
137 St. Martin (Boucicaut circle)
138 St. Anthony Abbot (Boucicaut work-shop)
139 St. Mary Magdalene (Boucicaut circle)
140 Martyrdom of St. Catherine of Alexandria (Boucicaut circle)

Paris

ARCH. NAT., ms. M M 397 (Musée 1580) (Fig. 79)

Recueil de pièces concernant le Collège de Fortet. 45 fols.; 730 × 700 mm. 1 miniature (fol. 3)

HISTORY: The documents in this miscellany relate to the foundation in the late fourteenth century of the Collège de Fortet; one of them is an inventory of the library of the Collège as it existed in December 1412. Shortly after this date the early part of the manuscript was no doubt written and the frontispiece painted.

STYLE AND DATE: The style of the single miniature, by a rather good follower of the Boucicaut Master, accords with a date of 1412 or 1413. In a symmetrical landscape the eight original scholars are presented to the Trinity by the founder of the college, Pierre Fortet, canon of Notre-Dame of Paris. A canon of the chapter of Paris, on which the college was dependent, kneels on either side of the Trinity, and François has suggested that they represent the uncles of the founder, to whom he owed his fortune. Jean Chanteprime, canon of Paris, was sole administrator of the new college at the period when the inventory was drawn up, and he presumably commissioned the early part of the manuscript and the illumination.

BIBLIOGRAPHY: Paris, Arch. nat. (François), 1938, p. 15 ff.

Paris

BIBL. DE L'ARSENAL, ms. 5077 (Figs. 405-418)

Livre du tresor des hystoires des plus notables et memorables hystoires qui ont esté depuis le commencement de la creacion du monde jusques au temps du pape Jehan XXII. 391 fols. (plus A, 163 *bis*, 347 *bis*; minus 15, 275); 386 × 280 mm. 223 miniatures (plus 2 miniatures formerly on fols. 359

and 365v of this manuscript, and now in Paris, Louvre, Cabinet des dessins, R.F. 1928). Several folios are missing at the beginning of the text.

HISTORY: Inscriptions both at the beginning and end of the book state that it belonged to Prigent de Coëtivy: *Ce livre est a Prigent, seigneur de Rais, de Coictivy et de Taillebourg, conseillier et chambellan du corps du roy et admiral de France.* The admiral was not only a man of valour, comparable to the maréchal de Boucicaut himself, he was also a bibliophile of some discrimination. A list of some twenty books that once belonged to him was compiled by Marchegay from fragments of accounts and inventories placed at his disposal by the Duke de la Trémoille, and among these '*Le Trésor des histoires, en un grant volume couvert de velours vermoil*' doubtless refers to this book. The admiral was not born until 1400, and it has usually been assumed that he was not the original owner of the book, but the text, an anthology of the most celebrated historical works in vogue at the time, would not be at all unsuitable for a boy of about twelve. Although the illustration, furthermore, is extensive, Prigent de Coëtivy acquired a taste for such works and also for illumination in the Boucicaut style. He possessed the Boccaccio now in the Gulbenkian Foundation. In the 1440's, furthermore, he was employing a Parisian illuminator named Jean Haincelin, who may be identical with an illuminator who had earlier worked with the Boucicaut Master, the Bedford Master (see Chapter V).

Doutrepont's assertion that the *Trésor de histoires* was executed for a Duke of Burgundy about 1405 is inaccurate with regard to date and provenance. The fact that a book answering to a similar description existed in the collection of the Duke of Burgundy in the late fifteenth century – [Barrois], *Bibl. protypographique*, 1830, p. 208 no. 1435 – is invalidated as a clue to original ownership by the definite knowledge that at an earlier date the manuscript now under discussion had belonged to Prigent de Coëtivy.

STYLE AND DATE: Two hundred and twenty-five miniatures represent a considerable undertaking, and the number of excellent paintings is exceptionally large for an illuminator who did not hold a court appointment. The clear, subtle, transparent color of many miniatures implies close control by the Boucicaut Master himself (see for example fols. 20v, 22, 49, 76v, 168v, 172v, 183, 252v, 278v, 295v, 298). He probably designed numerous other miniatures that

were then painted by adept assistants thoroughly trained in his style (for example fols. 18, 29, 78, 234, 258, 289). All the miniatures from 252v are in his style.

Though Martin in 1904 concluded that the illumination in the manuscript could be divided into two styles, three may actually be identified in addition to the variants within the Boucicaut group. They are surprisingly crude. Two of these illuminators were influenced by the Boucicaut Master, but the relatively flat figures, bold linear designs, and fluctuating chiaroscuro resemble rather the style of the Master of the Berry Apocalypse. Another hand, the dullest of all, executed only folio 305v. The miniature once on folio 365v and now in the Cabinet des dessins in our opinion is not, as has recently been claimed (Paris, Louvre [Sterling and Adhémar], 1965, p. 3), by the Bedford Master but by an assistant of the Boucicaut Master.

The deep spaces in many Boucicaut miniatures, the aerial perspective, and the luminous, rounded forms indicate a relatively late date for the manuscript, in other words towards 1415.

The gatherings illuminated by the Boucicaut atelier contain many marginal sketches for the corresponding miniatures that the painter did not trouble to erase. Martin published drawings made from them; they are too faint for photography and often scarcely legible. As in many Boucicaut manuscripts the miniatures do not follow the drawings closely. Furthermore, the subjects of both drawings and miniatures frequently do not coincide with the rubrics but derive rather from a certain passage in the text. In one instance (fol. 266) the subject of the miniature is not mentioned by either the rubric or the text.

BIBLIOGRAPHY: Paris, Arsenal, Martin, v, 1889, p. 40 f. no. 5077; Champeaux and Gauchery, *Travaux*, 1894, p. 203 f.; Delisle, 1900, p. 191 f.; Martin, *Rev. archéol.*, 1904, pp. 28, 31 f., 43 ff.; Martin, *Comptes rendus*, 1904, pp. 124, 131 f.; Durrieu, *Arts anciens de Flandre*, II [1906?], p. 17; Durrieu, *Rev. de l'art a. et m.*, xx, 1906, p. 22; Martin, *Miniaturistes*, 1906, p. 105 f.; Doutrepont, 1909, p. 407; Durrieu, *Rev. de l'art chrét.*, 1913, p. 313; Martin, *Miniature française*, 1923, pp. 80, 104; Martens, *Meister Francke*, 1929, p. 216 n. 46; Martin and Lauer, 1929, p. 35; Paris, Bibl. nat. (Porcher), 1955, p. 86 no. 178; Paris, Louvre, *Enluminures*, 1957, pp. 10 f. nos. 15-16; Paris, Louvre [Sterling and Adhémar], 1965, p. 3 no. 5.

MINIATURES (all are by the Boucicaut Workshop except those otherwise designated):

Folio 1 The author presenting his book to a king (presumably Charles VI)

17 Building of the Ark

18 Nimrod and the building of the Tower of Babylon

18v Semiramis receives a messenger while combing her hair

20v Abraham and the three angels

21 The sacrifice of Isaac

22 Jacob receives Isaac's blessing

23 Jacob takes leave of Laban

25v Benjamin brought to Joseph by his brothers

26 Jacob arrives in Egypt and greets Joseph

29 Crossing of the Red Sea

30 Hebrews attempt to kill Moses and Aaron

31v Joshua sends his spies to Canaan

34v Discovery of the child Oedipus by hunters

35v Oedipus confronted by the Sphinx

37 King Adrastus stops a duel between Tydeus and Polynices

39 Eteocles and Polynices in battle

40v Murder of a High Priest

42 War between King Vezones (sic) of Egypt and the Sithonians

43 Coronation of Sinopia

45v Jason and Hercules arriving on the island of Colchis

46v King Priam with a messenger

48 The Greeks arrive at Troy

48v Fourth battle of Troy

49 Hector's tomb

50 Struggle of Achilles, Paris, and their companions

50v Death of Queen Penthesilea

51 Evacuation and burning of Troy

52v Aeneas sails away from Troy

53v Aeneas received by Queen Dido

55 Death of Queen Dido

57 The Latin king receives messengers from Aeneas (French illuminator)

58 Pallas killed by Turnus in battle (French illuminator)

58v Aeneas, watched by the Latin king and his daughter, kills Turnus (French illuminator)

59 Samson with the lion (French illuminator)

61 Brutus defeats King Prandasus (French illuminator)

62 Brutus defeats Gaufrarius of Aquitaine (French illuminator)

62v Philistines capture the Ark from the Hebrews (French illuminator)

64v David and Goliath (French illuminator)

65 King Saul battling the Philistines (French illuminator)

67 Coronation of Isboseth (French illuminator)

67v Head of King Isboseth brought to King David (French illuminator)

69 The prophet Nathan comforts King David (French illuminator)

70 Death of Absalom (French illuminator)

73 Solomon's brother Adonijah killed by his order

73v Solomon inspects the building of the Temple of Jerusalem

76v Fire from heaven descends as Elijah sacrifices to God

77v Forces of the Kings of Judea and Syria meet

78 Fire descends from heaven as Elijah predicts the death of King Ahaziah

80v Capture of the city of Babylon by Arbaces (French illuminator)

82 Birth of Romulus and Remus (French illuminator)

82v Romulus building the city of Rome (French illuminator)

85 King Hezekiah orders the destruction of idols (French illuminator)

86v Tullius Hostilius, first king of Rome, killed by thunder (French illuminator)

87v Beheading of King Jehoahaz of Judea (French illuminator)

89v Tobias, his father and the angel (French illuminator)

91 Nebuchadnezzar's vision of the statue (French illuminator)

91v Nebuchadnezzar's vision of the tree (French illuminator)

92v Daniel in the lion's den (French illuminator)

95v Cyrus hesitates at the Ganges; Belshazzar's vision (French illuminator)

96 Cyrus watches the crucifixion of King Croesus of Lydia (French illuminator)

98 Queen Tomyris orders the beheading of Cyrus (French illuminator)

99v Holofernes receives the key to a city (French illuminator)

100v Judith goes to the tent of Holofernes (French illuminator)

101v Beheading of Holofernes (French illuminator)

102 Head of Holofernes borne back to Jerusalem by Judith (French illuminator)

103 Smerdis the Mage, King of Persia (French illuminator)

105 Xerxes, crowned as King of Persia, receiving gold cups from his brother (French illuminator)

108 Nehemiah rebuilding the city of Jerusalem (French illuminator)

108v Virginius kills his daughter Virginia (French illuminator)

109 Imprisonment of Socrates (French illuminator)

110v Death of Haman (French illuminator)

111v 'Tholomeus,' King of Veii, killed in battle with the Romans (French illuminator)

113v Queen Thoene makes peace between her sons, 'Brenius' and Belinus (French illuminator)

114 Rome sacked by the Gauls (French illuminator)

116v Marcus Curtius rides into the earth and is swallowed up (French illuminator)

117v Crowning of Philip of Macedonia (French illuminator)

119v Birth of Alexander the Great (French illuminator)

121 Roman envoys bring presents to Alexander (French illuminator)

122 Alexander, met by the Bishop of Jerusalem, adores the name of God on the Table of the Law (French illuminator)

124 Alexander vanquishes Darius for the second time in battle (French illuminator)

124v Final defeat of Darius by Alexander (French illuminator)

127 Messenger gives Alexander letter from

King Porus of India (French illumi-
nator)

128v Alexander communes with the sun, the
moon, and the trees (French illumi-
nator)

130v Alexander in Babylon receives the
homage of the kingdoms of the world
(French illuminator)

131v Alexander given a poisoned cup (French
illuminator)

134 Marcus Curtius refuses gifts from the
Samnites

137 The Roman Consul Fabritius rejects the
overtures of Pyrrhus

138 Consul Fabritius talking with envoy of
King Pyrrhus

139 The Pharos of Alexandria admired by a
king

140v Brennus the Gaul kills himself after
defeat in Greece and Macedonia

141v The elder Hannibal stoned by Cartha-
ginians

143 Consul Regulus killed by the Cartha-
ginians

144 Discord between Antiochus of Syria and
Ptolemy of Egypt

146 Crowning of the first king of the
Parthians

147v Hannibal's siege of Saguntum

150 Hannibal fights before the gates of Rome
(French illuminator)

152 Scipio Africanus on a triumphal journey
(French illuminator)

153 Antiochus the Great slain by priests in a
temple in Persia (French illuminator)

155v Romans attack Carthage (French illumi-
nator)

157 Judas Maccabeus puts renegade Hebrews
to death (French illuminator)

159 King Antiochus defeats Judas Maccabeus;
Eleazar attacks the elephant (French
illuminator)

160 Death of Judas Maccabeus (French
illuminator)

161v Settlement of rivalry between the
temples of Jerusalem and of Garisim
(French illuminator)

163v Jonathan battling the forces of Deme-
trius (French illuminator)

164 Simon, King of Jerusalem, killed by the

agents of Ptolemy Abodi (French
illuminator)

166 Romans in Spain wounded by Viriathus
and his followers

167v Micipsa watches murders

168v Division of the realm

170 Adherbal falls from castle of Cirta

172v Roman officers massacred at table by
Jugurtha's followers

174 King Bocchus receives a Roman envoy

175v Defeat of Bocchus and Jugurtha

177v The King of Jerusalem, Aristobulus,
watches his mother led into prison

179v Ptolemy's son about to be killed

181 Capitulation of Bithynia to King Mithri-
dates

183 Pompey borne in triumph

185 Convocation of senators and tribunes by
Catiline

187 Catiline replies to the Senate before
leaving Rome

188 Discovery of the Catiline conspiracy in
the Senate

190v Cato speaks against the Catiline con-
spiracy

192 Sallust speaks of the virtues of Cato
and Caesar and of the Catiline con-
spiracy

193v Catiline and his fellow conspirators in
battle

194v Mithridates gives poison to his wife and
daughters

196v Pompey, Crassus, and Julius Caesar are
elected by the Romans

197 Caesar goes to conquer Gaul

200 Caesar in battle against the Helvetii

203 Caesar receives messengers from cities
of Gaul asking for aid

204v Caesar and Ariovistus confer

206 Caesar conquers the Saxons

207 Delivery of further messages from Gaul
asking for help

209v Beauvais presents Caesar with the keys
of the city

211 Caesar and his army in Gaul move
against Nevers

214v Caesar's lieutenant Quintus Tiburius
triumphant in Normandy (French
illuminator)

215v Caesar in Flanders (French illuminator)

217v Bridge built for Caesar's army to cross the Rhine (French illuminator)

220 Caesar and his army in England (French illuminator)

223 Pompey receives a message requesting reinforcements

225v Capture of the leader and the people of Beauvais

226 Entry of Caesar's army into Sens

228 Surrender of the key to the city of Sens

228v Caesar receiving homage at gate to a city

229 Caesar at the Rubicon; in the river a satyr blowing a horn

233 Pompey assembles the princes and senators of Rome

234 Caesar's fleet sets out to follow Pompey to Greece

235v Pompey is besieged in the castle of Dyrrhachium

236v The son of Pompey asks a sorceress about the outcome of the battle

237 The battle of Thessaly between Caesar and Pompey

239 Pompey sails to Egypt

241 Caesar embarks; Pompey's head is shown to him by order of the King of Egypt

243 Caesar in battle against Cato and those who escaped from Thessaly

246 Caesar receives the homage of a city (French illuminator)

247 Assassination of Caesar (French illuminator)

251v Herod crowned King of Jerusalem by order of Augustus (French illuminator)

252v King Herod kneels to Augustus and renders him his kingdom

254 Gifts from East and West are brought to Augustus

255v King Herod orders the death of his son Antipater

258 Coronation of Tiberius

259v St. Peter placed by Christ in the Papal Chair

261v Conversion of St. Denis by St. Paul

263 Nero watching the murder and desecration of the body of his mother

264 The army of Vespasian attacks the city of Jerusalem

265v St. Cletus (Pope) is stoned by order of Domitian

266 Martyrdom of St. Lawrence (neither rubric nor chapter mentions this saint)

267 Pope Anacletus disembowelled

268v Monks of St. Denis receive the reliquary of St. Peregrinus

269 Crowning of Telesphorus as ninth Pope

271 Commodus chokes to death

272v Pope Calixtus I dictating

274 Martyrdom of Pope Fabian

278v Diocletian destroying a Christian church

279v Diocletian and Maximian renounce the Empire

280v Pope Silvester baptizes Constantine

285 Pope Julius (Julles) visited by the Emperor Constance

286 Pope Liberius exiled for maintaining the Arian heresy

286v Death of Julian the Apostate (iconography as for conversion of St. Paul)

289 Community of holy hermits

292 Pope Siricius visited by the Emperor

293v Pope Anastasius or Innocent writing in a book

295v Death of St. Augustine

296 Childeric crowned as King of France and Emperor

298 Arthur of Brittany in single combat with a Roman Consul

299v King Clovis baptized by St. Remy

301 Theodoric the Goth thrown in a well by devils

302v Theophilus with a devil and then with a statue of the Virgin

305v Coronation of Pope Gregory (weak illuminator)

307v In a vision Pope Gregory strikes Pope Sabinianus on the head

309 Battle of Kings Chlotaire and Dagobert

310 Emperor Heraclius with globe (iconography as for *Propriétés des choses* – nature of the earth)

312 Exile of Pope Martin I

314v The King of Brittany arrives at Rome to greet Pope Sergius

316v Charles Martel in battle against Saracens

318v Theodoric (for Childeric) is deposed and given monk's clothing

319v King Pepin greets Pope Stephen II in France

322v Charlemagne in battle with the Lombards

324v Coronation of Charlemagne as Emperor

327 Rome captured by the Saracens

328 Saracens drowned at sea

329v John the Scot pursued by his pupils

332 The body of Pope Formosus beheaded and thrown into the Tiber on order of Pope Sergius

334 Barons rebel against King Louis Outremer

335v King Charles the Simple thrown into dungeon by Hugh Capet

336v Pope Silvester II treats with the devil

337 *bis* v Dancers condemned to a year's dance for disturbing mass

341 Child born with two heads and four arms

342v English astronomers attempting to fly after reading the story of Dedalus

344v Pope Urban II gives a sword to a knight and a cross to a bishop

347 Pope Calixtus II leading anti-Pope Gregory VIII as prisoner

347 *bis* Death of Hugh, Canon of St. Victor's of Paris

348v Louis VII receives the Cross from Pope Eugenius III

350 The Kings of England and France agree to support Pope Alexander against Emperor Frederick and his rival popes

351v Saladin executes a young Christian knight

354 Funeral procession of Richard of England arrives at Fontevrault

359 A king giving audience (now in Cabinet des dessins)

360v Burning of heretics

364v The Count of Toulouse begs the King of England to make war on the King of France

365v Embarkation of St. Louis for the Crusade (now in Cabinet des dessins)

368 Burning of heretical books by order of Pope Alexander IV

370 Battle (probably Charles of Anjou against Manfred)

372 The King of Aragon acts as peacemaker between the King of France and the Count of Foix

374 Discovery of the body of St. Mary Magdalene, witnessed by Count of Provence

375 The King of Aragon leads his army

377 Pope Celestin V renounces the Papal crown

380 Burning of the Templars

385v Pope John XXII creates the order of Christ

Paris

BIBL. MAZARINE, ms. 469
<div align="right">(Figs. 118, 149, 164, 258-269)</div>

Book of Hours, Use of Paris. 209 fols. +7; 250 × 175 mm. 16 miniatures and border medallions in the style of the Boucicaut Master; 2 English miniatures of the later fifteenth century; Veronica on leather attached to first folio.

HISTORY: This Book of Hours is more beautifully illuminated than manuscripts normally produced for stock. There are, however, no marks of original ownership; all the large initials at the opening of each main section of the book have been left blank, probably because they were reserved for coats of arms. The original manuscript has undergone both modifications and additions. The calendar is lost. A Veronica head on leather added at the beginning of the book (fol. 3v) looks English and was probably added at the same time as fols. 123-140. The miniatures on fols. 126v and 141 are certainly English. A Latin prayer on fol. 140v has an English gloss.

STYLE AND DATE: Both the design and the execution of this manuscript engaged the Boucicaut Master himself to an unusual degree. It is full of fresh ideas and beautiful painting, of masterly organization of the entire folio as well as exquisite small details, such as the iris and wild delphinium on fol. 13. The levelling effect of assistants is conspicuous among the miniatures only in the four last (fols. 83, 110, 117, 150).

An illuminator trained in a very different style painted the four medallions and two heads in the border of fol. 83. He was a close follower of the Master of the Breviary of Jean sans Peur. Perhaps the same assistant collaborated with the Boucicaut workshop in the

Bible historiale, British Museum, Royal 15 D III, and it was probably the master himself who worked with Boucicaut assistants on a tiny, mutilated Book of Hours in Palermo, Bibl. Naz., I.A. 15. The style of the Breviary Master may be reflected elsewhere in the Mazarine Hours. The folio of the *Annunciation*, the most splendid in the manuscript, glistens with highly burnished and exquisitely tooled gold. Not only the haloes or the wings of angels show this technique; architecture, clouds, or arabesques are tooled in the gold backgrounds.

Each miniature in the Hours of the Virgin is surrounded by relevant scenes in the borders – a late stage in the development of the folio that could earlier be observed in Douce 144. Two folios of Bibl. nat., lat. 10538 are integrated architecturally, whereas in the Mazarine Hours the unity is accomplished by rhythmical sequence and the continuity of trees and vines. The manuscript was probably illuminated around 1415. Several compositions – the *Adoration of the Magi*, the *Crucifixion*, and the *Funeral Service* – represent a later version of corresponding scenes in the *Boucicaut Hours*.

BIBLIOGRAPHY: Paris, Mazarine, Molinier, I, 1885, p. 180 f. no. 469; Durrieu, *Arts anciens de Flandre*, II [1906?], p. 17; Durrieu, *Rev. de l'art a. et m.*, XX, 1906, p. 23 f.; Durrieu, *Rev. de l'art chrét.*, 1913, p. 313; Martin, *Miniature française*, 1923, pp. 83, 104; Paris, Bibl. nat. (Couderc), 1927, p. 85; Paris, Mazarine, La Batut, 1933, p. 44 f.; Schilling, 1952, p. 169; Panofsky, *Netherlandish Painting*, 1953, I, pp. 54 n. 1, 55 n. 2, 118 n. 3; Paris, Bibl. nat. (Porcher), 1955, p. 99 no. 205; Porcher, *Medieval Miniatures* [1959], fig. 75.

MINIATURES:

Folio	5	St. John
	7	St. Luke
	9	St. Matthew
	11	St. Mark
	13	Annunciation
	38	Visitation
	50	Nativity
	56v	Annunciation to the Shepherds
	61v	Adoration of the Magi
	66	Presentation in the Temple
	70v	Return of the Holy Family from Egypt
	77v	Coronation of the Virgin
	83	King David (weak assistant and, in border, assistant of Breviary Master)
	110	Crucifixion (weak assistant)
	117	Pentecost (assistant)
	126v	Christ in the sepulchre (English addition)
	141	The Virgin and Child (English addition)
	150	Illustration of Office of the Dead

Paris

BIBL. NAT., fr. 9-10 (Fig. 343)

Guiart des Moulins, *Bible historiale*. 599 fols.; 465 × 325 mm. 2 half-page miniatures and 135 smaller miniatures

HISTORY: There are no clues to the original owner of this manuscript. It has continuous foliation throughout and must originally have been bound in one volume. As in other manuscripts prepared without a specific purchaser in mind spaces were reserved for emblems or arms in the initials beneath each of the half-page miniatures, but they were never filled in.

STYLE AND DATE: Five distinct styles can be identified in the manuscript. Only two miniatures (not three, as claimed by Schilling) are by the Boucicaut workshop. Both are in fr. 10: the half-page frontispiece to the Book of Proverbs, with an elaborate border (fol. 318), and the smaller illustration of Ecclesiastes that follows it (fol. 330v). The style of the other half-page miniature, which opens the Book of Psalms (fol. 283), is probably by the Bedford Master and, contrary to the opinion of Martens, is the only work of this kind in the book. As I observed in 1956 the bulk of the illustration is in the style of the Master of the Cité des Dames (ex-Master of Christine de Pisan) and his assistants (see the next volume of this publication). A large contribution was made by an anonymous illustrator who shows some familiarity with the latter's style as well as that of the Boucicaut Master. Some miniatures can be attributed to the Egerton Master, as Schilling first pointed out.

The miniatures in the Boucicaut style are closer to the Master than most of those in the other *Bible historiale* to which the workshop contributed (British Museum, Royal 15 D III). Fr. 9-10 is probably a little earlier, perhaps around 1412.

BIBLIOGRAPHY: Berger, *Bible française*, 1884, pp. 197, 206, 218, 329; Durrieu, *Arts anciens de Flandre*, II [1906?], p. 16; Durrieu, *Rev. de l'art a. et m.*, XX, 1906, p. 22; Durrieu, *Rev. de l'art chrét.*, 1913, p. 312; Martens, *Meister Francke*, 1929, notes 217, 222, 427;

Schilling, 1954, pp. 274, 276 n. 15; Paris, Bibl. nat. (Porcher), 1955, p. 99 no. 204; Meiss, *Art Bull.*, 1956, pp. 193 n. 24, 194 n. 29.

MINIATURES (by the Boucicaut workshop):

Ms. fr. 10

Folio 318 The judgment of Solomon; Solomon's meeting with the Queen of Sheba; Solomon and the Queen before idols; Solomon teaches

330v Ecclesiastes: The Preacher

Paris

BIBL. NAT., fr. 259 (Figs. 431, 432, 434, 435, 441)

Titus Livius, *Histoire romaine*, translation by Pierre Bersuire. 639 fols.; 460 × 330 mm. 29 miniatures

HISTORY: There are no marks of original ownership.

STYLE AND DATE: Most of the miniatures were painted by uninteresting followers of the Boucicaut Master. One of the frontispieces (fol. 15), however, is much closer to the master's own style. The majestic, rather static figures and the massive, solid architecture are distributed with exceptionally wide spatial intervals. Reds, blues, and dark green predominate in a rather limited palette. The paint is applied thickly. A similar style appears in the *Propriétés des choses* (Cambridge, Fitzwilliam Museum, ms. 251). A second frontispiece (fol. 253), wrongly ascribed to the Boucicaut Master by Panofsky, shows the more fantastic, less balanced version of the Boucicaut style that appeared in the large miniature of Priam in the *Chroniques de France* in the British Museum (Cotton Nero E II, Volume I). The combination of elements suggests a date of *ca.* 1412–1413.

BIBLIOGRAPHY: Durrieu, *Arts anciens de Flandre*, II [1906?], p. 16; Durrieu, *Rev. de l'art a. et m.*, XX, 1906, p. 22; Durrieu, *Rev. de l'art chrét.*, 1913, p. 312; Panofsky, *Netherlandish Painting*, 1953, I, p. 184 n. 2; Paris, Bibl. nat. (Porcher), 1955, p. 97 no. 200.

MINIATURES:

First Decade

Folio 15 Frontispiece. Pierre Bersuire presents his book to Jean le Bon; on right, the shepherd of King Amulius discovers Romulus and Remus nurtured by the wolf; in background, the future city of Rome with its gate surmounted by the imperial eagle. An angel holds a crown above Jean le Bon.

40v Book II. Government of Rome after the period of the kings; despatch of a message, possibly from the Tarquinii to royalists in Rome

69 Book III. Virginius has his daughter Virginia killed

99v Book IV. Marriage between a patrician and a plebeian

126 Book V. Geese on the Roman Capitol betray the presence of the Gauls

150v Book VI. Rebuilding of Rome after the Gallic invasion

170v Book VII. Marcus Curtius appeases the gods and delivers the people by descending on horseback into the bowels of the earth

189v Book VIII. Combat between two armed men inside an enclosure

208v Book IX. Roman army confronts another

232 Book X. Romans assaulting a city

Second Decade

253 Book I. Frontispiece. Coronation of Hannibal as Emperor of Carthage

275 Book II. Hannibal sets out on the campaign in which he was to lose sight of one eye

298 Book III. Treasures of the city of Compsa handed to Hannibal

318 Book IV. Beheadings and burning at the stake (under Hieronymus of Syracuse)

335v Book V. Roman turning from native to foreign god

354 Book VI. Forces of Hannibal besieging Rome

378v Book VII. Defeat of the Consul Fulvius by Hannibal

403v Book VIII. Roman Consuls Marcus Livius and Claudius Nero entering Rome in triumph

428 Book IX. Ships of Scipio approaching Africa

445 Book X. Numidian king, Syphax, brought before Scipio

Third Decade

466 Book I. Frontispiece. The Roman envoy brings gifts to Massinissa

485v Book II. King Philip and Titus Quinctius, Roman consul, confer

Book III (Livy's text was not then known)

501v Book IV (in ms. Book III). Lucius Valerius, supported by Roman women, proposes to Cato that the Oppian law should be revoked

523v Book V (in ms. Book IV). Cavalry of Lucius Cornelius Merula discovers an ambush of the Boi

542v Book VI (in ms. Book V). Battle next to a castle by the sea, probably one of the battles against King Antiochus

558v Book VII (in ms. Book VI). Battle on both sides of a river; camp with tents

579v Book VIII (in ms. Book VII). As a prisoner, the wife of Ortiagontis kills the centurion

604v Book IX (in ms. Book VIII). Youth renders tribute to king

625 Book X (in ms. Book IX). The sons of King Philip duel with swords in his presence

Paris

BIBL. NAT., fr. 2810 (Figs. 80-100)

Le livre des merveilles. 297 fols.; 420 × 298 mm. 265 miniatures (including frontispieces to introduce main sections – Flamel's inscription states '266 hystoires')

HISTORY: The manuscript is a compilation of texts describing voyages in the East, and includes French translations of accounts by Marco Polo (1271-1295), Odoric of Pordenone (1331), William of Boldensele (1336), Sir John Mandeville (1322-1356), John Hayton (1307), and Ricold of Montecroce (1294-1309), as well as letters of the Grand Khan to Pope Benedict XII and the *Estate of the Grand Khan* by Archbishop Saltensis. The text of Marco Polo is the short French version of Thibault de Cépoy, written in Venice in 1307. It has not been published in its entirety, but Backer has printed from fr. 2810 parts of Odoric (pp. 89-123), Hayton (pp. 125-253), Ricold (pp. 256-333), Archbishop Saltensis (pp. 335-346), and letters of the Grand Khan to Pope Benedict XII (pp. 347-356).

The volume is richly illustrated, and an inscription on a guard folio at the beginning of the book in the hand of the Duke of Berry's secretary, Flamel, tells us that it was given to Jean de Berry by his nephew, John, Duke of Burgundy: '. . . le livre du merveilles du monde . . . lequel livre Jehan duc de Bourgoingne donna à son oncle, Jehan fils de Roy de France, duc de Berry . . .'. An item in the inventory of the Berry collection drawn up in 1413 amplifies this information by giving the date of the gift as January 1413. The book then bore the Burgundy arms on its clasp, and must certainly have been commissioned by Jean sans Peur, whose portrait, arms, and devices appear on fol. 226. The style of the miniatures indicates that it can have been in his possession only a short time. The shield of Burgundy, which was originally painted in the opening initial to each main section of the volume, was replaced by the Berry arms on fols. 1, 97, 136v, and 226, and by the arms of the next owner, Jacques d'Armagnac, Duke of Nemours, on fols. 116, 141, and 268. The arms of Nemours have also been added in the borders of fols. 1, 136v, and 226. His device 'Fortune d'amis' occurs in a number of places throughout the book and is painted on the book edge together with his arms. On his death the book passed to the House of Bourbon.

STYLE AND DATE: The illustration falls into two main stylistic groups, that of the Boucicaut Master and of the Bedford circle or trend (but not, as Schilling proposed, the Egerton Master). The compositions in the Boucicaut style are imaginative, showing flowery landscapes and deep, majestic interiors. The designer is also ingenious, especially when adapting his scenes to the low rectangles often allotted to them. In the *Crucifixion*, for instance, he maintains a rather large figure scale by scooping out a cleft in the terrain, in which the throng can stand (Fig. 93).

Whereas the Boucicaut Master himself must have taken part in the designing of many scenes, the execution is often perfunctory. Despite the importance of the patron assistants were given much of the work. Curiously, they painted all the frontispieces. The borders around these miniatures consist of heavy vines not characteristic of the Boucicaut Master. The remarkable portrait of Jean sans Peur in the frontispiece on fol. 226 (Fig. 98) was probably painted by the Boucicaut Master himself, following perhaps an approved model similar to a later copy in Antwerp. The manuscript was illuminated shortly before 1413, when the Duke gave it to Jean de Berry. The illuminators often failed to illustrate the text

accurately but drew instead upon the stock of medieval conventions for the representation of fabulous beings.

BIBLIOGRAPHY: Facsimile: Paris, Bibl. nat. (Omont), *Livres des merveilles*, 1907.

On the texts: Backer, *L'extrême orient au moyen-âge*, 1877; Marco Polo, *Il milione*, ed. Benedetto, 1928; Bennett, *The Rediscovery of Sir John Mandeville*, 1954 (esp. pp. 82 f., 228 f., 270); Marco Polo, *La description du monde*, ed. Hambis, 1955; Olschki, *Marco Polo's Asia*, 1960.

On the illumination: Delisle, *Cabinet*, I, 1868, p. 66; III, 1881, no. 196; *Histoire littéraire de la France*, XV, Paris, 1869, p. 503 ff.; Champeaux and Gauchery, *Travaux*, 1894, p. 153 f.; Guiffrey, *Inventaires*, I, 1894, pp. CLII, CLXXIII no. 49, 270 no. 1005; II, 1896, p. 242 no. 558; Paris, Louvre, *Exposition*, 1904, p. 25 no. 63; Durrieu, *Arts anciens de Flandre*, II [1906?], p. 16; Durrieu, *Rev. de l'art a. et m.*, XIX, 1906, p. 414 f.; XX, 1906, p. 28; Delisle, *Charles V*, 1907, II, pp. 254 no. 196, 305; Paris, Bibl. nat., *Portraits*, 1907, p. 23 f.; Couderc, *Portraits* [1910], p. 26 f.; Durrieu, *Rev. de l'art chrét.*, 1913, p. 312; Dvořák, *Brüder Van Eyck*, 1925, p. 195; Paris, Bibl. nat., *Exposition*, 1926, p. 38 f. no. 46; Paris, Bibl. nat. (Couderc), 1927, p. 81; Paris, Bibl. nat. (Martin), 1928, pp. 56, 107 f.; Martens, *Meister Francke*, 1929, p. 195 f. and see index; Panofsky, *Netherlandish Painting*, 1953, I, pp. 54 n. 1, 55 n. 4, 76, 244; Porcher, *Belles Heures*, 1953, p. 17 n. 31; Schilling, 1954, pp. 274, 276; Paris, Bibl. nat. (Porcher), 1955, p. 82 f. no. 169; Meiss, *Art Bull.*, 1956, p. 194 n. 29; Nordenfalk, 1956, p. 185; Wittkower, 1957, pp. 155-172; Porcher, *Medieval Miniatures* [1959], p. 69; Vienna, Kunsthist. Mus., *Katalog*, 1962, p. 175 no. 117.

TABLE OF ILLUMINATORS OF BIBL. NAT., FR. 2810

Boucicaut Workshop: Fols. 1-16v, 18, 18v, 20v, 21v, 23, 80-97, 104-141, 151-181, 198-226, 268, 275

Follower of Boucicaut Master: Fols. 292-299

The Bedford Trend: Fols. 17, 19v, 22v, 24, 25v, 26, 27, 28, 29v, 30v, 31v, 33, 34, 36-42, 44-78, 142v-147, 182-197, 227-266

Minor illuminators: Fols. 98v-103, 269-274v, 276-291v

Late fifteenth century: Fol. 42v

MINIATURES (The forms of the proper nouns in the miniatures illustrating Marco Polo conform with the usage of L. Olschki, *Marco Polo's Asia*. The other proper nouns conform with the text of fr. 2810):

Marco Polo

Folio 1 The brothers Nicolo and Maffeo Polo, departing to explore the world, take leave of King Baldwin II of Jerusalem

2 The brothers arrive at Bokhara (Bukhara) and are received by Barak

2v The brothers are presented by the ambassador from Alaù to the Grand Khan, Kublai

3 The brothers are invited by the Grand Khan to accompany his envoy to the Pope; the brothers kneel behind to take leave

3v The envoys are given the golden tablet with the imperial cipher to allow for their safe conduct within the imperial dominions

4 The brothers leave Venice accompanied by Marco, the son of Nicolo

4v The brothers, bearing the message from the Grand Khan, are received by Pope Gregory X

5 The brothers arrive at the Khan's court and bring him a book and a gold cross from the Pope

6 The brothers ask leave to depart

7 Economic activities in Lesser Armenia

8 King David approaches the Convent of St. Leonard in Georgia

9 In 1255 the conquering Tartars lock the Caliph of Baghdad within his treasury to die of hunger

10 In 1275 a caliph orders Christians to move a mountain

10v God moves the mountain for love of the Christians

11v The Three Magi, following a star, leave the city of Saba

12 The Three Magi worship the miraculous fire that issued from a stone given them by the child Jesus.

12v Persian horses

13v White oxen in Persia

14v Arrival of a boat at Ormus (Hormuz)

15v Marco Polo investigates the wonders of the country

16v The garden of paradise created by the Old Man of the Mountain

17 The Old Man of the Mountain gives an intoxicating drink to future assassins

18 Hunting of porcupines in a country beyond Casem

18v The mining of rubies in Balashan

19v Ascetic community in Kashmir. A hermit reads; a hermit preaches; a man is beheaded at the command of a king ('il ont leur roy qui les maintient en iustice')

20v The baptism of Zagatai in the church of St. John the Baptist at Samarkand

21v Encampment in the province of Yarkand

22v Idolatrous customs in the province of Tangut (Kansu)

23 Ceremony of burning the body of the dead in Tangut (Kansu)

24 A man burnt at the stake before a king (erroneous illustration of the incombustible metal called salamander in the province of Chinchitalas)

25v Coronation of Chingis-khan, first emperor of the Tartars

26 Ambassadors of Chingis-khan arrive at Prester John's court to ask for his daughter in marriage

27 Chingis-khan mortally wounded at the siege of Thaigin

28 Customs of the Tartars: a thief purchases exemption from punishment

29v Conventional medieval marvelous men (illustration of savage inhabitants of the land of the Mekriti, Siberia)

30v Wild cattle of Erginul

31v The Grand Khan goes hunting

33 Battle between the Grand Khan and Nayan the traitor (?)

34 The army of the Grand Khan surprises Nayan in bed with his queen in his tent

36 Wives and children of the Grand Khan

37 Palace of the Grand Khan, decorated with paintings of dragons and other animals in gold

38 City of Taidu (Cambalu or Peking)

39 The Grand Khan at table, served by three kings

40 The Grand Khan worshipping an idol

41 The Grand Khan travelling, surrounded by his barons in robes of uniform color he gave them

42 Preparations for the hunt in which lions and leopards as well as dogs are used

42v The Grand Khan transported by elephants (repainted in the latter half of the fifteenth century)

44 Festivities at the court of the Grand Khan

45 Paper money made from the bark of trees given in payment by order of the Grand Khan

46v Messengers and couriers leave Cambalu for many lands

47v The Grand Khan supervising the planting of trees

49 Bridge over the Pulisanghin River

50 King Dor compelled to act as herdsman for Prester John

51 Commerce at the mouth of the Caramoran (Yellow River)

52v Young women of Tebet (Tibet) are offered to strangers, who give them gold ornaments as tokens

54 Pearl fishing and search for turquoises in the province of Gaindu

55v Serpents of Carajan

58 Battle between the Grand Khan and the king of Mien (Burma); the latter equipped with elephants

59 Elephant and unicorn hunt by the Khan in the forest of Mien (Burma)

59v Wild animals in the forest of Mien (Burma)

61 Dogs coupled for the lion hunt

62v Singnimatu: return from the hunt

64 The queen of Mangi surrenders to the Grand Khan

67 City of Singui, in Manji, with its bridges

69 Collection of rent for the Grand Khan from Quinsai (Hangchow) and appurtenances

71 Wonders of Cipango (Japan) brought to the Lord of that land

72 Conflict of the lord of Cipango and the general of the Grand Khan

73v Survivors of the shipwreck near Cipango (Japan)

74v Animal worshippers of Sumatra

76v Men with the heads of dogs on the island of Andaman in the Gulf of Bengal

139 Commerce in grain and cloth

139v Image of dead relative kept in home and honored on birthday of the dead

John Mandeville

141 John Mandeville takes leave of King Edward II of England

142v Pilgrims on the route to Constantinople

144 Relics of the Passion taken from various churches of Constantinople

146 Narrating the wonders of the East

147 The king who opened the tomb of his wife

151 Phoenix rising from a fire; hermit and monster in the desert of Damietta

153 The road to Babylon

153v Etna and child-eating Sicilian serpents

154v Tomb and statue of St. Catherine on Mount Sinai

157v Adam delving and Eve spinning while the angel talks to them; the barren tree near Hebron

159 Jerusalem

161v Jacob's ladder; the Ark of the Covenant

163 Death of the Virgin

164 Agony in the Garden of Gethsemane

165v Tending of trees around the Dead Sea

167 Sacrifice of Isaac; Joseph thrown into the well

168 Antichrist

168v Annunciation; battle on Mount Gelboe and Saul's head above gate of Bethsaym

170 Pilgrims pay tribute to the Saracens in Galilee

171 Damascus: St. Paul ravished to Paradise

171v Miraculous image of the Madonna at Sardanek

173 Tartars preparing foxes for food

174 Mahometans reading the Koran; Annunciation to the Virgin

175v Religious controversy between Christians and Saracens; Mandeville with the Saracens

177 The hermit of Mount Sinai and Mahomet; Murder of the hermit by Mahomet's servants

178 Bishop Athanasius, patriarch of Alexandria, imprisoned by order of the Pope who composes psalm: *Quicumque vult*

178v Castle of the Sparrow-hawk

179v Mount Ararat and Noah's ark

180 Manna; Job

181 Kingdom of the Amazons

182 Wild animals in Ethiopia rendered harmless by precious stones worn in rings on the left hand

183 Eel-fishing in the Indus; infirmity of the inhabitants of Hermes (Hormuz)

184 Idolaters on the island of Cana (Tana)

185 Sacrifice of children on the coast of Malabar

186 Gathering of pepper in India

186v Tomb of St. Thomas with saint's hand being used to decide law-suits; human sacrifice before an idol belonging to the same church

188 Two merchants selling their children to the naked inhabitants of Lamori (Sumatra)

188v Navigation in the Indian Ocean by the stars and the astrolabe

190v Trees bearing nutmeg in Sumatra

191 The king of Calonach with wives and elephant

192 Custom in Cassoles of hanging the dying from trees so that birds rather than worms may devour them

193 Lake in Silha formed by the tears of Adam and Eve after the expulsion from Paradise

194v Fabulous creatures on the islands of the Indian Ocean

195v Land of hermaphrodites

197 Capital of the Grand Khan; Grand Khan ordering the hunt of an animal

198 The Grand Khan served at table by noblemen

199v The white knight sent to Chinghiz Khan by God in a vision at night

200v Chinghiz Khan escapes his enemies by hiding in a thicket

201 Chinghiz Khan recommends union to his children by analogy with the strength of the unbroken packet of arrows

201v The Caliph of Baghdad, confined to his treasury, dies of hunger after being offered only gold coins and precious stones

203 Nobles offering homage to the Grand Khan

204 The Grand Khan travelling with his escort

205 The Emperor shows his respect for the Cross brought to him in procession by the local bishop

206 Sinners passing through fire to receive absolution

207 The wife, chamberlain, horse, and arms of the Grand Khan are about to be buried with him

208 Encampment in the mountains of Comania

208v Alexander and the narrow passage through the Gate of Iron

209v Miraculous gloom stops the Persians when pursuing Christians

210v Animal-bearing trees of the region of Cadilhe

211v Griffins and centaurs in the land of Bakerie

212 The land of Prester John; Prester John directs mariners

213 The river of sand in which fishes live; horned men who live in the desert beyond

214 The 'Paradise' of Gacohonakes

215 The valley of the devil

216 Land of the giants in North India

217 Animals of India

218 Dwellers on the island of Baginey

219 Alexander and the Gymnosophists

219v Pygmies in the land of Pitan nourished by the smell of fruits

220 Alexander in India between the trees of the sun and the moon who talked to him of his death

221 Adam and Eve in the Earthly Paradise

222 The four rivers of the Earthly Paradise

223 Funeral customs of the inhabitants of Riboth

224 A rich man with long nails at table

Hayton

226 Hayton presents his book to Jean sans Peur, Duke of Burgundy

227 Priest (patriarch of Antioch?) of Corasme

228 St. Thomas preaching Christianity to the Hindus

228v City of Combaech

229v Kingdom of Georgia; King of Persia pursuing Christians

230 Veronica image presented to King Abgar

231 Inhabitants of Turkey and of Asia minor

232 Antioch surrenders to the Saracens

233 The Caliph of Baghdad receives allegiance from the men of Turkomania

233v The emperor of Dyogencor sets out against the Saracens

234 The Turks crown their first king, Salioth

234v Siege of Antioch in which the Greeks are vanquished

235 Persia invaded by the Turkomans

236 Poor, old Canguis's vision of a knight who told him that he would rule the seven nations of Mongols

237 Canguis Kaan escapes from his enemies by hiding in a bush

238 Canguis Kaan on his death bed recommends union to his children by analogy with the strength of the unbroken packet of arrows

239 Alexander in the Cocas mountains meeting a savage at the Gate of Hell?

240 Mangu Kaan sets out to conquer Cathay

241 King Hayton coming to Melch to visit the emperor of the Tartars?

242v Baptism of Mangu Kaan by a bishop, chancellor of the kingdom of Armenia

243 The city of 'halappe' is taken in 1260 by Halcon, brother of Mangu Kaan; capture of the wife and daughter of the sultan

244 Battle between Halcon and Bartha; ice-covered river swallows up 30,000 Tartars

245 Abaga-khan, son of Halcon, proclaimed Emperor of the Tartars in 1264

245v The elder son of Hayton I, King of Armenia, is taken prisoner by the Sultan of Egypt, and his younger brother is killed

246v Battle in Syria

247v By order of Tangodar, who has called himself Mohammed, Saracen riders pursue Christians

248v Kalgaito, lord of the Tartars, about to be drowned for his vices by his subjects

249 Victories of Kasan, lord of the Tartars,

over the Saracens of the Sultan of
Egypt

250v The keys of Damascus handed over to
Kasan

251v Kasan, seated before tent, receives a
sealed letter

253 How the king of Armenia deals with the
Saracens

254v The Emperor Carbanda

255 Tartars in transit

256 The Pope listens to brother Hayton
deliver a plan for a crusade

257 Hayton writing his *Fleur des histoires
d'Orient*

258 How the people of the Sultan of Egypt
invade their neighbors

258v Sahadin, Sultan of Egypt, about to
capture Jerusalem

260 The land of Egypt

261 Discussion of strategy in war against
the Saracens between an old Christian
king, his counsellors, and brother
Hayton

262 Brother Hayton advises the Pope as to
the manner and time for an attack
upon the enemies of the Faith

263 Ships to be used in the liberation of the
Holy Land

265 Pilgrims to the Holy Land (rubric says
Hayton continues to describe to the
Pope the manner of conquering the
Holy Land)

266 Combat between Christians and Sara-
cens

Ricold de Montcroix

268 Brother Bicul and another Dominican
receive the Pope's blessing before set-
ting out to preach the Christian faith
in foreign lands

269 Galilee: Multiplication of the loaves and
fishes

270 Nazareth: Annunciation and three cru-
saders

270v Elias and the prophets of Baal

271 Jerusalem: Last Supper

272 Bethlehem: Nativity and Annunciation
to the Shepherds

274 Pilgrims find the Church of the Holy
Sepulchre guarded by Saracens who
have to be paid

274v From Tripoli three pilgrims go to Mount
Lebanon to visit Maronites

275 Two Dominicans see how the Turco-
mans live in caverns

276 Tartar women armed against the enemy

277v Tartar women watch a beheading and
ask for the head to be boiled in a
cauldron for the army to eat

278v Hindu magician suspended in the air

280 Tartars file through mountain passes on
their way to the conquest of the
world

281 The Caliph of Baghdad and his treasure
fall into the hands of the Tartars who
shut him in his palace and give him
nothing but gold to eat

282 The city of Erzerum; the ark on Mount
Ararat

283 Cruelty of the Kurds, who are not
honored until they have committed
crimes

284 Two Dominicans talk with Jacobites,
who consecrate the Sacrament of
Mass in bread freshly cooked and still
hot

286v Jacobite church built in honor of a dog

287 Two Dominicans talk with a Nestorian
bishop, accompanied by two of his
own monks

290v Disputation between Nestorians and the
author with a companion

291 Mohammedans removing their shoes
before entering a mosque

291v Customary ablutions of the Moham-
medans before prayer

292 Saracens giving alms

292v Mohammedans praying

293v Harmony among the Saracens

294v A Saracen judge with the Koran

296v The Dominicans discuss the law with a
Saracen

299 Dancers (not mentioned in text)

Paris

BIBL. NAT., fr. 9141 (Figs. 447-451, and page 59)
Bartholomaeus Anglicus, *Le livre de la propriété des
choses*, translation by Jean Corbechon. 364 fols. (the
last later); 385 × 295 mm. 1 large composite miniature
and 19 smaller miniatures

HISTORY: The arms on fol. 55 and elsewhere in the book are those of Béraud III, comte de Clermont, who succeeded his father, Béraud II, in 1399 and died in 1426. His emblem of the basket suspended on a branch appears also in a *Cas des nobles hommes et femmes* of Boccaccio (Paris, Bibl. nat., fr. 16995), illuminated in the style of the Rohan Master. In the present manuscript the large initials may also have contained coats of arms, but they were repainted in the early sixteenth century. The daughter and only child of Béraud III, who was about fifteen years old in 1426, married Louis de Bourbon, comte de Montpensier, in the year of her father's death, and thus became the wife of a grandson of Jean de Berry. The Duke is probably represented in one of the miniatures (fol. 235v – see *Late XIV Century*, Fig. 504).

STYLE AND DATE: The illustration is homogeneous, without the intervention of the Bedford Master, as has been claimed. The designs appear to have engaged the attention of the Boucicaut Master himself. The landscapes are deep and full of atmosphere; touches of gold reflect the light from the distant, pale blue buildings. The birds and animals are freshly observed and rendered. The manuscript was illuminated after 1409–1410 (the presumed portrait of Jean de Berry suggests that) and probably towards 1414.

BIBLIOGRAPHY: Durrieu, *Arts anciens de Flandre*, II [1906?], p. 16; Durrieu, *Rev. de l'art a. et m.*, XX, 1906, pp. 21 f., 28; Delisle, *Charles V*, 1907, II, p. 302 f.; Durrieu, *Rev. de l'art chrét.*, 1913, p. 313; Paris, Bibl. nat. (Porcher), 1955, p. 85 f. no. 177.

MINIATURES:

Book I. God
Folio 9 Six scenes of Creation (the broad gold band was added in the sixteenth century and the miniatures were somewhat retouched)
 11v Trinity
Book II. The Angels
 17v Fall of the rebel angels
 20v Persons who adore the first hierarchy of angels
 23v The second hierarchy of angels worshipped by various persons
 25 The third hierarchy of angels
Book III. The Human Soul

29v God makes the soul enter into the body of Adam
Book IV. The Four Elements and the Four Humors of Man
 43 Cleric expounds to two noblemen, one of whom carries a mallet and wears a black *houppelande*. He is probably intended to represent Jean sans Peur
Book V. The Parts of the Human Body
 55 Teacher giving anatomy lesson, probably to Béraud III, comte de Clermont, whose arms appear on window and vault
Book VI. Phases and Functions of Life
 98 Children playing; young man hunting; merchant counting his gold; old men talking
Book VII. Maladies (no illustration)
Book VIII. The World and the Celestial Bodies
 138v Professor holding sphere and indicating the sun and moon to three young noblemen
Book IX. Movement and Time (no illustration)
Book X. Matter and the Elements
 171v Carnal love
Book XI. Air and Atmospheric Phenomena
 175 The ages of man (same subject as fol. 98, but different iconography)
Book XII. The Ornaments of the Air (i.e. the birds)
 183 Birds in four compartments
Book XIII. Water and Fish
 197 Scholar discoursing on water and fish to nobleman
Book XIV. The Earth and the Mountains
 207 Scholar and nobles discoursing in landscape
Book XV. Provinces of the Earth
 217v Scholar addressing nobleman about the regions of the world
Book XVI. Precious Stones, Colors and Metals
 235v The Duke of Berry (?) purchasing jewels
Book XVII. Trees and Plants
 258v Scholar indicates trees to nobleman (who seems to bear emblem of Order of Broom)
Book XVIII. Animals
 303v Unicorn, horse with dogs, lioness with cubs, bear, and monkey
Book XIX. On Color (no illustration)

Paris

BIBL. NAT., fr. 23279 (Figs. 67, 68, 70, 71)

Pierre Salmon, *Réponses à Charles VI et Lamentation au roi sur son état.* 121 fols.; 280 × 205 mm. 27 miniatures

HISTORY: This compilation of dialogues, 'lamentations', and letters was written by Salmon in 1409 at the request of Charles VI. This information is given in the middle of the manuscript (on fol. 53), and the date is confirmed by a statement in the preamble to a revised version of the text produced very shortly afterwards (cf. Geneva, Bibl. publique et universitaire, ms. fr. 165), which states that the book was presented to the king in the thirtieth year of his reign (Charles VI came to the throne in 1380). The present volume is usually assumed to be the presentation copy and, even if this could be disproved, the fact that the text was so rapidly superseded suggests that it must be very close to this date. Although the Boucicaut Master participated in the illustration of both versions of the text, the two miniature cycles have little in common otherwise. The series of miniatures representing Salmon's diplomatic missions was entirely omitted from the later version.

STYLE AND DATE: The illumination of this manuscript is at once interesting, important for the history of painting, and puzzling. Though it was undertaken for the king and produced under the eye of a royal counsellor, the Boucicaut Master painted only two of the three miniatures in his style. Damage does not conceal the original perfunctoriness of even the first of these miniatures that represents the presentation of the book to Charles VI. The third, while showing an elaborate and somewhat original 'English' cityscape that harbors even a nesting stork, is scarcely more inspired. Only the second miniature is really impressive. The panorama of Salmon presenting his *Lamentations* alongside an inattentive Jean de Berry and amidst casual activities outdoors is highly engaging if not spatially systematic (see Fig. 69 and *Late XIV Century*, p. 73). The paintings that the Boucicaut workshop produced in the same year for the most discriminating patron in France (see Bibl. nat., lat. 919), though more monumental, are equally dry.

The unusual elements in the borders, a sequence of small sprays with drop-like leaves, were probably inspired by the broom, emblem of Charles VI. This appears in two forms on the canopy over his head in fol. 1v, again in 19, and splendidly in Geneva, Bibl. publique et universitaire, fr. 165 (Fig. 69).

Many of the miniatures in the manuscript were painted, as I observed, by the Master of the Cité des Dames (in 1956 called the Master of Christine de Pisan). They are notable for their extraordinary landscapes (Fig. 71). One miniature in an allied style (fol. 69) has an astonishing cloud-flecked, brightly colored sky. This style recurs in the book, especially on fol. 117v, where the projection and lighting of the interior are unparalleled until about 1420. It is possible that the illumination of this copy of Salmon's text, like the one in Geneva made three years later, was not completed until a later date. Still, in the present manuscript, the miniatures by the Master of the Cité des Dames, the closely related miniature on fol. 69, and the miniature on fol. 117v seem linked to such a degree that they are not easily disconnected. (These miniatures will be reproduced in the following volume of this publication.)

BIBLIOGRAPHY: Salmon, ed. Crapelet; La Valliere, *Catalogue*, 1783, III, p. 197 f.; Levesque [1798–1799], p. 415 f.; Durrieu, *Arts anciens de Flandre*, II [1906?], p. 16 f.; Durrieu, *Rev. de l'art a. et m.*, XX, 1906, p. 22; Delisle, *Charles V*, 1907, I, p. 127; Couderc, *Portraits* [1910], p. 25 f.; Durrieu, *Rev. de l'art chrét.*, 1913, p. 313; Martin, *Miniature française*, 1923, pp. 76 f., 102; Bourges, Musées [1951], p. 38 f. no. 20; Panofsky, *Netherlandish Painting*, 1953, I, pp. 55 no. 3, 59; Paris, Bibl. nat. (Porcher), 1955, p. 96 no. 197; Meiss, *Art Bull.*, 1956, p. 193.

MINIATURES:

(Miniatures in the Cité des Dames style, except the one reproduced here, will be described in the next volume of this publication)

Folio 1v Pierre Salmon presenting his book to Charles VI in the presence of Jean sans Peur and another prince (Boucicaut workshop)

 8 The first virtue: King David and a king (possibly Philippe III of France) (Rhenish?)

 13 Four kings

 53 Pierre Salmon offering his *Lamentations* to Charles VI in the presence of the Duke of Berry (Boucicaut workshop)

 54 French and English nobility assemble at Calais for the wedding of Richard II of England and Isabelle of France; Richard about to take his bride to England (Master of Cité des Dames)

55 The King of England talking secretly with Salmon

57v Salmon acting as courier between the King of England and the King of France and Duke of Burgundy; channel separates England from France (style related to fol. 67)

58v Salmon presenting a cleric to the King of England

60v Salmon in discussion with King Richard II of England (Boucicaut workshop)

61v Salmon persuaded by the Queen's confessor to remain in England despite discord

67 Salmon goes to a chapel of the Virgin at Utrecht (illuminator influenced by the Master of Cité des Dames)

69 Salmon delivers a letter to the King of France and is despatched by him to Halle with a chalice and 'une chappelle de drap d'or' (related to fol. 67)

70 Salmon presents an epistle to the Duke of Orléans

72v Salmon asks permission of the King to go to Rome

74 Salmon delivers letters from the King of France to Pedro de la Luna in a castle near Grasse in Provence; Pedro de la Luna visited by French ambassadors (illuminator influenced by the Master of Cité des Dames)

75v Salmon returns to Paris with letters from Pedro de la Luna and the Maréchal de Boucicaut

102 Salmon shows the letters of Charles VI to King Louis in the Castle of Tarascon

115v Salmon before Pope Alexander V

117v Salmon interrogates a man called Hélye, who claims to be able to cure the king's madness. Salmon addresses also an Augustinian general and the master of the Pope's chapel (related to fol. 67)

119 Salmon gives to the Duke of Burgundy an account of his services for the King

Paris

BIBL. NAT., lat. 919 (Figs. 61, 62)

Grandes Heures of Jean de Berry. 126 fols.; 400 × 300 mm.

2 miniatures, initials, and some details by the Boucicaut Master and his workshop.

HISTORY: This manuscript, which was completed for the Duke of Berry in 1409, has been fully catalogued in *Late XIV Century*.

STYLE AND DATE: The illustration is described in the Duke's inventories as being 'de la main de Jacquemart de Hesdin et autres ouvriers de Monseigneur', and although the Boucicaut Master does not normally fall within the category of 'autres ouvriers' he and his workshop played a small part in its execution. The removal of the full-page illustrations, of which only one may be known (Paris, Louvre, *Way to Calvary* – see *Late XIV Century*), makes it impossible to say whether this contribution was originally greater than it now appears.

The Boucicaut workshop painted two miniatures, good but not stirring: *Christ in Limbo* (fol. 84), and *St. Gregory dictating* (fol. 100). Mediocre assistants painted the initials on these folios, and also on 37, 89, 93, 98. The Boucicaut Master's association with the Duke's artists would seem to have been brief, but it occurs also around the same time in the Lectionary presented by the Duke to the Sainte-Chapelle at Bourges (Bourges, Bibl. municipale, mss. 33-36). The repercussions of this experience can be seen in a few manuscripts in the present catalogue (see Bibl. nat., nouv. acq. lat. 3107; British Museum, Egerton 1070). The miniature in the *Grandes Heures* of *Jean de Berry received by St. Peter*, generally attributed to the Boucicaut Master, is rather very close to if not actually by his frequent collaborator, the Bedford Master (see above, p. 69, and *Late XIV Century*, p. 85, fig. 485).

BIBLIOGRAPHY (for Boucicaut miniatures): Durrieu, *Rev. de l'art a. et m.*, XIX, 1906, pp. 413-414; Durrieu, *Rev. de l'art chrét.*, 1913, p. 311; Panofsky, *Netherlandish Painting*, 1953, I, pp. 50, 53; Paris, Bibl. nat. (Porcher), 1955, p. 89; Porcher, *Medieval Miniatures* [1959], p. 60.

MINIATURES:

Folio 1v Most of vegetation

2 Bare trees

3 Virgin and most of vegetation

3v Figures in upper frieze and most of vegetation

4 Figures in upper frieze and most of vegetation

5 Vegetation lower left

5v Vegetation lower left
18v Secondary initial
19v Secondary initial
31 Two secondary initials
37 Initials
70 Initials, in part
74 Except Magdalen and a few other figures
81 Main initial
84 Descent into Limbo and Noli Me Tangere
89 Main initial
93 Main initial
97 Main initial
98 Main initial
100 St. Gregory dictating to a scribe and St. Gregory reading.

Assistants working in a style related to that of the Boucicaut Master made minor contributions to other folios, occasionally painting on a design that seems to have been provided by the Pseudo-Jacquemart. The drolleries on 8v through 15v were executed by an assistant of Pseudo-Jacquemart. This style appears occasionally on the following folios. The designs often depend upon Pucelle (see *Late XIV Century*, p. 259). From fol. 53 on most of the drolleries were painted in a style more closely related to that of the Boucicaut Master. The two styles still intermingle to a degree, even on fols. 98-99 that are two halves of one sheet. Marked changes in the design of the border frames occur on fols. 53 and 86.

Paris

BIBL. NAT., lat. 1161 (Figs. 125, 153, 188-204)

Book of Hours, Use of Paris. 308 fols.; 220 × 150 mm. 30 miniatures

HISTORY: The manuscript appears to have been executed for an unidentified lady, who is portrayed alone on fol. 290 and with her family (husband, son and daughter) on fol. 192. The majority of the prayers are in the feminine gender. There are no contemporary arms or signatures to help trace original ownership, and the shield on fol. A, tenta-

tively associated by Leroquais with the Beauveau family, as well as notes on fols. 191 and 274v, mentioning the name of a cleric, Claude Taroundeau, belong to a later period.

STYLE AND DATE: The manuscript has been recognized in all literature on the Boucicaut Master as an important product of his workshop. The character of both the miniatures and the borders indicates a relatively early date, around 1409. The borders lack the 'acanthus' introduced earlier in the *Boucicaut Hours*. Classification in this period is supported by the intervention on fol. 123 of an illuminator closely related to Pseudo-Jacquemart, who had long been working for Jean de Berry and who at this time was occupied with the *Grandes Heures*, to which the Boucicaut workshop also contributed. The style of the Pseudo-Jacquemart appeared alongside that of the Boucicaut workshop in only one other manuscript, Egerton 1070. This too was probably painted within a year or two of the *Grandes Heures*. Several compositions in lat. 1161 resemble miniatures in nouv. acq. lat. 3107, which also was influenced by painters of the Duke of Berry, in this instance the Limbourgs.

Like the miniatures in the *Grandes Heures* by the Boucicaut workshop those in lat. 1161 fall short qualitatively of the illumination of the *Boucicaut Hours*. The execution gives the impression of more perfunctory shop work. The supervision of the Master is, however, clearly implied by the continued study of the relation of figures, architecture, and landscape. The compositions lack the scale of those in the *Boucicaut Hours*, yet the extension into space, usually diagonal, is often great. The illuminator exploits the open room or loggia as a controlling and unifying form.

BIBLIOGRAPHY: Guyot de Villeneuve, 1889, p. 40; Durrieu, *Arts anciens de Flandre*, II [1906?], p. 17; Durrieu, *Rev. de l'art a. et m.*, XX, 1906, pp. 24, 31 n. 1; Couderc, *Portraits* [1910], p. 30; Durrieu, *Rev. de l'art chrét.*, 1913, p. 312; Leroquais, *Livres d'heures*, 1927, I, p. 82 ff.; Meiss, *Florence and Siena*, 1951, p. 142 n. 44; Panofsky, *Netherlandish Painting*, 1953, I, pp. 73 n. 5, 74 n. 1, 84 n. 3, 132 n. 6, 192 n. 4; Paris, Bibl. nat. (Porcher), 1955, p. 96 no. 198; Porcher, *Medieval Miniatures* [1959], pl. LXXVI.

MINIATURES:

Folio 20 St. John the Evangelist
 22 St. Luke

23 *bis* St. Mark
25 St. Matthew
27 Imago Pietatis
31 Annunciation
55v Visitation
68 Nativity
75 Annunciation to the Shepherds
79 Adoration of the Magi
83 Presentation in the Temple
87 Flight into Egypt
91 Coronation of the Virgin
101 David in prayer
123 Crucifixion (in a style less related to the Boucicaut Master than to Pseudo-Jacquemart)
127 Pentecost
130v Virgin of Humility, Christ Child playing psaltery, and angel musicians
137 Christ as judge with trumpeting angels and others carrying symbols of the Passion
142 Agony in the Garden
152 Betrayal
158 Christ before Pilate
162 Flagellation
168 Way to Calvary
174 Crucifixion
181 Descent from the Cross
187 Entombment
192 The Mass; four lay personages present
212 Illustration of Office of the Dead
268 St. Jerome
290 Virgin and Child adored by kneeling woman

Paris

BIBL. NAT., lat. 1379 (Figs. 237, 238)

Book of Hours, Use of Paris. 210 fols.; 137 × 95 mm. 12 miniatures and 1 historiated initial.

HISTORY: The original owner of this book is presumably to be identified with the woman kneeling to St. Catherine on fol. 202, but there are no clues to her actual identity. The book survives in a somewhat mutilated condition.

STYLE AND DATE: Leroquais observed a relationship of the manuscript with the Boucicaut Master's Book of Hours in Paris, Bibl. nat., lat. 1161. Lat.

1379, however, is, as he recognized, much inferior in quality. Some figures, such as the reverent angel and the slender Virgin in the *Annunciation*, closely resemble their counterparts in Mazarine 469. Lat. 1379 was produced by a follower of the Boucicaut Master in the second decade of the fifteenth century.

BIBLIOGRAPHY: Leroquais, *Livres d'heures*, I, 1927, p. 203 f.; Paris, Bibl. nat. (Porcher), 1955, p. 98 no. 202.

MINIATURES:

Folio 26 Annunciation
48 Visitation (initial)
58v Nativity
64v Annunciation to the Shepherds
69 Adoration of the Magi
73 Presentation in the Temple
77v Flight into Egypt
84 Coronation of the Virgin
90 David before the Lord
110v Pentecost
158 The Virgin enthroned; a basket of flowers offered by an angel
163 Last Judgment
202 St. Catherine with a donor

Paris

BIBL. NAT., lat. 10538 (Figs. 129, 253-257)

Book of Hours, Use of Rome. Hours of Philippe le Bon (so-called Hours of Joseph Bonaparte). 304 fols.; 180 × 130 mm. 45 miniatures and calendar illustration plus later miniatures by a Flemish artist working for Philippe le Bon

HISTORY: The manuscript was in the library of the Dukes of Burgundy either before 1419, when Jean sans Peur was still alive, or very soon afterwards when his son, Philippe le Bon, came to power. The old-style arms of Burgundy, as well as some Flemish miniatures from fol. 232 on, must have been added at this time. The alternative title derives from the fact that this Book of Hours was brought back from Spain in the early nineteenth century by Napoleon's brother, Joseph Bonaparte.

STYLE AND DATE: Most of the original illumination, which is rather consistent in style, must be ascribed to an assistant of the Boucicaut Master. As Dorothy Miner observed in 1949, the manuscript is related in

some respects to the Book of Hours, Baltimore, Walters Gallery, ms. 260. Lat. 10538 should be dated about 1416.

Two miniatures (fols. 31 and 116), show a unification of the entire folio, borders as well as miniatures, by the introduction of a large building consisting of several compartments. The Boucicaut Master himself no doubt designed these very original folios, and he probably derived the idea of a comprehensive architectural unification from Lombard illumination. The innovation proved influential in later illumination, Italian as well as French. The Boucicaut Master undertook a similar unification of the folios in another late Book of Hours (Florence, collection of Prince Corsini).

BIBLIOGRAPHY: Durrieu, *Arts anciens de Flandre*, II [1906?], p. 17; Durrieu, *Rev. de l'art a. et m.*, XX, 1906, p. 24; Durrieu, *Rev. de l'art chrét.*, 1913, p. 312; Leroquais, *Livres d'heures*, 1927, I, p. 338 f.; Baltimore, Walters (Miner), 1949, p. 33 no. 86; Panofsky, *Netherlandish Painting*, 1953, I, pp. 59 n. 2, 173 n. 1, 278 n. 1; Paris, Bibl. nat. (Porcher), 1955, p. 97 no. 199; Vienna, Kunsthist. Mus., *Katalog*, 1962, p. 174 f. no. 116.

MINIATURES:

Folio 15	St. John the Evangelist
17	St. Luke
19	St. Matthew
21	St. Mark
22v	Virgin and Child with three angels
27	Virgin, Christ Child playing on a psaltery, and angel musicians
31	Annunciation; *bas-de-page*: Virgin at the loom
50v	Visitation
63	Nativity
68	Annunciation to the shepherds
73	Adoration of the Magi
78	Presentation in the Temple
83	Flight into Egypt
91	Coronation of the Virgin
104	Crucifixion
110v	Pentecost
116	God the Father surrounded by the symbols of the Evangelists; *bas-de-page*: David in prayer
137v	Illustration of Office of the Dead
186	The Mass
191	The Mass

193	Funeral service
198	Trinity
199	Trinity
200	Madonna in Glory
201v	St. Michael
202v	St. John the Baptist
203v	St. Peter and St. Paul
204v	St. Andrew
205v	St. John the Evangelist
206v	St. James
207v	St. Simon and St. Jude
208v	St. Lawrence
209v	St. Christopher
210v	St. Stephen
211v	St. Denis
213	St. Martin
221v	Creation Scene (later Flemish addition)
223	St. Nicholas
224	St. Anthony Hermit
225	St. Fiacre
226v	St. Anne and the Virgin
227v	St. Mary Magdalene
228v	St. Catherine
229v	St. Margaret
230v	Group of Virgins
231v	Group of Saints

Original ms. ends here. Additions belong to the period of Philippe le Bon, sometimes, especially in the borders, imitating the earlier designs.

Paris

BIBL. NAT., nouv. acq. lat. 3107
(Figs. 127, 142, 147, 151, 210-221)
Book of Hours, Use of Rome (Hours of the family of Saint-Maur). 251 fols.; 220 × 165 mm. 46 miniatures and calendar illustration; one miniature added some fifteen years later.

HISTORY: The original manuscript (fols. 5-239) gives no indication of ownership, but additions made soon after its completion show that in the first half of the fifteenth century it belonged to a M. de Saint-Maur and his wife. From the nature of these additional prayers it can be deduced that this gentleman must have suffered from excruciating toothache and that his wife was of Portuguese origin, but attempts to trace the family have shed no light on the original commission. The final addition, a *Crucifixion* painted on fol. 1, was made by a Lower Rhenish hand – not, as Porcher proposed, Flemish.

STYLE AND DATE: The illustration was first ascribed to the Boucicaut Master by Durrieu in 1906, when it was in the collection of the Duke of Arenberg, after attention had been drawn to the book by Beissel subsequent to its exhibition at Düsseldorf in 1904. Only one miniature (fol. 175v), the last in the book, can be ascribed to the Boucicaut Master himself. The interior seen through an arch opened into a building is composed with remarkable consistency along an oblique axis, and its vividness is enhanced by the flow of light and the subtle modulations of the gray and brown mourners. The other miniatures are by closely interrelated followers of the Boucicaut Master and two more independent illuminators (Porcher's tentative attribution in 1961 of the calendar and the Evangelists to the Bedford Master is not acceptable). These followers of the Boucicaut Master are unusually eclectic. One probably had worked early on Douce 144. They were impressed above all by the *Belles Heures*, with which the Limbourgs were engaged from about 1408 on. Fols. 33 (*Madonna in Glory*) and 45 (*Annunciation*) depend upon corresponding miniatures in that manuscript, as Porcher observed. The lecterns in the present *Annunciation*, moreover, are crowned with statues, as in the *Belles Heures*, and the borders in the two manuscripts are remarkably similar. A date of about 1411 for the *Hours of St. Maur* is supported by the appearance in the *Grandes Heures*, which was finished in 1409, of a very similar version of Boucicaut style. The *Noli me tangere* on fol. 225 must be by the same hand as this subject on fol. 84 of the *Grandes Heures* (Fig. 61).

The illuminators of the *Hours of St. Maur* adopted for their backgrounds the large arabesques and the lacquered greens and mauves employed by the Egerton Master. The soft, doughy figures and landscapes seem to imply the influence of the Virgil Master, who painted a few miniatures (Figs. 216 and 217).

BIBLIOGRAPHY: Beissel, *Arts anciens de Flandre*, I [1905?], p. 49 f.; Durrieu, *Arts anciens de Flandre*, II [1906?], p. 18; Durrieu, *Rev. de l'art a. et m.*, XX, 1906, p. 24; Durrieu, 1914, p. 28; Paris, Bibl. nat. (Porcher), 1955, p. 98 no. 203; Paris, Bibl. nat., Porcher, *Boisrouvray*, 1961, p. 59 f. no. 12.

MINIATURES:

Folio 1 Crucifixion (Rhenish addition)
 5-16 Calendar
 17 St. John the Evangelist

18v St. Luke
20v St. Matthew
22v St. Mark
24 Standing Virgin and Child surrounded by angels
28 Madonna enthroned; God the Father in heaven
33 Madonna in Glory
45 Annunciation
56 Visitation
68 Nativity (Virgil Master)
72v Annunciation to the Shepherds (in part Virgil Master)
77 Adoration of the Magi
81v Presentation in the Temple
86 Flight into Egypt (Virgil Master)
94 Coronation of the Virgin
117 Trinity
120v Funeral Service (Monday, Matins)
124 All Saints
127v Christ as sovereign judge
130v Virgin and Child enthroned, with two angels
134 St. Catherine
139 King David in prayer
157 Crucifixion
163 Trinity
168 Burial (illustration of Vespers Office)
175v Funeral Service (First Nocturn) (Boucicaut Master)
211v St. Michael
212v Baptism of Christ by St. John the Baptist
213v St. John the Evangelist
214v St. Peter and St. Paul
215v Holy Apostles
216v St. Stephen
217v St. Christopher
218v St. Lawrence
219v St. Denis
220v St. Cosmas and St. Damian
221v St. Nicholas
222v Holy Martyrs
223v St. Martin
224v St. Anne
225v Noli me tangere
226v St. Catherine
227v Pentecost
232v Virgin and Child with angels in a garden
234v Angels bearing instruments of the Passion
237 Mass for the Dead

Paris

BIBL. SAINTE-GENEVIÈVE, ms. 2686

Book of Hours, Use of Rome (in Latin and French). 195 fols. (defective); 100 × 70 mm. 2 miniatures

HISTORY: The tiny original manuscript is defective and there are later interpolations. There is no indication of original ownership.

STYLE AND DATE: Neither of the two surviving miniatures is well preserved. *David in Prayer* on fol. 111 was repainted in the mid-fifteenth century, but the border and the frame are similar to fol. 97 representing the Flight into Egypt. The composition of the *Flight* resembles that in the *Boucicaut Hours*, with Joseph turning around, the Virgin inclining her head towards him, and, despite the minute scale, a deep landscape, a lake, and a golden sun.

BIBLIOGRAPHY: Paris, Bibl. Sainte-Geneviève (Kohler), II, 1896, p. 449; Durrieu, *Arts anciens de Flandre*, II [1906?], p. 17; Durrieu, *Rev. de l'art a. et m.*, XX, 1906, p. 24; Durrieu, *Rev. de l'art chrét.*, 1913, p. 313.

MINIATURES:

Folio 97 Flight into Egypt
 111 King David

Paris

BIBL. SAINTE-GENEVIÈVE, ms. 2701

Book of Hours (in Latin and French). 206 fols.; 169 × 120 mm. 6 miniatures

HISTORY: The original owner was probably the lady kneeling to St. James on fol. 195, but there are no clues to her identity. An inscription on fol. 1 reading: 'Martin Fournier, marchant drapier, demourant à Pontoise' is in a seventeenth-century hand and must refer to a later owner. The manuscript is damaged and incomplete.

STYLE AND DATE: Durrieu included the manuscript in all his lists of works by the Boucicaut atelier. The illuminator was no doubt trained in it, but he probably painted this manuscript when he was working independently. The book does not meet the minimum standards that appear to have been maintained in the workshop. In the *Funeral Service*, for instance, the bier extends deep into space, as in Add. 16997, but here it juts over a gold ground.

BIBLIOGRAPHY: Paris, Bibl. Sainte-Geneviève (Kohler), II, 1896, p. 458 ff.; Durrieu, *Arts anciens de Flandre*, II [1906?], p. 17; Durrieu, *Rev. de l'art a. et m.*, XX, 1906, p. 24; Durrieu, *Rev. de l'art chrét.*, 1913, p. 313.

MINIATURES:

Folio 92 King David
 122 Pentecost
 130 Illustration of Office of the Dead
 165 Madonna enthroned
 172 Man of Sorrows
 195 St. James and female donor

Paris

MUSÉE DE CLUNY, nos. 11315-11316

(Fig. 355)

2 fols. from a Missal. 560 × 260 mm.

HISTORY: The fate of the Missal from which these Canon pages have been taken is unknown. The miniatures, measuring 475 × 210 mm., originally confronted one another and the subjects are those commonly found in richly decorated Missals, in which the Canon pages are traditionally given prominence by the use of full-page miniatures: one shows God surrounded by the Evangelists and their symbols, the other the Crucifixion. The latter includes a bishop at the foot of the Cross, who can be identified by the arms on his cope (*d'argent à la croix d'azur, cantonnée de quatre aigles de gueules*) as a member of the Montaigu family, of whom the most celebrated member, Jean de Montaigu, Grand Master of France, was beheaded in 1409. Jean de Montaigu himself had a good library, which was confiscated by the Crown at the time of his death, and other members of the family were also bibliophiles. Two of his brothers were bishops. Gérard de Montaigu, who became Bishop of Poitiers in 1405 and of Paris in 1409 and who was Chancellor of the Duke of Berry, is regarded as the probable donor in the exhibition catalogue of 1904. He died in 1420. Boinet, however, in the *Bulletin* of 1922 points out that another brother is also a candidate for identification. This is Jean de Montaigu, who became Bishop of Chartres in 1390, Chancellor of France 1405-1409, Archbishop of Sens in 1407, and was killed at Agincourt in 1415. The available evidence is insufficient for a decision.

STYLE AND DATE: Although Durrieu's attribution to Jacques Coene is quoted in the 1904 catalogue he did not include the miniatures in his list of attributions to the Boucicaut Master. Bella Martens, however, did. The miniatures are rather the work of a somewhat mannered follower.

BIBLIOGRAPHY: Paris, Louvre, *Exposition*, 1904, p. 10 f. no. 25; Paris, Chambre des Députés, Boinet, 1922, p. 9 ff.; Martens, *Meister Francke*, 1929, p. 265 n. 485.

Paris

MUSÉE JACQUEMART-ANDRÉ, ms. 2
(Figs. 1-46, 48, 135)

Book of Hours, Use of Paris. 242 fols. The vellum is unusually heavy for a manuscript of this kind. 274 × 190 mm.

HISTORY: Many miniatures and initials show the motto 'ce que vous voudres' and the emblems of Jean le Meingre, Maréchal de Boucicaut, a spread eagle and a green and white checkered tablet. Frequently the motto was clumsily transformed by a later owner, Aymar de Poitiers, to 'sans nombre'. The arms too of the Maréchal: argent an eagle displayed gules beaked and membered azure, have disappeared below those of Aymar: azure a chief or six torteaux argent. A heavy, flat, opaque blue and a dull gilt cover the bright original charges, and they often impair the effect of the miniature. Aymar de Poitiers inserted his armorials more discreetly in other manuscripts in his collection, such as the *Livre de la chasse* (Bibl. nat., fr. 616) or the great *Bible moralisée* (Bibl. nat., fr. 166). Some of Aymar's shields in the *Boucicaut Hours* may have been introduced where there were none originally. The facts can be established only by microscopic study, but the shields on the prie-dieu on fols. 26v and 38v are remarkably clumsy (Villeneuve claimed, mistakenly I believe, that half of each of the shields on 26v goes back to the time of Boucicaut; nor can I detect, as he did, the arms of Beaufort-Turenne below those of Poitiers). Traces of the original light red eagle painted by the Boucicaut Master are visible below the shield of Aymar to the left of the Virgin in the *Pentecost*, and to the right of her an entire original half eagle has been left uncovered (Fig. 38). The original eagle is visible also in three shields of the *Trinity* (Fig. 39)

and there are traces of it in the lowest medallion in Sts. Peter and Paul (Fig. 5). The eagles of Aymar, on the other hand, are painted in a heavy brown.

The heraldic robes worn by the Maréchal and his wife on fol. 26v have been transformed by Aymar. The Poitiers motto 'sans nombre' has been painted over the Boucicaut 'ce que vous voudres' on fols. 17v, 26v, 35v, 37v, 95v, 112v. Boucicaut's emblem and motto have been left unchanged on fols. 42v and 53v, and, among the initials, on fols. 84 (Fig. 45) and 106. All the other initials have been more or less altered. Only strong designs would survive such mistreatment.

Both the Maréchal's wife and his only child, a son, predeceased him, and his property passed at his death in 1421 to his brother Geoffroy. Geoffroy, the husband of Isabeau de Poitiers, died in 1430, and their son Jean le Meingre added fols. 240-242, which include a portrait and his motto 'et puis ho la'. At the death of Jean in 1490 the manuscript came into the possession of his cousin, Aymar de Poitiers, seigneur of Saint-Vallier, whom we have mentioned above. From Aymar, the manuscript apparently passed from his son Jean de Poitiers to his granddaughter, the famous Diane de Poitiers, whose library was in the Château d'Anet. Subsequent owners are discussed by Guyot de Villeneuve, fols. 62 ff.

STYLE AND DATE: Nordenfalk proposed a date for the *Boucicaut Hours* during the Genoese stay of the Marshal (1401–1408) and Panofsky believed the manuscript was painted in three campaigns from 1400 to 1411, but most historians have accepted 1410, or 1410–1415, as the most probable date, without, however, offering any particular evidence. Despite the mastery the painter manifests in the *Boucicaut Hours* many aspects of the illumination indicate, I believe, that it is the earliest work by him that we possess, with the possible exception of two or three comparatively unimportant miniatures. The Book of Hours is more closely related than any other manuscript from the Master's workshop to the *Brussels Hours* by Jacquemart (finished by 1402) and to the miniatures by the Master of the Coronation and his circle of the very first years of the century. The *Boucicaut Hours* is also closest to Tuscan and Lombard painting. The miniatures vary more than those of other cycles by the workshop in mode and intention, manifesting the uncertainty, the eagerness to explore, of a great artist rather early in his career.

The execution of the illumination may have

continued over a period of two or three years. During this time the Master's style shows some development, but it is not constant. The miniatures that seem to be the most advanced – they are closest to works that are actually dated later – are the *Trinity* (fol. 118v) and *David before the Lord* (fol. 125v).

The presence of St. Bridget strongly suggests a date after 1401, when the Marshal settled in Genoa, for this saint was venerated there but not in France. The illumination beginning with the *Adoration of the Magi* was very probably painted after November 23, 1407, when Louis d'Orléans was assassinated, because the youngest Magus, apparently wearing the emblem (*bâton noueux*) of Louis, is dressed in black, and Boucicaut's eagle bears the same emblem in the initial at the beginning of the Office of the Dead. Joining these indications to those of style the most likely date seems 1405–1408.

BIBLIOGRAPHY: Paris, Louvre, *Exposition*, 1904, p. 32 no. 86; Durrieu, *Arts anciens de Flandre*, II [1906?], pp. 12-22; Durrieu, *Rev. de l'art a. et m.*, XIX, 1906, pp. 404-408; XX, 1906, pp. 21-35; Durrieu, 1912, pp. 90-96; Durrieu, *Rev. de l'art chrét.*, 1913, pp. 73-81, 145-164, 300-308; 1914, pp. 28-35; Martens, *Meister Francke*, 1929, I, pp. 95, 194 f., 215 n. 44, 237 f. n. 198, 256 n. 379, 265 f. n. 486, 267 nn. 526, 530; [Anon.], Thieme-Becker, XXXVII, 1950, p. 222 f.; Ring, *French Painting*, 1949, p. 196 no. 36; Baldass, *Jan van Eyck* [1952], pp. 7 f., 12 f.; Panofsky, *Netherlandish Painting*, 1953, I, pp. 54-61, and see index; Paris, Bibl. nat. (Porcher), 1955, pp. 97 f. no. 201; Winkler, 1955, p. 10 f.; Porcher, *Medieval French Miniatures* [1959], p. 69; Nordenfalk, 1961, p. 389 ff.

MINIATURES:

Folio 1 Arms of the Marquise de Verneuil (mistress of Henry IV)

 1v Notes on the birth of her children

Calendar. No illumination

Suffrages or *Intercessory Prayers to the Saints*

 9v St. Leonard with two prisoners

 11v St. Michael conquering the devil

 13v St. John the Baptist (silver in the stream has flaked and oxidized)

 15v St. John the Evangelist

 17v St. Peter and St. Paul

 18v St. James Major (a few lines of silver in the water have oxidized)

 19v Stoning of St. Stephen in the presence of Saul (later St. Paul; much pigment has flaked)

 20v Roasting of St. Lawrence (some abrasion, especially around center)

 21v Martydom of St. Sebastian

 23v St. George killing the dragon (a large spot of ink before the front hoofs of the horse)

 24v Martyrdom of St. Thomas of Canterbury (paint on and near figures damaged)

 26v The Marshal and his wife in prayer before the Madonna as the Apocalyptic Woman (the arms of Aymar de Poitiers have been painted over parts of both kneeling figures. A black line was added to strengthen the elbow of Antoinette de Turenne)

 28v St. Christopher

 29v Martyrdom of St. Pancras (a scroll bearing this saint's name was introduced near his head because the preceding prayer to St. Christopher is so long it left no space on folio 29 for a rubric)

 30v St. Peter Martyr (the white of his tunic has flaked, disclosing the gray drawing on parchment)

 31v St. Denis

 32v St. Augustine

 33v St. Nicholas reviving three young men

 34v St. Martin sharing his cloak with the beggar (water spot in upper right corner; considerable abrasion)

 35v St. Anthony Abbot

 36v St. Honoratus

 37v Stigmatization of St. Francis

 38v The Marshal in prayer before St. Catherine. The Marshal's *houppelande* bears green and white stripes

 40v Saints Catherine, Margaret, Martha, Christine, and Barbara (faces abraded)

 41v St. Mary Magdalene (white pattern has peeled from the silver of the floor, some retouching probable)

 42v An angel receiving the praying hands of St. Bridget

 43v St. William of Gellone (his helmet redrawn in ink, motto of Aymar de Poitiers written in sky at horizon)

Mass of the Virgin

> 46v The Virgin and Child enthroned with music-making angels

Hours of the Virgin

> 53v Annunciation (the flesh color of the Virgin's face is abraded, disclosing the green underpainting)
>
> 65v Visitation (most of the pinkish white pigment of the Virgin's tunic has been lost; the black ribbons of clouds are oxidized silver)
>
> 73v Adoration of the Child at the Nativity
>
> 79v Annunciation to the Shepherds
>
> 83v Adoration of the Magi
>
> 87v Presentation in the Temple
>
> 90v Flight into Egypt
>
> 95v Coronation of the Virgin (gilt scrolls on the tent added by Aymar de Poitiers; an area of damage in the floor; the numerous conspicuous black lines, especially around scrolls, mottoes, and shields, were added by Aymar's painter)

Hours of the Cross

> 105v Crucifixion

Hours of the Holy Ghost

> 112v Pentecost

Hours of the Trinity

> 118v Trinity

Penitential Psalms

> 125v King David has a vision of the Lord

Office of the Dead

> 142v Funeral service (the surface is damaged; much of the white pigment on the surplices has been lost; some of the drawing was strengthened later)

Abridged Psalter

> 171v St. Jerome in his study approached by the lion

Additions to the Original Manuscript

> 241 Jean le Meingre witnesses the Vision of St. Gregory
>
> 242 The holy wound and symbols of the Passion

Boucicaut Hours – Gatherings

Folios 1-7	Folios 126-134
8-11	135-142
12-19	143-150
20-27	151-158
28-35	159-165
36-43	166-175
44-53	176-183
54-61	184-192
62-69	193-207 (probably two
70-77	gatherings)
78-85	208-215
86-93	216-223
94-101	224-231
102-109	232-239
110-119	240-244 (late 15th
120-125	century

Paris

COLL. OF MADAME LA BARONNE DE CHARNACÉ (formerly Paul Durrieu)

(Figs. 131, 272-275)

Book of Hours, Use of Paris (so-called *Hours of the Order of the Holy Ghost*). Not paginated. 184 × 135 mm. 13 miniatures and calendar illustration; small illustrations of suffrages are by an inferior and negligible hand.

HISTORY: The manuscript was presumably executed for the woman who kneels in veneration before John the Baptist on the folio opposite the opening of the Hours of the Virgin. She is accompanied by five young women and four young men, who probably represent her family, but none bears any mark of identification. The book was in Durrieu's possession in 1913, when he compiled his final list of manuscripts attributable to the Boucicaut workshop. He gave it the title of *Livre d'Heures dit de l'Ordre du Saint-Esprit* because it was thus inscribed during a late sixteenth-century rebinding, when it was also embellished with the insignia of the *Ordre du Saint-Esprit* founded by Henri III.

STYLE AND DATE: Though the illuminator adopted for several miniatures the patterns of the earlier phase of the Boucicaut workshop there is much in his work that could have been accomplished only around 1415, or even later. The transformation of the *Nativity* into the *Preparation of the Child's Bath* occurs first in

Arsenal 623 of 1412 and then in Bibl. nat., lat. 10538 and the Book of Hours in the Victoria and Albert Museum. Christ clasping the joined hands of the Virgin in the *Coronation* may be seen in Mazarine 469 (Figs. 268, 275). The beautiful *Annunciation* shows the relatively consistent structure of the late works. Even God the Father is allotted an architectural space; he and his cherubim occupy the tympanum, below the star-studded vaults. The attenuation of the figures, notably the Baptist (Fig. 274) and the Virgin in the *Flight*, conforms with the general tendency of French illumination around 1420. A much weaker member of the workshop (influenced by the Egerton Master) painted the calendar and the smaller miniatures (which do not appear in the following list).

BIBLIOGRAPHY: Durrieu, 1914, p. 28; Toesca, 1917, p. 122; Paris, Bibl. nat. (Porcher), 1955, p. 99, no. 206.

MINIATURES:

Verso: John the Baptist preaching to a group of young people accompanied by a woman
Recto: Annunciation } These two miniatures face one another

Visitation (badly re-painted)
Preparing the bath after the Nativity
Annunciation to the Shepherds
Adoration of the Magi
Presentation in the Temple
Flight into Egypt
Coronation of the Virgin
King David in prayer
Crucifixion (damaged)
Pentecost
Virgin and Child enthroned under canopy with angels

Paris

COLL. OF COUNT JEAN DURRIEU (formerly Paul Durrieu) (Figs. 251-252)

Book of Hours. Not paginated. 190 × 135 mm. 8 miniatures

HISTORY: This manuscript was in Paul Durrieu's private collection in 1906 and it appeared in all his lists of manuscripts attributed to the Boucicaut work-shop. Its Use, he said, was Paris, but the catalogue of the Paris exhibition of 1955 described the Use as Nantes, with Vigils of the Dead for the Use of Paris. It has not been possible to verify these facts.

STYLE AND DATE: Three miniatures (*King David in Prayer, Crucifixion* and *Pentecost*) are in the Boucicaut style. Though ascribed by previous scholars to the Boucicaut Master, they seem only workshop products. The remainder were executed by followers of the Bedford and Egerton Masters, workshops that frequently collaborated with that of the Boucicaut Master. The manuscript was illuminated probably towards 1415.

BIBLIOGRAPHY: Durrieu, *Arts anciens de Flandre*, II [1906?], p. 17; Durrieu, *Rev. de l'art a. et m.*, XX, 1906, p. 24; Durrieu, 1914, p. 28; Paris, Bibl. nat. (Porcher), 1955, p. 99 no. 207.

MINIATURES:

Man of Sorrows (follower of Egerton Master)
Annunciation (follower of Bedford Master)
King David in prayer (Boucicaut workshop)
Crucifixion (Boucicaut workshop)
Pentecost (Boucicaut workshop)
Illustration of Office of the Dead (follower of Bedford Master)
Martyrdom of St. Sebastian (follower of Egerton Master)
St. Christopher (follower of Egerton Master)

Peterborough

MUSEUM AND ART GALLERY (Fig. 321)

Book of Hours, Use of Paris. 197 fols.; 200 × 149 mm. 13 miniatures

HISTORY: There are no indications of original ownership. The manuscript was in the Sibthorp collection in England at least from the early years of the nineteenth century, and it belonged subsequently to Chester Beatty. Its resemblance to manuscripts from the Boucicaut workshop was then recognized.

STYLE AND DATE: The manuscript is a relatively late, routine product of the workshop. The border of fol. 96, with medallions set amidst vines and narrow leaves, resembles the Book of Hours Mazarine, ms. 469. *Pentecost* shows an advanced type of interior and the Dove enters through the open window in a

rather naturalistic manner. The figures recall those in the *Corsini Hours*. An assistant who was responsible for certain miniatures in the *Heures de Guise* (Chantilly, Musée Condé, ms. 64) would seem to have painted the *Coronation of the Virgin*, where his characteristic 'Punch'-like features appear, and the two manuscripts seem to be of approximately the same date (*ca.* 1418).

BIBLIOGRAPHY: London, Sotheby, Wilkenson and Hodge, January 30, 1920, lot 131; London, Sotheby, June 7, 1932, lot 23.

MINIATURES:

Folio 13 St. John
15 St. Luke
17 St. Mark
51 Visitation
62v Nativity
69 Annunciation to the Shepherds
74 Adoration of the Kings
83 Flight into Egypt
90 Coronation of the Virgin
96 King David in landscape kneels to God the Father in heaven
123 Pentecost
176 Virgin of Humility nurses the Christ Child while angel plays organ (Fifteen Joys)
182 Christ displays his wounds and angels carry symbols of the passion (Five Wounds)

Ripon (Yorkshire)

ESTATE OF H. L. BRADFER-LAWRENCE
(Figs. 124, 249, 250)

Book of Hours, Use of Rome. 194 fols.; 170 × 120 mm. 12 miniatures

HISTORY: There are no indications of original ownership.

STYLE AND DATE: The manuscript passed through London sale rooms twice during the last twenty years, and its relationship to the style of the Boucicaut Master was then recognized. It must be regarded as an attractive but perfunctory production of the workshop. A date earlier than about 1412 is unlikely; the border on fol. 27 with proportionately large pseudo-

acanthus leaves is of a type more popular after that date than before it.

BIBLIOGRAPHY: London, Sotheby, July 12, 1948, lot 59; Panofsky, *Netherlandish Painting*, 1953, I, p. 54 n. 1; London, Martin Breslauer, *Catalogue Eighty* (n.d.), no. 1.

MINIATURES:

Folio 27 Annunciation
47 Visitation
60 Nativity
65v Annunciation to the Shepherds
70v Adoration of the Magi
75v Presentation in the Temple
80 Flight into Egypt
88v Coronation of the Virgin
103 David in penitence
124v Crucifixion
132 Pentecost
138 Illustration of Office of the Dead

Seville

BIBL. COLOMBINA
(Fig. 230)

Book of Hours. 168 fols.; 165 × 120 mm. 22 miniatures

STYLE AND DATE: Only one miniature in the Boucicaut style in this manuscript is noteworthy. To illustrate the Penitential Psalms it shows the novel scene of a man (David?) in bed praying to Christ, who appears in the heaven above. The miniature is outstanding stylistically, and seems to imply an intervention of the Boucicaut Master, though this opinion must remain tentative until the writer can study the manuscript itself. The *rinceaux* and quatrefoils on gold that surround this miniature may be found in other Boucicaut manuscripts illuminated around 1410.

BIBLIOGRAPHY: J. van den Gheyn, *Annales de l'Académie Royale d'Archéologie de Belgique*, LVIII, 1906–1907, p. 326; Durrieu, *Rev. de l'art chrét.*, 1913, p. 314; Domínguez Bordona, *Manuscritos con pinturas*, 1933, p. 143 f. (no. 1717).

MINIATURES:

Folio 13 St. John the Evangelist (Egerton workshop)
15 St. Luke (Egerton workshop)

17 St. Matthew (Egerton workshop)
19v St. Mark (Egerton workshop)
 (Annunciation missing)
42 Visitation (Egerton workshop)
47v Nativity (Boucicaut follower)
55v Annunciation to the Shepherds (related
 to Egerton – repainted?)
61v Adoration of the Magi (Boucicaut fol-
 lower)
67v Massacre of the Innocents (Egerton
 workshop)
80 Presentation in the Temple (Egerton
 workshop)
94 Pentecost (Boucicaut follower)
105v Coronation of the Virgin (Egerton
 workshop)
106 Dying man (David?) before the Lord.
 In the quatrefoils David playing the
 harp, praying, and an angel (Bouci-
 caut workshop)
158v Trinity (Boucicaut follower)
159v Death of the Virgin (Boucicaut follower)
160v St. Michael
161v St. John the Baptist (follower of the
 Egerton Master)
162v Stoning of St. Stephen (follower of the
 Egerton Master)
163v Martyrdom of St. Lawrence (follower
 of the Egerton Master)
165v St. Ive (follower of the Egerton Master)
166v Male donor praying before St. Catherine
 of Alexandria (follower of the Egerton
 Master)
167v St. Margaret (Egerton workshop)

Turin

BIBL. REALE, Var. 74 (originally part of ms. Var.
77) (Figs. 186, 187)

Small miniatures and initials from a Book of Hours

HISTORY: In 1912 Toesca attributed the five minia-
tures under this number to the Boucicaut Master and
suggested that they might have been removed from
the *Visconti Hours* (Turin, Bibl. Reale, Var. 77). This
suggestion can be converted into fact. The precise
patterns of these initials recur in the *Visconti Hours*,
and the Italian script of that *Horae* appears on the
backs of these miniatures. The *bas-de-page* of the
Betrayal corresponds in size to the *Burial* in ms. 77.

Finally, the combination of Boucicaut miniatures
and Italian script is otherwise unknown.
Two of the historiated initials belong to this same
cycle and show the *Way to Calvary* (Bedford trend)
and the *Flagellation*. The three remaining miniatures
represent scenes of preaching, and may possibly have
been associated with readings from the Gospels. Only
three of these five historiated initials were exhibited
in Rome in 1953. The large miniature of a Crucifixion
associated with them in the library under the same
number is, however, Dutch of *ca.* 1400.

BIBLIOGRAPHY: Toesca, *Lombardia*, 1912, p. 413 n.
5; Durrieu, *Rev. de l'art chrét.*, 1913, p. 314; Rome,
Pal. Venezia, *Mostra della miniatura* [1953], p. 284
no. 451; Milan, Pal. Reale, *Arte lombarda* [1958], p.
38.

MINIATURES:

Folio 1 Crucifixion (Dutch, early fifteenth cen-
 tury, probably from another manu-
 script)
 2 Flagellation. Initial [damaged] (Boucicaut
 workshop)
 3 Saint celebrates Mass (Boucicaut work-
 shop)
 4 Saint preaching (Boucicaut workshop)
 5 Saint preaching (Boucicaut workshop)
 6 Saint preaching (Boucicaut workshop)
 7 Betrayal and Flight of the Apostles
 [damaged] (Boucicaut workshop)
 8 Way to Calvary. Initial (Bedford trend)

Turin

BIBL. REALE, Var. 77 (Figs. 122, 143, 156, 183-185)

Book of Hours, Use of Rome. 71 fols.; 195 × 140 mm.
9 historiated initials and one marginal vignette. The
manuscript originally contained the five miniatures and
two initials now ms. Var. 74.

HISTORY: The manuscript is written in an Italian
script and bears the arms of the Visconti family of
Milan. As Durrieu recognized, however, the minia-
tures and marginal decoration are in the style of
the Boucicaut Master and his workshop. The case
for the identification of the Boucicaut Master with
Jacques Coene, who is known to have been in Milan
in 1399, is strengthened by the existence of this
Visconti book. The manuscript has usually been

attributed, without adequate reason, to the turn of the century, and the arms would then refer to Gian Galeazzo Visconti (d. 1402). The dead figure in the *Funeral Service* (fol. 49) wears a crown.

STYLE AND DATE: Though the script is Italian the manuscript could have been illuminated in Paris. It would seem to be one of the comparatively early surviving works by the Boucicaut workshop, but the advanced character of the landscape in the *Annunciation to the Shepherds* indicates a date no earlier than the *Boucicaut Hours* itself. The illustration of the Office of the Dead is related to that in the *Belles Heures*, on which the Limbourgs worked around 1408–1411. Probably 1410–1411 would be the right period for the Visconti Hours also.

BIBLIOGRAPHY: Durrieu, *Arts anciens de Flandre*, II [1906?], p. 18; Durrieu, *Rev. de l'art a. et m.*, XX, 1906, p. 25 f.; Toesca, *Lombardia*, 1912, p. 413 n. 5; Durrieu, *Rev. de l'art chrét.*, 1913, p. 314; Rome, Pal. Venezia, *Mostra della miniatura* [1953], p. 284 no. 451; Milan, Pal. Reale, *Arte lombarda* [1958], p. 38 f.

MINIATURES:

Folio 1 Annunication; lower border: arms of the Visconti of Milan
16 Adoration of the Child
18v Annunciation to the Shepherds
21 Adoration of the Magi
23 Presentation in the Temple
25v Flight into Egypt
29 Coronation of the Virgin
37 Last Judgment (Penitential Psalms)
49 Funeral service of a king (in pink mantle); *bas-de-page*: two monks present at the burial of a naked corpse, three crosses in background

Washington, D.C.

LIBRARY OF CONGRESS, ms. acc. 4560 (7)
(Figs. 165, 296-298)

Book of Hours, Use of Paris. 221 fols.; 133 × 102 mm. 5 miniatures (the others were removed from the book)

STYLE AND DATE: These miniatures were ascribed to the Boucicaut workshop in 1966 by M. Marcel Thomas, who called them to my attention and generously permitted me to include them in this book. The style of the borders as well as of the miniatures seems to imply a date towards 1420.

BIBLIOGRAPHY: De Ricci, *Census*, I, 1935, p. 235 no. 120; Supplement, 1962, p. 120, no. 92; Baltimore, Walters (Miner), 1949, p. 35 no. 92.

MINIATURES:

Folio 21 Annunciation — damaged (Boucicaut workshop)
33 Visitation (Boucicaut workshop)
45v Nativity (Boucicaut workshop)
93 Dead man and the battle for his soul (Boucicaut follower)
176v Trinity (Boucicaut workshop)

WHEREABOUTS UNKNOWN (formerly New York, H. P. Kraus) (Figs. 235, 236)

Book of Hours, Use of Paris. 197 fols.; 189 × 140 mm. 46 miniatures

HISTORY: The original owner is portrayed in veneration before the Virgin on fols. 4 and 6, but there are no indications of the lady's identity.

STYLE AND DATE. This Book of Hours is elaborate and iconographically exceptional, and although it was clearly produced on commission none of the major illuminators participated personally in its execution. Three miniatures are influenced by the Boucicaut Master's style. The *Annunciation* reflects the same scene in the *Belles Heures* by the Limbourgs, with which it shares 'acanthus' architectural ornament and a broad border with busts of angels who make music. Among Boucicaut manuscripts a similar border appears in the Berlin Book of Hours (Kupferstichkab., ms. 78.C.4). The relatively naturalistic foliage in the border around another miniature in the Boucicaut style (fol. 88) may be seen in a late Book of Hours by the Boucicaut Master himself (London, British Museum, Add. 16697).

Many of the miniatures were painted by an illuminator who was influenced by the Egerton Master but who still preserves compositions and motifs of the late fourteenth and very early fifteenth centuries. The Gothic throne of the *Coronation*, for example, belongs to that period, and the angels reflect the figures of the early painters of Jean de Berry. The manuscript was nevertheless painted after 1409, when the Boucicaut workshop collaborated on the *Grandes Heures* for the Duke of Berry, and when the Limbourgs were working on the *Belles Heures*.

The Job cycle in the Office of the Dead is unique.
In the borders the silhouette of a drollery appearing
on the recto of a folio frequently corresponds to and
determines that of another drollery on its verso.
This kind of mechanical economy was practiced also
in the *Heures de Guise* (Chantilly, Musée Condé, ms.
64).

BIBLIOGRAPHY: London, Sotheby, December 7,
1953, lot 52; New York, Kraus, *Catalogue 100*
[1962], p. 49 no. 23.

MINIATURES:

Folio 13 St. John
 14v St. Matthew
 16 St. Luke
 17v St. Mark
 19 Virgin and Child with donor
 23 Virgin and Child with donor
 27 Annunciation (Boucicaut follower)
 48v Visitation
 58v Nativity
 64v Annunciation to the Shepherds
 67 Presentation in the Temple
 76 Flight into Egypt
 82v Coronation of the Virgin
 88 God the Father (Boucicaut follower)
 104v Crucifixion
 110 Pentecost

 114v Virgin and Child
 119v Christ in Glory on the Rainbow
 123 Illustration of Office of the Dead
 135 Job praying
 136v Job meditating
 138 Job pointing to the earth
 144 Job pointing to a cloak
 145v Job pointing to flowers
 147 Job pointing to a corpse
 153v Job pointing to a tomb
 155 Job on the dunghill
 156v Job pointing to the mouth of Hell
 158v David in prayer
 171 Priest celebrating mass
 173v Illustration of Office of the Dead
 181v Priest at the altar (Boucicaut follower)
 184 Trinity
 185 St. John the Baptist
 186 St. John the Evangelist
 187 St. Matthias
 188 St. Peter and St. Paul
 189 St. Matthew
 190 St. Thomas
 191 St. Philip and St. James
 192 St. George
 193 St. Nicholas
 194 St. Stephen
 195 St. Mark
 196 St. Mary Magdalene
 197 St. Catherine

SOME MINIATURES OF THE BOUCICAUT CIRCLE

AN ANNOTATED LIST

This list contains miniatures and manuscripts not included in the Catalogue and not classified, if they are mentioned at all, in the text. They do not seem of great interest either for their quality, their iconography, or for the information they give us about the career of the Boucicaut Master. The style of some of them is rather close to the Master: this is true of an *Adoration of the Magi* belonging to Mrs. Rosy Schilling, the calendar scenes in Bibl. nat., lat. 10529, and a miniature from a *Cité de Dieu* formerly in the collection of C. L. Ricketts, Chicago. Others, formerly ascribed to the Boucicaut Master, seem to me so remote from him that the ascription is misleading. Between these two categories fall numerous other works at almost all conceivable distances.

This list makes no attempt to include all the dozens of manuscripts that are connected with the Boucicaut workshop in one way or another.

BOURNEMOUTH (formerly). H. G. Commin, Sale Catalogue 133, 1949, no. 2.
Nativity and *Funeral Service*.
Follower.

BRUSSELS, Bibl. Roy. 11140.
Though ascribed to the Boucicaut workshop by Delaissé (1956, p. 242) the miniatures are influenced by the Master of the Coronation.

CHICAGO (formerly). C. L. Ricketts.
Miniature from a *Cité de Dieu*.
See below: Whereabouts Unknown.

CLEVELAND, Museum of Art.
Four miniatures from a Book of Hours, 53.366, 53.367, 55.79, 55.80.
Close Follower.

CLEVELAND, Museum of Art.
Four miniatures from a Book of Hours, 42.169.
Mediocre follower. (For both these Cleveland groups see Delaissé, 1960, p. 97 f.; Cleveland, *Gothic Art 1360–1440*, 1963, p. 202.)

JENA, Universitätsbibliothek. Ms. El.f.86.
Légende dorée.
Follower, *circa* 1425.

LONDON, Courtauld Institute (formerly Gambier-Parry).
Nine miniatures from a Book of Hours. Ascribed by

K. Morand (*Burl. Mag.*, CIX, 1967, p. 174) to the Boucicaut workshop.
Followers.

LONDON, Mrs. Rosy Schilling.
Adoration of the Magi.
Close follower.

LONDON, Mrs. Scudamore.
Horae.
Follower.
(On loan to Victoria and Albert Museum, September 1967.)

MODENA, Bibl. Estense, lat. 893.
Book of Hours.
Follower.

NEW YORK, Pierpont Morgan Library, ms. 455.
Horae.
Follower and Master of the Harvard Hannibal.

OXFORD, Bodl. Library. Douce 215.
The miniatures on fols. 3v and 32 described as 'fine miniatures by the school of the Boucicaut Master' by Pächt and Alexander (*Bodleian Library*, 1966, p. 44 no. 571) seem to me mediocre and unrelated.

OXFORD, Bodl. Library. Rawl. Liturg. e 24.
Horae. Annunciation (ascribed to Boucicaut Master by Pächt and Alexander, *Bodleian Library*, 1966, p. 52 no. 664) is rather the work of a follower.

PARIS, Bibl. de l'École des Beaux-Arts, Fond Le Soufaché 483.
Horae, fol. 111.
Boucicaut Workshop.

PARIS, Bibl. nat., lat. 10529.
Calendar.
Boucicaut Workshop.

PHILADELPHIA, Free Library. Widener no. 6.
Horae.
Ascribed to the Boucicaut Master by Durrieu, but by a rather late follower (see Chapter I, n. 6).

SAN MARINO (Cal.). Huntington Library, mss. HM1099 and HM1137.

Two Books of Hours.
Followers.

WHEREABOUTS UNKNOWN. 4 folios of a *Cité de Dieu*. 463 × 340 mm.
See Laborde, *Cité de Dieu*, I, p. 288, pl. XIX; Ricci, *Census*, I, 1935, p. 642 no. 164. See also Chicago (formerly), C. L. Ricketts.
Follower.

WHEREABOUTS UNKNOWN.
Horae.
See Delaissé, 1948, p. 78 ff.
Workshop.

APPENDIX TO CHAPTER V
DOCUMENTS ON JACQUES COENE

DOCUMENT I

April 13, 1399. 'Deliberaverunt quod ille pinctor nationis Flandriæ nominatus Jacobus Cova, commorans Parisii, cum duobus discipulis suis, acceptetur et tollantur pro inzigneriis fabricæ cum salario francorum 24 seu florenorum 24 ad computum s. 32 pro quolibet floreno quolibet mense, et similiter acceptetur et tollatur pro inzignerio fabricæ ille Johannes Companiosus nationis Normaniæ, cum suo sotio nationis Parisii, vocatus Johannes Mignotus, cum salario francorum seu florenorum 20 quolibet mense, pro persona sua tantum cum uno bachalari quem secum conducere volunt.' (*Annali della fabbrica del Duomo di Milano*, I, 1877, p. 194.)

DOCUMENT 2

July 20, 1399. 'Quod magister Jacobus Cova de Bruges proquo alias missum fuit cum litteris Johannes Alcherii, et pactis factis per eum nomine fabricae incipiat die crastina designare ecclesiam a fundamento usque ad summitatem. (*Ibid.*, I, p. 197.)

DOCUMENT 3

September 1399. 'Preso a servizio Jacobo Cona de Flandria pinctori, dategli I. 16 a conto. – Magistro Jacobo Cona de Bruges pinctor, solitus habitare Parixius, pro se et uno famulo, qui decesserunt a Parixius die 20 julii p. p., ut patet per litteras Johannis Alcherii datas Parixius die 30 julii, et accesserunt Mediolanum die 7 augusti, I. 52 per due mesi (parti da Parigi e giunse a Milano col Mignotto).' (*Ibid.*, *Appendici*, I, 1883, p. 246.)

DOCUMENT 4

September 14, 1399. 'Pagarsi i maestri Giovanni Mignoto di Parigi, et Giacomo Cova di Bruges pittori, soliti dimorare in Parigi, che ne partirono il 21 luglio e arrivarono a Milano il 7 agosto, il convenuto salario di fior. 20 al mese al Mignoto, di flor. 25 al Cova col suo domestico.' (*Annali*, I, 1877, p. 197 f.)

DOCUMENT 5

May 22, 1407. 'A Jaques Rapponde, la somme de LX fr. d'or, lesquelz du commandement de feu mons. le duc, cui Dieu perdoint! et par ordonnance de maistre Jehan Durant, conseiller de mondit Sr, ycellui Jaques bailla et délivra pour faire ystoires en la Bible en latin et en françoiz que ledit feu Monsr faisoit faire; laquelle mondit Sr. a donnée à Monsr de Berry; aux personnes qui s'ensivent, c'est assavoir: à Ymbert Stanier, enlumineur, XXIIII fr. le premier jour de mars mil cccc et III. Item, le IIIe jour dudid mois en suivant à Jacques Cone, paintre, XX fr. Item à Hainsselin de Haguenot, enlumineur, le XVIIe jour de mai mil cccc et quatre, XVI fr. Pour ce, par mandement de mondit Sr donné à Conflans-lez-Paris le XXIIe jour de mai, mil cccc et sept.' (*Archives de la Côte-d'Or*, B.1547, fol. 142v.) The summary of this document given by G. Peignot, *Bibliothèque des ducs de Bourgogne*, 1841, p. 33, is ambiguous. Prost, 1891, pp. 343-344 n. 9, read 'pour faire ystorier' but Champeaux and Gauchery, *Travaux*, 1894, p. 121 f., as well as Monget, *Chartreuse de Dijon*, II, 1901, p. 27, independently read 'pour faire histoires'.

FRENCH WORKSHOPS:
ADDITIONS TO LISTS PUBLISHED IN
'LATE FOURTEENTH CENTURY'

BRUSSELS INITIALS MASTER

Amsterdam, Rijksmuseum, Prentenkabinet	37.1	A prophet (from the same ms. as Cini and Maggs cuttings)
Oxford, Bodleian Library	e Mus. 43	*Songe du Vergier* (Pächt and Alexander, 1966, p. 50)

MASTER OF THE HARVARD HANNIBAL

Cambridge, Mass., Harvard College Library	Richardson 32, Vol. II, fol. 263	*Tite-Live*
Lisbon, Gulbenkian Foundation	L.A. 143	*Cleres femmes*
New York, Morgan Library	M 455	*Horae*

OROSIUS MASTER

Châteauroux, Bibliothèque municipale	ms. 2	Breviary
Geneva, Bibliothèque publique et universitaire	fr. 77, fol. 46v	*Tite-Live*
Paris, Bibliothèque nationale	fr. 301	*Histoires d'Orose*
Paris, Bibliothèque nationale	lat. 9321	Boethius, *De Consolatione*
Philadelphia, Museum of Art	'46-65-1	*Cité de Dieu*
Vienna, Nationalbibliothek	1254	Breviary of Benedict XIII

PSEUDO-JACQUEMART

Paris, Bibliothèque nationale	fr. 170, fol. 1	*Cité de Dieu*
Paris, formerly Alexandrine Rothschild		*Horae*

VIRGIL MASTER

Brussels, Bibliothèque Royale	ms. 9001	*Bible Historiale*
Cambridge, Trinity College	B.II. 31	*Horae*
Paris, Bibliothèque nationale	Nouv. acq. lat. 3107	*Horae*

Errata

Brussels, Bibliothèque Royale, ms. 9049-50 contains some miniatures related to the Master of Berry's Cleres Femmes, not to the Coronation Master.

Paris, Bibliothèque nationale, fr. 606 and 835-836 are inadvertently included among the works of the Master of the Cité des Dames, to which they are only related (for the correct listing see *ibid.*, p. 358, Épître Master).

NOTES TO THE TEXT

NOTES TO INTRODUCTION

1. See *Late XIV Century*, p. 27.

2. *Ibid.*, p. 294, and Champeaux and Gauchery, *Travaux*, p. 138.

3. See below, p. 61.

4. *Late XIV Century*, p. 46.

5. *Ibid.*, pp. 33 ff., 347.

6. In 1889 Durrieu ascribed the Boucicaut Master's Livy in the Phillipps Collection (see the present catalogue, p. 75) to the Limbourgs, but this error occurred at the very beginning of his work. There are two mistakes in his article of 1914 (pp. 25 f.). He gave to the Boucicaut Master a Book of Hours known to him only in photographs; the ms. was, he said, in the collection of J. P. Morgan, and it had earlier been in the Chapter Library of the Cathedral of Bayeux (cf. *Catalogue général des manuscrits des bibliothèques publiques de France*, Paris, x, 1889, pp. 338 f.). Because of the identity of contents and of an inscription this ms. is the same as the Book of Hours that is now Widener No. 6 in the Free Library of Philadelphia (cf. De Ricci, *Census*, II, 1937, p. 2116). The ms. was previously in the collection of Peter Widener in the same city. It contains no miniatures by the Boucicaut Master or workshop. Some are by a follower, others by a follower of the Egerton Master.

NOTES TO CHAPTER I

1. Another instance is the Beaufort Hours, Brit. Mus. Royal 2 A XVIII, English towards 1410 (London, Brit. Mus., Warner and Gilson, 1921, I, p. 32).

2. See the catalogue, p. 131, and Guyot de Villeneuve, fols. 8 ff.

3. The document concerns the founding of anniversaries in the family chapel in St. Martin at Tours, where the Marshal's father, his wife, and his brother were buried. See Guyot de Villeneuve, fol. 88.

4. *Livre des faicts*, 1850, p. 231.

5. The date March 10, 1409 (n.s.) is mentioned in the third of the four parts of the text, at the end of chapter xx. See *ibid.*, pp. 205 ff.

6. The 'journal et ung cahier de parchemin' ready for further entries were bequeathed by the Marshal in a codicil of 1421 to his will (Guyot de Villeneuve, fols. 97 ff.).

7. Poirion, *Le poète et le prince*, 1965, p. 146.

8. *Livre des faicts*, p. 319.

9. P. 318. This passage was quoted by Nordenfalk, 'St. Bridget of Sweden', in *De Artibus Opuscula XL*, 1961, p. 391.

10. Dated 1407 and 1416. See Justel, *Turenne*, 1645, p. 139, and Guyot de Villeneuve, fol. 83.

11. Paris, Arch. nat., K, 53, 88. See Guyot de Villeneuve, fols. 22 f.

12. See the extracts from Raymond's will of 1399 in Justel, *Turenne*, 1645, p. 135, and in Guyot de Villeneuve, fols. 25 f.

13. Statement of Raymond of 1407. Bibl. nat., Archives de la maison de Turenne, Baluze XXIII, p. 148. See Guyot de Villeneuve, fol. 79.

14. Justel, *Turenne*, 1645, p. 134 f.; Guyot de Villeneuve, fol. 25. For the conflict of Boucicaut and Raymond in Provence see Busquet, *Histoire de Provence*, 1954, pp. 204-206.

15. See a letter of 1401 of Jean de Berry. Justel, *Turenne*, 1645, p. 135; Guyot de Villeneuve, fol. 26.

16. Guyot de Villeneuve, fol. 79.

17. These fragments, mentioned by Durrieu when they were in the Economos Collection in Paris (*Rev. de l'art chrét.*, 1913, p. 76), are now in the Metropolitan Museum of Art, the Boston Museum of Fine Arts, the Rhode Island School of Design, and elsewhere.

18. Panofsky, *Netherlandish Painting*, 1953, I, p. 60. It should be added that one other manuscript that belonged to the Marshal has survived: a *Livre de l'information des princes*, Grenoble, Bibl. publique, ms. no. 870 (see France, Ministère de l'Éducation, *Catalogue général des manuscrits des bibliothèques publiques de France. Départements . . .*, VII, 1889, p. 261). The miniatures, *circa* 1410 and related in style to that of the Apocalypse Master, are mediocre. Three initials show the silver double-eagle of Boucicaut. This is very probably the manuscript mentioned in Boucicaut's will (Guyot de Villeneuve, fol. 98).

19. Guyot de Villeneuve ascribes it to the intervention of Antoinette.

20. '... autour du bras une targe d'or esmaillée de verd, à tout une dame blanche dedans'. See *Livre des faicts*, part I, chaps. 38-39. The *Livre* does not substantiate the view of Nordenfalk, *op. cit.*, p. 392, that the order was dedicated to St. Catherine.

21. He always held this position because, among other things, the rubric appears at the beginning of the prayer to him on the facing folio rather than on the folio preceding the miniature, as in the rest of the series of saints except the second (Michael) which resembles Leonard.

22. *Livre des faicts*, p. 242. There was, however, a tradition for representing prisoners in undershorts, when with St. Leonard also (see for example the Hours of Jeanne de Navarre [Cockerell, 1902, p. 177]). Sometimes Leonard holds only chains (Fig. 474).

23. See Nordenfalk, *op. cit.*, p. 391.

24. Nordenfalk, *op. cit.*, p. 392, tends to prefer the fact that Honorat was the apostle of Lérins, islands captured by Genoa in 1400.

25. She gave funds for a chalice to St. Antoine de Viennois (Guyot de Villeneuve, fol. 81).

26. *Table des noms historiques*, in Froissart, *Œuvres*, ed. Lettenhove, xx, 1875, p. 371.

27. For St. Pancras in Tours see *Les Petits Bollandistes*, v, Paris, 1885, p. 488, and for the saint in Books of Hours see Leroquais, *Livres d'heures*, 1927.

28. D. Castagna and M. Masini, *Guida di Genova*, Genoa, 1929, p. 304.

29. *Op. cit.*, p. 392. It may be added that Leroquais lists no St. Bridget of Sweden in either his *Livres d'heures* or his *Bréviaires*.

30. The period 1410-1415 has been favored by (to cite only more recent opinion) Ring, *French Painting*, 1949, p. 196, no. 36; L. Baldass, *Jan van Eyck*, London [1952], pp. 7 f.; Paris, Bibl. nat. (Porcher), 1955, pp. 97 f.; F. Winkler, 1955, pp. 10 f.; Porcher, *Medieval French Miniatures* [1959], p. 69. Nordenfalk, 1961, p. 392, proposed the Genoese period (1401-1408), while Panofsky, *Netherlandish Painting*, 1953, argued for three campaigns from 1400 to 1410. For Panofsky's hypothesis see below, p. 20 and note 69.

31. Panofsky, *Netherlandish Painting*, 1953, I, p. 55 n. 5, suggests it may be simply a rustic circlet.

32. I thank Professor Nordenfalk for permitting me to refer to his *hypothèse de travail* and for the photograph of the collar. If the Hohenlohe necklace is really as late as 1440-1450, the date recently assigned to it by the authorities on *orfèvrerie* (T. Müller and E. Steingräber, 'Die französische Goldemailplastik um 1400',

Münchner Jahrbuch der bildenden Kunst, v, 1954, p. 75 no. 21, fig. 48), the relation to Louis d'Orléans and hence the significance and even identity of the emblems become unclear. Nordenfalk has kindly reminded me that in the miniature by the Épître Master in fr. 606, fol. 1, Louis d'Orléans wears as pendant another emblem – the porcupine, badge of an order he created in 1391.

For the emblem of Philip I see Chantilly, *Manuscrits à peintures* (J. Meurgey), 1930, p. 173. I am much indebted to Baron Meurgey de Tupigny, president of the Société Française d'Héraldique et de Sigillographie, for valuable counsel on emblems. The *bâton noueux* as the badge of Louis d'Orléans is cited by Vulson de la Columbière, *La science héroïque*, Paris, 1669, p. 506, and by H. Tausin, *Supplément au dictionnaire des devises historiques et héraldiques*, Paris, 1895, p. 258. The motto of Louis was 'je l'envie' (rather than 'je l'ennuie', which is sometimes given).

33. London, Zwemmer Coll., fol. 72; Paris, Bibl. nat., lat. 1161, fol. 79; Turin, Bibl. Reale, var. 77, fol. 21; Seville, Bibl. Colombina, Bordona, no. 1717, fol. 61v.

34. Black may signify evil also. It has no negative meaning, however, in the representation of one Magus as a Moor, which began to be popular from the later fourteenth century on (H. Kehrer, *Die heiligen drei Könige*, Leipzig, II, 1909, p. 223).

In the *Très Riches Heures* the youngest Magus wears deep blue-black sprinkled with gold.

35. In 1389 Louis offered a fund to the 'chevalier Boucicaut', and in 1396 he gave the Marshal a *houppelande* trimmed with fur (A. Champollion-Figeac, *Louis et Charles, Ducs d'Orléans*, Paris, 1884, pp. 56, 114). In 1393 Louis paid Boucicaut 2000 francs for tennis 'pour cause de jeu de paulme' (see Comte de Laborde, *Ducs de Bourgogne*, Paris, 1852, III, no. 5547a). In 1398 Louis appointed Boucicaut lieutenant of Guyenne (M. Nordberg, *Les ducs et la royauté*, Uppsala, 1964, p. 50). It should be recalled here that Boucicaut owed his life after the defeat at Nicopolis to Jean sans Peur.

36. Lavisse, *Histoire de France depuis les origines jusqu'à la révolution*, IV, part I, Paris, n.d., pp. 312 ff.

37. *Ibid.*, p. 313. Jarry, *Vie de Louis d'Orléans*, 1889, *passim*. *Livre des Faicts*, p. 302.

38. Nordberg, *op. cit.*, pp. 49, 192.

39. See the extraordinary praise of Charles in Boucicaut's will (Guyot de Villeneuve, fol. 98). In 1412 the Marshal stood with the King and Jean sans Peur against the Armagnacs. The *Livre des faicts* (chap.

xii) declares that both Louis d'Orléans and Jean sans Peur were annoyed with the Marshal in 1406 because he had not sufficiently supported the Pisans against the Florentines.

40. See R. Delachenal, *Histoire de Charles V*, v, 1931, p. 94.

41. See *Late XIV Century*, p. 259. The versos of several of the miniatures representing saints are blank, and this practice became normal (though not invariable) in the latter part of the book.

42. On his visit to Paris in 1378 Charles IV probably gave a ms. or two to Charles V and possibly the Dukes. See *ibid.*, p. 132.

43. *Ibid.*, p. 246, figs. 481, 749, 750, 780.

44. *Ibid.*, fig. 344.

45. Martin, *Miniature française*, 1923, figs. III-IV.

46. See *Late XIV Century*, figs. 6, 7.

47. See, for example, Bibl. nat., fr. 2090-2, of 1317 (H. Martin, *Légende de St. Denis*, Paris, 1908). Pucelle also favored such frames, especially for full-page miniatures that had no surrounding borders or text.

48. For instructive observations on these forms see Birkmeyer, 1961, pp. 5 ff.

49. See *Late XIV Century*, figs. 10, 14, 193, p. 121.

50. Ambrogio, for example, in the fresco of Boniface VIII receiving St. Louis (Fig. 430 and G. Rowley, *Ambrogio Lorenzetti*, Princeton, 1958, fig. 104).

51. Though sometimes, as in the *Martyrdom of St. Pancras* (Fig. 14), the color of the diaphragm is that of the interior behind.

It was Panofsky who first discussed the use of the diaphragm in the work of the Boucicaut Master (*Netherlandish Painting*, 1953, I, p. 58). Our account differs from his by distinguishing the entrance from the true diaphragm arch and by pointing to the special role of the diaphragm in illumination.

We would therefore ascribe less importance to Jan van Eyck's abandonment of it in panels. The *Office of the Dead* in Morgan Library, ms. 515, dated 1402, cited by Panofsky as one of the earliest instances of the diaphragm, shows only the front face of an arch that, like a similar arch behind, belongs to the interior that is represented.

52. *Late XIV Century*, figs. 7, 12.

53. *Ibid.*, fig. 185.

54. The right post in the *Nativity* is pushed back into space (inconsistently) by the angel and the bed.

55. Glazed in red: fols. 15v, 17v, 30v. In green: fol. 33v.

56. When the metal is oxidized one can be certain it is silver; when it is still bright it has been protected by a transparent glaze or it is not silver but a silvery metal. Jean Lebègue, writing in 1431, referred to the use of tin to give the effect of silver (Alexander, 1964-1965, p. 43). On Lebègue see below, p. 60.

57. See the very end of Book II of *Della pittura*.

58. *Late XIV Century*, p. 141 ff.

59. *Ibid.*, fig. 264.

60. Bibl. nat., lat. 8886, fol. 393 (*Stoning of St. Stephen*).

61. This collaborator of the Épître Master in Bibl. nat., fr. 606 (*circa* 1405-1408) was obsessed with a kind of heady saffron color. By 1409 the representation of clouds began to become more frequent: see the *Belles Heures*, for example, or a miniature by a collaborator of the Cité des Dames Master in Bibl. nat., fr. 23279 of 1409, cited by Panofsky, *Netherlandish Painting*, I, 1953, p. 57, fig. 68, as the earliest example and ascribed to the Boucicaut Master.

62. See Martens, *Meister Francke*, 1929, pp. 101 ff.

63. This is also true of the *Adoration of the Magi* (Fig. 33).

64. For Bondol see *Late XIV Century*, fig. 382, and Panofsky, *op. cit.*, I, 1953, p. 37.

65. Fra Angelico, Museo di S. Marco, Florence (J. Pope-Hennessy, *Fra Angelico*, London, 1952, pl. 129). Leonardo, *Adoration of the Magi*, Uffizi, Florence.

66. Here we strike the grounds for Durrieu's erroneous attribution of the main cycles of the *Brussels Hours* to the Boucicaut Master. On his relation with Jacquemart see Panofsky, *op. cit.*, I, 1953, p. 56.

67. See, for example, Mariotto di Nardo, Pinacoteca Vaticana (G. Kaftal, *Iconography of the Saints in Tuscan Painting*, Florence, 1952, fig. 881).

68. For reasons not specified, Guyot de Villeneuve, fol. 57, identified the donor on 38v as the Marshal's beloved brother, Geoffroy. However, the Marshal's motto is written on St. Catherine's canopy.

Boucicaut was born in 1365, so that shortly after 1405, when the realistic portrait on fol. 38v was in our opinion painted, he was in his early forties, and he looks it.

69. Panofsky, *Netherlandish Painting*, I, 1953, p. 56 n. 1. His three groups are: Group I: 13v, 15v, 17v, 18v, 19v, 23v, 24v, 26v, 36v, 37v, 40v. Group II: 11v, 30v, 32v, 35v, 43v. Group III: 20v, 38v, 65v, 73v, 79v, 83v, 90v, 105v, 118v, 128v.

In general these groups of miniatures follow the actual sequence of the book. Some miniatures, however, fall far out of line: *St. Michael* on 11v, for instance, is in Group II, and both *St. Lawrence* on 20v

and *St. Catherine* on 38v are in Group III, which includes the scenes of the Hours of the Virgin and other paintings in the latter part of the book. Nearly a half of the miniatures are not classified, and among the missing are the last two in the book.

70. *Table des noms historiques* in Froissart, *Œuvres*, ed.

Lettenhove, XX, 1875, p. 371.

71. See *Late XIV Century*, p. 235 n. 44. Also Revelation XII, 1. The composition may have been influenced by the iconography of the Aracoeli, the Marshal and his wife taking the place of Augustus and the Sibyl.

72. Leroquais, *Livres d'heures*, I, 1927, p. XXVII.

NOTES TO CHAPTER II

1. See *Late XIV Century*, p. 218, fig. 385.

2. This miniature was painted about the same time as the *Très Riches Heures*, for which Panofsky, referring to an observation of Robert M. Harris, claimed the priority in the interposition of a middle ground (*Renaissance and Renascences*, 1960, p. 160).

3. See *Late XIV Century*, p. 240.

4. See *Late XIV Century*, p. 360; also S. Cockerell in London, Burlington Fine Arts Club, *Exhibition of Illuminated Manuscripts*, London, 1908, nos. 204, 205; O. Pächt, 'Early Italian Nature Studies and the Early Calendar Landscape', *Warburg Journal*, XIII, 1950, p. 44 n. 1; Meiss, 1956, p. 195, fig. 9.

5. Panofsky, *Netherlandish Painting*, 1953, I, p. 55 n. 2, referring to an opinion expressed verbally by Adolph Goldschmidt.

6. See J. Evans, *Dress in Mediaeval France*, Oxford, 1952, p. 40. Charles VI conferred the Order of the Broom-Pod on Richard II of England, and he wears it in the Wilton diptych (see Wormald, 1954, p. 199, and Clarke, 1931, pp. 288 f.).

7. The plant worn by the older man is not one of Berry's common emblems. I have been unable to associate the shielded arrow held by the younger prince with any particular person.

8. See *Late XIV Century*, p. 33.

9. Hubert, 1924–1927, pp. 25 ff.

10. See *Late XIV Century*, fig. 428.

11. *Ibid.*, figs. 419–425.

12. Meiss, *Painting in Florence and Siena*, 1951, fig. 94.

13. *Late XIV Century*, p. 294.

14. As Hubert, *loc. cit.*, has said.

15. See G. Vitzthum, 'Ein Stadtbild im Baptisterium von Castiglione d'Olona', *Festschrift zum sechzigsten Geburtstag von Paul Clemen*, Düsseldorf, 1926, pp. 401 ff.

16. *Late XIV Century*, fig. 94. See also the chapel in the *Annunciation* in Cleveland by the Master of the Brussels Initials (*ibid.*, fig. 745).

17. See *ibid.*, p. 212, fig. 182. The posture was adopted in the period 1400–1410 by an excellent illuminator active probably in Ypres (Panofsky, *Netherlandish Painting*, 1953, II, figs. 156, 161).

18. Martens, *Meister Francke*, 1929, p. 195.

19. See *Brussels, Bibl. Roy. (van den Gheyn)*, 1911, pl. 32.

20. See the unpublished doctoral dissertation of Don Denny (New York University, 1965). Denny argues that the composition has a religious significance, increasing the importance of the angel and diminishing that of the Virgin.

21. See *Late XIV Century*, pp. 144 f., fig. 585.

22. See also the Dante in the Marciana, illuminated in Venice *circa* 1400 (Meiss, 'La prima interpretazione dell'Inferno nella miniatura veneta', in *Dante e la cultura veneta*, Venice, 1966, pl. 15).

23. See also Morgan Library, ms. 515 (dated 1402), fol. 153.

24. For the miniature in Vienna see E. Trenkler, *Livre d'heures: Handschrift 1855 der Österreichischen National-bibliothek*, Vienna [1948], pl. 15.

25. The text for this miniature on fol. 120v (Bibl. nat., nouv. acq. lat. 3107) is for Monday, Matins.

26. This miniature will be reproduced in the next volume of this publication.

27. Madrid, Bibl. Nacional, vit. 25-1, fol. 272. The miniature was painted by the Egerton Master, but the Boucicaut workshop contributed to the book (see p. 101).

28. The funeral procession, including the transportation of the bier, was earlier connected with the Office, as in the *bas-de-page* in the *Très Belles Heures de Notre-Dame* (*Late XIV Century*, fig. 14). See also the *bas-de-page* in the *Horae circa* 1300 in Brussels (Brussels, Bibl. Roy., Gaspar and Lyna, I, 1937, pl. XLIX).

29. See E. Panofsky, *Tomb Sculpture*, New York [1964], p. 64.

30. Victoria and Albert Museum, ms. A. L. 1646–1902 (Reid ms. 4), fol. 178v, Boucicaut follower; Morgan

Library, ms. 455, fol. 121v, French, *circa* 1417; also, a little later, Morgan Library, ms. 453, fol. 133v; Swiss private collection (to be published by H. Hahnloser); similar style, *Horae* (L. Olschki, *Manuscrits sur velin avec miniatures du Xᵉ au XVIᵉ siècle*, Florence, 1910, pl. XVI); Walters Art Gallery, ms. 289, fol. 156 (naked corpse); New York, H. P. Kraus, *De Lévis Hours*. All but the first four are by followers of the Bedford Master. Furthermore, a follower of the Limbourgs, Spitz Collection, Chicago (Fig. 154). Also Rohan workshop, de Buz Hours (E. Panofsky, 'The de Buz Book of Hours', *Harvard Lib. Bull.*, III, 1949, pl. VIIIa). Paris, Bibl. nat., lat. 1158, fol. 137, shows two women lowering a corpse into a coffin in the room of a house.

31. See above, p. 24.

32. A skeleton, mourned however by laymen, illustrates the Office of the Dead in a North French (?) Book of Hours of *circa* 1435, Walters Art Gallery, ms. 239.

33. This was first observed by Porcher (*Belles Heures*, 1953, p. 42).

34. See *Late XIV Century*, p. 144, fig. 584. A skeleton illustrates the Mass of the Dead in the *Hours of Charles le Noble*, Cleveland (p. 654). A skull appears in the Lombard ms. *circa* 1380, Paris, Bibl. nat., Smith–Lesœuf 22, fol. 95. The tradition continued in North Italy into the Renaissance; see, for example, the famous Bible of Borso d'Este, Modena, Biblioteca Estense.

35. Brit. Mus. Harley 2934, fol. 106, shows a very similar composition.
In the illustration of Vespers of the Dead in Princeton University, Garrett ms. 48, fol. 63, the Rohan work-shop added the Meeting of the Living and the Dead to the main scene of the lamentation of a naked corpse stretched out on a floor (E. Panofsky, 'Reintegration of a Book of Hours Executed in the Workshop of the "Maître des Grandes Heures de Rohan" ', *Medieval Studies in Memory of A. Kingsley Porter*, Cambridge, 1939, II, p. 487, fig. 6).

36. On the display of the effigy of the French king in the funeral procession see R. E. Giesey, *The Royal Funeral Ceremony in Renaissance France*, Geneva, 1960, pp. 24 ff.

37. From a Book of Hours in the Library of Congress, acc. 4560 (7), kindly called to my attention by M. Marcel Thomas, who recognized the relationship of the manuscript to the Boucicaut workshop. See Baltimore, Walters Art Gallery (D. Miner), 1949, p. 35 no. 92. Also S. de Ricci, *Census*, I, p. 235 no. 120, dated *circa* 1450. The date given in the *Supplement*, 1962, p. 120 no. 92, is *circa* 1425, much nearer the truth. The manuscript has five large miniatures.

38. See the iconographically related miniature in another, unpublished ms. from the workshop of the Rohan Master formerly in the collection of Colonel McKell, Chillicothe, Ohio. Heimann (1932, pp. 54 ff.), who did not know several miniatures cited above, ascribed the invention of this type of illustration of the Office to the Rohan Master. In her discussion, the first on the subject, she suggested that the *Pèlerinage de l'âme* might have inspired the appearance of the corpse.

39. See Paris, Bibl. nat., lat. 10538, fol. 137v; New York, private collection, fol. 158; London, Brit. Mus., Harley 2940, fol. 126.

NOTES TO CHAPTER III

1. See *Late XIV Century*, figs. 225, 241, 243, 244.

2. See the Catalogue.

3. The head of St. Luke is very similar to that of Joseph in the *Adoration of the Magi* in the *Boucicaut Hours* (Fig. 33).

4. This subject appeared in the initial in the Parement style below the *Annunciation* in the *Très Belles Heures de Notre-Dame* (see *Late XIV Century*, fig. 6) and at None of the Hours of the Virgin in the *Grandes Heures*, by Pseudo-Jacquemart (*ibid.*, fig. 234).

5. See *Late XIV Century*, p. 252, figs. 291, 822, 824, 829.

6. Perhaps therefore an associate rather than the Bedford Master himself should now be considered responsible for the execution of *Jean de Berry before St. Peter* in the *Grandes Heures* (*ibid.*, p. 78, fig. 231).
Eleanor Spencer, who has very recently made two contributions to the definition of the later style of the Bedford Master (1965, pp. 495 ff.; 1966, pp. 607 ff.), believes no work can be ascribed to the illuminator before the Châteauroux Breviary (1966, p. 612). I owe to Professor Spencer's articles and to opinions she has kindly communicated to me my own renewed examination of the problem. The difficulties were already sensed by Martens, *Meister Francke*, 1929, p. 241 n. 222, when she listed as probably the work of one master the Bedford group and the earlier *Missel*

de St. Magloire group. Panofsky, *Netherlandish Painting*, 1953, I, p. 61 n. 3, adopted a similar tentative position. Porcher introduced a new, and I believe untenable, expansionism (*Medieval French Miniatures* [1959], pp. 67 ff., and *Jean Lebègue*, 1962, p. 13 f.).

Other miniatures are related to this group: Vienna 2657, datable 1408, for example, and Walters 209, which seems particularly close in style though not in time to Brit. Mus., Cotton Domitian A XVII. Certain folios in Harley 4431 (56v, 221, 259v, 261v, 265) should also be mentioned, and fr. 226, fol. 6v (later).

7. *Ibid.*, p. 246. The angels making music in quatrefoils around the *Annunciation* in Douce 144 anticipate by a year or two those on the corresponding folio of the *Belles Heures* (Fig. 126).

8. See *Late XIV Century*, fig. 724. Also *May* in the Torre dell'Aquila, or *April* in the *Très Riches Heures*. For a similar scene in secular ivories see Koechlin, *Ivoires*, 1924, pl. CXCIX.

9. *Late XIV Century*, p. 117.

10. The quatrefoils in the border of *St. Luke* in Douce 144 are filled with human or animal heads painted in higher values of the same colors used for the backgrounds. These cameo-like effects derive from Bohemian illumination, where they appear as early as the *Viaticum* of Johann von Neumarkt.

11. This miniature is discussed in *Late XIV Century*, p. 93.

12. *Ibid.*, p. 73.

13. *Ibid.*, p. 27.

14. The miniatures by this illuminator (see the list in *ibid.*, pp. 356 f.) will be discussed in the following volume of this publication.

15. See Catalogue.

16. See *Late XIV Century*, p. 49.

17. See the Catalogue. Also Paris, Bibl. nat., *Livre des merveilles* (Omont) [1907], pls. 1, 85, 102, 121, 195, 238.

18. See *Late XIV Century*, fig. 506.

19. Meiss, 1956, p. 195.

20. Originally ascribed to the Rohan Master by the writer (1935, pp. 9 ff.). The following year, studying the manuscripts in the collection of the late Baron Maurice de Rothschild, I was astonished to discover a copy of the five central figures in a miniature representing the same very rare scene, one of the illustrations of the story of the Cross in a striking Dutch Book of Hours. The owner would not permit any photographs of this or other miniatures to be made, and by a curious coincidence the miniature has finally been published, thirty years later, just as I write the lines about the drawing in the text above (J. Plummer, *The Hours of Catherine of Cleves*, New York, n.d. [1966], pl. 86). The Dutch miniature might well have been taken from a miniature executed in the Rohan circle on the basis of the drawing.

NOTES TO CHAPTER IV

1. See *Late XIV Century*, p. 18.

2. The event is described in Matthew II, 21. It is occasionally represented, as early as the Farfa Bible of the eleventh century (Bibl. Vat., lat. 5729, fol. 366v). See also Brit. Mus., Add. 39627, fol. 11v, a Byzantine Gospels of 1356.

3. An English alabaster relief in the Victoria and Albert Museum shows a hand-clasp of Christ and the Virgin at a corresponding moment. It has been dated, perhaps too early, *circa* 1365 (W. L. Hildburgh, 'English Alabaster Tables', *Art Bull.*, XXXII, 1950, pp. 7 ff., fig. 27).

4. The illuminator placed the Virgin alongside Christ in this representation of Paradise but in the relevant Book XXII Augustine did not include her.

5. In the miniature on fol. 86 the ship certainly represents Noah in the ark with his wife, three sons and their wives. An identical man appears again behind, but this Book (XVI) goes from Noah to Abraham, and the latter would be the most likely figure to appear with three angels. (Laborde, *Cité de Dieu*, pl. XXVIII b identified this man as Noah). The combination of Noah and Abraham to illustrate this book is, however, unique in illustrations of the *City of God*.

6. The dove is anachronistic and without precedent in illustrations of the *City of God*.

7. The frontal mouth of Hell is not uncommon earlier (see Laborde, *Bible moralisée*, 1921, IV, pl. 626) but the column is rare.

8. *Aeneid*, VI, 733. *City of God*, Book XXI, Chap. 13.

9. In Brussels, Bibl. Roy. ms. 9024, and Brit. Mus. Royal 19 D VI.

10. See Berger, *Bible française*, pp. 290 f. This passage was called to my attention by Sharon Off Katić.

11. *Late XIV Century*, fig. 195.

12. On the Duke of Berry's death the *Merveilles* was appraised at 125 livres tournois, a moderately high price (Guiffrey, *Inventaires*, I, p. 270 no. 1005). For comparative prices see *Late XIV Century*, pp. 257, 301.

13. For recent literature on these texts see the Catalogue.

14. The Duke of Berry himself owned the most beautiful earlier Hayton, Paris, Bibl. nat., fr. 12201, illuminated in the circle of the Master of the Coronation (see *Late XIV Century*, p. 315, fig. 438). Vienna, ms. 2623 is a late fourteenth-century illustrated Provençal Hayton [Vienna, Nationalbibl. (Hermann), 1936, pls. 50–52]. Oxford, Bodleian Lib., ms. 264 contains splendid early fifteenth-century English illustrations of Marco Polo (some miniatures reproduced in color in *Il Milione*, ed. Benedetto, opp. pp. xl and 8).

15. See *Late XIV Century*, p. 14.

16. Fol. 3v shows the Polo brothers (father and uncle of Marco) receiving the golden tablet.

17. Guiffrey, *Inventaires*, II, pp. 207 f.

18. *Ibid.*, I, p. 268 no. 1000. The Duke had a third copy of Marco Polo, not illustrated (*ibid.*, I, p. 262 no. 982).

19. The text says that the King wore also 'par ses bras 3 braceaux d'or ... et aussy en porte es jambes et es dois des piés'.

20. For this passage see L. de Backer, *L'extrême Orient au moyen-âge*, Paris, 1877, pp. 110 f.

21. On this creature see Wittkower, 1957, pp. 157 f.

22. See above, p. 41; also the domical rings surrounding the Madonna and a donor, London, Brit. Mus., Add. 16997, fol. 223.

23. For the nude Christ see *Late XIV Century*, pp. 125 ff.

24. The church was represented again with flying buttresses on fol. 155.

25. See fols. 80, 139v, 155. See also *St. Catherine* in the *Boucicaut Hours* (Fig. 23).

26. Olschki, *Marco Polo's Asia*, 1960, pp. 13 ff.

27. For Marco Polo's exceptionally acute observations of fauna and flora see *ibid.*, p. 158 and *passim.*

28. Olschki refers to many instances of conventional imagery in Marco Polo (see, for instance, his description of the Great Khan, *ibid.*, p. 399) and of the effect upon him of the Alexander legend (*ibid.*, pp. 47 ff.). Wittkower, on the other hand, stresses rather the independence of Marco (1960, pp. 155 ff.). He also says that Polo's observations were widely disbelieved, whereas Olschki (p. 124) discounts this view.

29. *Op. cit.*, p. 157.

30. See especially the *Journey* and the *Adoration of the Magi*, the *Purification of the Virgin*, and the *Miracle of the Loaves and Fishes*.

31. See for instance fol. 109v.

32. See *Late XIV Century*, pp. 3 f. The French text of *De mulieribus claris* was completed in 1401 by an unidentified translator. Brussels, Bibl. Roy., Gaspar and Lyna, I, 1937, p. 459, ascribes the translation for reasons not given (and not known to the writer) to Laurent de Premierfait. This ascription is made also by the *Catalogue of Printed Books* of the British Museum.

33. Martin, *Boccace*, 1911, p. 8.

34. The interconnections between these manuscripts, indicated in the text that follows, will be more fully discussed in a subsequent volume of this publication.

35. Once again, as in the instance of the travel books and *De mulieribus*, there are no comparable earlier Italian cycles.

Jean sans Peur's copy also bears the dedication to Jean de Berry. For this manuscript see Martin, *Boccace*, 1911.

36. The miniature in fr. 598, fol. 11, adds a man who threshes; otherwise the iconography is the same as in fr. 12420.

37. From the translation into English by G. A. Guarino, *Concerning Famous Women*, New Brunswick, 1963, p. 13. For the tradition that shaped Boccaccio's ideas see A. O. Lovejoy and G. Boas, *Primitivism and Related Ideas in Antiquity*, Baltimore, 1935.

38. '... elle entra ... et une nef de qui lenseuigne estoit une vache'.

In fr. 598, fol. 16, the foremost man on the shore holds an open box, perhaps a welcoming gift.

39. Fr. 598, fol. 29, places the scene outdoors. Arachne hangs from a gibbet, the cloth from a tree.

40. *Metamorphoses*, VI, 130–133, and *Ovide moralisé*, ed. C. de Boer, Amsterdam, 1954, p. 187.

41. In fr. 12420, fol. 20, neither repetition occurs, and only the last act – the stabbing of Thisbe – is represented.

42. Fr. 598, fol. 43; fr. 12420, fol. 42v.

43. 'Et la apres un certain temps [Manto] mouru et fust ensevelie. Envers le tombel de laquelle Achnone son fils et constitua une cite et la nomma manchue du nom de sa mere' (Gulbenkian *Cleres femmes*, fol. 48).

44. Bibl. nat., fr. 1178 and 1179; Brussels, Bibl. roy., ms. 9393.

45. '... tantost il me sêbla que devant moy estoit ung homme que dieu mavoit envoye ... il portoit sur son chief une couronne de laurier vert ...'. This extract and others from the *Cas des nobles hommes et femmes*

are taken from the edition of 1494 of Laurent's translation. For access to this incunable I am deeply indebted to the kindness of Mr. Lessing Rosenwald.

46. For Arsenal 5193, fol. 311, see Martin, *Boccace*, 1911, fig. III.

47. Arsenal 5193, fol. 272v (see *ibid.*, fig. CIV). Geneva, vol. II, fol. 66.

48. Geneva, vol. I, fol. 28 (see Gagnebin, 'Le Boccace du duc de Berry', *Genava*, V, 1957, fig. 51); Arsenal 5193, fol. 27v (Martin, *op. cit.*, fig. VIII). The same subject was inserted again on fol. 30 of Arsenal (*ibid.*, fig. IX), but it is one of the miniatures related to the Bedford trend (see above, p. 35), all of which are comparatively unrelated to the corresponding miniatures in the Geneva manuscript.

49. Arsenal 5193, fol. 144 (Martin, *op. cit.*, fig. LXII).

50. For this usage see Godefroy, *Dictionnaire de l'ancienne langue française*, s.v. 'anel'.

51. Martin, *op. cit.*, fig. LXV. The horses are wounded, as in Geneva, but Darius apparently is not.

52. The Geneva miniature is in volume II, fol. 30v.

53. '... elle avoit les yeulx arda(n)s et sembloit quilz menaccassent ceulx quelle regardoit. fortu(n)e avoit la face cruelle et horrible. elle avoit ses cheveux espez lo(n)gz et pendans sur sa bouche. Je croy que fortune en son corps avoit ce(n)t mains et autretant de bras pour don(n)er et pour tollir aux hommes les bie(n)s mo(n)dai(n)s. et pour abatre en bas et pour lever en hault les hommes de ce monde. Fortune avoit robe de maintes et diverses couleurs. car nul homme ne la co(n)gnoist. ... Je advisay ces parties du corps de fortune Et touteffois ie ne peu apparcevoir ne congnoistre les pilz par quoy elle alloit ... elle ficha les yeulx envers moy et me dist O Jehan Boccace.' (ed. 1494, p. CLXXVII).

54. See, for example, the late fourteenth-century Guillaume de Machaut, Bibl. nat., fr. 1586, fol. 30v. (H. R. Patch, *The Goddess Fortuna in Medieval Literature*, Cambridge, 1927, pl. 9). See also *ibid.*, p. 44.

55. Though the text describes Poverty as a woman the Geneva copy shows a man, and Fortune furthermore is blindfolded again (Vol. I, fol. 83 – see Meiss, 1956, fig. 4).

56. '... les hystoriens croient que iugurta fust trebuche du hault de la montaigne torpée ou fut le capitolle de romme dedens la rivière du tibre ...' (ed. 1494, p. CLXXV).

57. For the Arsenal miniature (fol. 226) see Martin, *Boccace*, 1911, fig. XCIII.

58. Laurent does not refer to a closed Garden of Eden.

He does, however, speak of the brightness of the sun and moon, which the illuminator represented.

59. See Martin, 1904, and *Late XIV Century*, p. 11.

60. The tomb, lacking four statues, does not conform with the tradition established by the principal medieval epic on the Trojan war, the *Roman de Troie* (see H. Buchthal, 'Hector's Tomb', in *De Artibus Opuscula XL. Essays in Honor of Erwin Panofsky*, New York, 1961, I, pp. 29 ff.).

61. Martin, *Boccace*, 1911, pp. 20 f., pl. LXXXV.

62. Paris, Bibl. Ste. Geneviève, ms. 777; see Martin, *Miniature française*, 1923, p. 47.

63. Fols. 69 (Virginia killed at her father's command – First Decade, Bk. III, Chap. 48); 126 (geese on Roman Capitol betray presence of the Gauls – First Decade, Bk. V, Chap. 47); 354 (forces of Hannibal besiege Rome – Second Decade, Bk. VI, Chaps. 10 and 11); 579v (the wife of Ortiagontis kills her captor – Third Decade, Bk. VIII, Chap. 24); 625 (the sons of King Philip duel in his presence – Third Decade, Bk. X, Chap. 6).

64. Fr. 259, fol. 335v. Here a veiled woman points to a flying dragon that menaces the statue.

65. See the lists of miniatures in the Catalogue. This illuminator favored, among other things, curved wooden ceilings and tie-beams.

66. Livy himself in this book speaks of the acclamation of Hannibal only as a military leader. For the notion of Hannibal as emperor see the commentary on Livy by Nicholas Trevet kindly called to my attention by Professor A. H. McDonald.

67. For a dull copy in the Burgundian library (Brussels ms. 9094) see Brussels, Bibl. Roy. (Gaspar and Lyna), 1937, pl. 81. A somewhat earlier illustrated manuscript is in Paris, Bibl. Ste. Geneviève, ms. 1028-9.

68. The illustrations correspond though they appear at different points in the text. The scenes of Creation are above the translator's prologue, whereas the Fitzwilliam miniature precedes the table of contents.

69. Again lilies in the background, here potted.

70. See Paris, Bibl. nat., fr. 23279, fol. 1v (Fig. 70) and Geneva, fr. 165, fol. 4 (Fig. 72).

71. See *Late XIV Century*, p. 73, fig. 504. It is noteworthy that Bartolomeus Anglicus and perhaps also his period did not esteem the ruby as highly as Jean de Berry.

72. For enlightening comments on the unicorn, white stallion, lioness, and monkey riding a bear that illustrate Book XVIII (*Animals*) see H. W. Janson, *Apes and Ape-Lore*, London, 1952, p. 264 and n. 27.

NOTES TO CHAPTER V

(APPENDIX TO CHAPTER V IS ON PAGE 141)

1. For Jacquemart de Hesdin and the *Brussels Hours* see *Late XIV Century*, pp. 209 ff. and 224 ff. For a negative view of Durrieu's hypothesis see for example Panofsky, *Netherlandish Painting*, I, 1953, p. 54.

2. Porcher, *Lebègue*, 1962, pp. 13 f., but for no specified reason, and Nordenfalk, 1961, p. 393, for the interesting reason that the *Boucicaut Hours* might have been painted in Genoa after Coene's trip to Milan.

3. Bibl. nat., lat. 6741. For Lebègue's extracts from Alcherius see Merrifield, *Treatises*, 1849, I, pp. 4 ff., 97 ff. See also Porcher, *Lebègue*, 1962, p. 12.

4. '. . . per verba et signamenta quae sibi dixit Jacobus Cona flamingus pictor commorans tunc Parisiis, qui toto tempore suo ut dixerat temptaverat et usus fuerat ipsem et de contentis in sequentibus . . .' (Bibl. nat., lat. 6741, fol. 81v). See also Champeaux and Gauchery, *Travaux*, 1894, p. 122.

5. Meiss, *Arte antica e moderna*, 1961, pp. 125 ff. See also *Late XIV Century*, p. 145.

6. See for example *Annali della fabbrica del Duomo di Milano*, Milan, I, 1877, pp. 224 f.

7. See Appendix, Document I. It is quite possible that Johannes Companiosus, one of two French painters mentioned in this document, is identical with the 'magister Iohannes de . . . normanus' who was living in the house of Pierre de Vérone in 1412 (see *Late XIV Century*, p. 64).

8. For Giovannino see *Annali*, I, p. 50 (1391); p. 202 (1400). For Nicolas see Ackerman, 1949, p. 87.

9. Coene left Paris on July 20, according to a letter written on July 30 to the authorities in Milan by Alcherius, or on July 21, according to the record of September 1399 (see Appendix, Documents 3 and 4). The account of Mignot in Thieme–Becker, XXIV, p. 549, fails to mention that he was a painter.

10. See Appendix, Documents I and 4.

11. See Appendix, Document 2.

12. Ackerman, 1949, p. 96.

13. *Annali*, I, pp. 224 f. See also Ackerman, *op. cit.*, p. 97. H.-A. von Stockhausen, referring to the phrase describing Coene's task at Milan, assumed that the façade was intended ('Der erste Entwurf zum Strassburger Glockengeschoss', *Marburger Jahrbuch für Kunstwissenschaft*, XI–XII, 1938–1939, p. 590). Because the building was in an early stage (see the text above) a drawing of details or of a section seems possible. Drawings of sections were made before 1400 by, for example, Villard de Honnecourt for Reims. See also the section of the Cathedral of Prague drawn about 1370 (O. Kletzl, *Plan-Fragmente aus der deutschen Dombauhütte von Prag*, Stuttgart, 1939, pl. 1). I am grateful to François Bucher for references to these publications.

14. Durrieu, *Arts anciens de Flandre* [1906?], p. 7.

15. See Appendix, Document 5.

16. See *Late XIV Century*, p. 294.

17. *Ibid.*, p. 252. Berry's copy is now Bibl. nat., fr. 12201.
 It seems more probable that Philippe ordered two Bibles rather than that he asked all the painters, the Coene group as well as the Limbourgs, to work on one manuscript, as Hulin at one moment supposed (1908, pp. 183 ff.). A *Bible moralisée* calls for more than five thousand miniatures, but the Limbourgs were given four years for their work.

18. See *Late XIV Century*, p. 252.

19. H. Martin had read Haimbert in Bibl. nat., lat. 7907A, fol. 39, but M. Thomas, 1958, pp. 114 f., has shown that this word is 'chamberie(re)', and refers to a figure in the illustration.

20. In 1403, 'Haincelin peintre demeurant à Paris' painted arms and devices on two leather containers for books for Queen Isabeau de Bavière (Champeaux and Gauchery, *Travaux*, 1894, p. 127 n. 1).
 'Hagenau' is probably the town in Alsace.

21. 'Lancelin de Haguenoe enlumineur' is listed as no. 14 of 'vallets de chambre' of Dauphin Louis in a seventeenth-century copy of the registers of the 'estat de l'ostel' of the Duc de Guyenne (Bibl. nat., fr. 7853, p. 70). See also Prost, 1889–1890, p. 426.

22. See Catalogue for this manuscript.

23. Laborde, *Ducs de Bourgogne*, III, 1852, p. 341.

24. Champeaux and Gauchery, *Travaux*, 1894, p. 128.

25. Champeaux and Gauchery, *Travaux*, 1894, p. 127 n. 1.

26. As Nordenfalk, 1961, pp. 392 f., suggested.

NOTES TO CHAPTER VI

1. *Meister Francke*, 1929, p. 241, n. 221; Panofsky, *Netherlandish Painting*, 1953, pp. 52 f.; Porcher, *Medieval Miniatures* [1959], p. 58.

2. See *Late XIV Century*, pp. 252 f., 354 f.

3. See *ibid.*, p. 312. A third closely related manuscript, a *Fleur des histoires* given by Philippe le Hardi to Jean de Berry by March 1403, is somewhat less exceptional, and need not concern us here. See *ibid.*, p. 315.

4. The miniature was first published by Porcher, *Belles Heures*, 1953, p. 9 and fig. 1, as perhaps an early work of the Limbourgs. The numerous miniatures in the text of this manuscript, all in grisaille, are by at least two conservative illuminators, unrelated to the author of the *Coronation*.

5. The relatively early date of this Bible is indicated also by the very first miniatures, which were painted by an undistinguished master working with pictorial conventions established around 1390.

6. Contemporary domestic buildings appear also in the background of *St. Martin* in the *Boucicaut Hours* (Fig. 19). A star-strewn background like those in the *Boucicaut Hours* is used on fol. 538v of the Bible, and there are many in fr. 242, though by different masters.

7. See *Late XIV Century*, p. 174, figs. 13, 96.

8. See *ibid.*, p. 149, figs. 189, 587.

9. See also Berlin; Brussels 10767 and 11051; London, Zwemmer Coll.; Paris, Bibl. nat., nouv. acq. lat. 3107.

10. See *Late XIV Century*, fig. 193.

11. E.g., the temple in the *Presentation* (*Late XIV Century*, fig. 187). The figure in the *Annunciation* blesses with the right hand and holds an orb surmounted by a cross in the left, and presumably therefore represents God the Father.

12. See for example Baldass, *Jan van Eyck* [1952], p. 18, who like many other historians failed to recognize a direct influence of Italian art upon the Boucicaut Master.

13. See *Late XIV Century*, p. 60.

14. See G. Kaftal, *Iconography of the Saints in Tuscan Painting*, Florence [1952], fig. 881.

15. See J. Roussel, *La sculpture française, époque gothique*, Paris, n.d., I, pl. 10.

16. See for example Giovanni Pisano, *Justice*, pulpit in the Duomo, Pisa (P. Toesca, *Il Trecento*, 1951, fig. 219).

17. See *Late XIV Century*, pp. 252 f., and figs. 826, 827. To what is said there should be added the fact that the inscription on the scroll of the Coronation Master's St. John in fr. 159 (fol. 531), which I described as 'Teutonic', is definitely German. One can make out '. . . got allein . . . der ist . . .' G. I. Lieftinck believes that the script is later than that of the manuscript itself. The inscription on Cassandra's scroll in fr. 598 by the Master of Berry's Cleres Femmes ('hort het wort'), which I called Netherlandish, is specifically Dutch, according to Professor Lieftinck, who agrees that this inscription was added somewhat later. This linguistic evidence may connect these masters with regions still further north, and they may indeed have come from the Lower Rhine and Holland, but their style nevertheless seems to me to show greater similarity with miniatures known to have been painted in the southern Netherlands.

18. Panofsky, *Netherlandish Painting*, 1953, II, fig. 114.

19. See *Late XIV Century*, p. 143. Also the important recent study of Arslan, 1963, pp. 25–66, and the fundamental work by Pächt (1950).

20. Meiss, *loc. cit.*; Thompson, *The Materials of Medieval Painting*, 1936, p. 66.

21. Including the octopus-like radiance that may be seen, for instance, half inside and half outside the frame, on fol. 54 of the part of the Visconti Hours in Florence (Toesca, *Landau-Finaly*, 1951, fol. 54).

22. See above, p. 15.

23. On the practical value of associations of painters see *Late XIV Century*, p. 8.

24. The Bedford group painted the canon pages of this manuscript (Paris, Bibl. de l'Arsenal, ms. 623) and the initial on fol. 1. Of the remaining initials some were executed by illuminators influenced by the Boucicaut style (especially fols. 15 and 153, *Nativity* and *Pentecost*).

25. For the 'Bedford' miniature in lat. 919 see *Late XIV Century*, fig. 231. Porcher, *Medieval Miniatures* [1959], p. 67 f., referred to the association, but he saw the Bedford Master as the principal figure, mostly because he ascribed to him numerous manuscripts or parts of manuscripts that I do not believe are his.

26. Schilling (*Scriptorium*, 1954, p. 277) stressed that the Egerton atelier worked with Boucicaut Associates but it collaborated also with other groups, especially in early manuscripts. See, for example, fr. 606, fr. 835-836, Add. 30899, all listed in *Late XIV Century*, p. 357.

27. The saints in the Provinzialmuseum in Bonn ascribed by Durrieu (*Arts anciens de Flandre*, II [1906?],

p. 20) are German. *Lazarus and Dives*, attributed by G. Ring (*French Painting* [1949], pl. 7) must be Catalan.

28. See *Late XIV Century*, pp. 63, 280, figs. 830-832. Also Ring, *idem*, pls. 4, 5, 6, 18, 20, 25.

29. The portrait of a woman in Washington should likewise be ranged with the trend of Malouel. Its narrow, high proportions, lively ellipses, and searching definition of form bring it, in my opinion, to or even after 1420.

30. See p. 139 f.

31. For the *Funeral Service* in Vienna 1855 see Trenkler, *Livres d'heures* [1948], fig. 15.

32. For the famous calendar pictures see, among countless reproductions, *Late XIV Century*, figs. 422, 844.

33. Meiss, 1963, and Pächt, 1963.

34. See the round church, perhaps signifying Jerusalem, in the background of the *Crucifixion* in Add. 16997 (Fig. 299), and also the round building in the *Flagellation* in Bibl. nat., lat. 1161, fol. 162.

35. For Normandy see Milan, Bibl. Trivulziana, *Horae*, ms. 446. For England see Brit. Mus., Harley 2900, *circa* 1435. For the Zweder Master see Panofsky, *Netherlandish Painting*, 1953, p. 103, fig. 124.

36. *Ibid.*, fig. 210.

37. Baldass, *Jan van Eyck* [1952], p. 25, fig. 23.

38. Baldass, *op. cit.*, pp. 18 f., pointed to some of these resemblances, but he seems to me to have ended by over-estimating the influence of the Boucicaut Master on the Master of Flémalle.

39. As Pächt, 1956, p. 114, rightly asserted.

40. For the Ypres *Madonna* see Baldass, *op. cit.*, fig. 129.

41. This relationship was pointed out by Panofsky, *Netherlandish Painting*, 1953, I, p. 192.

BIBLIOGRAPHY

The principal entries for all catalogues of exhibitions and of permanent holdings of libraries and museums are listed topographically. For instance *Arte lombarda dai Visconti agli Sforza* appears under Milan, Palazzo Reale.

KEY TO ABBREVIATIONS

Gaz. B.-A. = *Gazette des Beaux-Arts.*

Late XIV Century = Meiss, M., *French Painting in the Time of Jean de Berry. The Late Fourteenth Century and the Patronage of the Duke.* London, 1967. 2v.

Rev. de l'art a. et m. = *Revue de l'art ancien et moderne.*

SFRMP = Société Française de Reproductions de Manuscrits à Peintures.

Ackerman, J. A., '"Ars Sine Scientia Nihil Est." Gothic Theory of Architecture at the Cathedral of Milan', *Art Bull.*, XXXI, 1949, pp. 84-111.

Adhémar, H., *see* Paris, Musée du Louvre.

Alexander, J. G., *see* Pächt and Alexander.

Alexander, S. M., 'Medieval Recipes Describing the Use of Metal in Manuscripts', *Marsyas*, XII, 1964–1965, pp. 34-51.

Arslan, E., 'Riflessioni sulla pittura gotica "internazionale" in Lombardia nel tardo Trecento', *Arte lombarda*, VIII, pt. 2, 1963, pp. 25-66.

Aubert, H., 'Notice sur les manuscrits Petau, conservés à la Bibliothèque de Genève', *Bibl. École des Chartes*, LXX, 1909, pp. 247-302, 471-522; LXXII, 1911, pp. 279-313, 556-599.

Aubert, H., 'Les principaux manuscrits à peintures de la Bibliothèque publique et universitaire de Genève', *Bull. SFRMP*, II, 1912, pp. 55-107.

Backer, Louis de, *L'extrême orient au moyen-âge*, Paris, 1877.

Baldass, L., *Jan van Eyck*, London [1952].

Baltimore. Walters Art Gallery. *Illuminated Books of the Middle Ages and Renaissance* . . . (D. Miner), Baltimore, 1949.

Baltimore. Walters Art Gallery. *The International Style* (mss. ed. by D. Miner, much else by P. Verdier), [Baltimore, 1962].

Beissel, S., 'Exposition de l'histoire de l'art à Düsseldorf, 1904', *Arts anciens de Flandre*, I, [1905?], pp. 49-51.

Benedetto, L. F., *see* Polo, Marco

Bennett, J. W., *The Rediscovery of Sir John Mandeville*, New York, 1954.

Berger, S., *La Bible française au moyen-âge. Étude sur les plus anciennes versions de la Bible écrite en prose de langue d'oïl*, Paris, 1884.

Berlin. Staatliche Museen. Gemäldegalerie und Kupferstichkabinett. Winkler, F., 'Die spanischen und französischen Primitiven in der Gemäldegalerie und im Kupferstichkabinett', *Berliner Museen, Berichte*, XLIX, 1928, pp. 6-12.

Berlin. Staatliche Museen. Kupferstichkabinett. *Beschreibendes Verzeichnis der Miniaturen-Handschriften und Einzelblätter des Kupferstichkabinetts der Staatlichen Museen, Berlin* (P. Wescher), Leipzig, 1931.

Bierstadt, O. A., *see* New York, Hoe Library.

Birkmeyer, K. M., 'The Arch Motif in Netherlandish Painting of the Fifteenth Century, Part One', *Art Bull.*, XLIII, 1961, pp. 1-20.

Boccaccio, G., *Des cas des nobles hommes et femmes*, tr. Laurent de Premierfait, Paris: A. Vérard, 1494.

Boinet, A., *see* Paris, Bibliothèque de la Chambre des Députés.

Bourges. Musées. *Chefs-d'œuvre des peintres-enlumineurs de Jean de Berry et de l'école de Bourges* [Bourges, 1951].

Bradley, J. W., *A Dictionary of Miniaturists, Illuminators, Calligraphers, and Copyists* . . ., London, 1887–1889, 3v.

Brussels. Bibliothèque Royale de Belgique. *Catalogue des manuscrits de la Bibliothèque Royale de Belgique* (J. van den Gheyn), Brussels, 1901–1936. 12 v.

Brussels. Bibliothèque Royale de Belgique. *Deux livres d'heures attribués à l'enlumineur Jacques Coene* (J. van den Gheyn), Brussels [1911].

Brussels. Bibliothèque Royale de Belgique. Gaspar, C., and F. Lyna, *Les principaux manuscrits à peintures de la Bibliothèque Royale de Belgique*, SFRMP, Paris, 1937–1947, 2 pts. in 3v.

Busquet, R., *Histoire de Provence des origines à la Révolution française*, Monaco, 1954.

Cambridge. Fitzwilliam Museum. *Illuminated Manuscripts in the Fitzwilliam Museum* (F. Wormald and P. M. Giles), Cambridge, 1966.

Cambridge. Harvard University. *Illuminated and Calligraphic Manuscripts; an Exhibition Held at the Fogg Art Museum and Houghton Library, February 14–April 1, 1955*, Cambridge, 1955.

Carta, F., C. Cipolla, and C. Frati, *Atlante paleografico –*

artistico compilato sui manoscritti esposti in Torino alla Mostra d'arte sacra nel MDCCCXCVIII, Turin, 1899.

Champeaux, A. de, and P. Gauchery, *Les travaux d'art exécutés pour Jean de France, duc de Berry, avec une étude biographique sur les artistes employés par ce prince*, Paris, 1894.

Chantilly. Musée Condé. *Le cabinet des livres: manuscrits*, Paris, 1900–1901. 3v.

Chantilly. Musée Condé. *Les principaux manuscrits à peintures du Musée Condé* (J. Meurgey), SFRMP, Paris, 1930. 2v.

Cipolla, C., *see* Carta, Cipolla, and Frati.

Clarke, M. V., 'The Wilton Diptych', *Burl. Mag.*, LVIII, 1931, pp. 283-294.

Cleveland. Museum of Art. Wixom, W. D., *Treasures from Medieval France*, Cleveland, 1967.

Cockerell, S. C., *see* London, Thompson Collection (formerly), 1902.

Couderc, C., *Album de portraits d'après les collections du Département des manuscrits, Bibliothèque nationale*, Paris [1910].

Couderc, C., *see also* Paris, Bibliothèque nationale.

Cracow. Muzeum Narodowe. Gąsiorowska, M. (Jarosławiecka), 'Les principaux manuscrits à peintures de Musée des princes Czartoryski, à Cracovie', *Bull. SFRMP*, XVIII, 1935. 2v.

Crapelet, G., *see Les demandes faites par le roi Charles VI . . . et les réponses de Pierre Salmon.*

Delaissé, L. M. J., *Medieval Illuminations from the Library of Burgundy in the Department of Manuscripts of the Royal Library of Belgium*, Brussels, 1958. French ed., Geneva, 1959.

Delaissé, L. M. J., 'Une production d'un atelier parisien et le caractère composite de certains livres d'heures', *Scriptorium*, II, 1948, pp. 78-84.

Delisle, L., *Le cabinet des manuscrits de la Bibliothèque impériale*. Paris, 1868–1881. 3v. and atlas. In v. 2-3 and atlas Bibliothèque nationale is substituted for Bibliothèque impériale.

Delisle, L., *Notes sur quelques manuscrits du Musée britannique*, Paris, 1878.

Delisle, L., *Recherches sur la librairie de Charles V*, Paris, 1907. 2v. and plates.

Delisle, L., 'Les heures de l'amiral Prigent de Coëtivy', *Bibl. École des Chartes*, LXI, 1900, pp. 186-200.

Les demandes faites par le roi Charles VI touchant son état et le gouvernement de sa personne, avec les réponses de Pierre Salmon, son secrétaire et familier, ed. G. A. Crapelet, Paris, 1833.

Deschamps, E., *Œuvres*, ed. Q. de Saint-Hilaire and G. Raynaud, Paris, 1878–1903. 11v.

Domínguez Bordona, J., *Manuscritos con pinturas*, Madrid, 1933. 2v.

Doutrepont, G., *La littérature française à la cour des ducs de Bourgogne* (Bibl. du XVe siècle, VIII), Paris, 1909.

Durrieu, P., 'Les manuscrits à peintures de la bibliothèque de Sir Thomas Phillipps à Cheltenham', *Bibl. École des Chartes*, L, 1889, pp. 381-432.

Durrieu, P., 'Jacques Coene', *Arts anciens de Flandre*, II [1906?], pp. 5-22.

Durrieu, P., 'Le maître des Heures du Maréchal de Boucicaut', *Rev. de l'art a. et m.*, XIX, 1906, pp. 401-415; XX, 1906, pp. 21-35.

Durrieu, P., 'Une vue de l'église du Saint-Sépulcre vers 1436, provenant du bon roi René', in *Florilegium . . . Melchior de Vogüé*, Paris, 1909, pp. 197-207.

Durrieu, P., 'Le Musée Jacquemart-André. Les manuscrits à peintures', *Gaz. B.-A.*, LIV, 1912, pp. 85-96.

Durrieu, P., 'Les Heures du Maréchal de Boucicaut du Musée Jacquemart-André', *Rev. de l'art chrét.*, LXIII, 1913, pp. 73-81, 145-164, 300-314; LXIV, 1914, pp. 28-35.

Dvořák, M., *Das Rätsel der Kunst der Brüder Van Eyck*, Munich, 1925.

Eisler, C., *see* Meiss and Eisler.

François, M., *see* Paris, Archives nationales.

Frati, C., *see* Carta, Cipolla, and Frati.

Froissart, J., *Œuvres*, ed. K. de Lettenhove, Brussels, 1867–1877.

Fry, R. E., 'On Two Miniatures by de Limbourg', *Burl. Mag.*, VII, 1905, pp. 435-445.

Gagnebin, B., 'Le Boccace du duc de Berry', *Genava*, V, 1957, pp. 129-148.

Gąsiorowska, M. (Jarosławiecka), *see* Cracow, Muzeum Narodowe.

Gaspar, C., *see* Brussels, Bibliothèque Royale de Belgique.

Gauchery, P., *see* Champeaux and Gauchery.

Gheyn, J. van den, *see* Brussels, Bibliothèque Royale de Belgique.

Giles, P., *see* Cambridge, Fitzwilliam Museum.

Gilson, J. P., *see* London, British Museum.

Griseri, A., *Jacquerio e il realismo gotico in Piemonte*, Turin, n.d.

Guiffrey, J., *Inventaires de Jean duc de Berry (1401-1416)*, Paris, 1894-1896. 2v.

Guyot de Villeneuve, F. G. A. de, *Notice sur un manuscrit français du XIV^e siècle; les Heures du maréchal du Boucicaut* (Société des Bibliophiles, Français), Paris, 1889.

Hambis, L., *see* Polo, Marco.

Heimann, A., 'Der Meister der "Grandes Heures de Rohan" und seine Werkstatt', *Städel-Jahrbuch*, VII-VIII, 1932, pp. 1-61.

Hermann, H. J., *see* Vienna, Nationalbibliothek.

Hubert, J., 'Quelques vues de la cité au XV^e siècle dans un bréviaire parisien conservé à la bibliothèque municipale de Châteauroux', *Mémoires Société Antiquaires de France*, LXXVII, 1924-1927, pp. 25-42.

Hulin de Loo, G., 'La Bible de Philippe le Hardi historiée par les frères de Limbourc', *Bull. de Gand*, XVI, 1908, pp. 183 ff.

James, M. R., *see* London, Thompson Collection (formerly).

Jarry, E., *La vie politique de Louis de France duc d'Orléans, 1372-1407*, Paris, 1889.

Jerchel, H., 'Die Niederrheinische Buchmalerei der Spätgotik (1380-1470)', *Wallraf-Richartz Jahrbuch*, X, 1938, pp. 65-90.

Justel, C., *Histoire généalogique de la maison de Turenne*, Paris, 1645.

Kohler, C., *see* Paris, Bibliothèque Sainte-Geneviève.

La Batut, G. de, *see* Paris, Bibliothèque Mazarine.

Laborde, A. de, *Les manuscrits à peintures de la Cité de Dieu de saint Augustin*, Paris, 1909. 3v.

Laborde, A. de, *La Bible moralisée illustrée, conservée à Oxford, Paris et Londres . . .*, Paris, 1911-1927. 5v.

Laborde, L., *Les ducs de Bourgogne*, Paris, 1849-1852. 3v.

Laclotte, M., *Primitifs français*, Paris, n.d. [1966].

Lauer, P., *see* Paris, Bibliothèque de l'Arsenal.

Laurent de Premierfait, *see* Boccaccio.

La Vallière, L. C. de la Baume Le Blanc. Library. *Catalogue des livres de la bibliothèque de feu M. le duc de la Vallière*, Paris, 1783. 3v. in 6.

Lazzareschi, E., *see* Mirot and Lazzareschi.

Leroquais, V., *Les livres d'heures; manuscrits de la Bibliothèque nationale*, Paris, 1927. 3v. (Text and Plates); *Supplément*, 1943.

Leroquais, V., *Les bréviaires manuscrits des bibliothèques publiques de France*, Paris, 1934. 5v., index.

Lettenhove, K. de, *see* Froissart, J.

Levesque, P., 'Notice du livre de Pierre Salmon, présenté par l'auteur à Charles VI', *Notices et extraits*, V [1798/99], pp. 415-432.

Le livre des faicts du bon messire Jean le Maingre, dit Boucicaut, in *Nouvelle collection des mémoires pour servir à l'histoire de France depuis le XIII^e jusqu'à la fin du XVIII^e siècle*, ed. [J. F.] Michaud and [J. J. F.] Poujoulat, Ser. 1, II, 1850, pp. 203-332.

London. Martin Breslauer. *Catalogue Eighty* (n.d.)

London. British Museum. *A Catalogue of the Harleian Manuscripts in the British Museum*, London, 1808-1812. 4v.

London. British Museum. Warner, G. F., *Illuminated Manuscripts in the British Museum*, Series I-IV, London, 1903.

London. British Museum. Warner, G. F., and J. P. Gilson, *Catalogue of Western Manuscripts in the Old Royal and King's Collections* [London], 1921. 4v.

London. British Museum. *Miniatures from a French Horae, British Museum Add. Ms. 16997, Fifteenth Century. Reproduced in Honour of John Alexander Herbert* [London], 1927.

London. British Museum. Millar, E. G., *Souvenir de l'exposition de manuscrits français à peintures organisée à la Grenville Library (British Museum) en janvier-mars, 1932*, Paris, 1933.

London. Burlington Fine Arts Club. *Exhibition of Illuminated Manuscripts*, London, 1908.

London. Sotheby & Co. *Catalogue of Ninety-one Manuscripts on Vellum . . . chiefly from the famous Hamilton Collection*, May 23, 1889.

London. Sotheby & Co. *Catalogue of Valuable Illuminated and Other Illuminated Manuscripts . . . the Property of Coningsby C. Sibthorp, Esq. . . .*, January 30, 1920.

London. Sotheby & Co. *The Renowned Collection of Western Manuscripts, the Property of A. Chester Beatty, Esq.*, June 7, 1932.

London. Sotheby & Co. *Catalogue of Very Important Illuminated Manuscripts and Printed Books Selected from the Renowned Library Formed by Baron Horace de Landau (1824-1903), Maintained and Augmented by his Niece Madam Finaly of Florence (d. 1938)*, July 12, 1948.

London. Sotheby & Co. *Catalogue of Fine Western and Oriental Manuscripts and Miniatures*, December 7, 1953.

London. Sotheby & Co. *Bibliotheca Phillippica. Catalogue of Thirty-Nine Manuscripts of the 9th to the 16th Century*, November 30, 1965.

London. Thompson Collection (formerly). James, M. R., *A Descriptive Catalogue of Fifty Manuscripts*

from the Collection of Henry Yates Thompson, Cambridge, 1898.

London. Thompson Collection (formerly). *A Descriptive Catalogue of the Second Series of Fifty Manuscripts (Nos. 51 to 100) in the Collection of Henry Yates Thompson* (this entry by S. C. Cockerell), Cambridge, 1902, pp. 151-183.

London. Thompson Collection (formerly). *A Descriptive Catalogue of Fourteen Illuminated Manuscripts, nos. XCV to CVII and 79a, Completing the Hundred in the Library of Henry Yates Thompson* (H. Y. Thompson), Cambridge, 1912.

London. Thompson Collection (formerly). *Illustrations of One Hundred Manuscripts in the Library of Henry Yates Thompson*, v: *Consisting of Ninety Plates Illustrating Sixteen MSS. Each of Which Belonged to Some Individual of Note in France or Italy in the XIVth or XVth Century*, London, 1915.

London. Victoria and Albert Museum. Anonymous, 'New Acquisitions at the National Museums, Victoria and Albert Museum. The Reid Gift – I', *Burl. Mag.*, I, 1903, p. 389 f.

Lyna, F., *see* Brussels, Bibliothèque Royale de Belgique.

Madan, F., *see* Oxford, Bodleian Library.

Marchegay, Paul, *Documents relatifs à Prégent de Coëtivy . . .*, Tours, 1878.

Martens, B., *Meister Francke*, Hamburg, 1929. 2v.

Martin, H. M. R., *Les miniaturistes français*, Paris, 1906.

Martin, H. M. R., *Le Térence des ducs*, Paris, 1907.

Martin, H. M. R., *Le Boccace de Jean sans Peur. Des cas des nobles hommes et femmes*, Brussels, 1911.

Martin, H. M. R., *La miniature française du XIIIᵉ siècle au XVᵉ siècle*, Paris, 1923.

Martin, H. M. R., 'Les esquisses des miniatures', *Rev. archéol.*, IV, 1904, pp. 17-45.

Martin, H. M. R., 'L'illustration des livres au moyen âge', *Académie des Inscriptions et Belles-Lettres, Comptes rendus*, 1904, pp. 121-132.

Martin, H. M. R., *see also* Paris, Bibliothèque de l'Arsenal.

Martin, H. M. R., *see also* Paris, Bibliothèque nationale.

Matalon, S., *Affreschi lombardi del Trecento*, Milan, 1963.

Meiss, M., *Painting in Florence and Siena after the Black Death*, Princeton, 1951.

Meiss, M., *French Painting in the Time of Jean de Berry. The Late Fourteenth Century and the Patronage of the Duke*. London, 1967. 2v.

Meiss, M., 'Un dessin par le maître des Grandes Heures de Rohan', *Gaz. B.-A.*, LXXVII, pt. I, 1935, pp. 65-75.

Meiss, M., 'The Exhibition of French Manuscripts of the XIII-XVI Centuries at the Bibliothèque nationale', *Art Bull.*, XXXVIII, 1956, pp. 187-196.

Meiss, M., and C. Eisler, 'A New French Primitive', *Burl. Mag.*, CII, 1960, pp. 233-240, 489.

Meiss, M., 'An Early Lombard Altarpiece', *Arte antica e moderna*, 1961, no. 13-16, pp. 125-133.

Meiss, M., '"Highlands" in the Lowlands: Jan van Eyck, the Master of Flémalle, and the Franco-Italian Tradition', *Gaz. B.-A.*, LVII, 1961, pp. 273-314.

Meiss, M., 'French and Italian Variations on an Early Fifteenth-Century Theme: St. Jerome and His Study', *Gaz. B.-A.*, LXII, 1963, pp. 147-170.

Mély, F. de, *Les primitifs et leurs signatures. Les miniaturistes*, Paris, 1913.

Merrifield, (Mrs.) M., *Original Treatises, Dating from the XIIth to XVIIIth Centuries on the Arts of Painting . . .*, London, 1849. 2v.

Meurgey, J., *see* Chantilly, Musée Condé.

Michaud, J. F., *see Le livre des faicts du bon messire Jean le Maingre, dit Boucicaut.*

Milan. Palazzo Reale. *Arte lombarda dai Visconti agli Sforza*, Milan [1958].

Millar, E. G., *see* London, British Museum.

Miner, D., *see* Baltimore, Walters Art Gallery.

Mirot, L., and E. Lazzareschi, 'Lettere di mercanti lucchesi da Bruges e da Parigi, 1407–1421', *Bollettino storico lucchese*, I, 1929, pp. 165-199.

Molinier, A., *see* Paris, Bibliothèque Mazarine.

New York. American Art Association, *The Cortlandt F. Bishop Library*, part two [I-Q], April 25-27, 1938.

New York. American Art Association – Anderson Galleries. *Illuminated Manuscripts, Incunabula and Americana, from the Libraries of the Marquess of Lothian*, January 27, 1932.

New York. L. C. Harper. *Catalogue 10: Fine Books and Illuminated Manuscripts* [1960].

New York. Hoe Library. *The Library of Robert Hoe* (O. A. Bierstadt), New York, 1895.

New York. H. P. Kraus. *Catalogue 100.* New York [1962].

Nordenfalk, C. A. J., 'Französische Buchmalerei 1200-1500', *Kunstchronik*, IX, 1956, pp. 179-189.

Nordenfalk, C. A. J., 'Saint Bridget of Sweden As Represented in Illuminated Manuscripts', in *De Artibus Opuscula XL. Essays in Honor of Erwin Panofsky*, New York, 1961, I, pp. 371-393.

Olschki, L., *Marco Polo's Asia*, Berkeley, 1960.

Omont, H. A., *see* Paris, Bibliothèque nationale.

Oxford. Bodleian Library. Madan, F., *A Summary Catalogue of Western Manuscripts in the Bodleian Library at Oxford*, Oxford, 1895–1953. 7v.

Oxford. Bodleian Library, *see also* Pächt and Alexander.

Pächt, O., and J. G., Alexander, *Illuminated Manuscripts in the Bodleian Library, Oxford. I. German, Dutch, Flemish, French and Spanish Schools*, Oxford, 1966.

Pächt, O., 'Early Italian Nature Studies and the Early Calendar Landscape', *Warburg Journal*, XIII, 1950, pp. 13-47.

Pächt, O., 'Panofsky's "Early Netherlandish Painting" – I', *Burl. Mag.*, XCVIII, 1956, pp. 110-116.

Pächt, O., 'Zur Entstehung des "Hieronymus im Gehäus" ', *Pantheon*, XXI, 1963, pp. 131-142.

Panofsky, E., *Early Netherlandish Painting: Its Origins and Character*, Cambridge, Mass., 1953. 2v.

Panofsky, E., 'A Parisian Goldsmith's Model of the Early Fifteenth Century?' in *Beiträge für Georg Swarzenski*, Berlin, 1951, pp. 70-84.

Paris, P., 'Hayton, prince d'Arménie, historien', *Hist. litt.*, XXV, 1869, pp. 479-507.

Paris. Archives nationales. 'Les plus beaux manuscrits à peintures conservés aux Archives nationales' (M. François), in *Trésors des bibliothèques de France*, XXIV, 1938, pp. 3-25.

Paris. Bibliothèque de l'Arsenal. Martin, H. M. R., *Catalogue des manuscrits de la Bibliothèque de l'Arsenal*, V, 1889.

Paris. Bibliothèque de l'Arsenal. *Les principaux manuscrits à peintures de la Bibliothèque de l'Arsenal à Paris; ouvrage posthume de H. Martin, terminé par Ph. Lauer*, SFRMP, Paris, 1929.

Paris. Bibliothèque de la Chambre des Députés. Boinet, A., 'Les principaux manuscrits à peintures de la Bibliothèque de la Chambre des Députés à Paris', *Bull. SFRMP*, VI, 1922, pp. 31-61.

Paris. Bibliothèque Mazarine. Molinier, A., *Catalogue des manuscrits de la Bibliothèque Mazarine*, Paris, 1885–1892. 4v.

Paris. Bibliothèque Mazarine. La Batut, G. de, 'Les principaux manuscrits à peintures conservés à la Bibliothèque Mazarine de Paris', *Bull. SFRMP*, XVI, 1933, p. 44 f.

Paris. Bibliothèque nationale. *Exposition de portraits peints et dessinés du XIIIᵉ au XVIIᵉ siècle*, Paris, 1907.

Paris. Bibliothèque nationale. *Livres des merveilles . . . reproduction des 265 miniatures du manuscrit français 2810 . . .* (H. A. Omont), Paris [1907]. 2v.

Paris. Bibliothèque nationale. *Catalogue de l'exposition du moyen âge: manuscrits, estampes, médailles et objets d'art, imprimés . . .*, Paris, 1926.

Paris. Bibliothèque nationale. *Les enluminures des manuscrits du moyen âge (du VIᵉ au XVᵉ siècle) de la Bibliothèque nationale* (C. Couderc), Paris, 1927.

Paris. Bibliothèque nationale. *Les joyaux de l'enluminure à la Bibliothèque nationale* (H. M. R. Martin), Paris and Brussels, 1928.

Paris. Bibliothèque nationale. *Les manuscrits à peintures en France du XIIIᵉ au XVIᵉ siècle* (J. Porcher), Paris, 1955.

Paris. Bibliothèque nationale. Porcher, J., *Manuscrits à peintures offerts à la Bibliothèque nationale par le comte Guy du Boisrouvray*, Paris, 1961.

Paris. Bibliothèque Sainte-Geneviève. *Catalogue des manuscrits de la Bibliothèque Sainte-Geneviève* (C. Kohler), Paris, 1893–1896. 2v.

Paris. Musée du Louvre. *Exposition des primitifs français au palais du Louvre . . . et à la Bibliothèque nationale*, Paris, 1904.

Paris. Musée du Louvre. *Peintures, école française, XIVᵉ, XVᵉ, et XVIᵉ siècles* (C. Sterling and H. Adhémar), Paris, 1965.

Paris. Musée du Louvre. Cabinet des Dessins. *Enluminures et dessins français du XIIIᵉ au XVIᵉ siècles*, Paris, 1957.

Poirion, D., *Le poète et le prince, l'évolution du lyrisme courtois de Guillaume de Machaut à Charles d'Orléans*, Paris, 1965.

Polo, Marco, *Il milione*, ed. L. F. Benedetto, Florence, 1928.

Polo, Marco, *La description du monde*, ed. L. Hambis, Paris, 1955.

Porcher, J., *Les Belles Heures de Jean de France, duc de Berry*, Paris, 1953.

Porcher, J., *Medieval French Miniatures*, New York [1959]. French ed. *Enluminure française*, Paris, 1959.

Porcher, J., *Jean Lebègue, les histoires que l'on peut raisonnablement faire sur les livres de Salluste*, Paris, 1962.

Porcher, J., *see also* Paris, Bibliothèque nationale.

Poujoulat, J. J. F., see *Le livre des faicts du bon messire Jean le Maingre, dit Boucicaut*.

Prost, B., 'Liste des artistes mentionnés dans les états de la maison du roi et des maisons des princes, du XIIIᵉ siècle à l'an 1500', *Archives historiques, artistiques et littéraires*, I, 1889–1890, pp. 425-437.

Prost, B., 'Quelques acquisitions de manuscrits par les ducs de Bourgogne Philippe le Hardi et Jean sans

Peur (1396–1415)', *Archives historiques*, II, 1891, pp. 337-353.

Raynaud, G., *see* Deschamps, E.

Ricci, S. de, ed., *Census of Medieval and Renaissance Manuscripts in the United States and Canada*, New York, 1935–1940. 3v. Supplement, 1962.

Ring, G., *A Century of French Painting, 1400–1500*, London [1949].

Ringbom, S., *Icon to Narrative. The Rise of the Dramatic Close-up in Fifteenth-Century Devotional Painting* (Acta Academiae Aboensis, Ser. A, Vol. XXXI, Nr. 2) Åbo, 1965.

Rome. Palazzo Venezia. *Mostra storica nazionale della miniatura. Catalogo*, Florence [1953].

Saint-Hilaire, Q. de, *see* Deschamps, E.

Salmon, Pierre, see *Les demandes faites par le roi Charles VI . . . avec les réponses de Pierre Salmon.*

Schaefer, L., 'Die Illustrationen zu den Handschriften der Christine de Pizan', *Marburger Jahrbuch für Kunstwissenschaft*, X, 1937, pp. 119-208.

Schilling, R., 'The Nativity and Adoration of the Child Christ in French Miniatures of the early Fifteenth Century', *Connoisseur*, CXXX, 1952, pp. 167-169, 221.

Schilling, R., 'The Master of Egerton 1070 (Hours of René d'Anjou)', *Scriptorium*, VIII, 1954, pp. 272-282.

Spencer, E., 'The Master of the Duke of Bedford: The Bedford Hours', *Burlington Magazine*, CVII, 1965, pp. 495-502.

Spencer, E., 'The Master of the Duke of Bedford: The Salisbury Breviary', *Burlington Magazine*, CVIII, 1966, pp. 607-612.

Sterling, C., *see* Paris, Musée du Louvre.

Thieme, U., and F. Becker, *Allgemeines Lexikon der bildenden Künstler*, Leipzig, 1910-1950.

Thomas, M., 'Une prétendue signature de peintre dans un manuscrit du début du XVᵉ siècle', *Bulletin de la Société Nationale des Antiquaires de France*, 1958, p. 114 f.

Thompson, D. V., Jr., *The Materials of Medieval Painting*, New Haven, 1936.

Thomson, H. Y., *see* London, Thompson Collection (formerly).

Toesca, P., *La pittura e la miniatura nella Lombardia dai più antichi monumenti alla metà del Quattrocento*, Milan, 1912.

Toesca, P., *L'uffiziolo visconteo Landau-Finaly*, Florence, 1951.

Toesca, P., 'Manoscritti miniati della Biblioteca del Principe Corsini a Firenze', *Rassegna d'arte*, XVII, 1917, pp. 117-128.

Trenkler, E., *Livre d'heures; Handschrift 1855 der Österreichischen Nationalbibliothek*, Vienna [1948].

Verdier, P., *see* Baltimore, Walters Art Gallery.

Vienna. Kunsthistorisches Museum. *Europäische Kunst um 1400, Ausstellungskatalog*, Vienna, 1962.

Vienna. Nationalbibliothek. *Die westeuropäischen Handschriften und Inkunabeln der Gotik und der Renaissance. Englische und französische Handschriften des XIV. Jahrhunderts*, ed. H. J. Hermann (Beschreibendes Verzeichnis der illuminierten Handschriften in Österreich, N.F. VII, pt. VII, 2), Leipzig, 1936.

Vollmer, H., 'Drei neue Miniaturisten-Namen des XV. Jahrhunderts', *Repertorium für Kunstwissenschaft*, 1910, pp. 233-238.

Waagen, G. F., *Treasures of Art in Great Britain . . .*, London, 1854. 3v.

Warner, J. F., *see* London, British Museum.

Wescher, P., *see* Berlin, Staatliche Museen.

Winkler, F., 'Die Spanischen und Französischen Primitiven in der Gemäldegalerie und im Kupferstichkabinett', *Berliner Museen, Berichte aus den Preussischen Kunstsammlungen*, XLIX, 1928, pp. 6-12.

Winkler, F., rev. of E. Panofsky, 'Early Netherlandish Painting; its Origins and Character', *Kunstchronik*, VIII, 1955, pp. 9-26.

Winkler, F., *see also* Berlin, Staatliche Museen.

Wittkower, R., 'Marco Polo and the Pictorial Tradition of the Marvels of the East', *Oriente Poliano*, 1957, pp. 155-172.

Wixom, W. D., *see* Cleveland, Museum of Art.

Wormald, F., 'The Wilton Diptych', *Warburg Journal*, XVII, 1954, pp. 191-203.

Wormald, F., *see also* Cambridge, Fitzwilliam Museum.

'THE LATE FOURTEENTH CENTURY':
CORRIGENDA TO THE FIRST EDITION

PARIS, BIBL. NAT., FR. 13091.

The names of the Prophets, correctly given in the text on pp. 139 f., according to my conclusions, must be made to conform in the list of miniatures on p. 332, in the captions and in the list of illustrations as follows:

fol. 17v. (fig. 61): Micah, *not* Zephaniah.
fol. 21v. (fig. 65): Zephaniah, *not* Malachi.
fol. 29v. (fig. 73): Malachi, *not* Micah.

p. 12, line 25. *Read* fig. 232, *not* 235.
p. 50, sect. 6, line 3. *Read* fig. 485, *not* 478.
p. 98, col. 2, line 4. *Read* painted, *not* repainted.
p. 120, line 2. *Read* fig. 49, *not* 46.
p. 300, line 2. *For first date read* 1401, *not* 1404.
p. 317, col. 1, lines 15, 24. *Read* National, *not* Royal Library.
p. 320, col. 2, line 3. Fig. 253 is from Bourges ms. 48, *not* 33.
p. 336, col. 1, line 8; fig. 105; and List of Illustrations. *Read* St. Gregory, *not* St. Ambrose (?).
p. 341, col. 2; line 30. *Delete*: and bathing of Christ Child.
fig. 94. *Read* Jeremiah, *not* David.

ILLUSTRATIONS

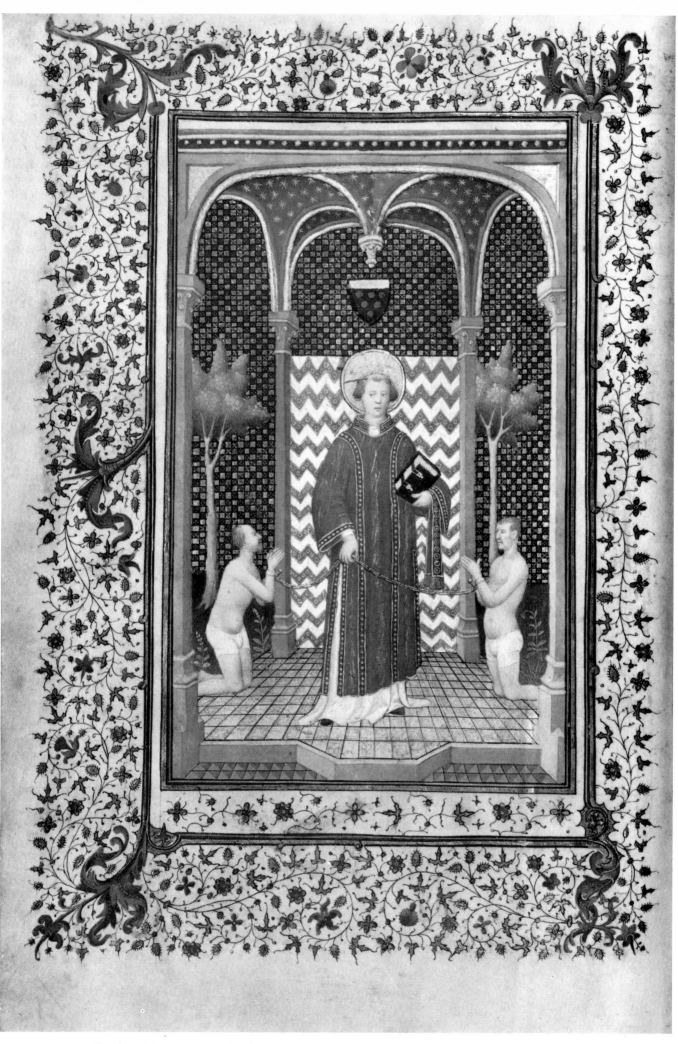

1. Boucicaut Master: *St. Leonard with two prisoners*. Paris, Musée Jacquemart-André, ms. 2, fol. 9v (arms altered).

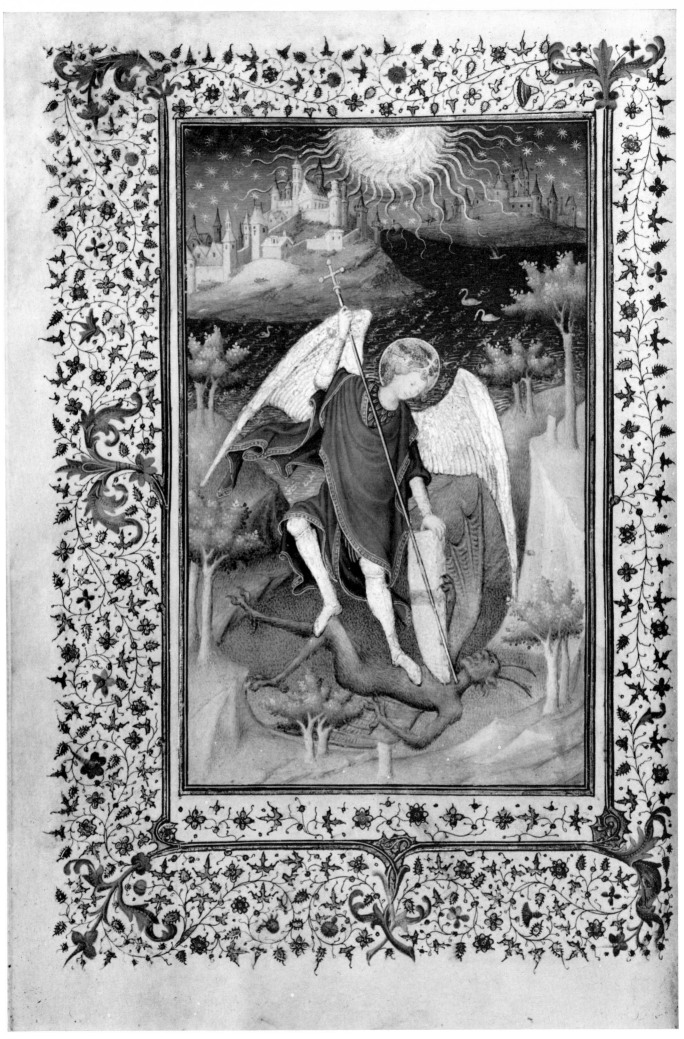

2. Boucicaut Master: *St. Michael conquering the devil*. Paris, Musée Jacquemart-André, ms. 2, fol. 11v.

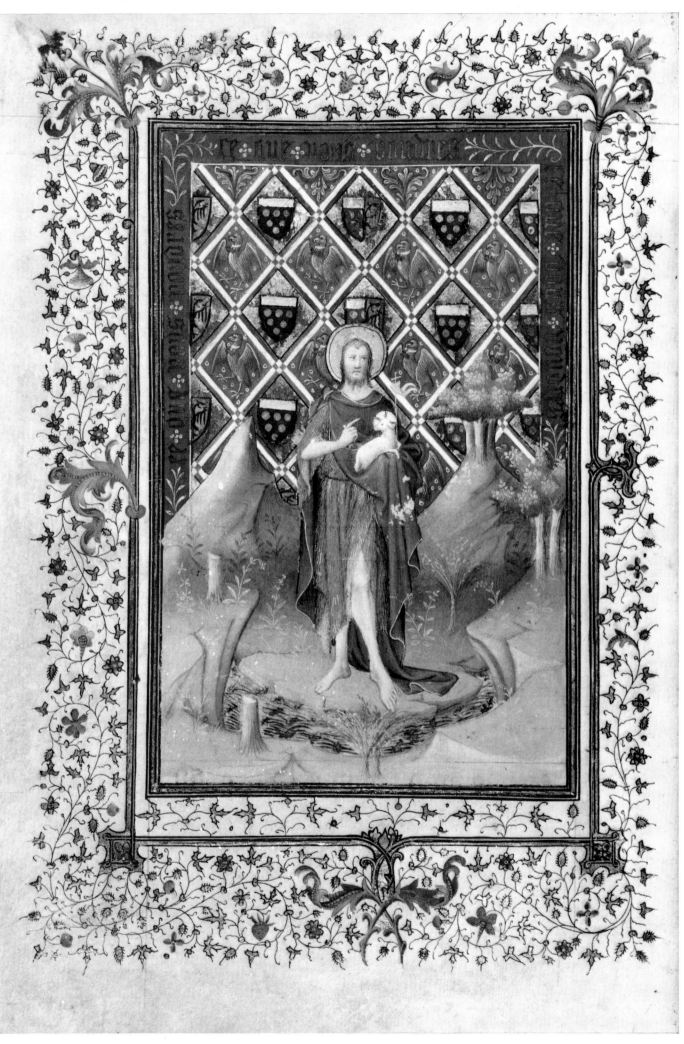

3. Boucicaut Master: *St. John the Baptist*. Paris, Musée Jacquemart-André, ms. 2, fol. 13v (arms altered).

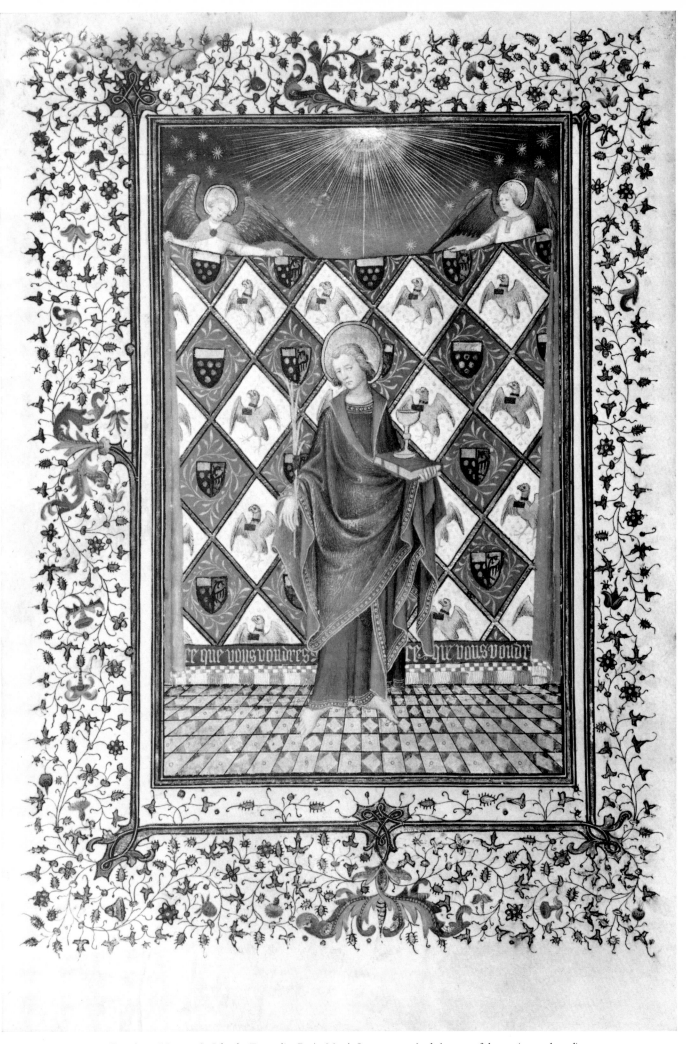

4. Boucicaut Master: *St. John the Evangelist*. Paris, Musée Jacquemart-André, ms. 2, fol. 15v (arms altered).

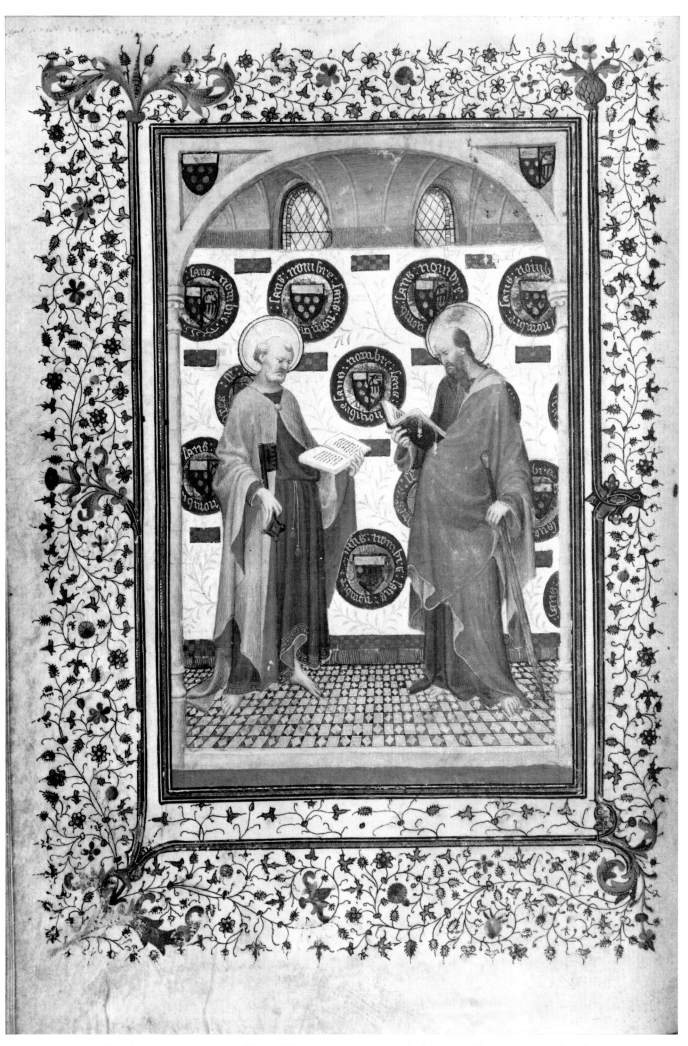

5. Boucicaut Master: *St. Peter and St. Paul*. Paris, Musée Jacquemart-André, ms. 2, fol. 17v (armorials altered).

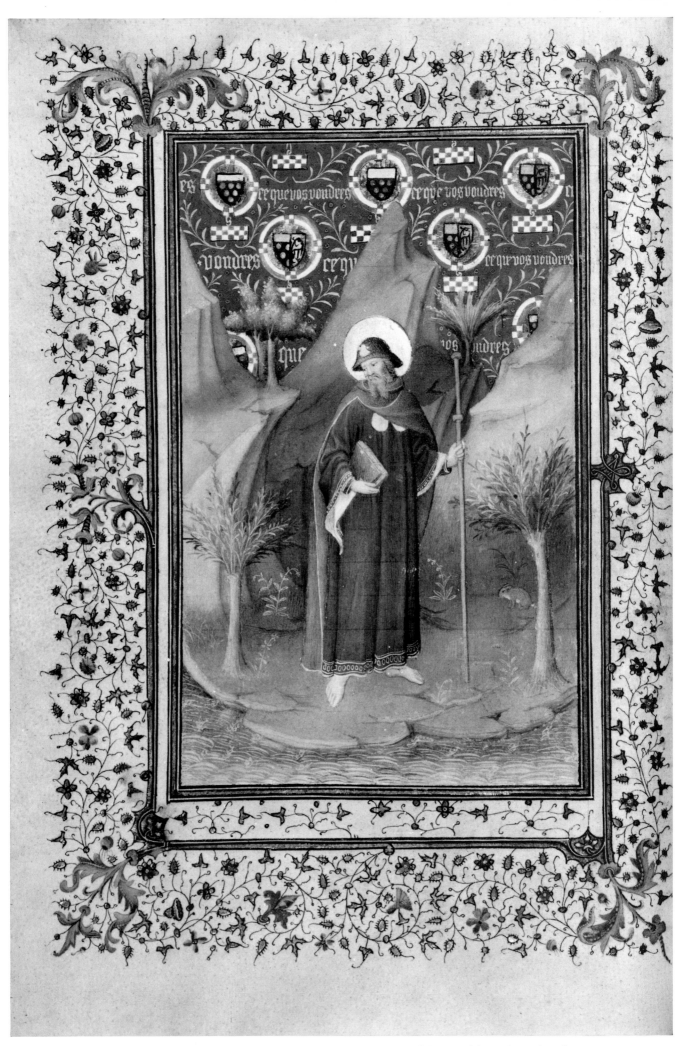

6. Boucicaut Master: *St. James Major*. Paris, Musée Jacquemart-André, ms. 2, fol. 18v (arms altered).

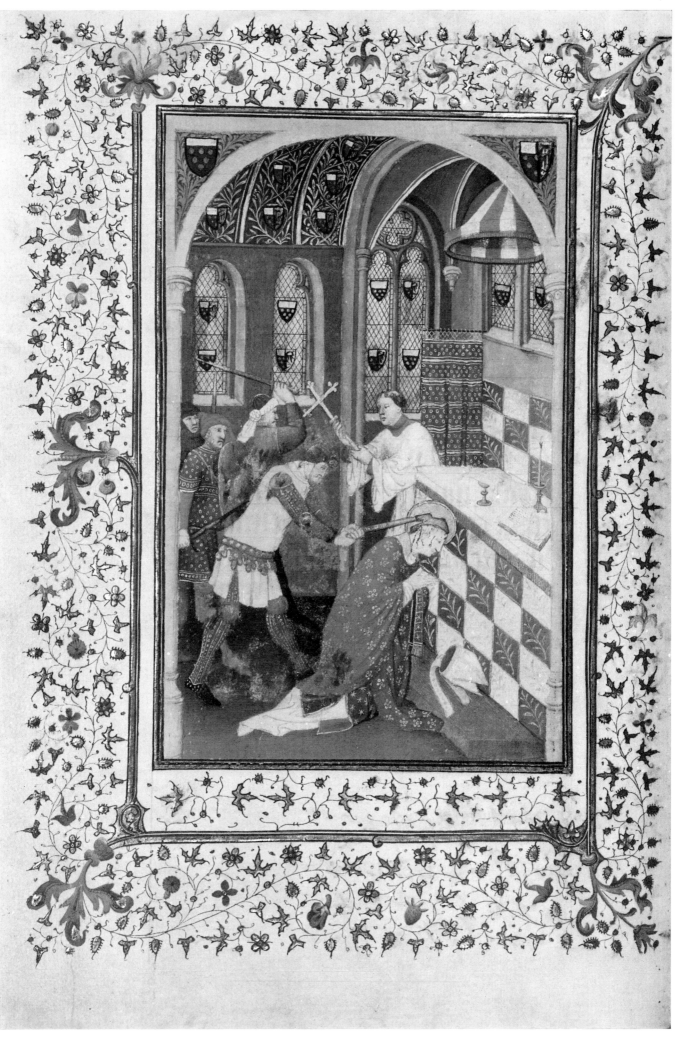

11. Boucicaut Master: *Martyrdom of St. Thomas of Canterbury*. Paris, Musée Jacquemart-André, ms. 2, fol. 24v (arms altered).

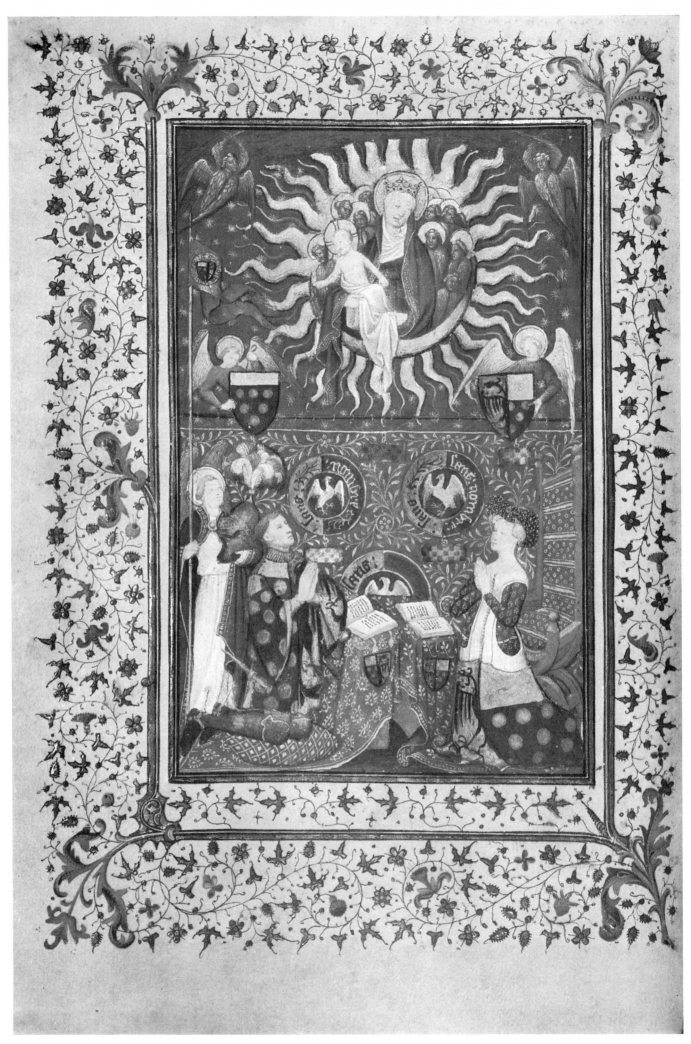

12. Boucicaut Master: *The Marshal and his wife in prayer before the Madonna*. Paris, Musée Jacquemart-André, ms. 2, fol. 26v (armorials altered).

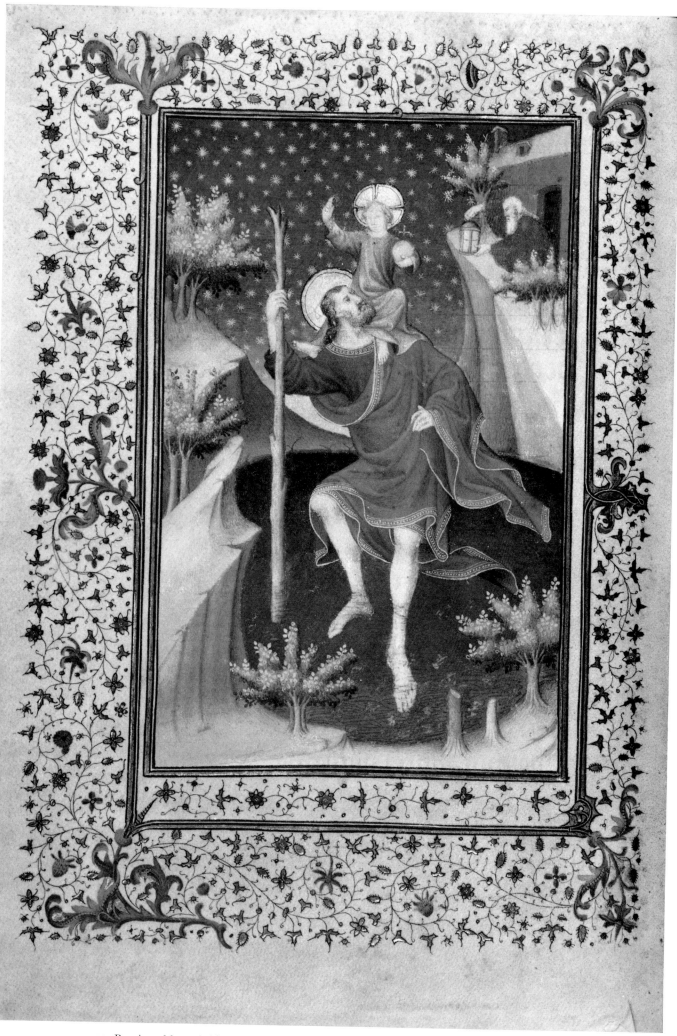

13. Boucicaut Master (with assistant): *St. Christopher*. Paris, Musée Jacquemart-André, ms. 2, fol. 28v.

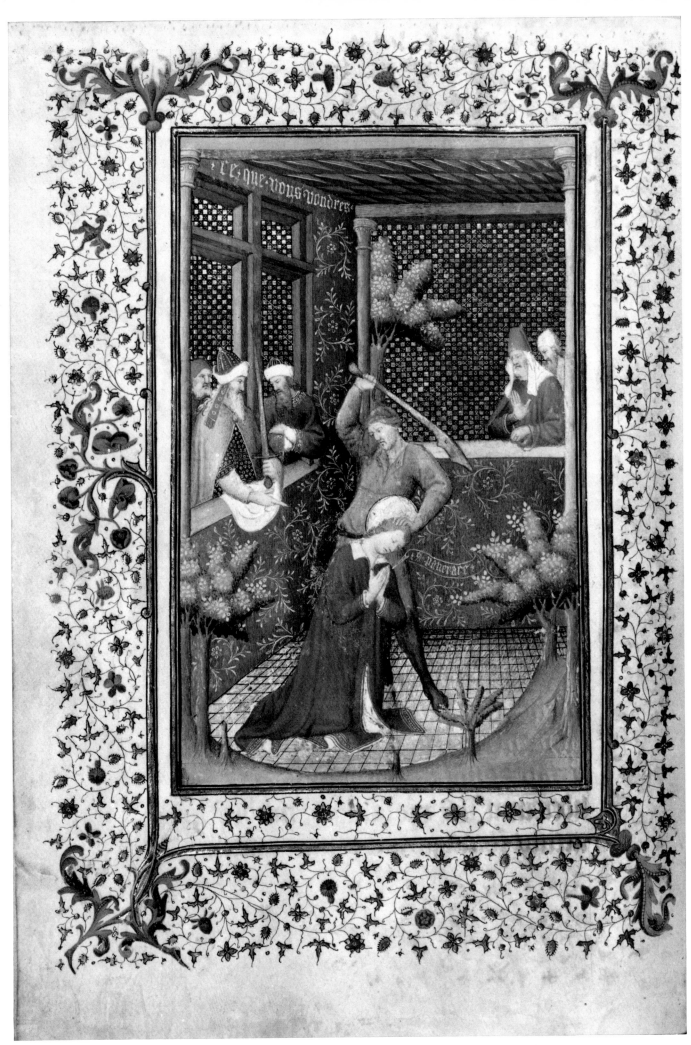

14. Boucicaut Master: *Martyrdom of St. Pancras*. Paris, Musée Jacquemart-André, ms. 2, fol. 29v.

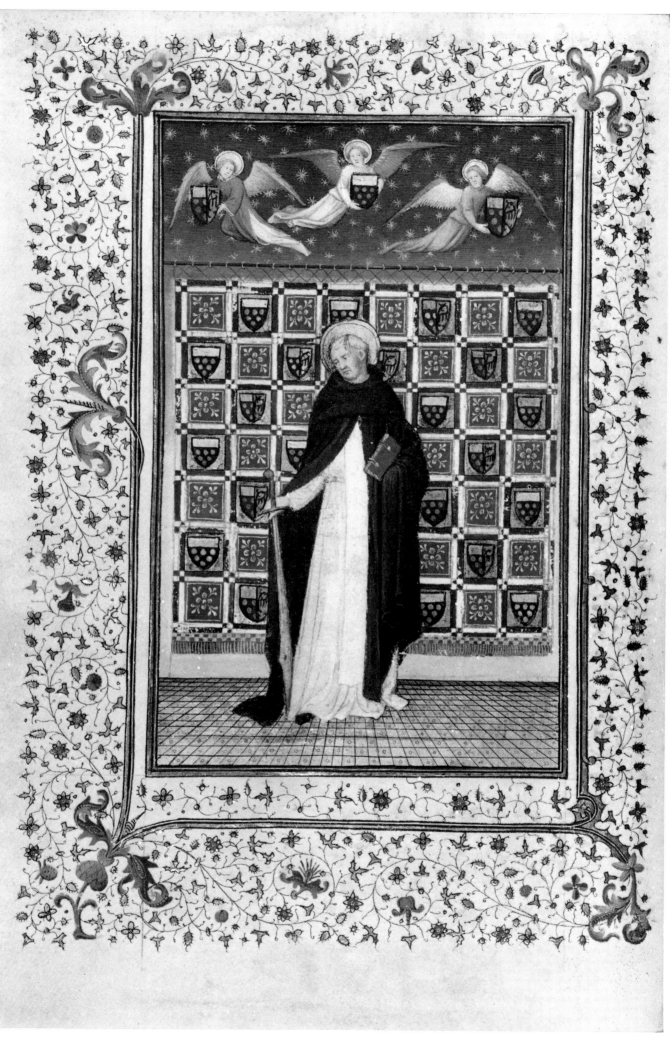

15. Boucicaut Master: *St. Peter Martyr*. Paris, Musée Jacquemart-André, ms. 2, fol. 30v (arms altered).

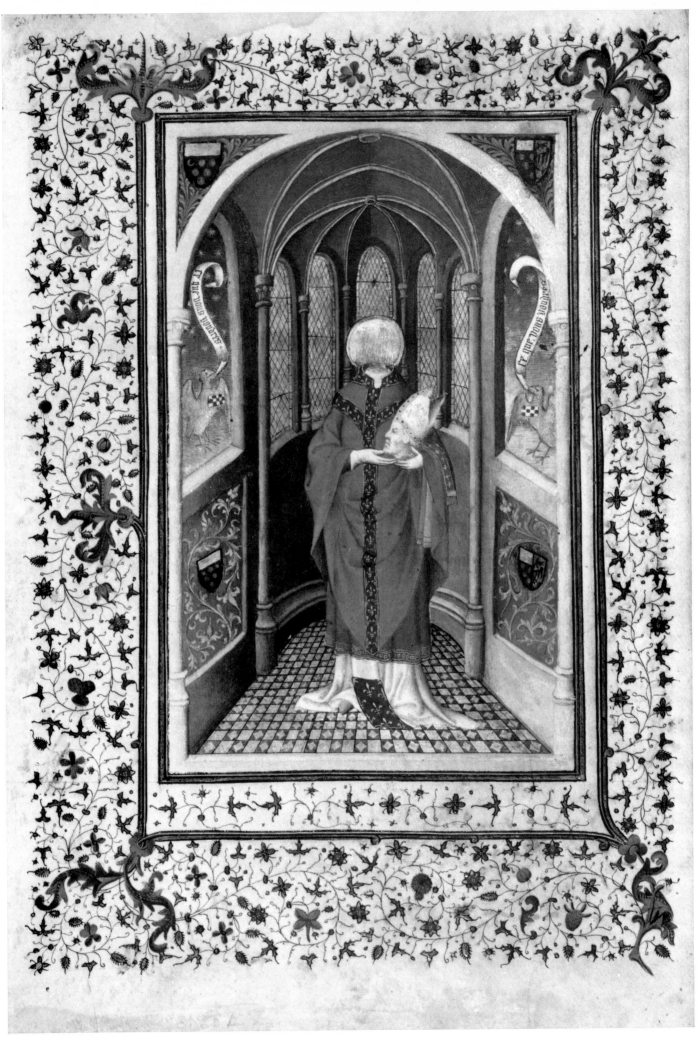

16. Boucicaut Master (with assistant?): *St. Denis*. Paris, Musée Jacquemart-André, ms. 2, fol. 31v (arms altered).

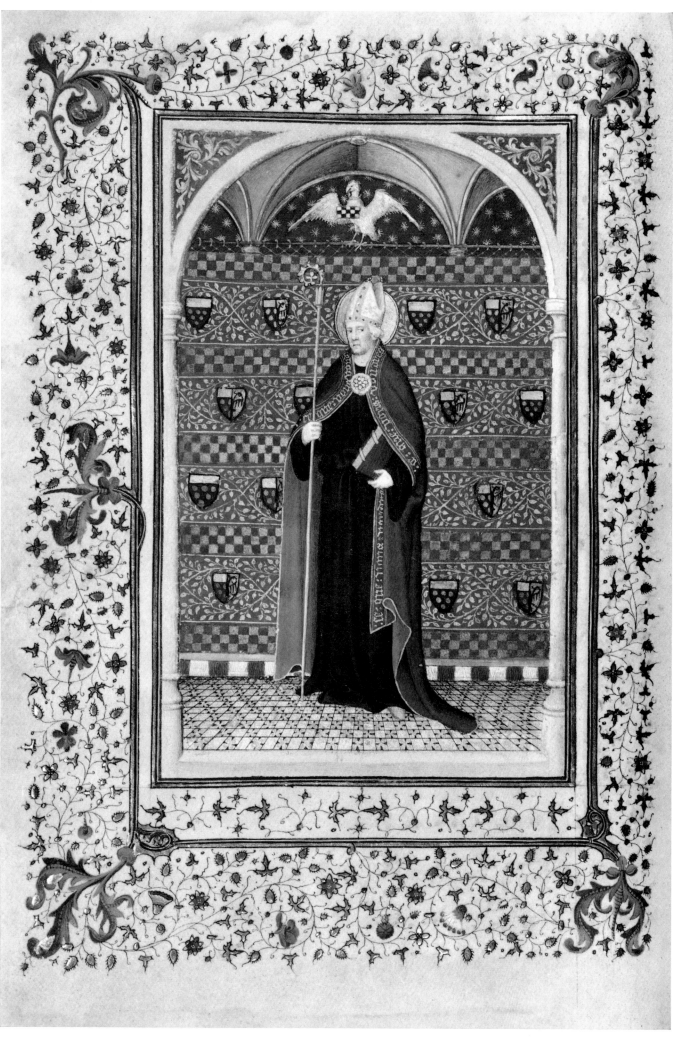

17. Boucicaut Master: *St. Augustine*. Paris, Musée Jacquemart-André, ms. 2, fol. 32v (arms altered or added).

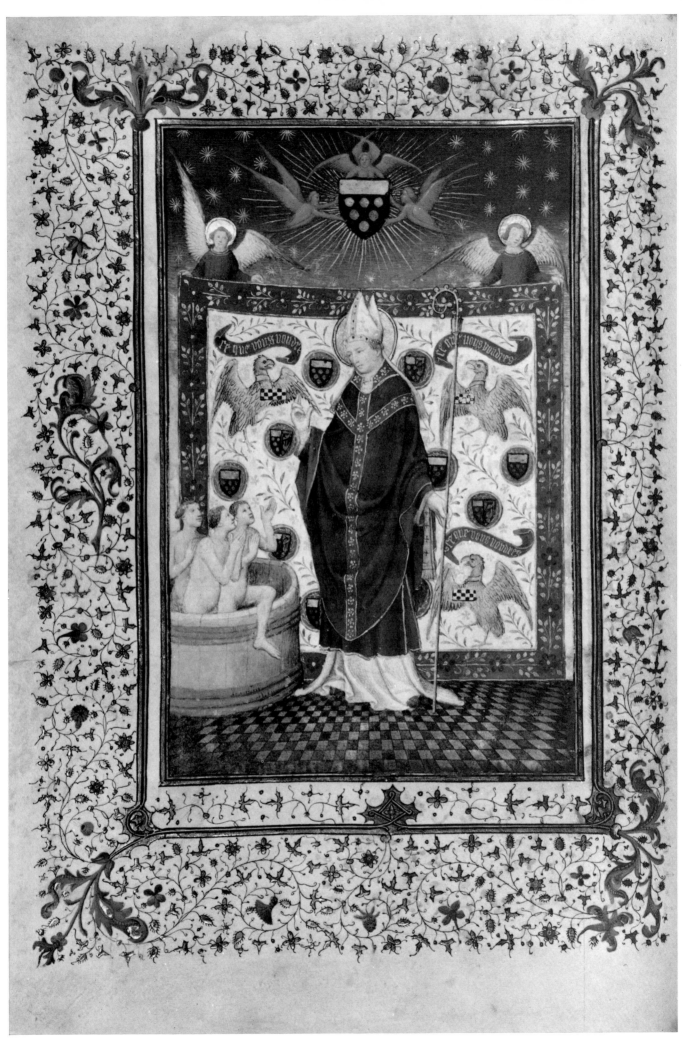

18. Boucicaut Master: *St. Nicholas reviving three men*. Paris, Musée Jacquemart-André, ms. 2, fol. 33v (arms altered).

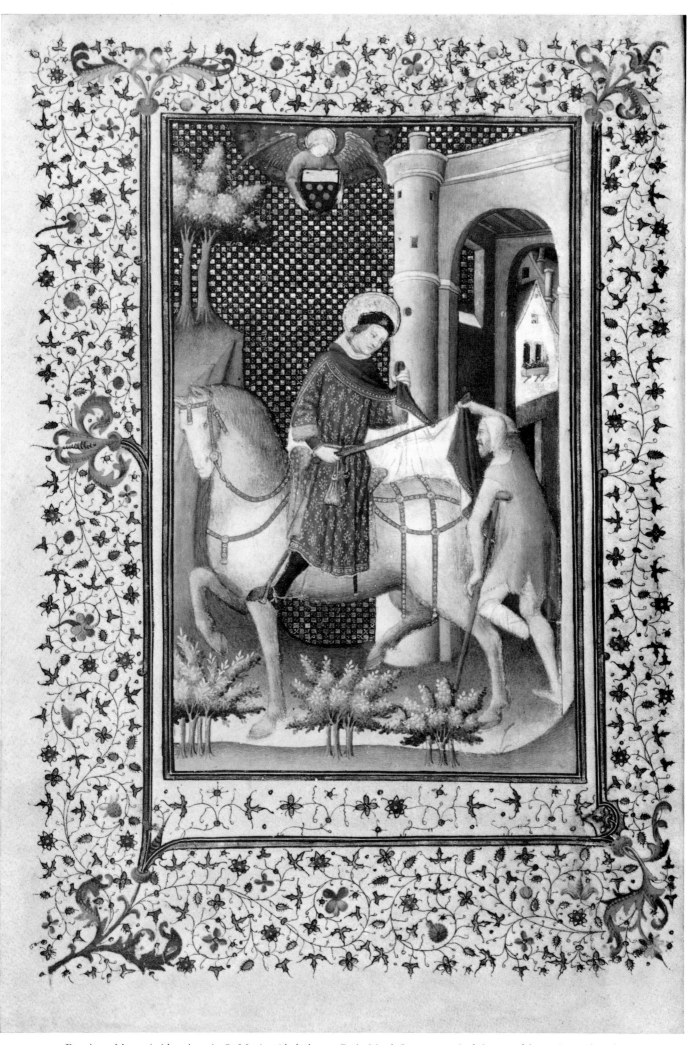

19. Boucicaut Master (with assistant): *St. Martin with the beggar*. Paris, Musée Jacquemart-André, ms. 2, fol. 34v (arms altered).

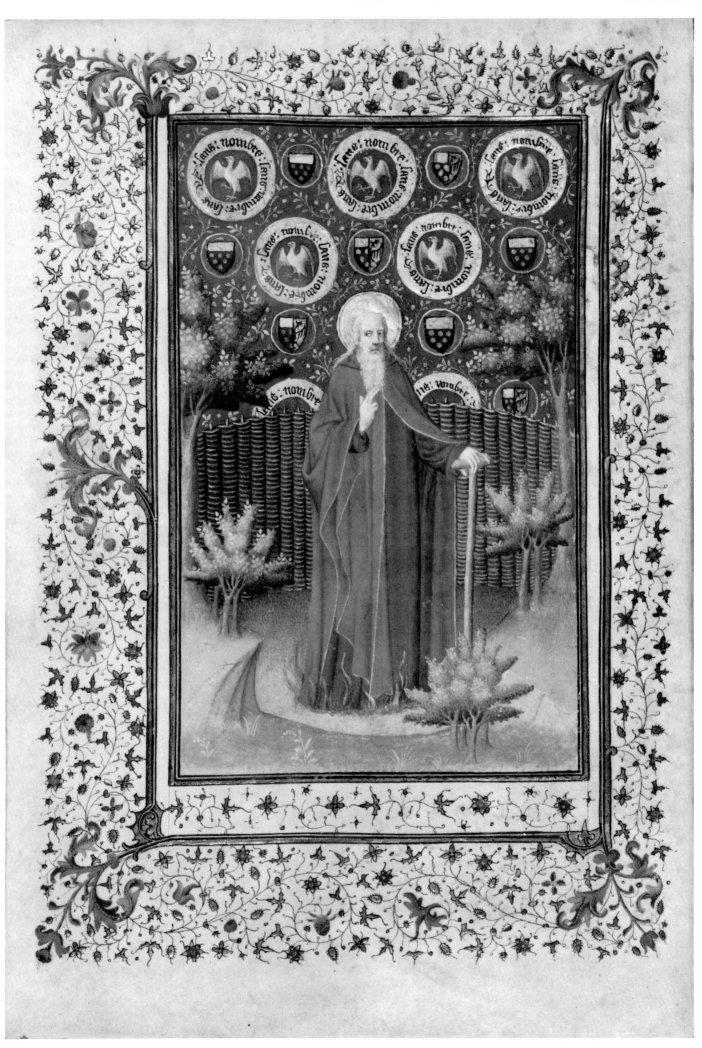

20. Boucicaut Master: *St. Anthony Abbot*. Paris, Musée Jacquemart-André, ms. 2, fol. 35v (armorials altered).

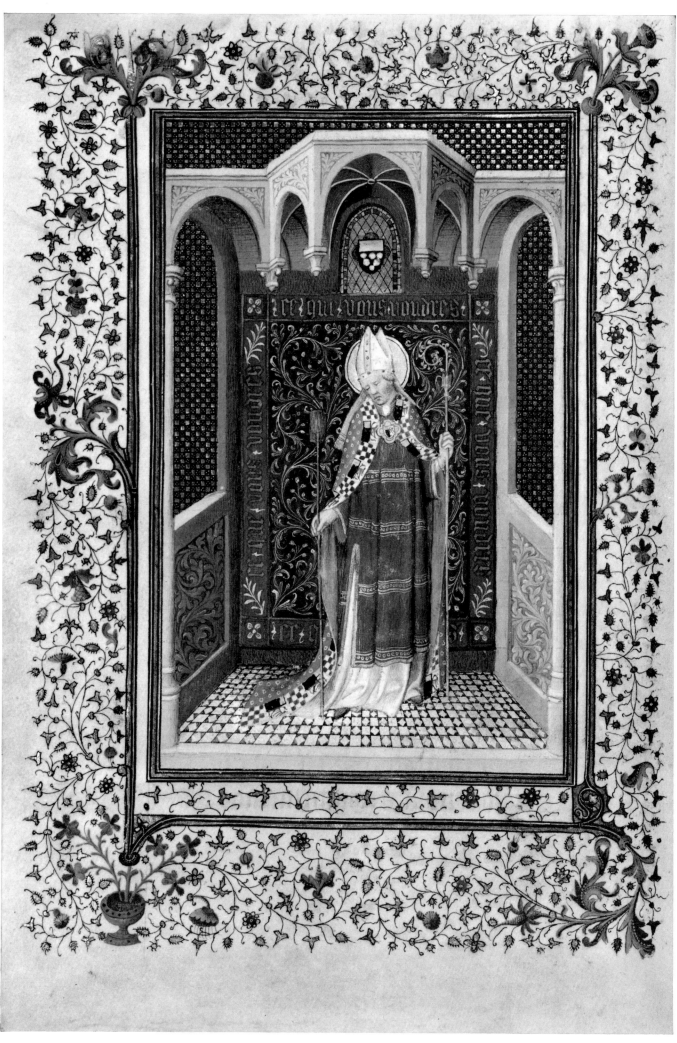

21. Boucicaut Master: *St. Honoratus*. Paris, Musée Jacquemart-Andre, ms. 2, fol. 36v (arms altered).

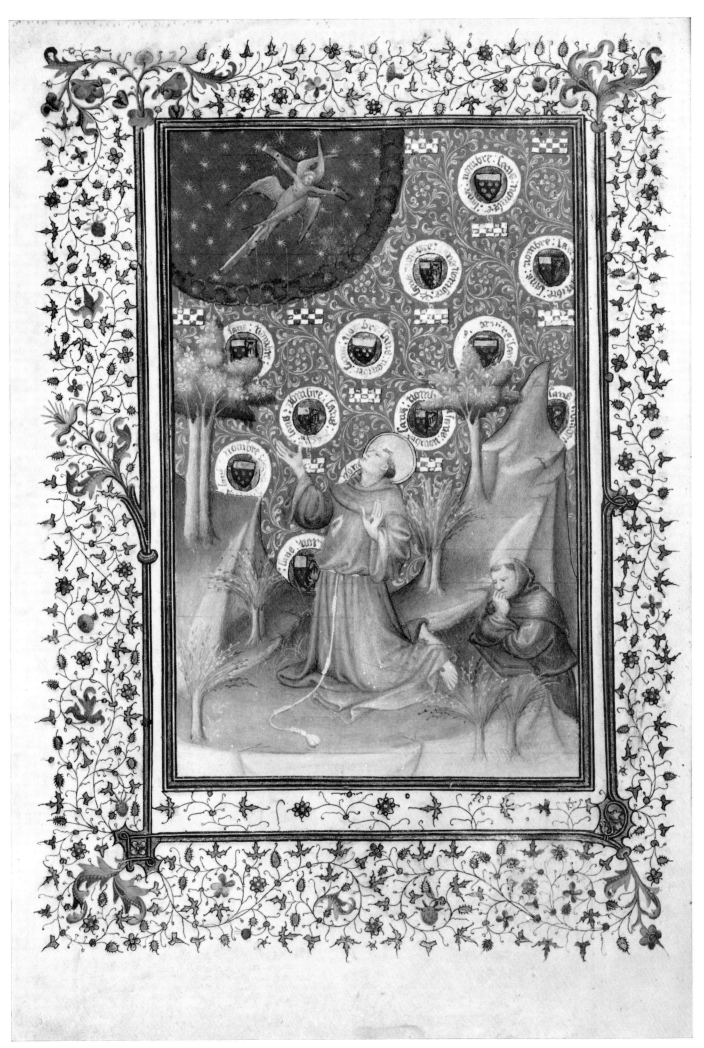

22. Boucicaut Master: *Stigmatization of St. Francis*. Paris, Musée Jacquemart-André, ms. 2, fol. 37v (armorials altered).

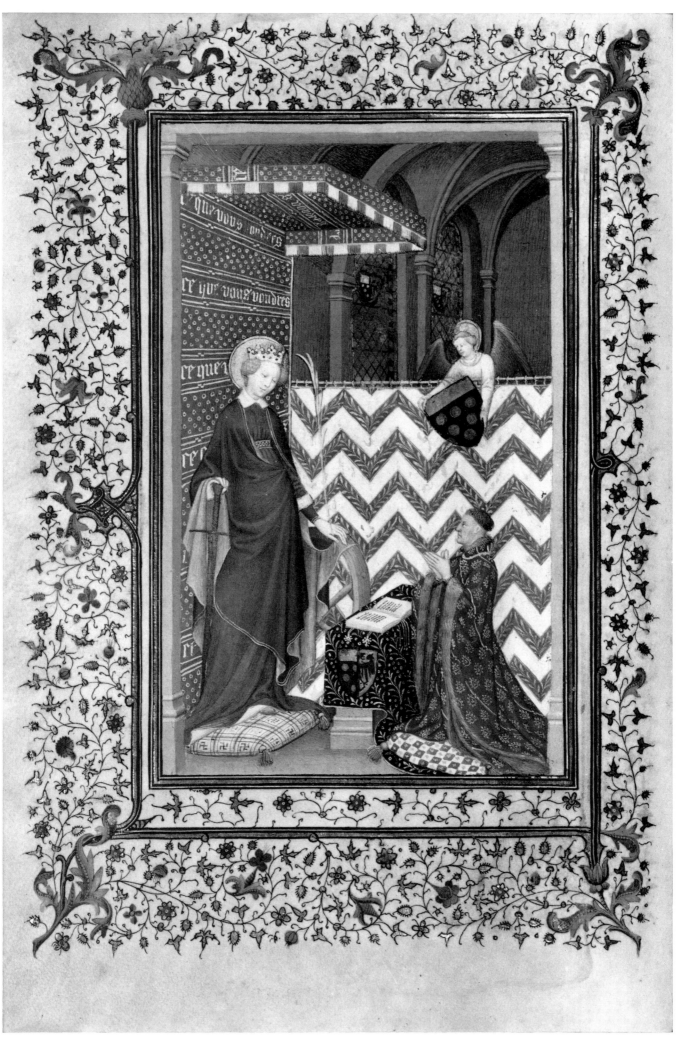

23. Boucicaut Master: *The Marshal in prayer before St. Catherine*. Paris, Musée Jacquemart-André, ms. 2, fol. 38v (arms altered and added).

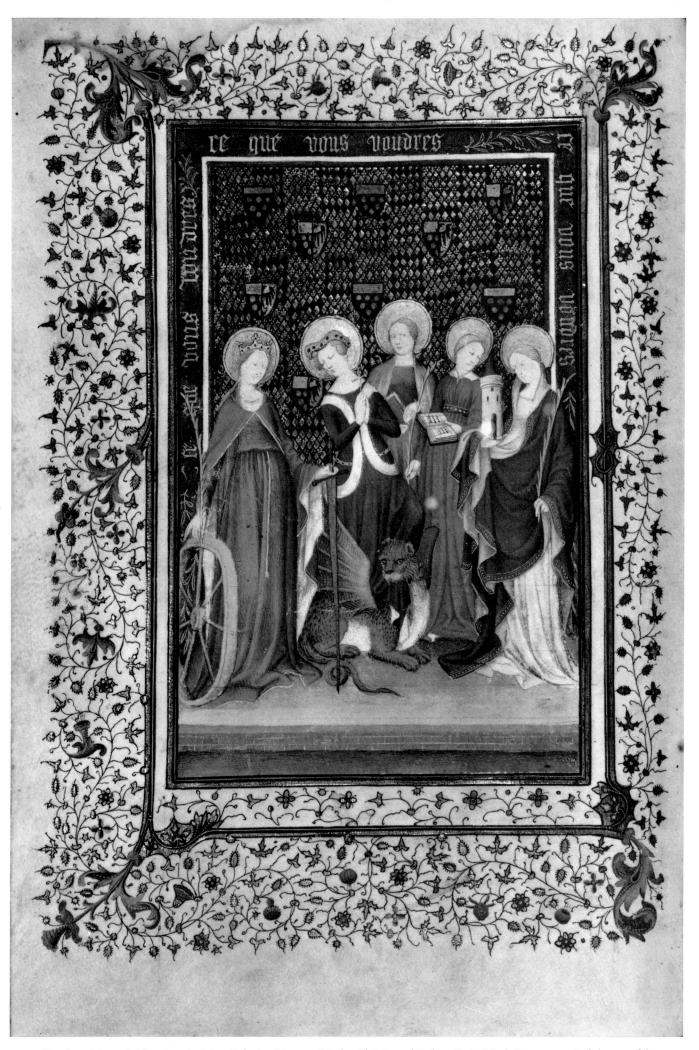

24. Boucicaut Master (with assistant): *Saints Catherine, Margaret, Martha, Christine and Barbara.* Paris, Musée Jacquemart-André, ms. 2, fol. 40v
(arms altered).

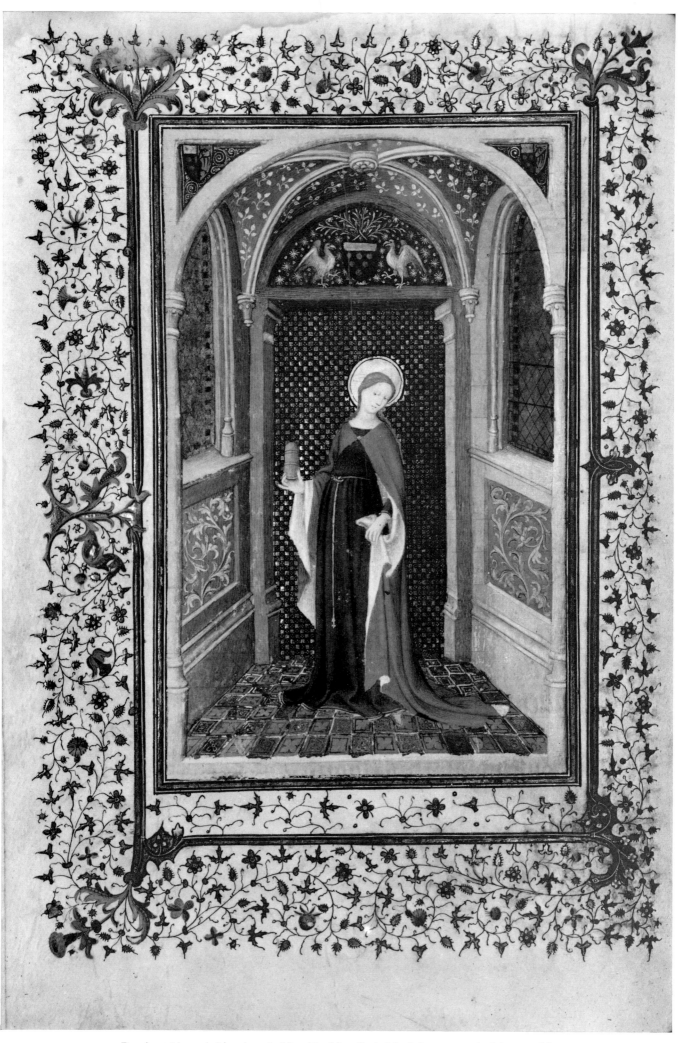

25. Boucicaut Master (with assistant): *Mary Magdalene*. Paris, Musée Jacquemart-André, ms. 2, fol. 41v
(arms altered and added?).

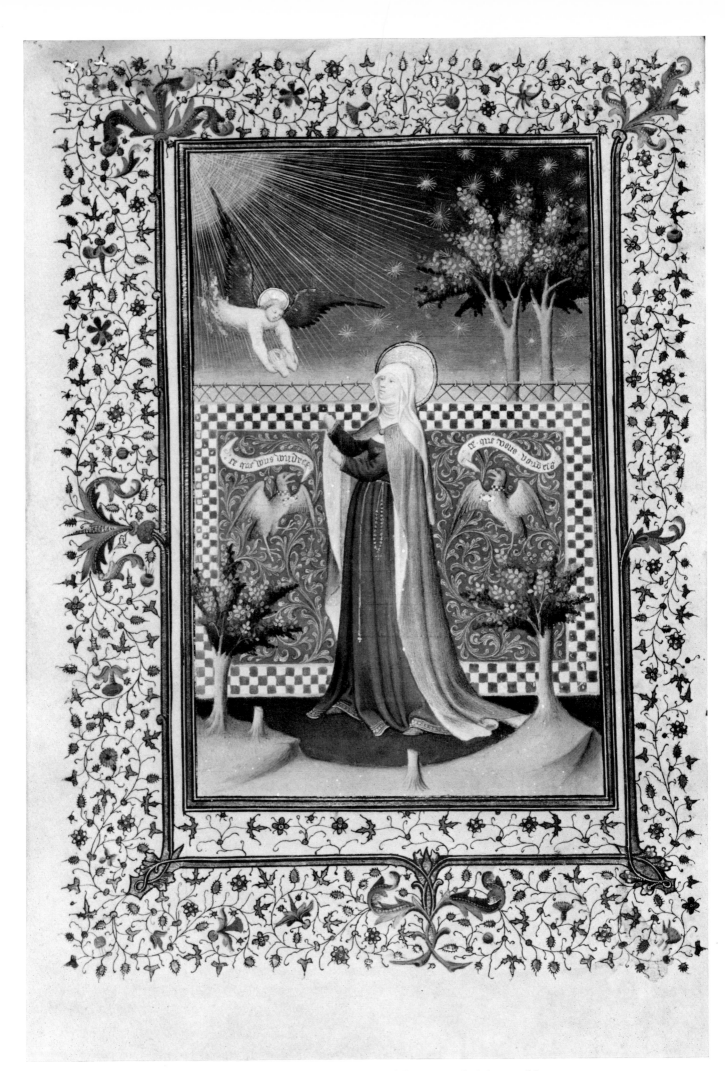

26. Boucicaut Master: *St. Bridget*. Paris, Musée Jacquemart-André, ms. 2, fol. 42v.

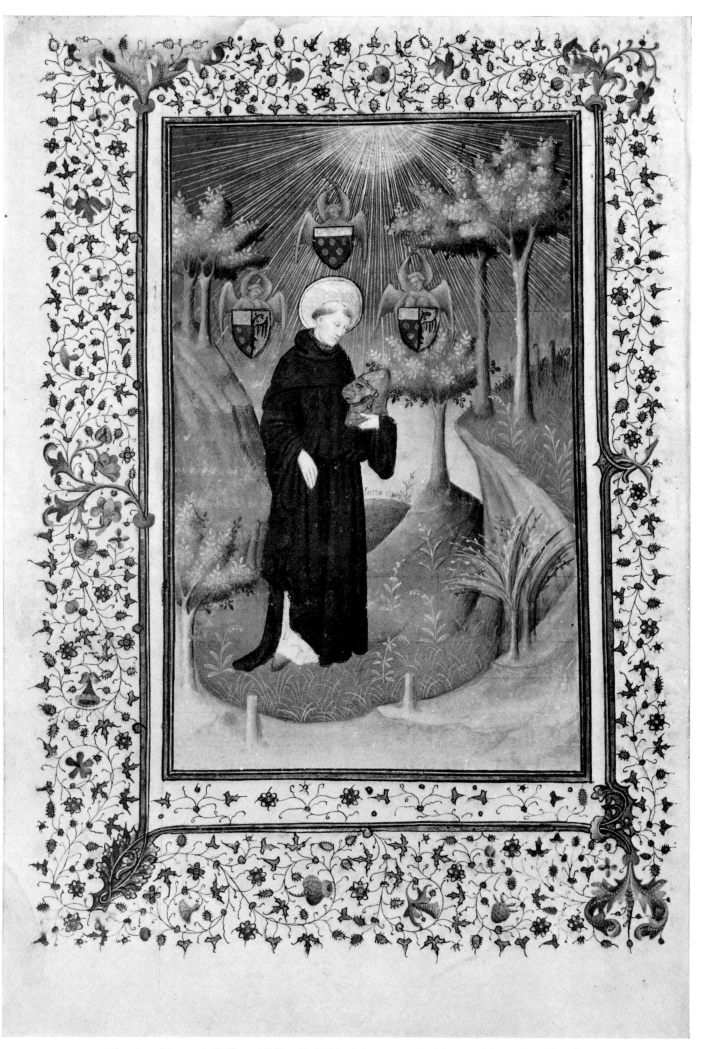

27. Boucicaut Master: *St. William of Gellone*. Paris, Musée Jacquemart-André, ms. 2, fol. 43v (arms altered).

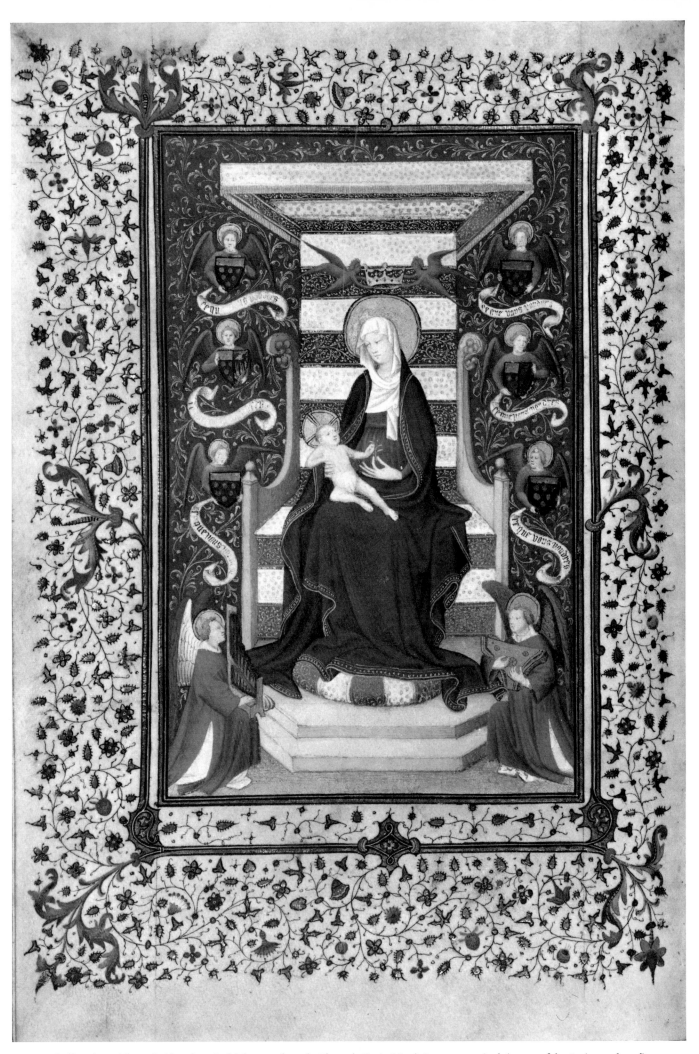

28. Boucicaut Master (with assistant): *Madonna enthroned with angels*. Paris, Musée Jacquemart-André, ms. 2, fol. 46v (arms altered).

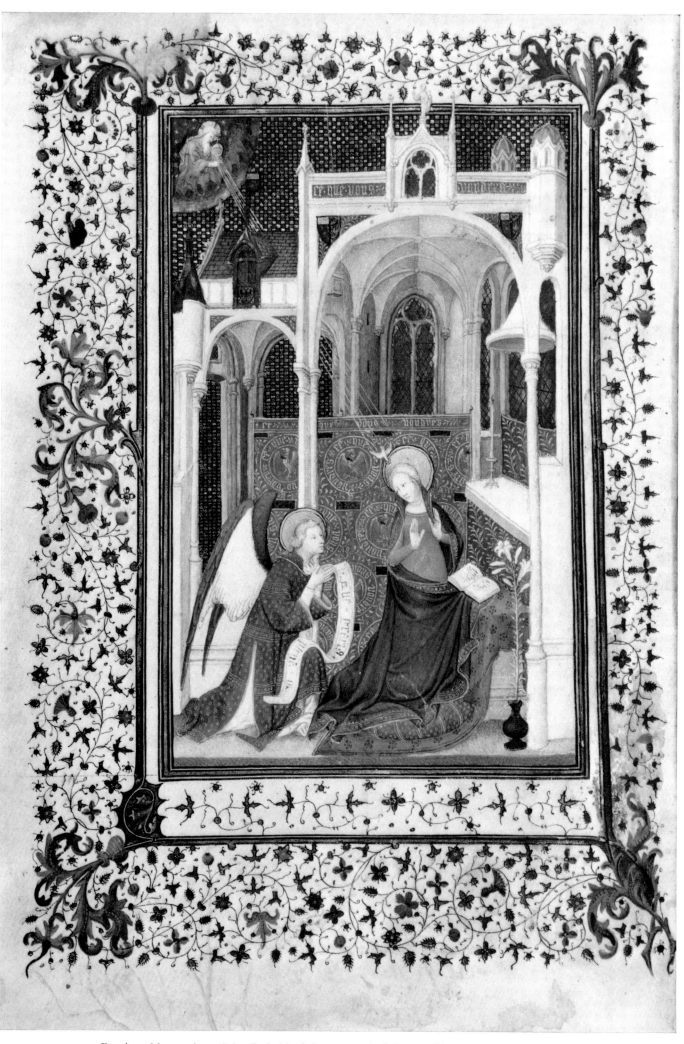

29. Boucicaut Master: *Annunciation*. Paris, Musée Jacquemart-André, ms. 2, fol. 53v (arms altered or added).

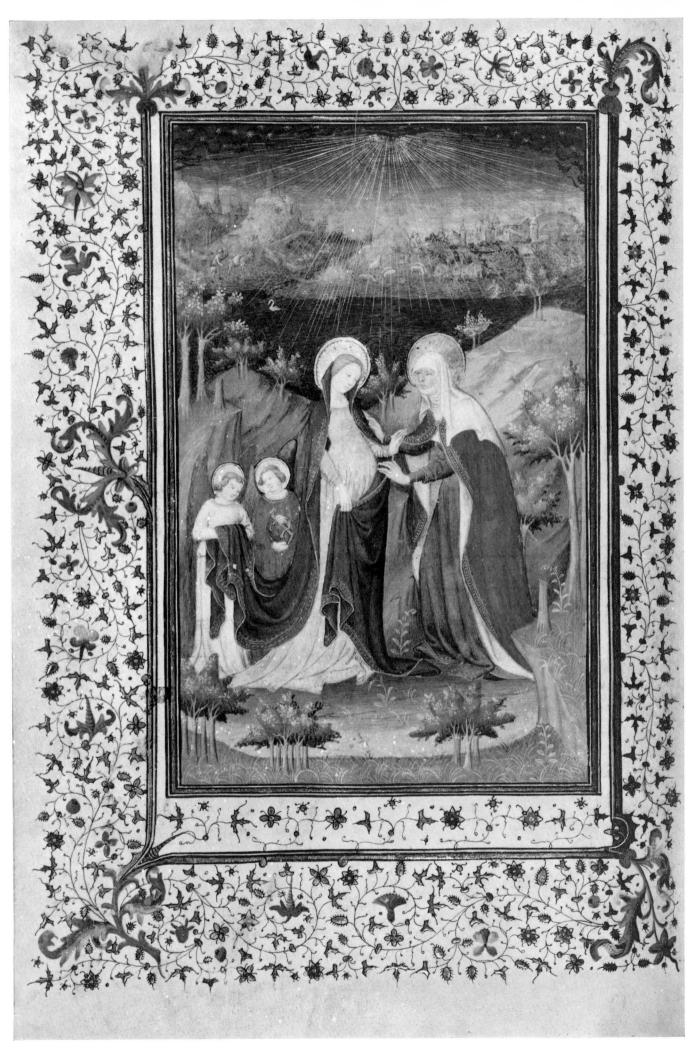

30. Boucicaut Master: *Visitation*. Paris, Musée Jacquemart-André, ms. 2, fol. 65v (much pigment lost from Virgin's tunic).

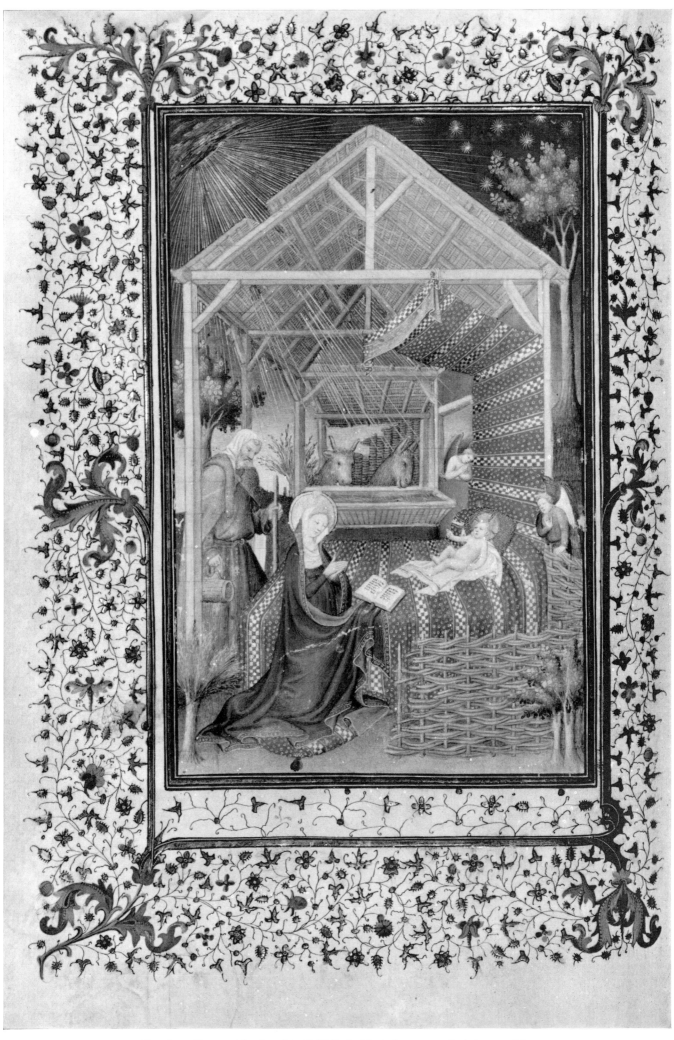

31. Boucicaut Master: *Adoration of the Child*. Paris, Musée Jacquemart-André, ms. 2, fol. 73v.

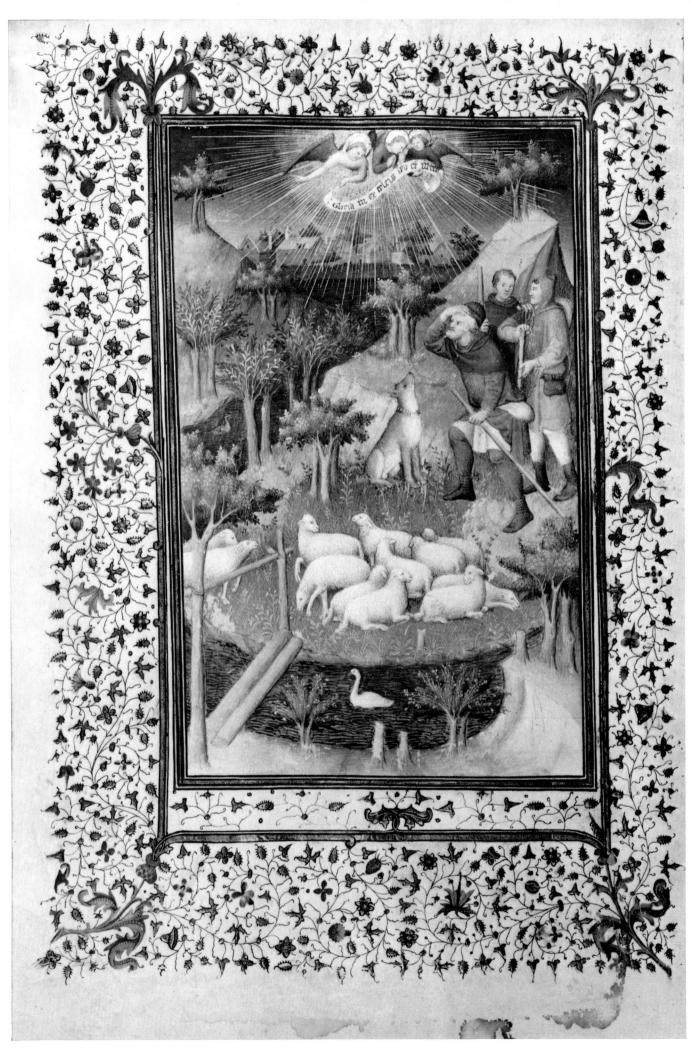

32. Boucicaut Master: *Annunciation to the Shepherds*. Paris, Musée Jacquemart-André, ms. 2, fol. 79v.

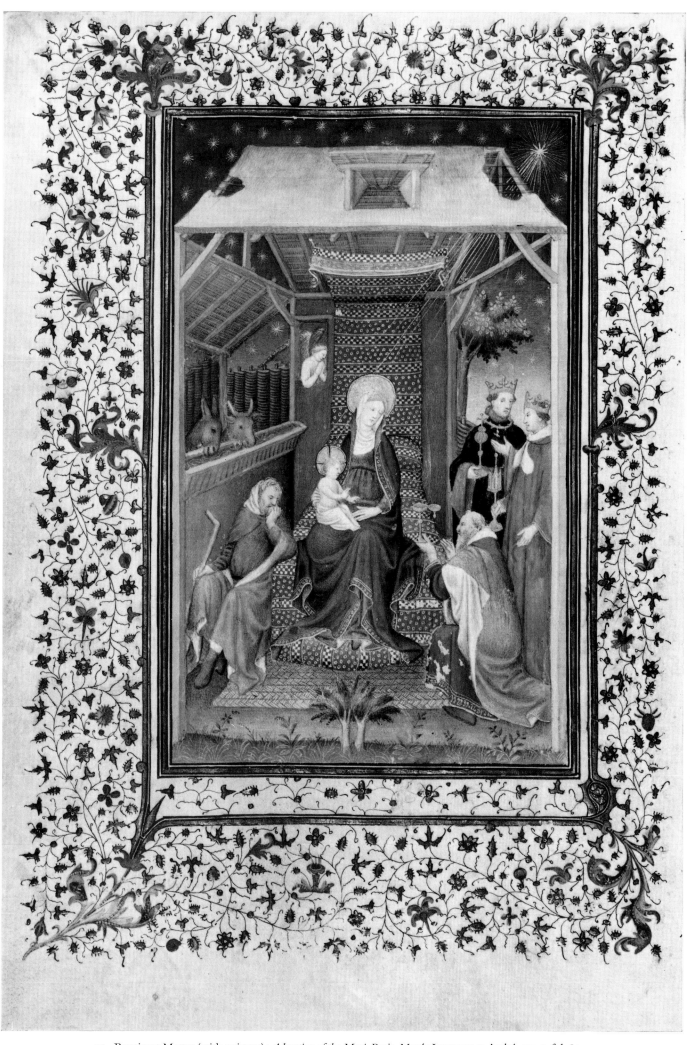

33. Boucicaut Master (with assistant): *Adoration of the Magi*. Paris, Musée Jacquemart-André, ms. 2, fol. 83v.

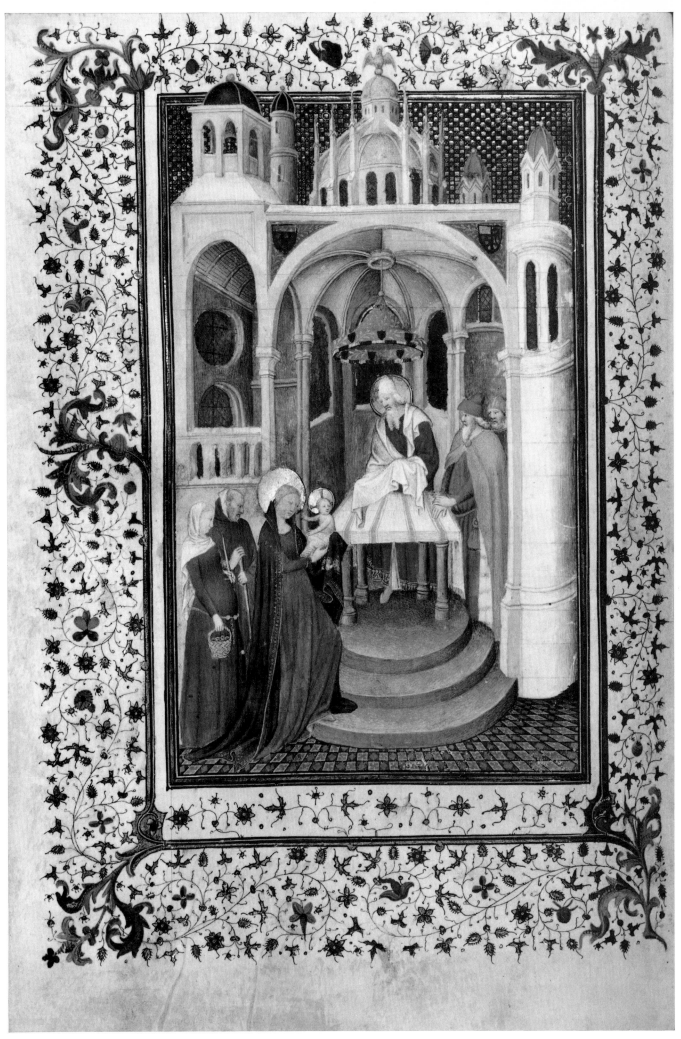

34. Boucicaut Master (with assistant): *Presentation in the Temple*. Paris, Musée Jacquemart-André, ms. 2, fol. 87v (arms altered or added).

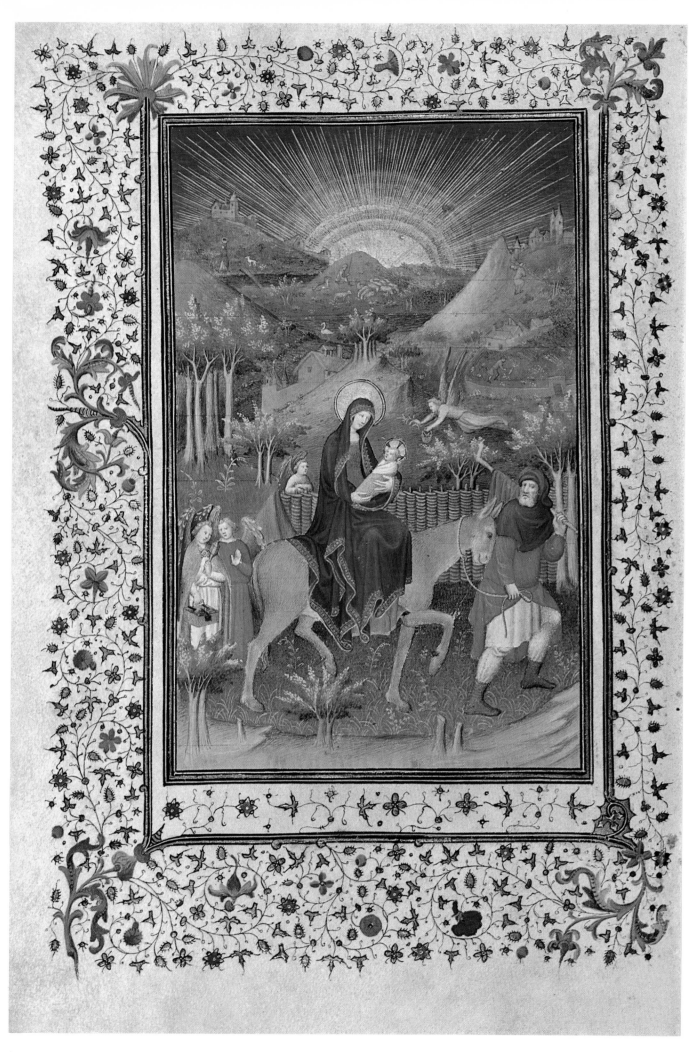

35. Boucicaut Master: *Flight into Egypt*. Paris, Musée Jacquemart-André, ms. 2, fol. 90v.

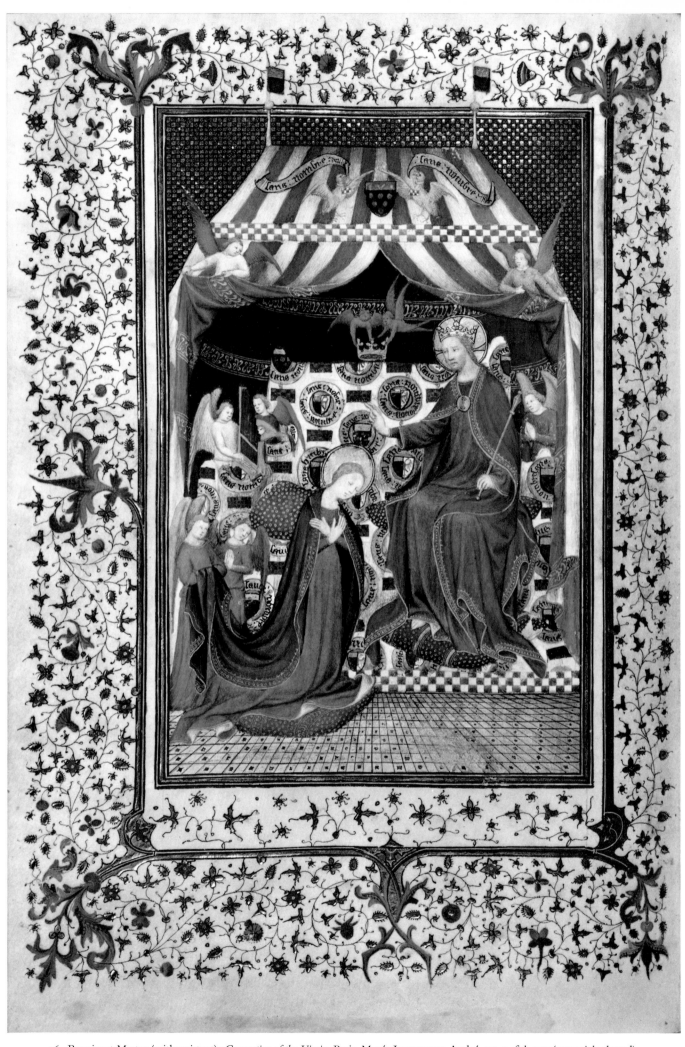

36. Boucicaut Master (with assistant): *Coronation of the Virgin*. Paris, Musée Jacquemart-André, ms. 2, fol. 95v (armorials altered).

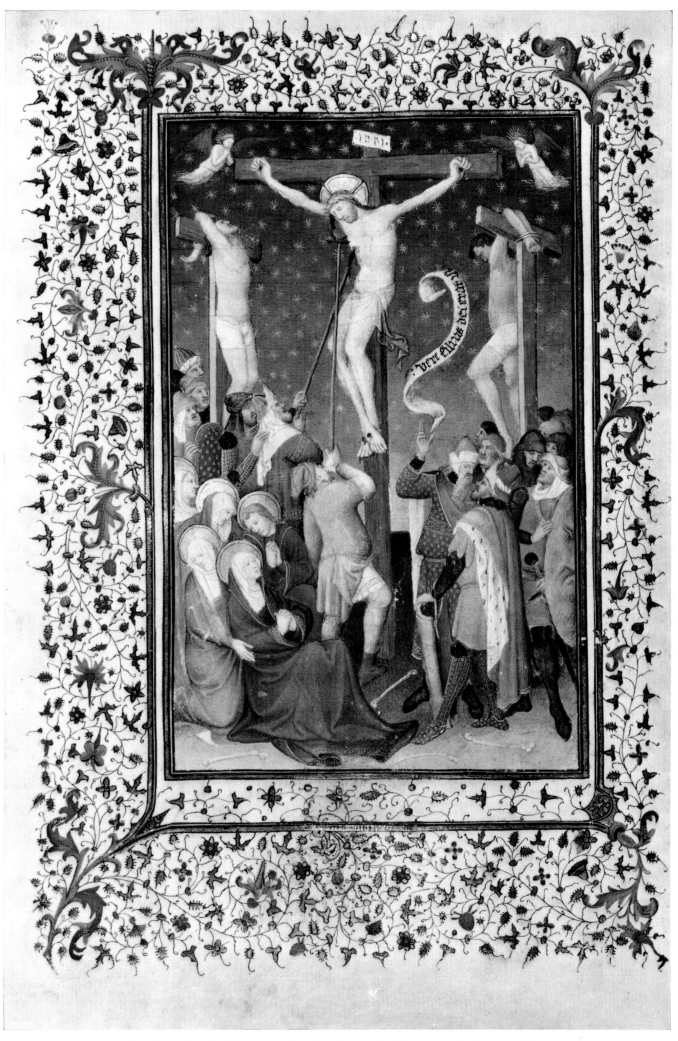

37. Boucicaut Master (with assistant): *Crucifixion*. Paris, Musée Jacquemart-André, ms. 2, fol. 105v.

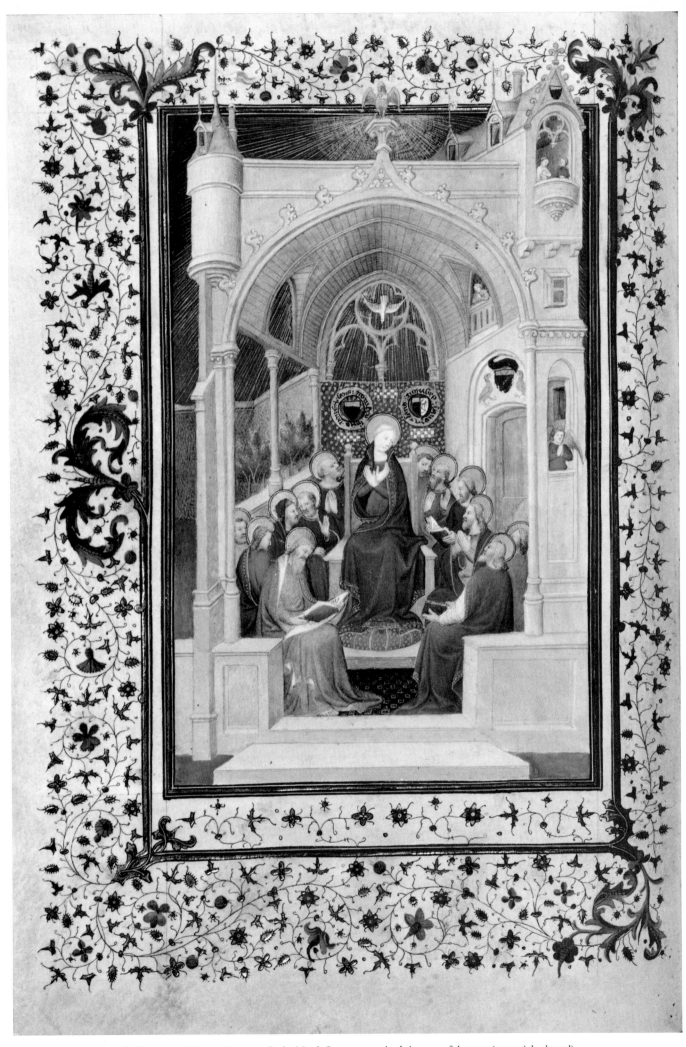

38. Boucicaut Master: *Pentecost*. Paris, Musée Jacquemart-André, ms. 2, fol. 112v (armorials altered).

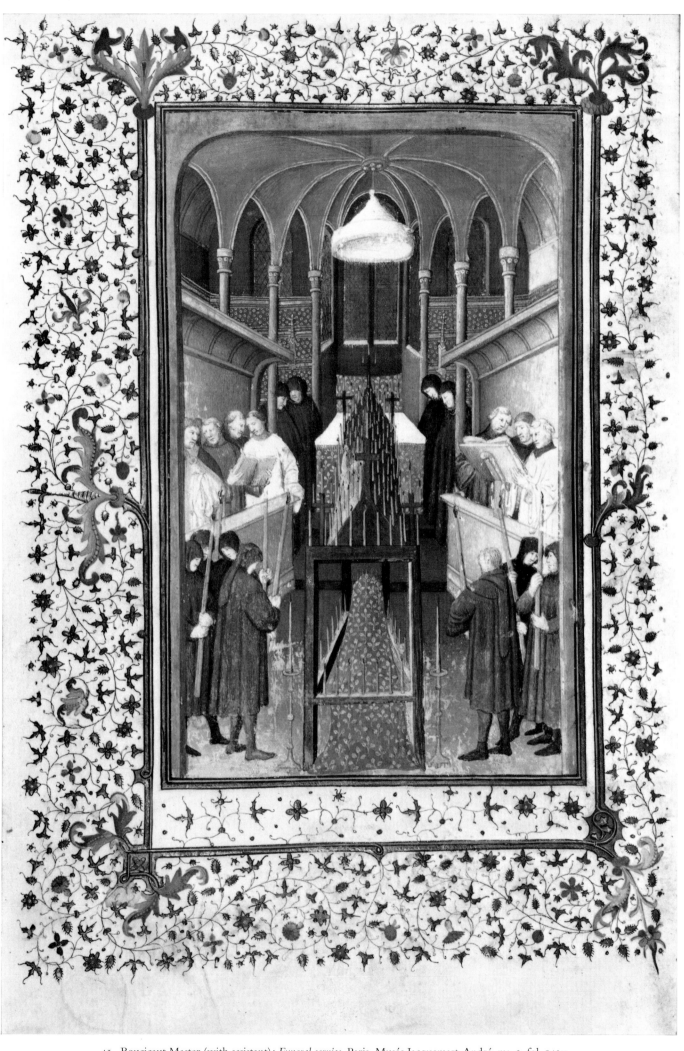

41. Boucicaut Master (with assistant): *Funeral service*. Paris, Musée Jacquemart-André, ms. 2, fol. 142v.

42. Boucicaut Master (with assistant): *St. Jerome*. Paris, Musée Jacquemart-André, ms. 2, fol. 171v.

43. French, 3rd quarter XV century: *Jean le Meingre witnesses the Vision of St. Gregory.* Paris, Musée Jacquemart-André, ms. 2, fol. 241.

44. French, 3rd quarter XV century: *The holy wound and symbols of the Passion*. Paris, Musée Jacquemart-André, ms. 2, fol. 242.

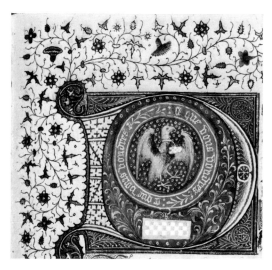

45. Boucicaut Workshop:
Initial with emblems and motto of the Maréchal.
Paris, Musée Jacquemart-André, ms. 2, fol. 84.

46. Boucicaut Workshop: *Initial with emblem of
the Maréchal, le bâton noueux, and motto of Aymar de Poitiers.*
Paris, Musée Jacquemart-André, ms. 2, fol. 143.

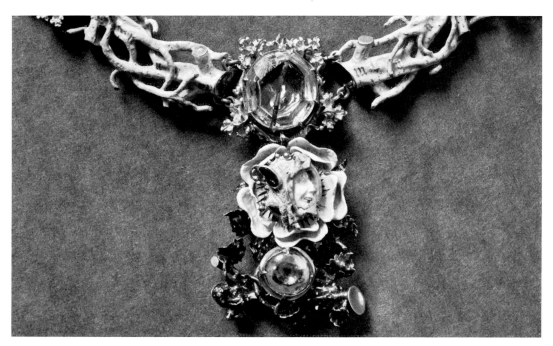

47a. French: Armagnac Collar with Caricature of Jean sans Peur (?). Schloss Neuenstein, Hohenlohe Museum.

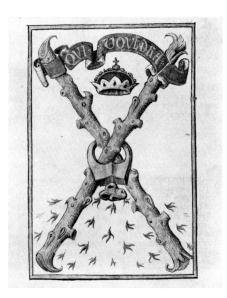

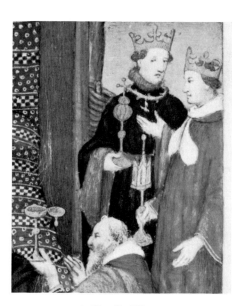

47b. Spanish, early XVI century: Emblem of Philip I of Spain.
Chantilly, Musée Condé, ms. 1339, fol. 3v.

48. Detail of Fig. 33.

49. Boucicaut Workshop: *St. Luke.*
Oxford, Bodl. Lib., Douce 144, fol. 2v. 1407.

50. French (Bedford trend): *St. Mark.*
Oxford, Bodl. Lib., Douce 144, fol. 5v. 1407.

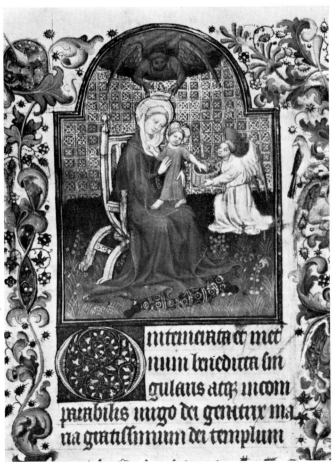

51. Boucicaut Workshop: *Angel brings food to Mary at the loom.*
Oxford, Bodl. Lib., Douce 144, fol. 19. 1407.

52. Associate of Boucicaut Master: *Virgin and Child enthroned,*
angel offering cherries. Oxford, Bodl. Lib., Douce 144, fol. 23. 1407.

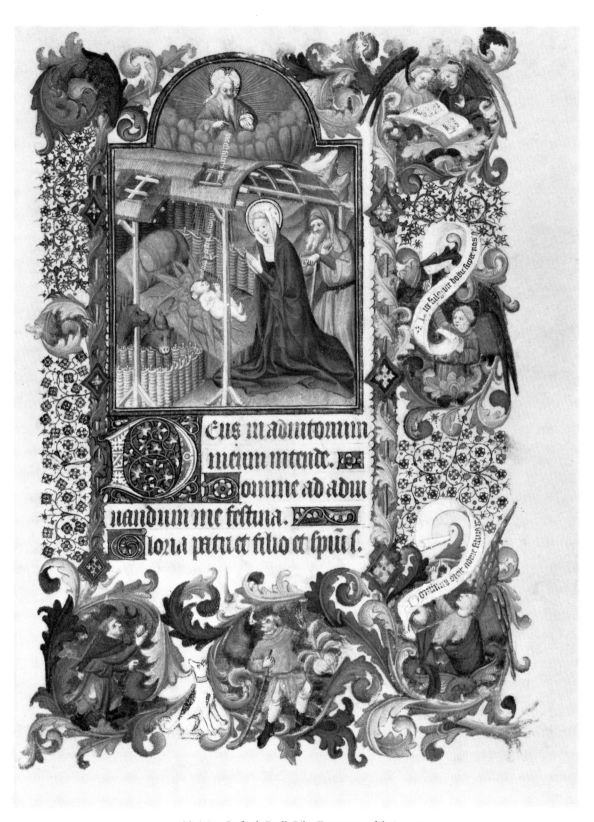

53. *Nativity*. Oxford, Bodl. Lib., Douce 144, fol. 63. 1407.

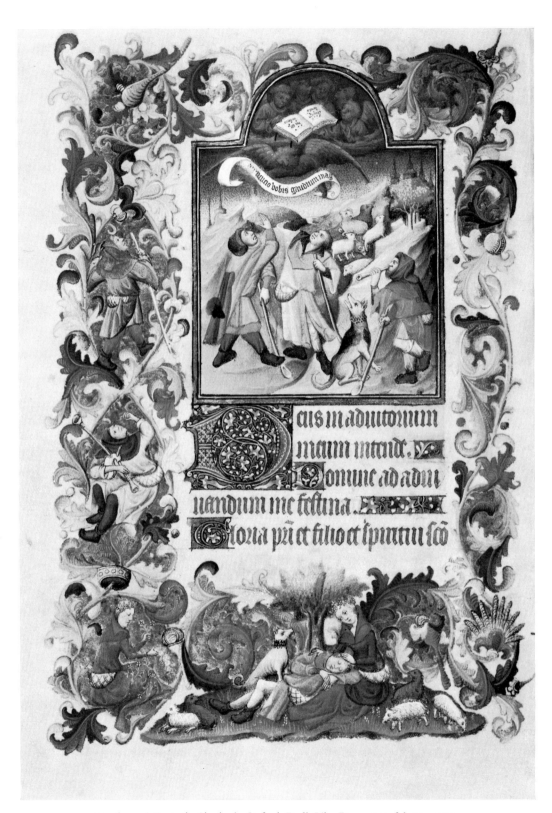

54. *Annunciation to the Shepherds*. Oxford, Bodl. Lib., Douce 144, fol. 68v. 1407.

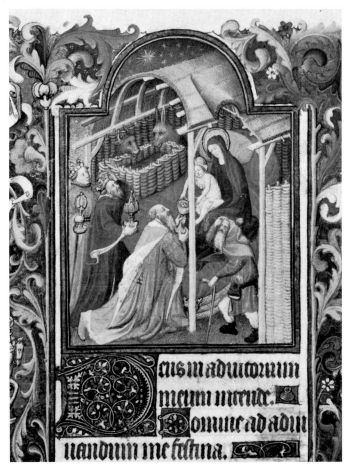

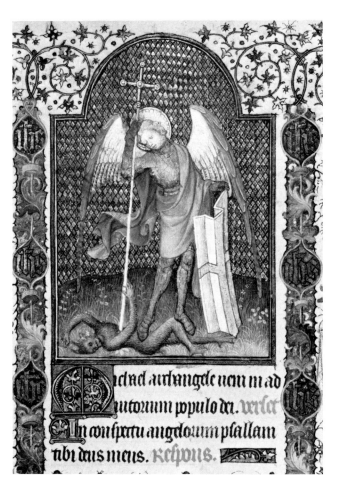

55. *Adoration of the Magi.*
Oxford, Bodl. Lib., Douce 144, fol. 72v. 1407.

56. Boucicaut Workshop: *St. Michael.*
Oxford, Bodl. Lib., Douce 144, fol. 129. 1407.

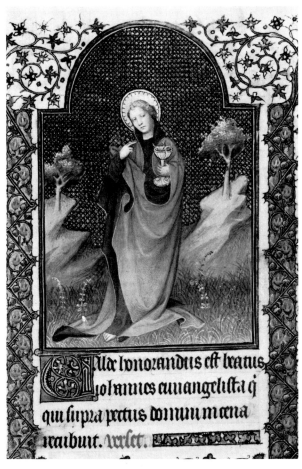

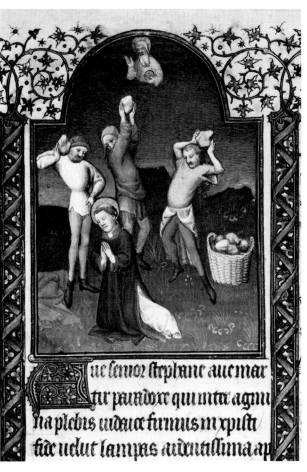

57. Boucicaut Workshop: *St. John the Evangelist.*
Oxford, Bodl. Lib., Douce 144, fol. 133. 1407.

58. Associate of Boucicaut Master: *Martyrdom of St. Stephen.*
Oxford, Bodl. Lib., Douce 144, fol. 134. 1407.

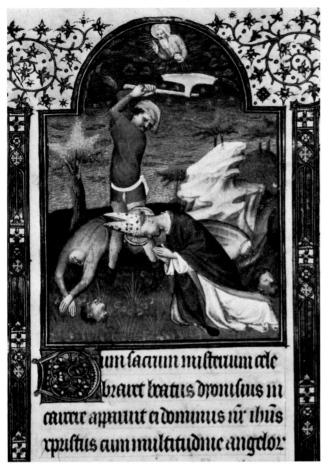

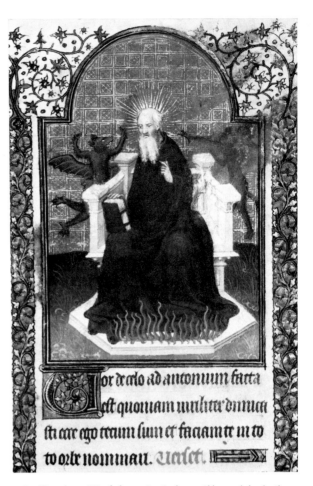

59. Boucicaut Circle: *Martyrdom of St. Denis and his companions.*
Oxford, Bodl. Lib., Douce 144, fol. 135. 1407.

60. Boucicaut Workshop: *St. Anthony Abbot and the devils.*
Oxford, Bodl. Lib., Douce 144, fol. 138. 1407.

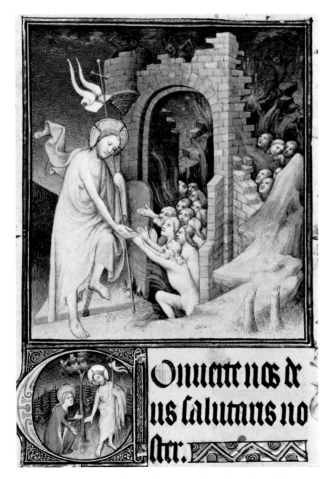

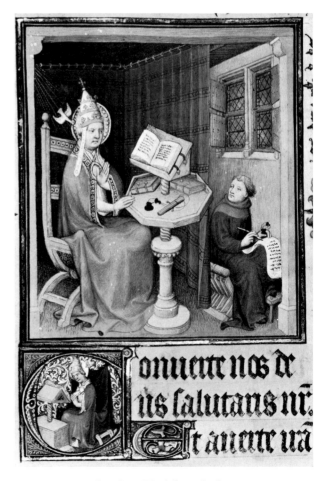

61. Boucicaut Workshop: *Christ in Limbo and Noli Me Tangere.*
Paris, Bibl. nat., lat. 919, fol. 84. 1409.

62. Boucicaut Workshop: *St. Gregory.*
Paris, Bibl. nat., lat. 919, fol. 100. 1409.

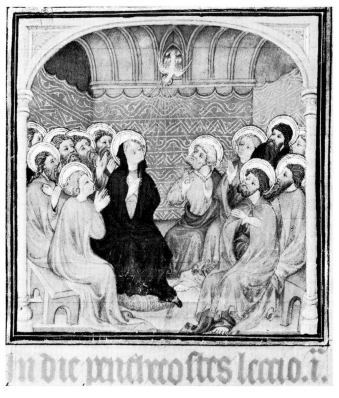

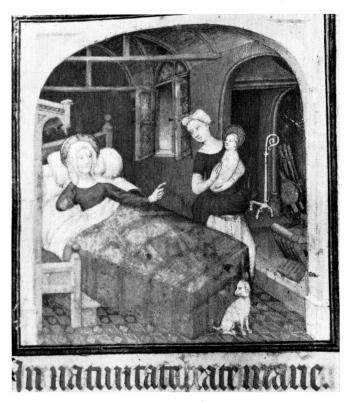

63. Pseudo-Jacquemart: *Pentecost.*
Bourges, Bibl. municipale, ms. 33, fol. 178v.

64. Boucicaut Workshop: *Birth of the Virgin.*
Bourges, Bibl. municipale, ms. 34, fol. 46v.

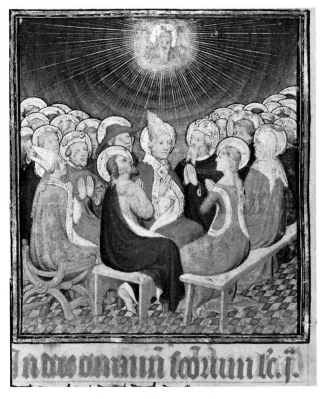

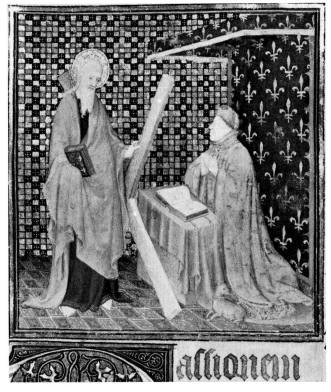

65. Boucicaut Workshop: *All Saints.*
Bourges, Bibl. municipale, ms. 34, fol. 138v.

66. Boucicaut Workshop: *The Duke of Berry and St. Andrew.*
Bourges, Bibl. municipale, ms. 35, fol. 17v.

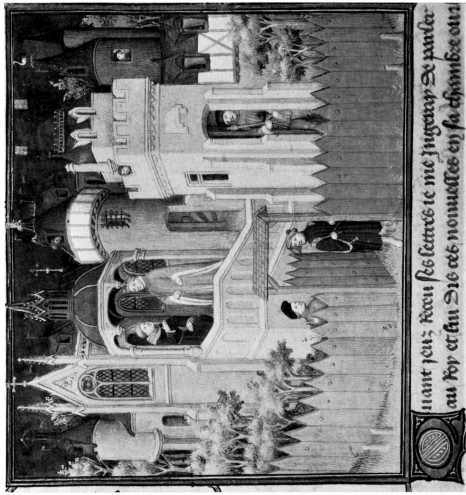

68. Boucicaut Workshop: *Salmon with Richard II of England.*
Paris, Bibl. nat., fr. 23279, fol. 6ov. 1409.

67. Boucicaut Master and Workshop: *Salmon giving his book to Charles VI
in the presence of Jean de Berry and others.* Paris, Bibl. nat., fr. 23279, fol. 53. 1409.

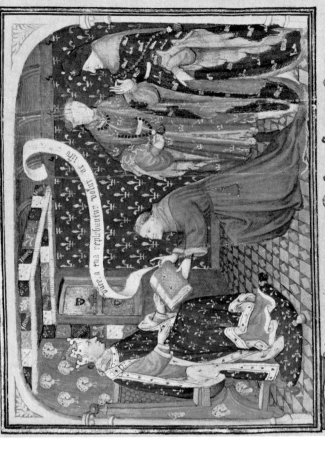

70. Boucicaut Workshop: *Salmon presenting his book to Charles VI in the presence of Jean sans Peur and another prince.* Paris, Bibl. nat., fr. 23279, fol. 1v. 1409.

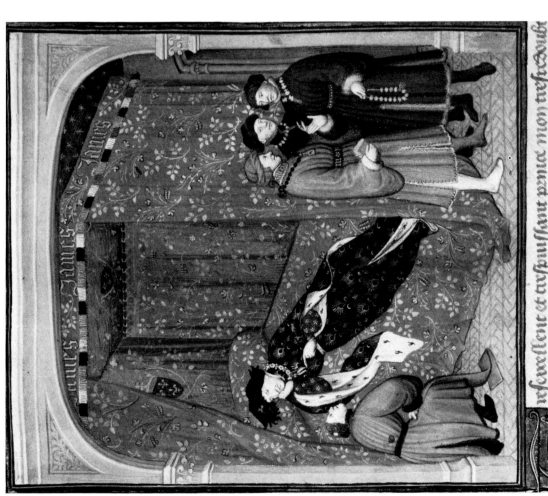

69. Boucicaut Workshop: *Charles VI, Salmon, and courtiers.* Geneva, Bibl. publique et universitaire, fr. 165, fol 7. 1412 (certainly after 1411).

71. Cité des Dames Master: *Richard II with his bride Isabelle of France at Calais, about to sail for England.*
Paris, Bibl. nat., fr. 23279, fol. 54. 1409.

79. Boucicaut Workshop: *Scholars of Collège de Fortet presented by Founder to the Trinity, which is adored by two canons of Notre-Dame of Paris*. Paris, Arch. nat., ms. MM 397 (Musée 1580), fol. 3. 1412–1413.

80. Boucicaut Workshop: *Nicolo and Maffeo Polo take leave of Baldwin II of Jerusalem*. Paris, Bibl. nat., fr. 2810, fol. 1. Before 1413 (quatrefoils later).

81 and 82. Boucicaut Workshop: *Hunting porcupines near Casem. Baptism of Zagatai in church of the Baptist at Samarkand.*
Paris, Bibl. nat., fr. 2810, fols. 18 and 20v. Before 1413.

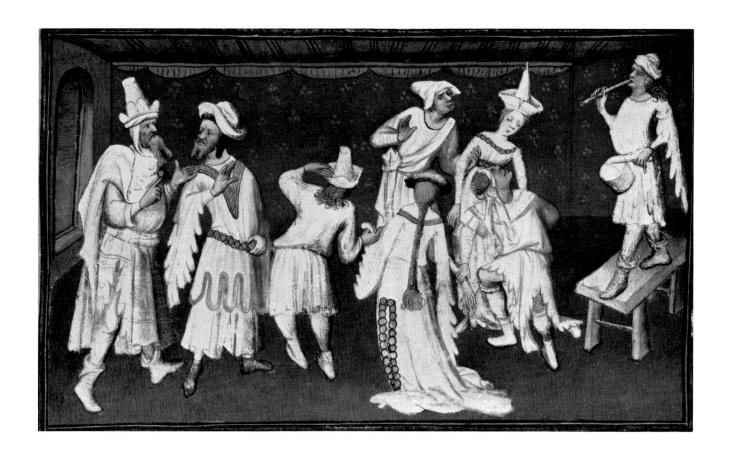

83 and 84. Bedford trend: *Festivities at court of Grand Khan. The King of Maabar wearing his jewels.*
Paris, Bibl. nat., fr. 2810, fols. 44 and 78. Before 1413.

85 and 86. Boucicaut Workshop: *Female votaries dance before a goddess. Wild animals in Comorin, Southern India.*
Paris, Bibl. nat., fr. 2810, fols. 80 and 85. Before 1413.

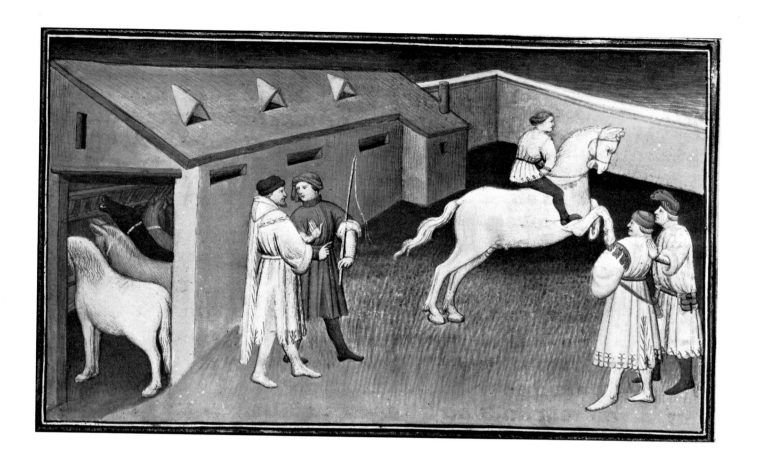

90 and 91. Boucicaut Workshop: *Arab horses sold to merchants from India. Search for precious stones in water in Sillan (Ceylon), where Adam and Eve wept for their sins.* Paris, Bibl. nat., fr. 2810, fols. 92 and 106v. Before 1413.

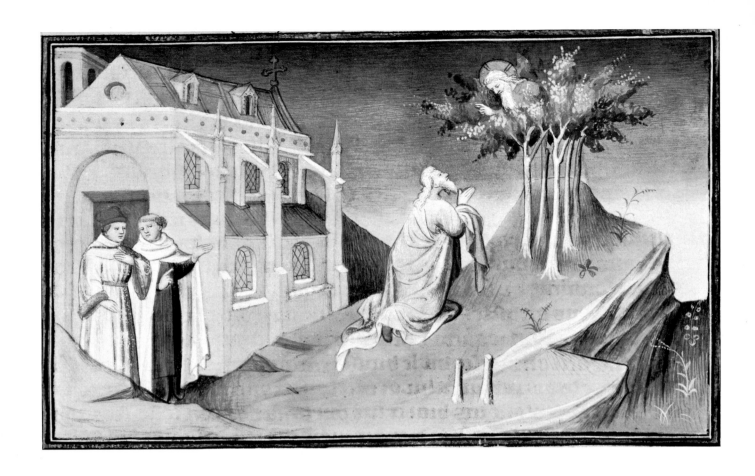

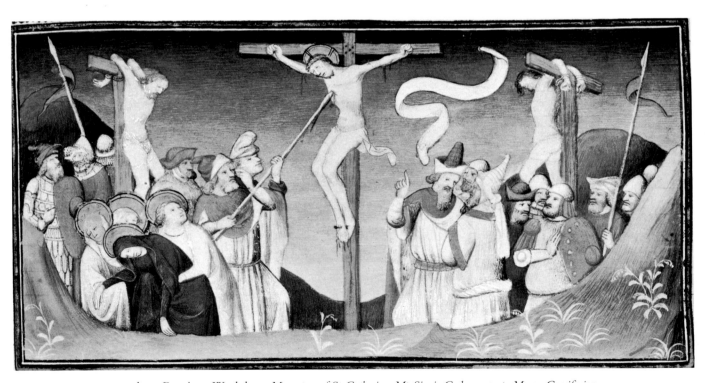

92 and 93. Boucicaut Workshop: *Monastery of St. Catherine, Mt. Sinai; God appears to Moses. Crucifixion.*
Paris, Bibl. nat., fr. 2810, fols. 122 and 126. Before 1413.

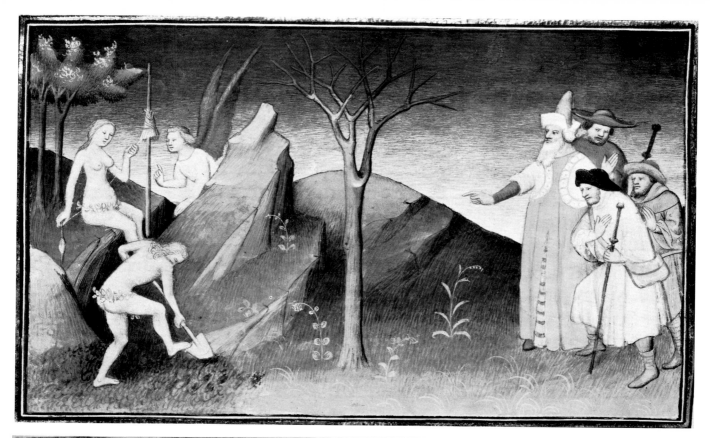

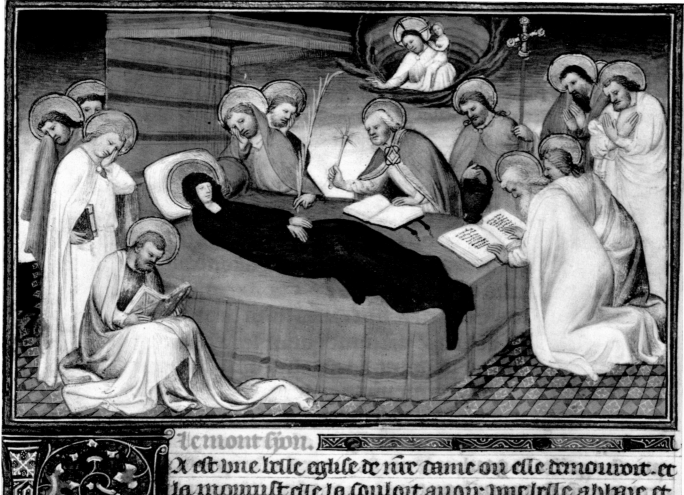

94 and 95. Boucicaut Workshop: *Angel addresses Eve, who spins, and Adam, who delves; the barren tree near Hebron. Death of the Virgin.*
Paris, Bibl. nat., fr. 2810, fols. 157v and 163. Before 1413.

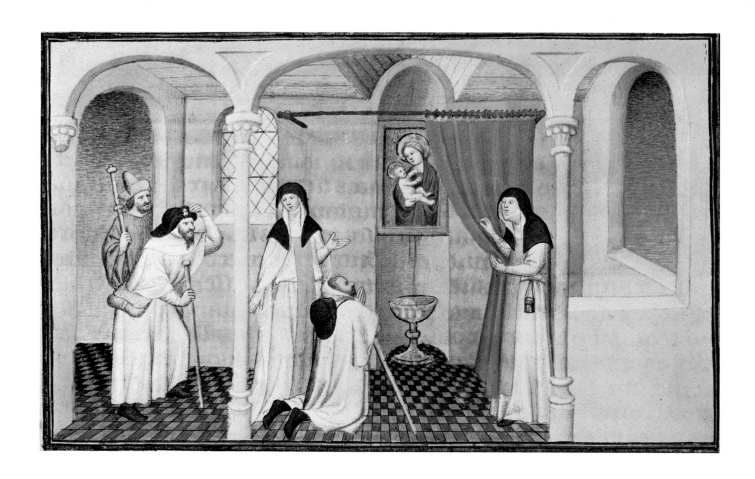

96 and 97. Boucicaut Workshop: *Miraculous image of the Madonna at Sardanek*. Bedford trend: *Land of hermaphrodites*.
Paris, Bibl. nat., fr. 2810, fols. 171v and 195v. Before 1413.

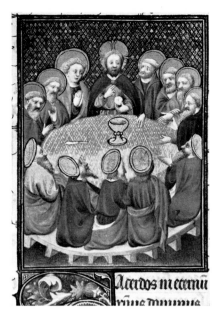

101 and 102. Bedford Workshop: *Institution of the Eucharist. Dedication of a church.*
Châteauroux, Bibl. municipale, ms. 2, fols. 113v and 171. Before 1415.

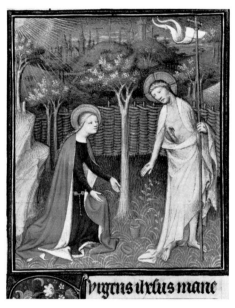

103 and 104. Boucicaut Workshop: *St. Victor. Noli Me Tangere.*
Châteauroux, Bibl. municipale, ms. 2, fols. 237 and 238. Before 1415.

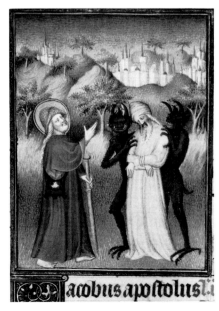

105 and 106. Orosius Master: *Demons leading Hermogenes before St. James Major.*
Boucicaut Master and Assistant: *The Croix d'Anseau carried into Notre-Dame, Paris.* Châteauroux,
Bibl. municipale, ms. 2, fols. 243v and 265. Before 1415.

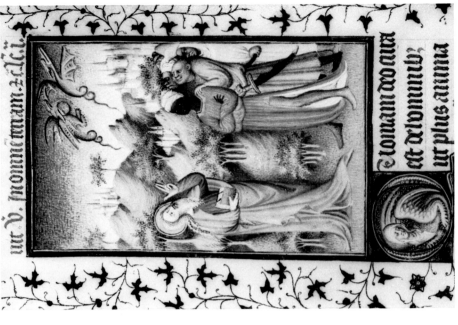

109. Orosius Master: *St. Matthew putting dragons to flight.*
Châteauroux, Bibl. municipale, ms. 2, fol. 337v. Before 1415.

108. Bedford Master and Workshop: *David playinng bells.*
Châteauroux, Bibl. municipale, ms. 2, fol. 48v. Before 1415.

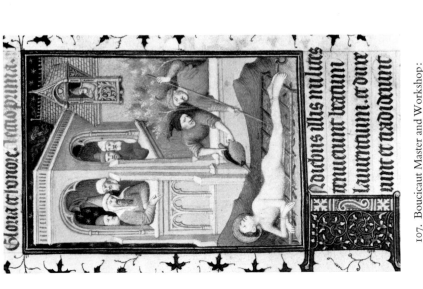

107. Boucicaut Master and Workshop:
Martyrdom of St. Lawrence. Châteauroux, Bibl.
municipale, ms. 2, fol. 270v. Before 1415.

110 and 111. Bedford Master: *Trinity. Death, Assumption and Coronation of the Virgin*. Châteauroux, Bibl. municipale, ms. 2, fols. 106 and 282v. Before 1415.

 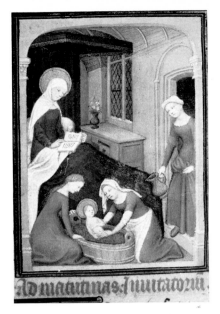

112 and 113. Boucicaut Workshop: *Veneration of the Crown of Thorns in the Sainte-Chapelle.*
Birth of the Virgin. Châteauroux, Bibl. municipale, ms. 2, fols. 274 and 323v. Before 1415.

 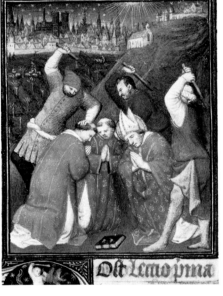

114 and 115. Boucicaut Master and Workshop: *St. Michael and the bull on Mount Gargano.*
Martyrdom of St. Denis and his companions at Montmartre; Paris in the background.
Châteauroux, Bibl. municipale, ms. 2, fols. 345v and 364. Before 1415.

 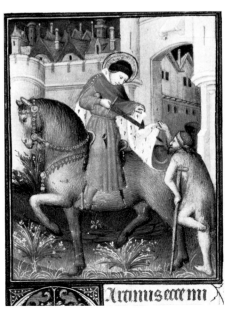

116 and 117. Boucicaut Master and Workshop: *Preaching of St. Denis near Paris. St. Martin and the beggar.*
Châteauroux, Bibl. municipale, ms. 2, fols. 367v and 404v. Before 1415.

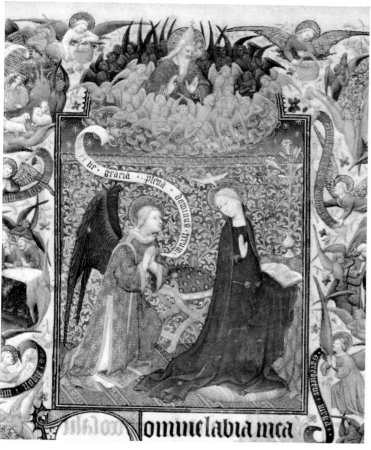

118. Boucicaut Master and Workshop: *Annunciation with scenes from the life of the Virgin and of her parents*. Paris, Bibl. Mazarine, ms. 469, fol. 13.

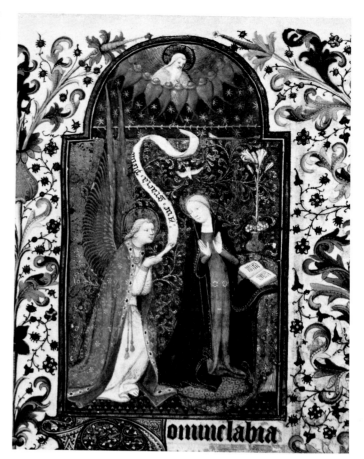

119. Boucicaut Workshop: *Annunciation*. Brussels, Bibl. Royale, ms. 10767, fol. 30.

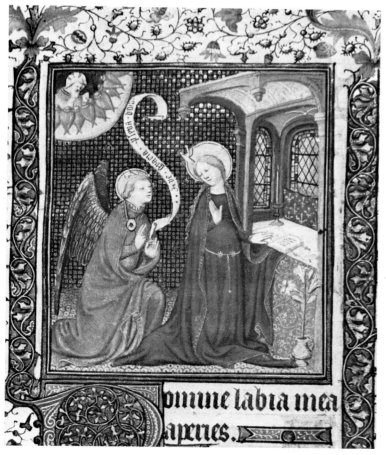

120. Boucicaut Workshop: *Annunciation*. London, Collection Zwemmer, Book of Hours, fol. 21.

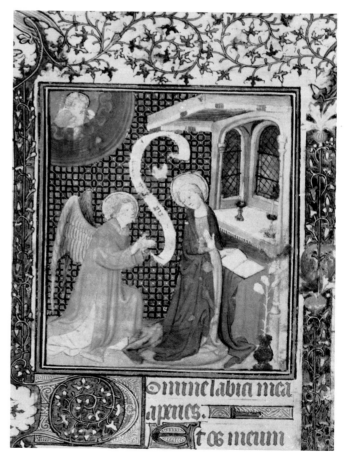

121. Boucicaut Workshop: *Annunciation*. Baltimore, Walters Art Gallery, ms. 238, fol. 25.

123. Boucicaut Workshop: *Annunciation* (border by inferior illuminator).
Berlin–Dahlem, Staatliche Museen, Kupferstichkabinett, ms. 78 C 4, fol. 25.

122. Boucicaut Workshop: *Annunciation* (Visconti emblem below).
Turin, Bibl. Reale, Var. 77, fol. 1.

125. Boucicaut Workshop: *Annunciation.*
Paris, Bibl. nat., lat. 1161, fol. 31.

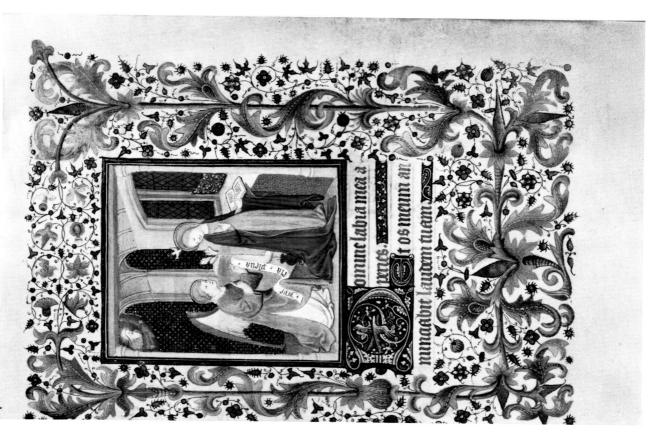

124. Boucicaut Workshop: *Annunciation.* Ripon (Yorkshire),
Collection Bradfer-Lawrence, Book of Hours, fol. 27.

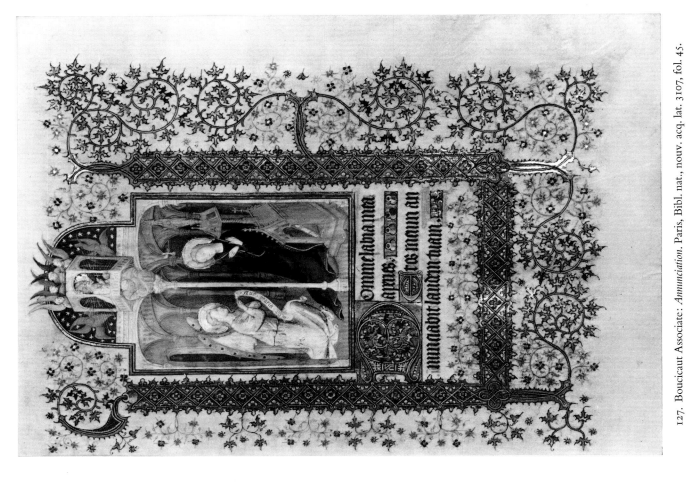

127. Boucicaut Associate: *Annunciation*. Paris, Bibl. nat., nouv. acq. lat. 3107, fol. 45.

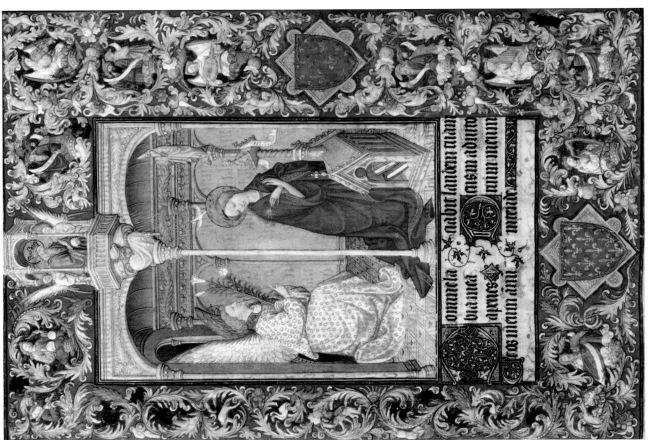

126. The Limbourgs: *Annunciation*. New York, The Cloisters, *Belles Heures*, fol. 30.

129. Boucicaut Master and Workshop: *Annunciation, angels, and Virgin weaving.*
Paris, Bibl. nat., lat. 10538, fol. 31.

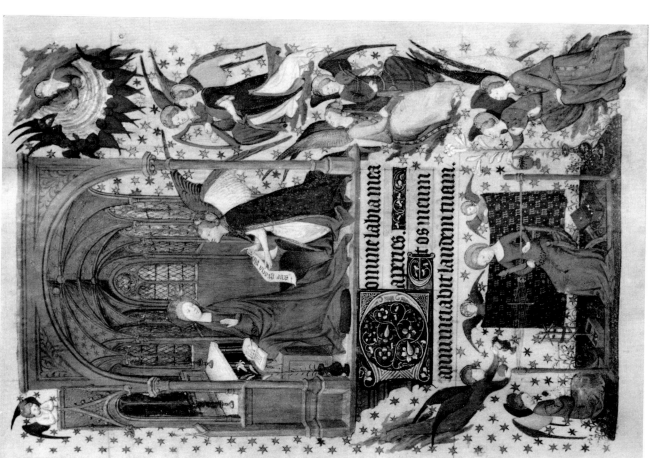

128. Boucicaut Master: *Annunciation, angels, and the Virgin weaving.*
Florence, Corsini Collection, Book of Hours.

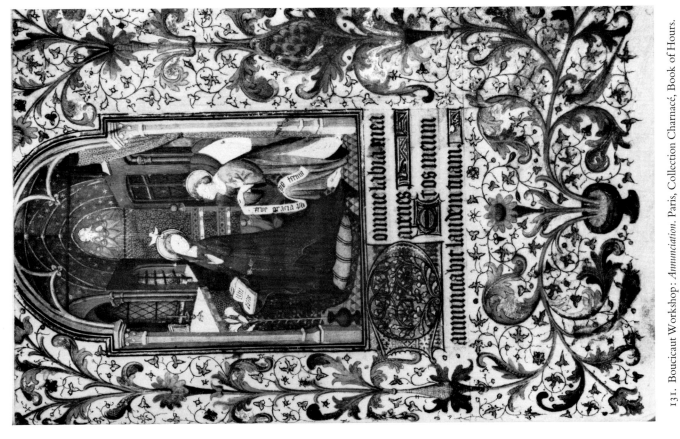

131. Boucicaut Workshop: *Annunciation*. Paris, Collection Charnacé, Book of Hours.

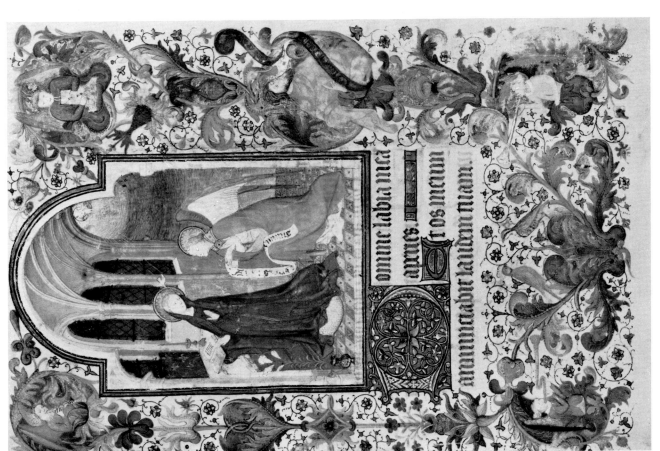

130. Boucicaut Workshop: *Annunciation*. Baltimore, Walters Art Gallery, ms. 260, fol. 27.

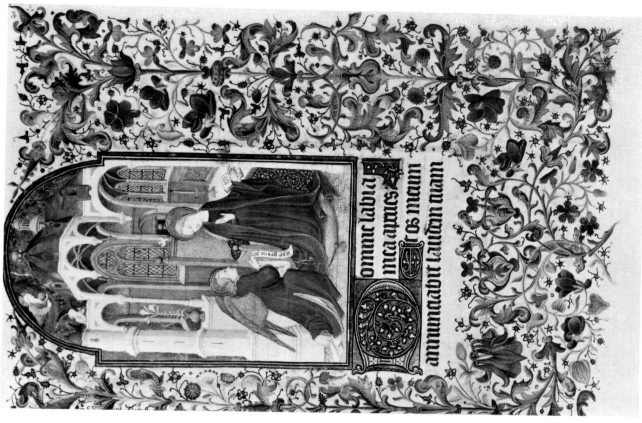

132. Boucicaut Workshop: *Annunciation.*
Chantilly, Musée Condé, ms. 64, fol. 25.

133. Follower of the Boucicaut Master: *Annunciation.*
New York, Private Collection, Book of Hours, fol. 33.

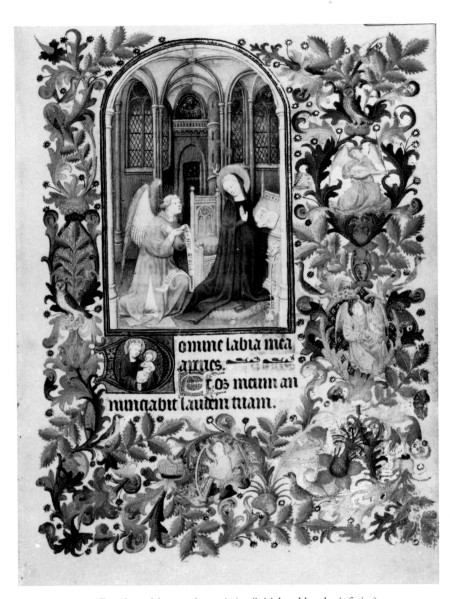

134. Boucicaut Master: *Annunciation* (initial and border inferior).
London, Brit. Mus., Add. 16997, fol. 21.

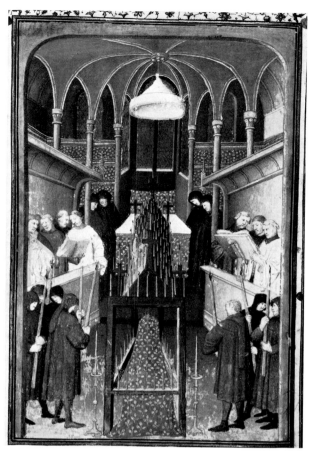

135. Boucicaut Master and Assistant: *Funeral Service* (Vespers).
Paris, Musée Jacquemart-André, ms. 2, fol. 142v.

136. Jacquemart de Hesdin: *Funeral Service* (Vespers).
Brussels, Bibl. Royale, ms. 11060–61, p. 202. Before 1402.

137. French, *ca.* 1405: *Funeral Service* (Vespers).
Baltimore, Walters Art Gallery, ms. 209, fol. 161.

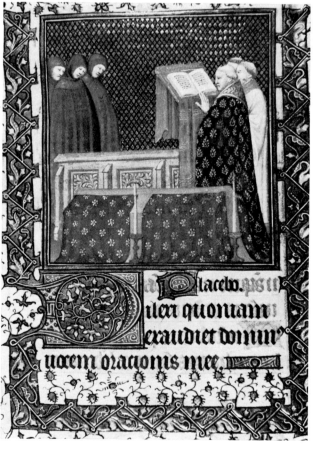

138. Boucicaut Workshop: *Funeral Service* (Vespers).
London, Collection Zwemmer, Book of Hours, fol. 147.

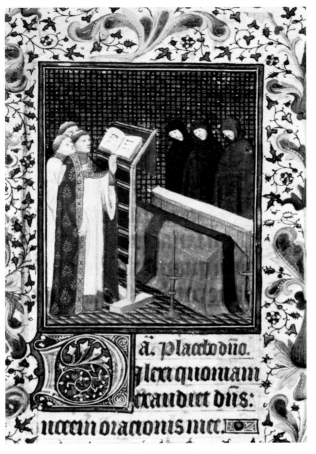

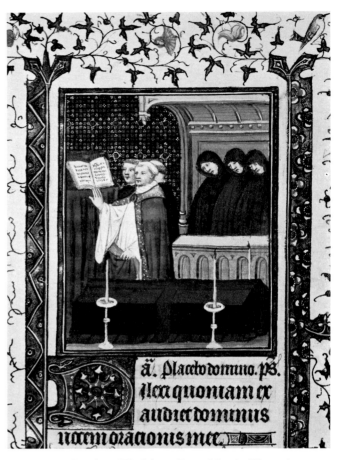

139. Boucicaut Workshop: *Funeral Service* (Vespers).
Brussels, Bibl. Royale, ms. 10767, fol. 166v.

140. Boucicaut Workshop: *Funeral Service* (Vespers).
Brussels, Bibl. Royale, ms. 11051, fol. 138.

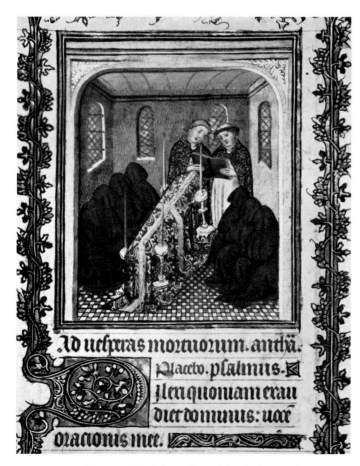

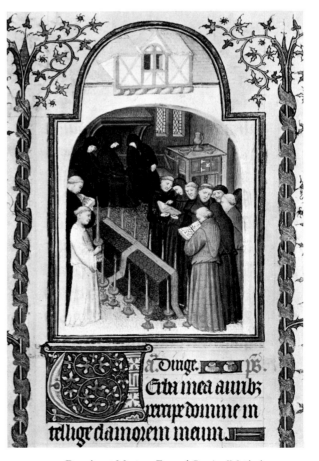

141. Egerton Workshop: *Funeral Service* (Vespers).
Madrid, Bibl. Nacional, Vit. 25 no. 1, fol. 272.

142. Boucicaut Master: *Funeral Service* (Matins).
Paris, Bibl. nat., nouv. acq. lat. 3107, fol. 175v.

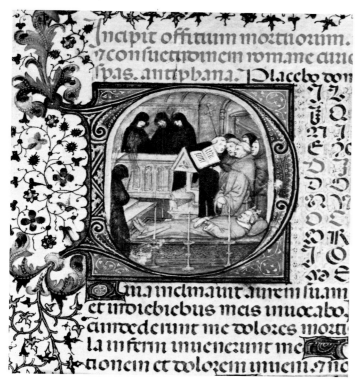

143. Boucicaut Master and Workshop: *Funeral Service* (Vespers).
Turin, Bibl. Reale, Var. 77, fol. 49.

144. Close follower of the Limbourgs: *Funeral Service* (Vespers).
London, Seilern Collection, Book of Hours, fol. 81v.

145. The Limbourgs: *Funeral Service* (Mass for the Dead).
New York, The Cloisters, *Belles Heures*, fol. 221.

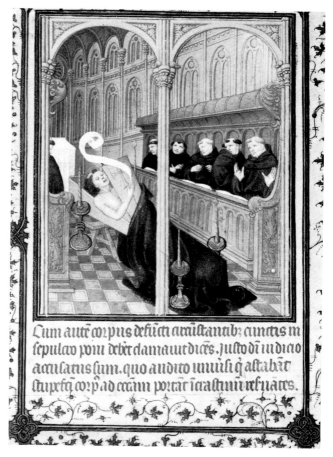

146. The Limbourgs: *Diocrès speaks from his coffin*.
New York, The Cloisters, *Belles Heures*, fol. 94v.

147. Associate of Boucicaut Master: *Funeral Service* (Monday, Matins).
Paris, Bibl. nat., nouv. acq. lat. 3107, fol. 120v.

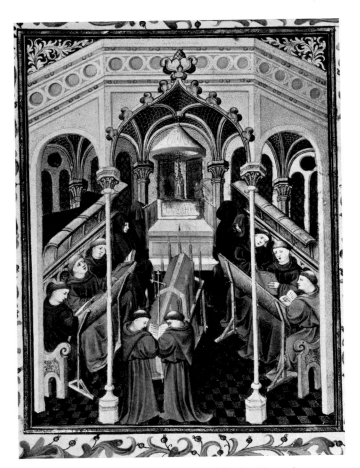

148. Egerton Workshop: *Funeral Service* (Vespers).
London, Brit. Mus., Egerton 1070, fol. 54v.

149. Boucicaut Workshop: *Funeral Service* (Vespers).
Paris, Bibl. Mazarine, ms. 469, fol. 150.

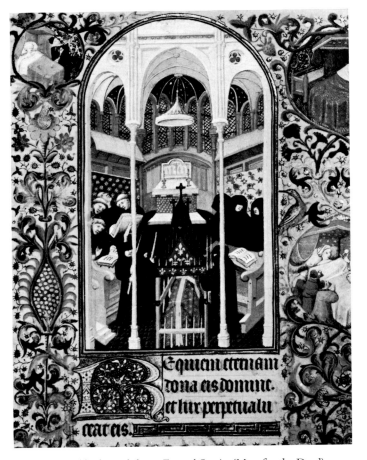

150. Bedford Workshop: *Funeral Service* (Mass for the Dead).
London, Brit. Mus., Add. 18850, fol. 120.

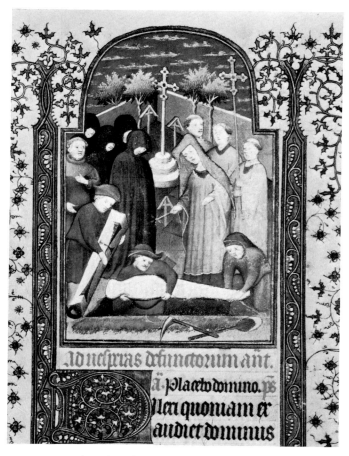

151. Associate of Boucicaut Master: *Burial Service*
(Illustration of Vespers). Paris, Bibl. nat., nouv. acq. lat. 3107, fol. 168.

152. Boucicaut Workshop: *Burial Service* (Illustration of Vespers).
Berlin–Dahlem, Staatliche Museen, Kupferstichkabinett, ms. 78 C 4, fol. 128v.

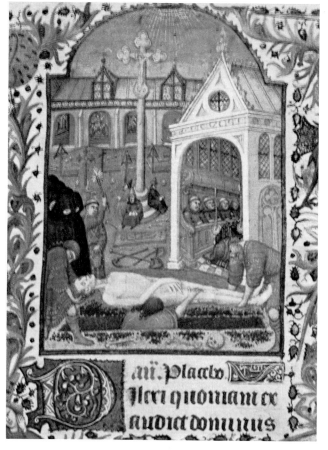

153. Boucicaut Workshop: *Burial Service* (Illustration of Vespers).
Paris, Bibl. nat., lat. 1161, fol. 212.

154. Follower of the Limbourgs: *Burial Service* (Illustration
of Vespers). Chicago, Spitz Collection, Book of Hours.

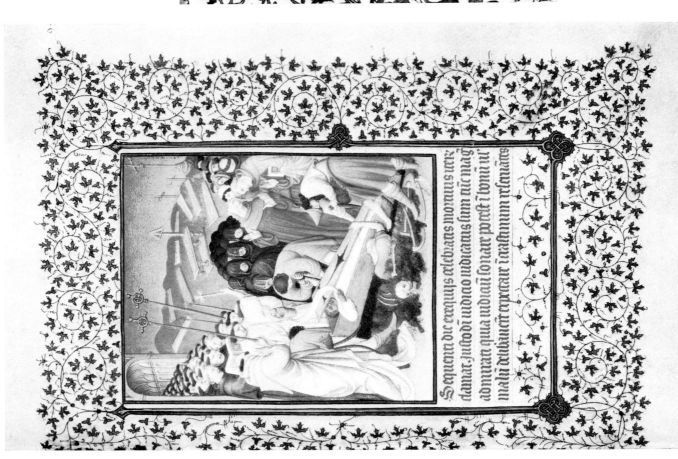

155. The Limbourgs: *Burial of Diocrès*. New York, The Cloisters, *Belles Heures*, fol. 95.

156. Boucicaut Master and Workshop: *Burial of corpse* (Illustration of Vespers). Turin, Bibl. Reale, *Var.* 77, fol. 49.

158. Rohan Workshop: Illustration of the Office of the Dead (Vespers). Paris, Bibl. nat., lat. 1156A, fol. 114.

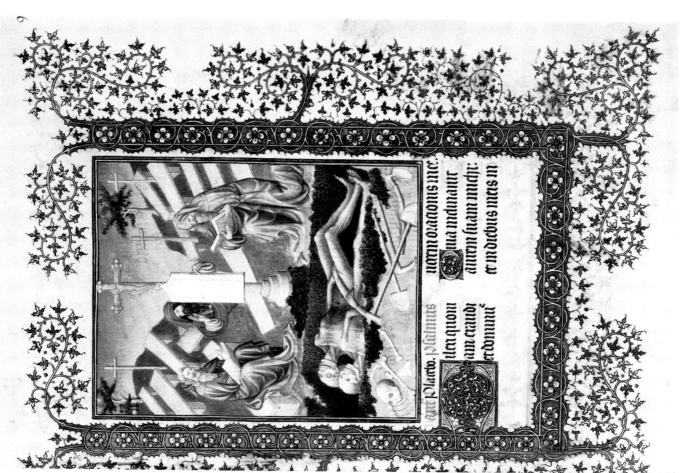

157. The Limbourgs: Illustration of the Office of the Dead (Vespers). New York, The Cloisters, *Belles Heures*, fol. 99.

159. Follower of the Rohan Master:
Illustration of the Office of the Dead (Vespers). Baltimore,
Walters Art Gallery, ms. 741, fol. 102.

160. Bedford Workshop: Corpse in *bas-de-page* below *Last Judgment*.
London, Brit. Mus., Add. 18850, fol. 157.

161. Giovanni di Benedetto da Como, before 1378:
The Three Living and the Three Dead.
Munich, Bayrische Staatsbibliothek, lat. 23215, fol. 178v.

162. Orosius Master: *Hermit reading near sarcophagus
with transi and death's-heads*; below, *A dead or dying man.*
Châteauroux, Bibl. municipale, ms. 2, fol. 395v.

164. Boucicaut Master and Workshop:
Dead man and battle for his soul (*bas-de-page* of Office of the Dead). Paris, Bibl. Mazarine, ms. 469, fol. 150.

163. Boucicaut Follower:
Dead man and battle for his soul. Orange (Texas),
Stark Coll., Book of Hours, fol. 130.

166. Rohan Master:
Dead man, struggle for his soul, and dialogue with God.
Paris, Bibl. nat., lat. 9471, fol. 159.

165. Boucicaut Follower: *Dead man and the battle for his soul*.
Washington, Library of Congress, ms. acc. 4560 (7), fol. 93.

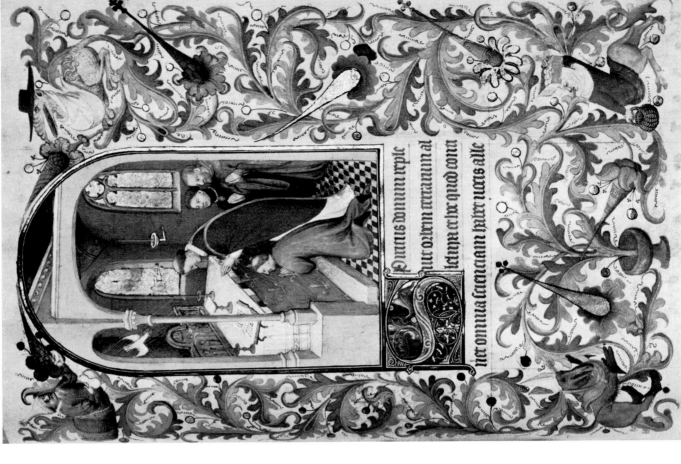

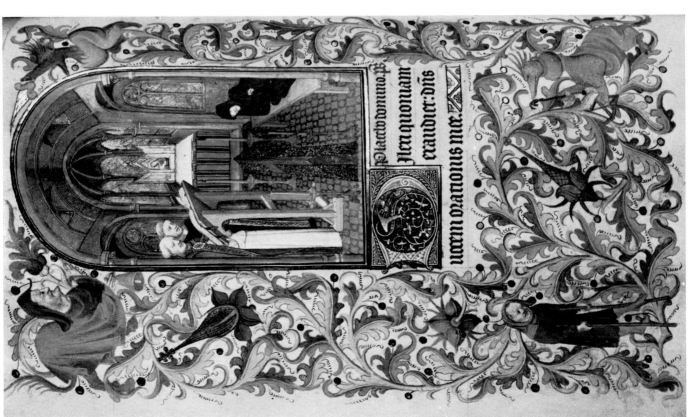

167 and 168. Boucicaut Workshop (borders by Egerton Workshop): *Funeral Service* (Vespers). *Mass.* Florence, Corsini Collection, Book of Hours.

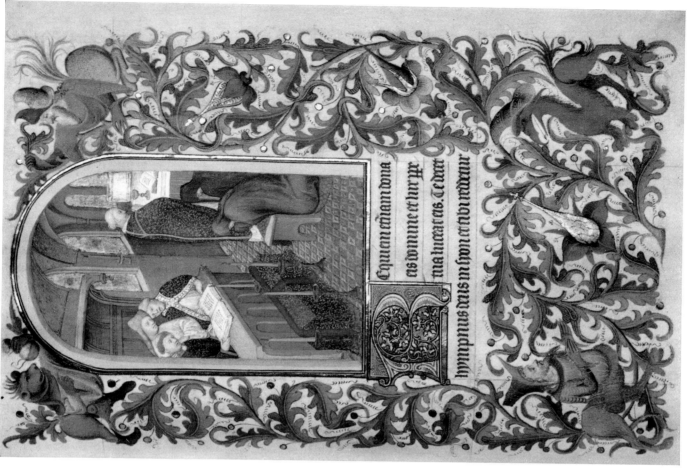

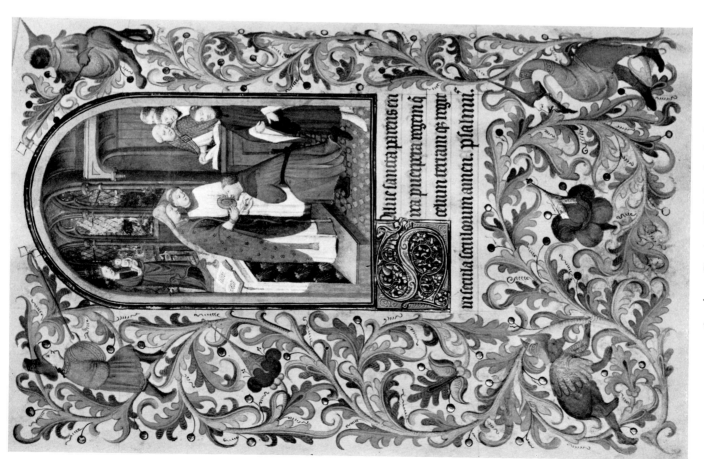

169 and 170. Boucicaut Workshop (borders by Egerton Workshop): *Kissing the Pax. Mass for the Dead.* Florence, Corsini Collection, Book of Hours.

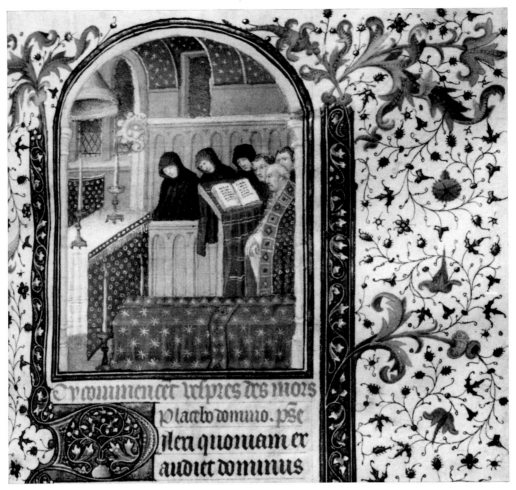

171. Boucicaut Follower: Illustration of Office of the Dead (Vespers).
Cracow, Muzeum Narodowe, ms. Czart. 2032, p. 275.

172. Boucicaut Master: Illustration of Office of the Dead (Vespers).
London, Brit. Mus., Add. 16997, fol. 171v.

173. Jan van Eyck: *Mass for the Dead*.
Turin, Museo Civico, *Heures de Milan*, fol. 116.

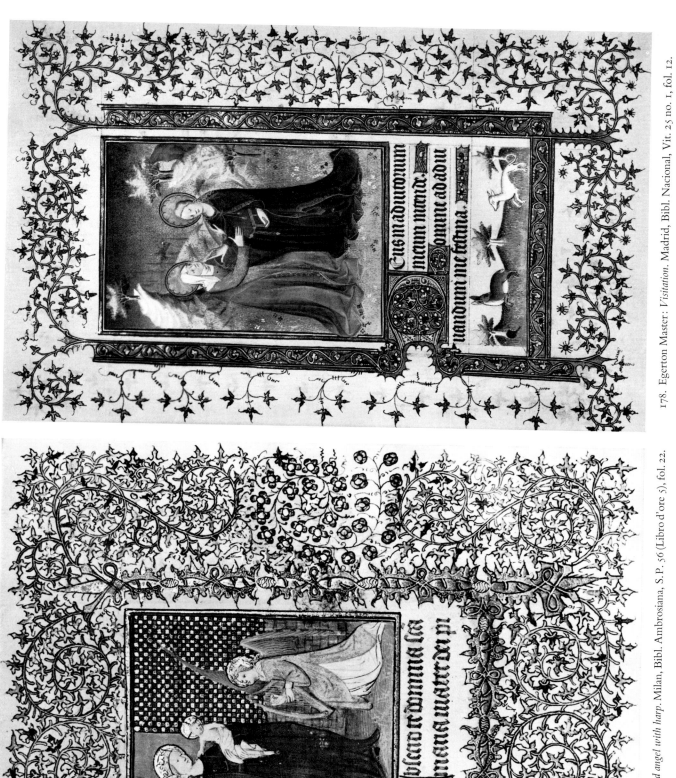

177. Boucicaut Workshop: *Madonna and angel with harp*. Milan, Bibl. Ambrosiana, S.P. 56 (Libro d'ore 5), fol. 22.

178. Egerton Master: *Visitation*. Madrid, Bibl. Nacional, Vit. 25 no. 1, fol. 12.

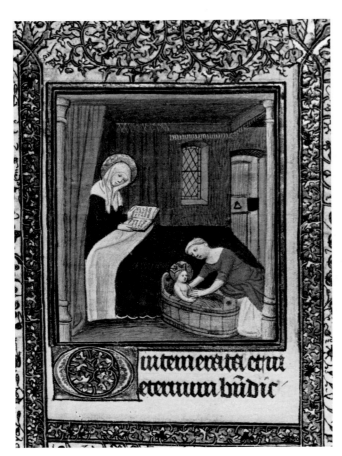

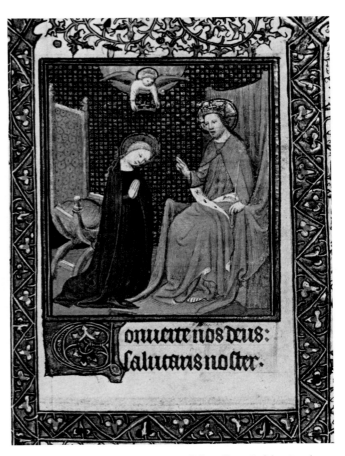

179 and 180. Boucicaut Workshop: *Birth of the Virgin. Coronation of the Virgin.* Milan, Bibl. Ambrosiana, S.P. 56 (Libro d'ore 5), fols. 28 and 129.

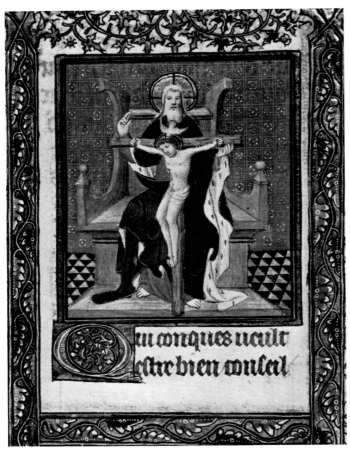

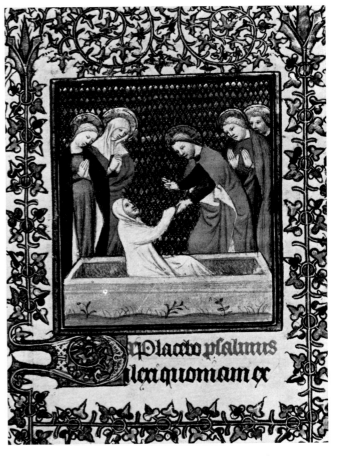

181 and 182. Boucicaut Workshop: *Trinity. Raising of Lazarus.* Milan, Bibl. Ambrosiana, S.P. 56 (Libro d'ore 5), fols. 199 and 205.

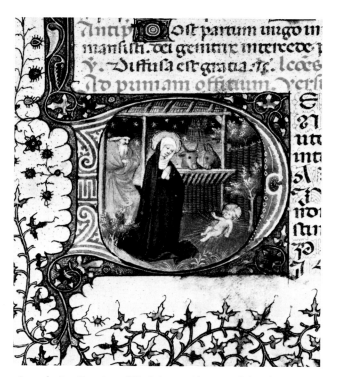

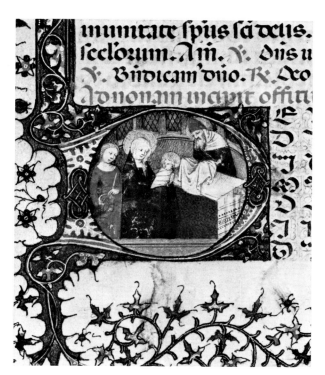

183 and 184. Boucicaut Workshop: *Adoration of the Child. Presentation of Christ in the Temple.* Turin, Bibl. Reale, Var. 77, fols. 16 and 23.

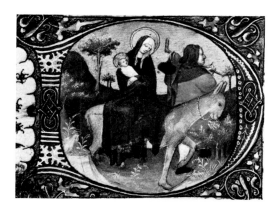

185. Boucicaut Workshop: *Flight into Egypt.*
Turin, Bibl. Reale, Var. 77, fol. 25v.

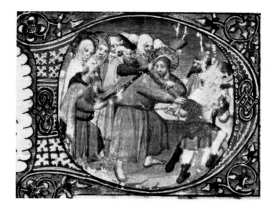

186. Bedford trend: *Way to Calvary.*
Turin, Bibl. Reale, Var. 74, fol. 8.

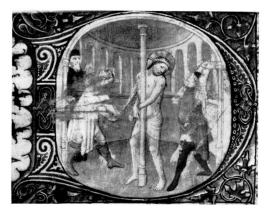

187. Boucicaut Workshop: *Flagellation.*
Turin, Bibl. Reale, Var. 74, fol. 2.

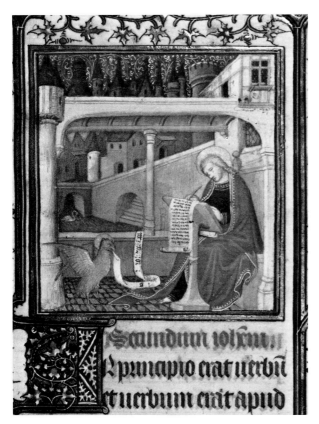

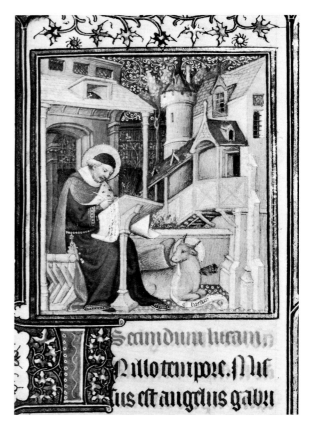

188 and 189. Boucicaut Workshop: *St. John. St. Luke*. Paris, Bibl. nat., lat. 1161, fols. 20 and 22.

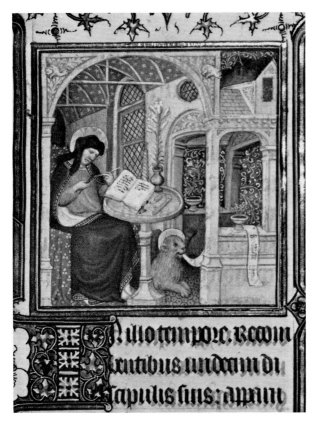

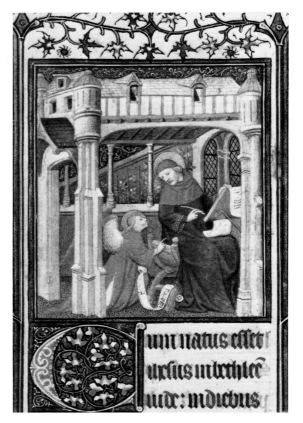

190 and 191. Boucicaut Workshop: *St. Mark. St. Matthew*. Paris, Bibl. nat., lat. 1161, fols. 23 *bis* and 25.

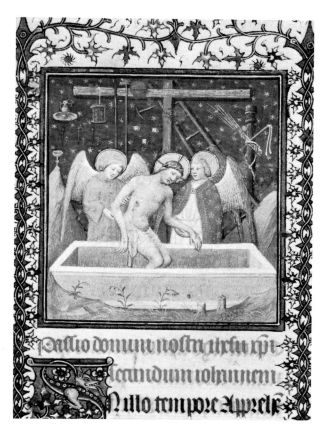

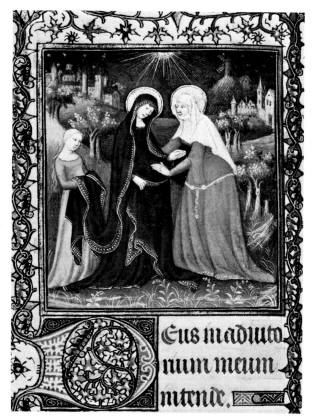

192 and 193. Boucicaut Workshop: *Man of Sorrows with two angels. Visitation.* Paris, Bibl. nat., lat. 1161, fols. 27 and 55v.

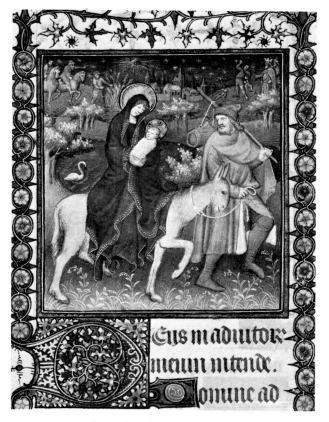

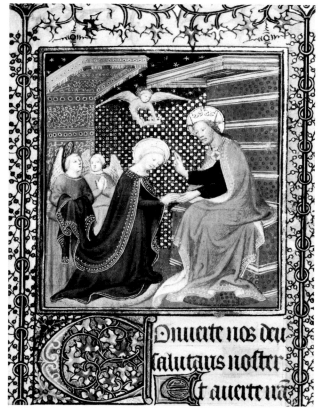

194 and 195. Boucicaut Workshop: *Flight into Egypt. Coronation of the Virgin.* Paris, Bibl. nat., lat. 1161, fols. 87 and 91.

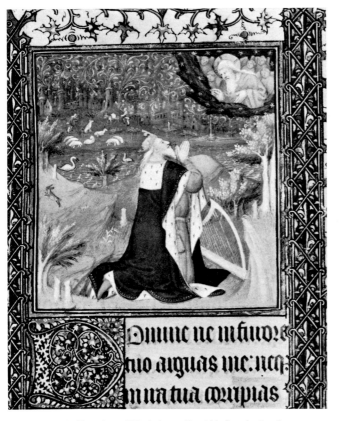

196. Boucicaut Workshop: *David before the Lord*.
Paris, Bibl. nat., lat. 1161, fol. 101.

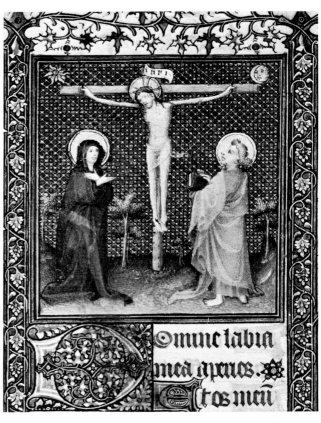

197. French, influenced by Pseudo-Jacquemart: *Crucifixion*.
Paris, Bibl. nat., lat. 1161, fol. 123.

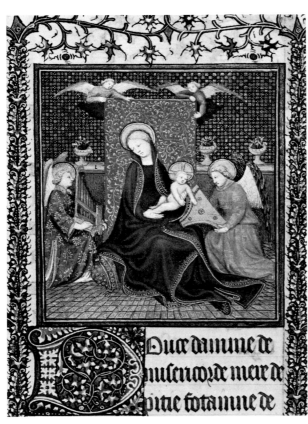

198. Boucicaut Workshop: *Madonna of Humility*.
Paris, Bibl. nat., lat. 1161, fol. 130v.

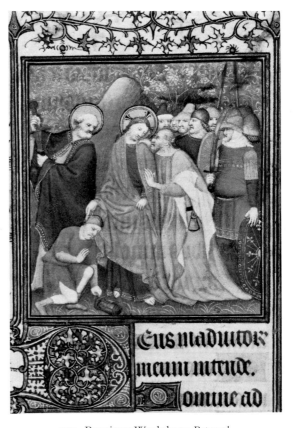

199. Boucicaut Workshop: *Betrayal*.
Paris, Bibl. nat., lat. 1161, fol. 152.

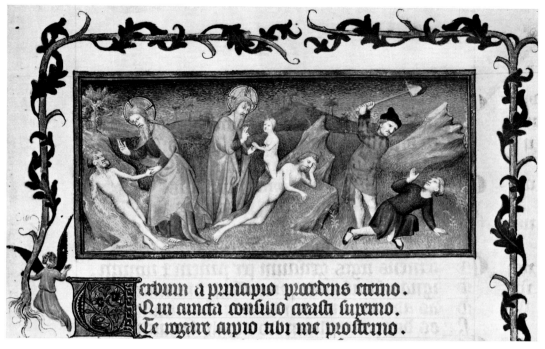

205. Boucicaut Workshop: *Creation of Adam and of Eve, and Cain killing Abel.*
London, Brit. Mus., Egerton 1070, fol. 140.

206. gerton Workshop: *Adoration of the Magi.* London, Brit. Mus., Egerton 1070, fol. 83v. – 207. Follower of Jacquemart: *St. Luke.* London, Brit. Mus., Egerton 1070, fol. 104v. – 208. Imitator of the Parement Master: *St. Anne, the Virgin, and the Child.* London, Brit. Mus., Egerton 1070, fol. 97.

209. Boucicaut Workshop: *Angels* (in the lower border). London, Brit. Mus., Egerton 1070, fol. 92.

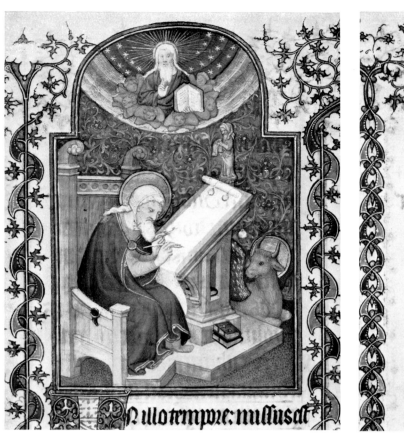

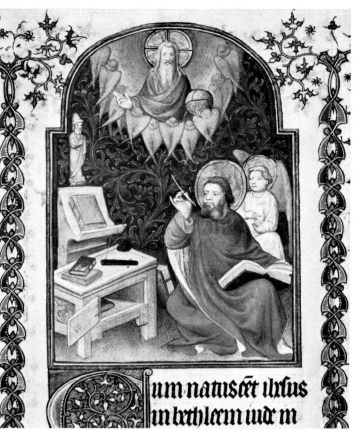

210 and 211. Boucicaut Associate: *St. Luke. St. Matthew*. Paris, Bibl. nat., nouv. acq. lat. 3107, fols. 18v and 20v.

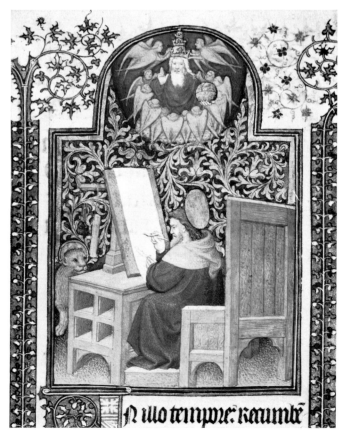

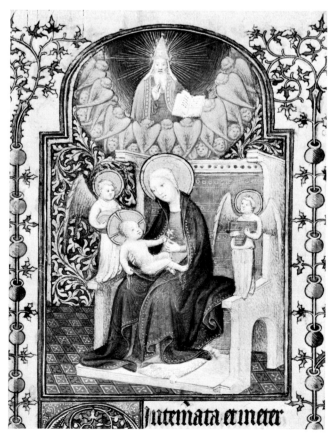

212 and 213. Boucicaut Associate: *St. Mark. Madonna enthroned*. Paris, Bibl. nat., nouv. acq. lat. 3107, fols. 22v and 28.

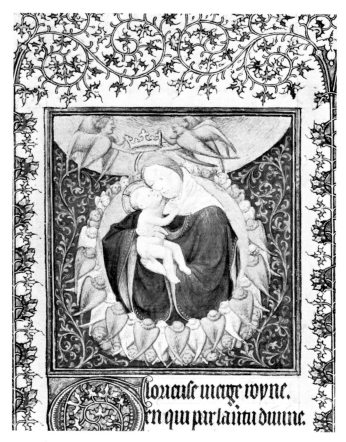

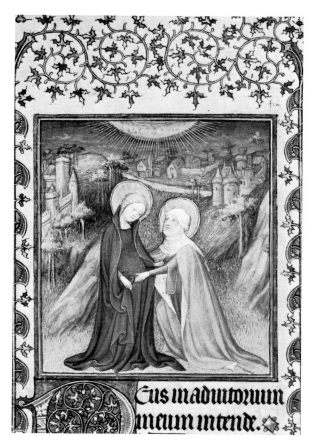

214 and 215. Boucicaut Associate: *Madonna in glory*. Workshop of Virgil Master: *Visitation*. Paris, Bibl. nat., nouv. acq. lat. 3107, fols. 33 and 56.

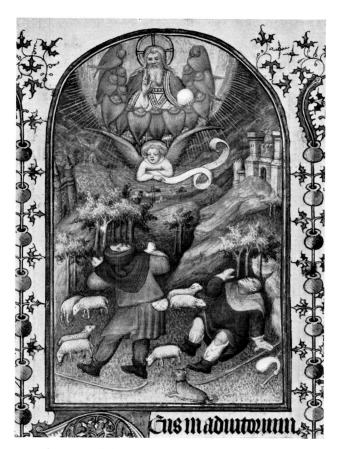

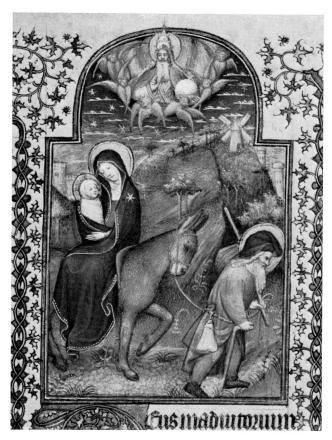

216 and 217. Workshop of Virgil Master: *Annunciation to the Shepherds*. *Flight into Egypt*. Paris, Bibl. nat., nouv. acq. lat. 3107, fols. 72v and 86.

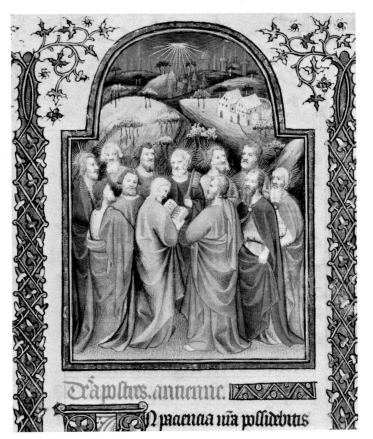

218 and 219. Boucicaut Follower: *The Apostles. St. Christopher.* Paris, Bibl. nat., nouv. acq. lat. 3107, fols. 215v and 217v.

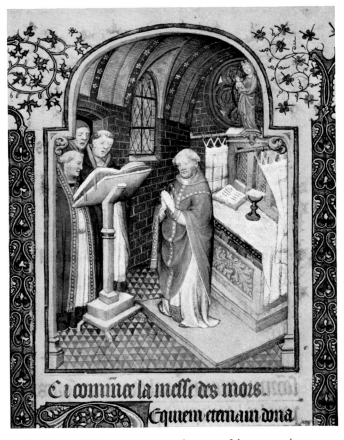

220 and 221. Boucicaut Follower: *Madonna of Humility and angels. Mass for the Dead.* Paris, Bibl. nat., nouv. acq. lat. 3107, fols. 232v and 237.

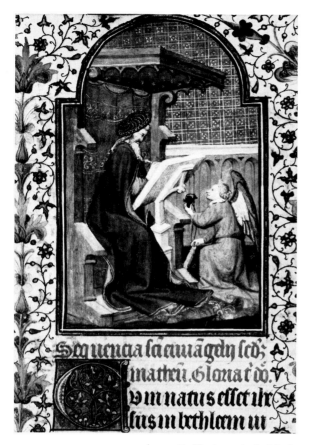

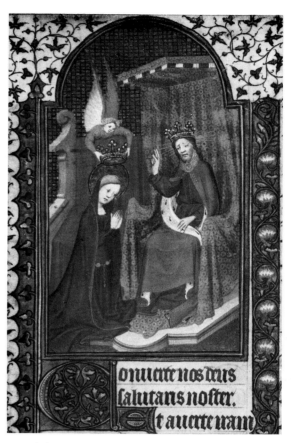

222 and 223. Bedford trend: *St. Matthew*. Egerton Workshop: *Coronation of the Virgin*.
Orange (Texas), Stark Coll., Book of Hours, fols. 17 and 94.

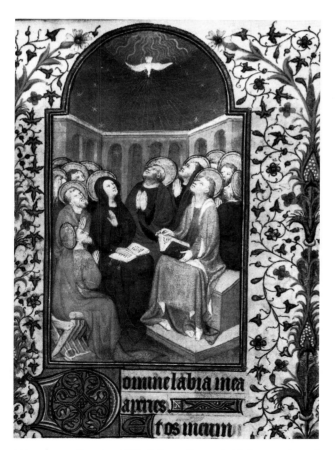

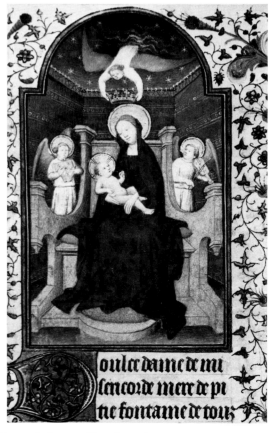

224 and 225. Boucicaut Workshop: *Pentecost. Madonna enthroned, crowned by angel.* Orange (Texas), Stark Coll., fols. 123 and 179.

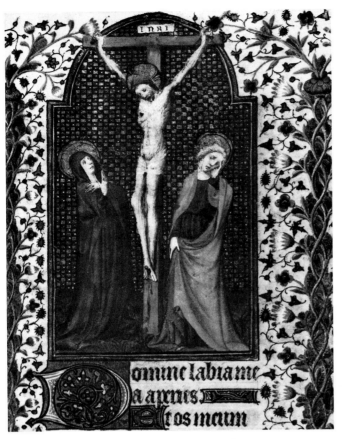

226. French Illuminator: *Crucifixion*.
Orange (Texas), Stark Coll., fol. 115.

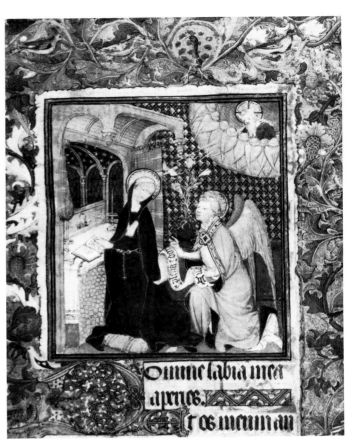

227. Boucicaut Workshop: *Annunciation*.
Oxford, Bodl. Lib., Canon Liturg. 75, fol. 25.

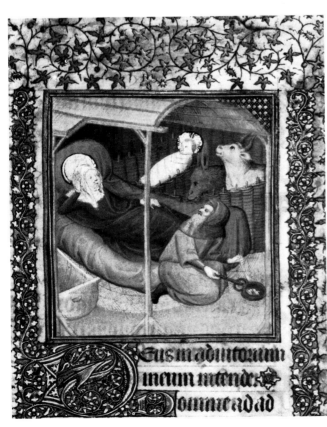

228. French Illuminator: *Nativity*.
Oxford, Bodl. Lib., Canon Liturg. 75, fol. 62.

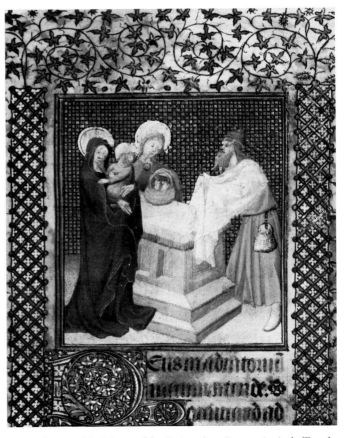

229. Follower of the Master of the Coronation: *Presentation in the Temple*.
Oxford, Bodl. Lib., Canon Liturg. 75, fol. 78.

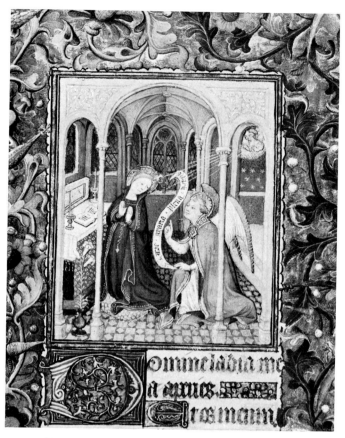

235. Boucicaut Follower: *Annunciation*. Whereabouts unknown (formerly New York, H.P. Kraus), Book of Hours, fol. 27.

236. French Illuminator: *Job pointing to a corpse*. Whereabouts unknown (formerly New York, H.P. Kraus), Book of Hours, fol. 147.

237 and 238. Boucicaut Follower: *Annunciation. Madonna, Child and angel*. Paris, Bibl. nat., lat. 1379, fols. 26 and 158.

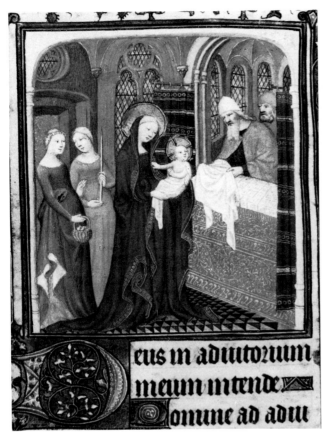

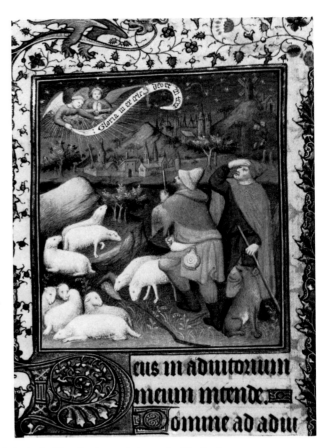

239 and 240. Boucicaut Workshop: *Presentation of Christ in the Temple. Annunciation to the Shepherds.*
London, Collection Zwemmer, fols. 76v and 67.

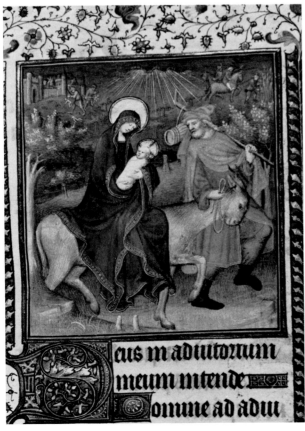

241. Boucicaut Workshop: *Flight into Egypt.*
London, Collection Zwemmer, Book of Hours, fol. 81.

242 and 243. Rohan Workshop: *January. June.*
London, Collection Zwemmer, Book of Hours.

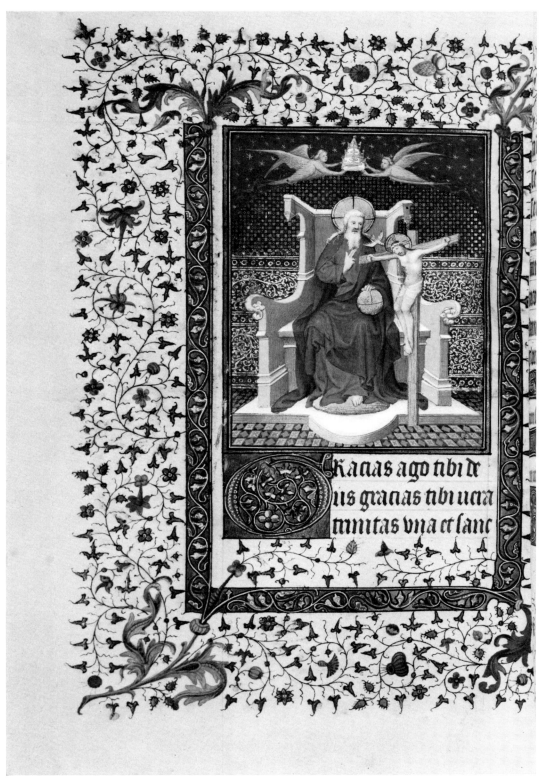

244. Boucicaut Workshop: *Trinity*. London, Collection Zwemmer, Book of Hours, fol. 212v.

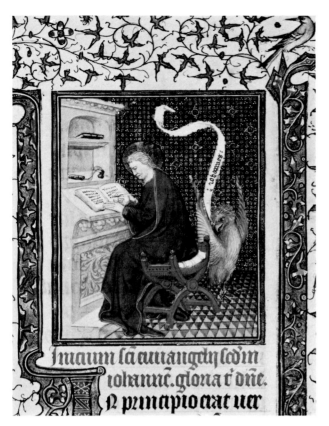

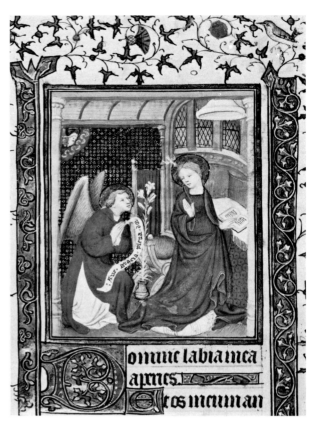

245 and 246. Boucicaut Workshop: *St. John. Annunciation*. Brussels, Bibl. Royale, ms. 11051, fols. 17 and 33.

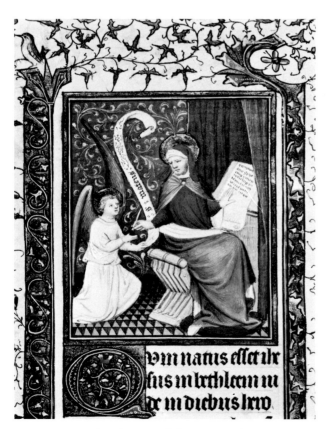

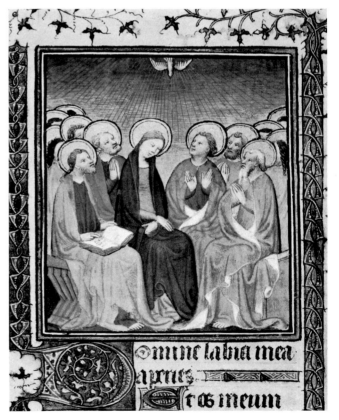

247. Boucicaut Workshop: *St. Matthew*.
Brussels, Bibl. Royale, ms. 11051, fol. 22v.

248. Boucicaut Workshop: *Pentecost*.
Baltimore, Walters Art Gallery, ms. 238, fol. 82v.

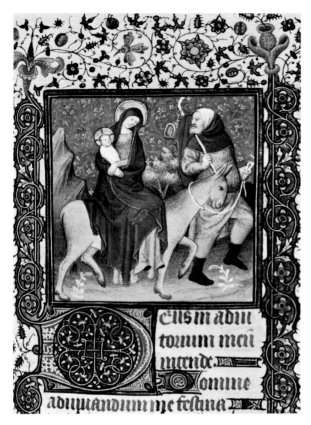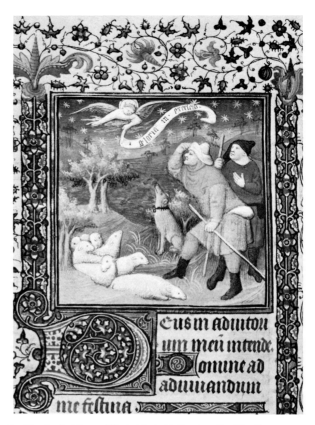

249 and 250. Boucicaut Workshop: *Flight into Egypt. Annunciation to the Shepherds.* Ripon (Yorkshire), Collection Bradfer-Lawrence,
Book of Hours, fols. 80 and 65v.

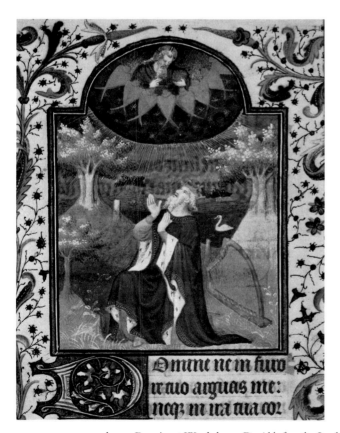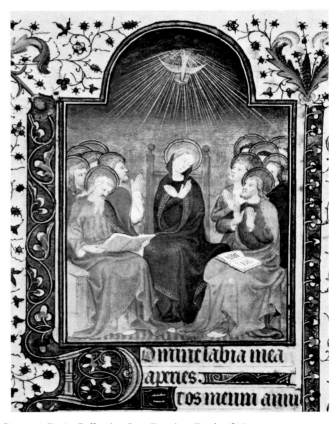

251 and 252. Boucicaut Workshop: *David before the Lord. Pentecost.* Paris, Collection Jean Durrieu, Book of Hours.

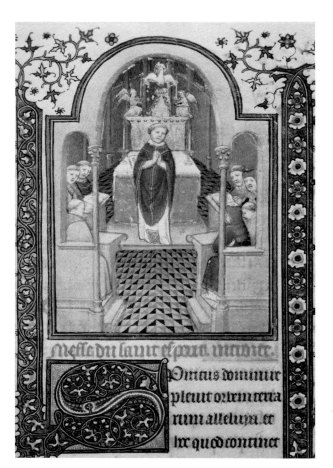

253 and 254. Boucicaut Workshop: *Mass of the Holy Ghost. Mass.* Paris, Bibl. nat., lat. 10538, fols. 186 and 191.

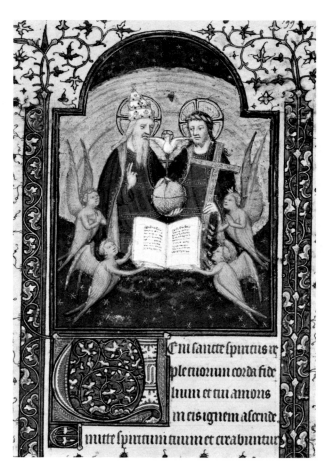

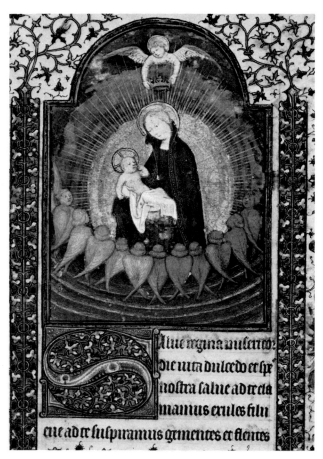

255 and 256. Boucicaut Workshop: *Trinity. Madonna in glory.* Paris, Bibl. nat., lat. 10538, fols. 199 and 200.

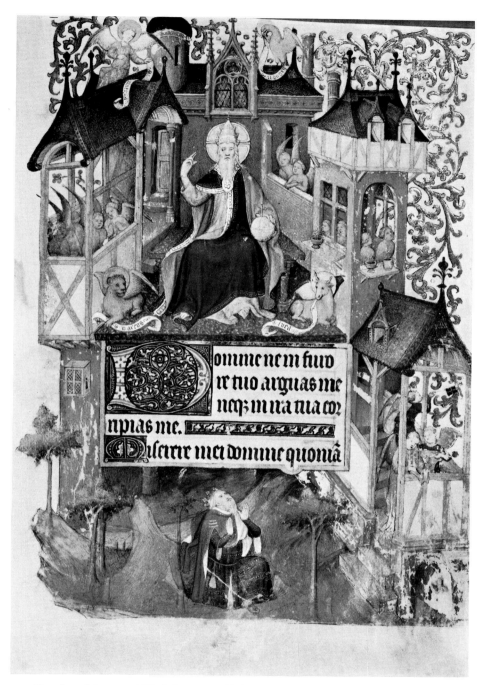

257. Boucicaut Master and Workshop: *David before the Lord*. Paris, Bibl. nat., lat. 10538, fol. 116.

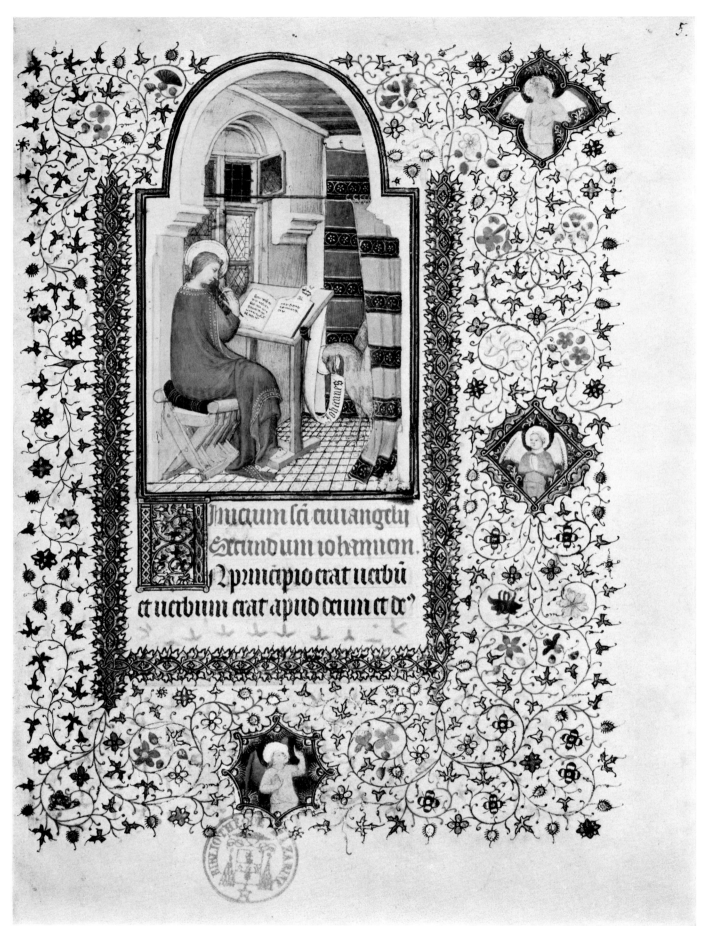

258. Boucicaut Master and Workshop: *St. John*. Paris, Bibl. Mazarine, ms. 469, fol. 5.

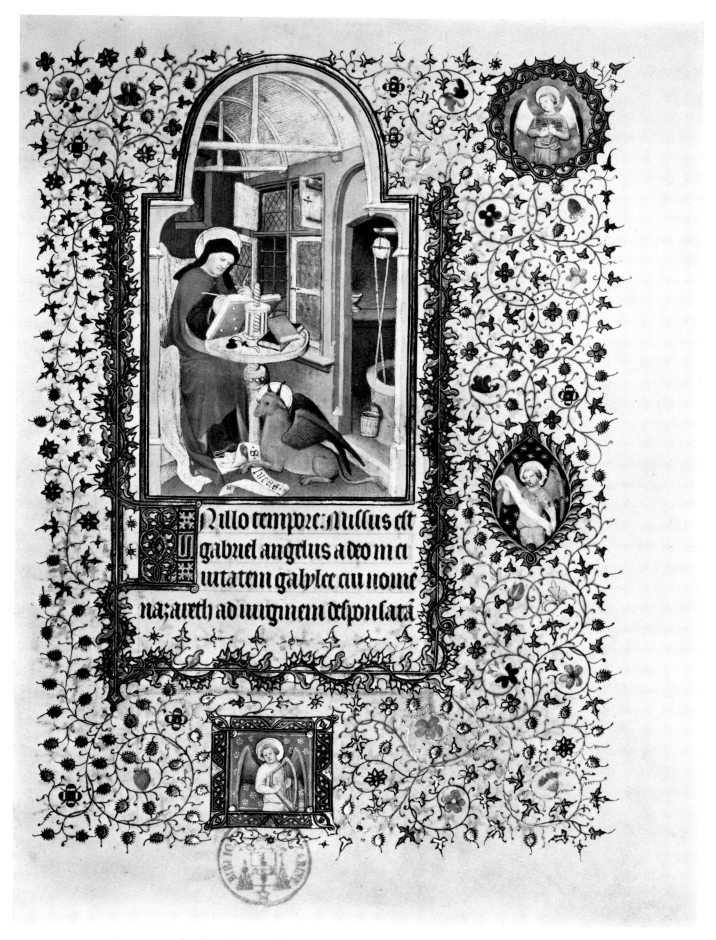

259. Boucicaut Master and Workshop: *St. Luke*. Paris, Bibl. Mazarine, ms. 469, fol. 7.

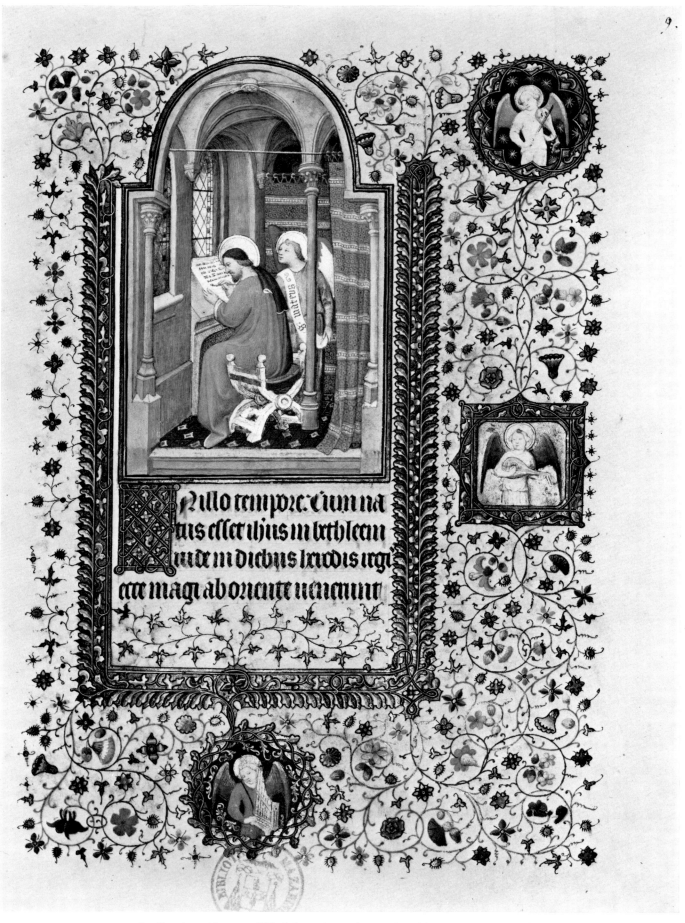

260. Boucicaut Master and Workshop: *St. Matthew*. Paris, Bibl. Mazarine, ms. 469, fol. 9.

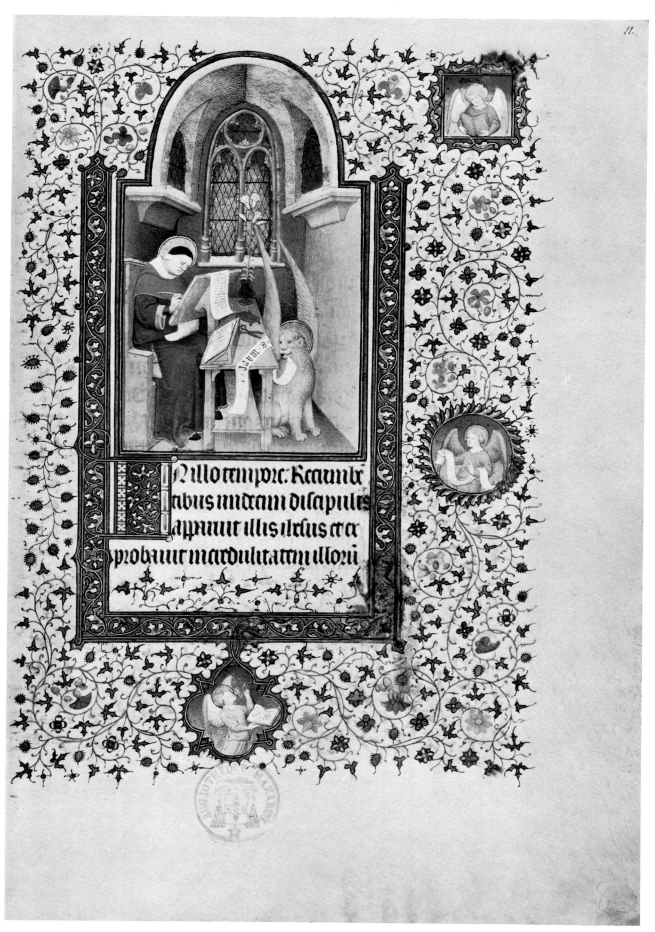

261. Boucicaut Master and Workshop: *St. Mark*. Paris, Bibl. Mazarine, ms. 469, fol. 11.

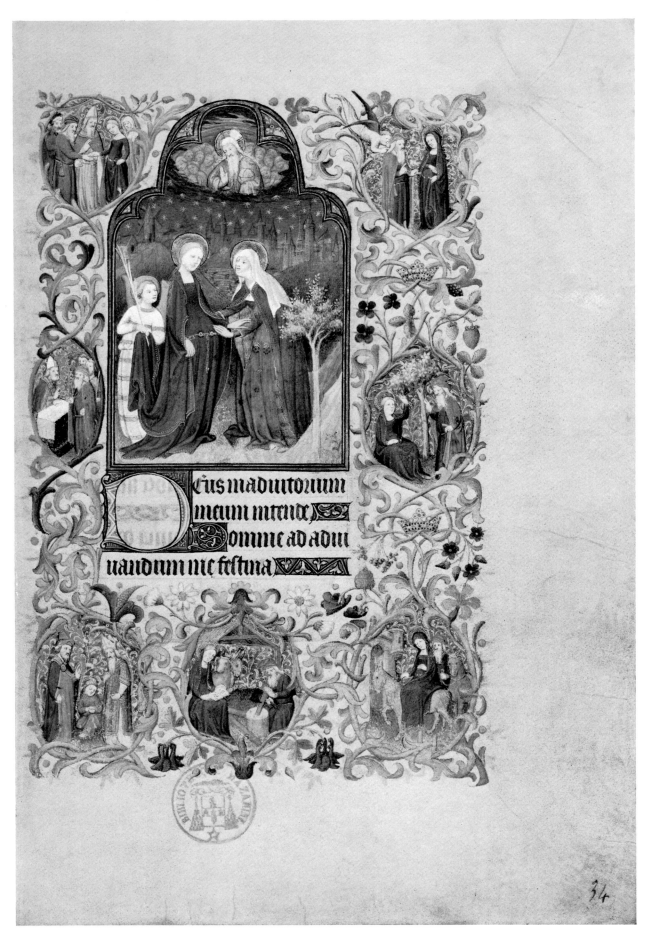

262. Boucicaut Master and Workshop: *Visitation, with vignettes of the life of the Virgin and Christ*. Paris, Bibl. Mazarine, ms. 469, fol. 38.

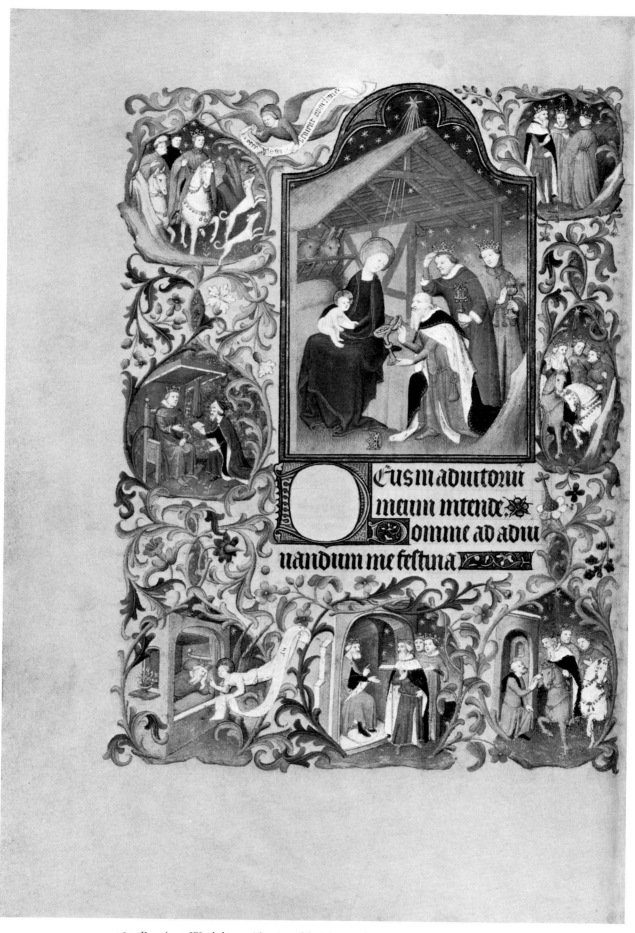

265. Boucicaut Workshop: *Adoration of the Magi, with scenes of the legend of the Magi.*
Paris, Bibl. Mazarine, ms. 469, fol. 61v.

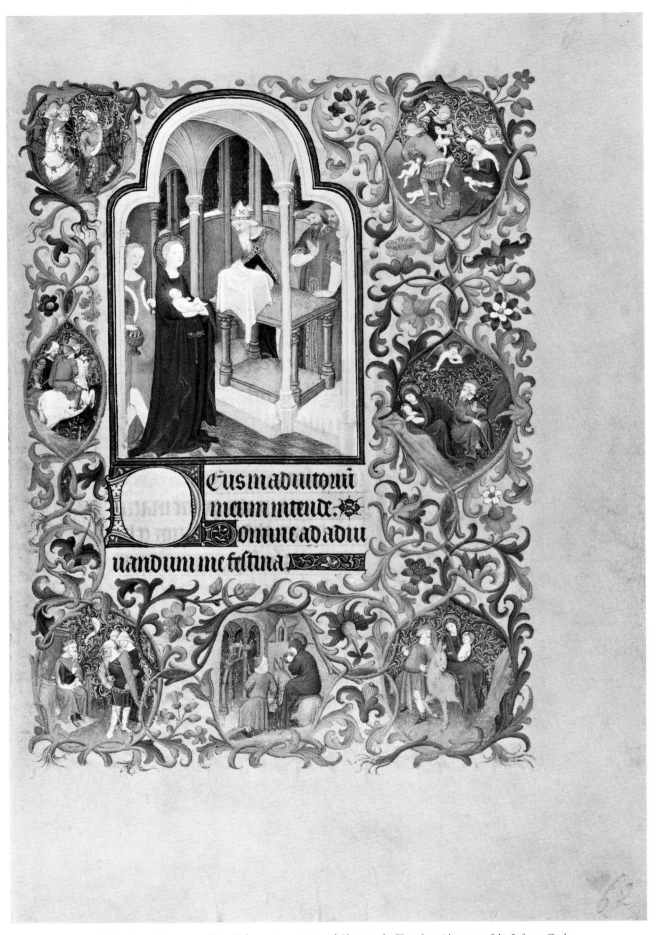

266. Boucicaut Master and Workshop: *Presentation of Christ in the Temple, with scenes of the Infancy Cycle.*
Paris, Bibl. Mazarine, ms. 469, fol. 66.

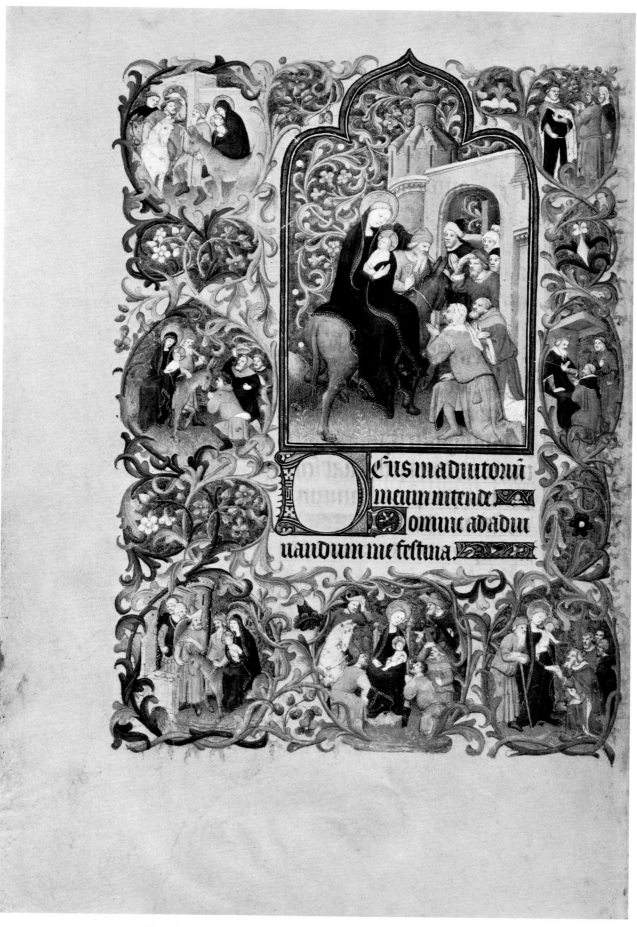

267. Boucicaut Master and Workshop: *Return from the Flight, with related scenes.*
Paris, Bibl. Mazarine, ms. 469, fol. 70v.

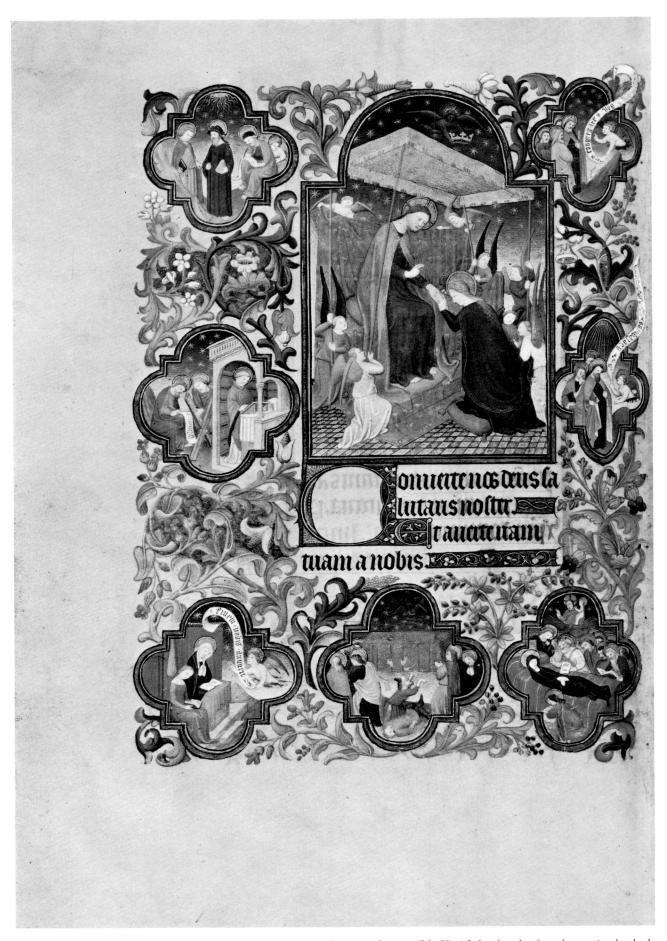

268. Boucicaut Master and Workshop: *Christ receiving the Virgin in heaven, with scenes of the Virgin's last days, her funeral procession, her death, and the congregation of the apostles.* Paris, Bibl. Mazarine, ms. 469, fol. 77v.

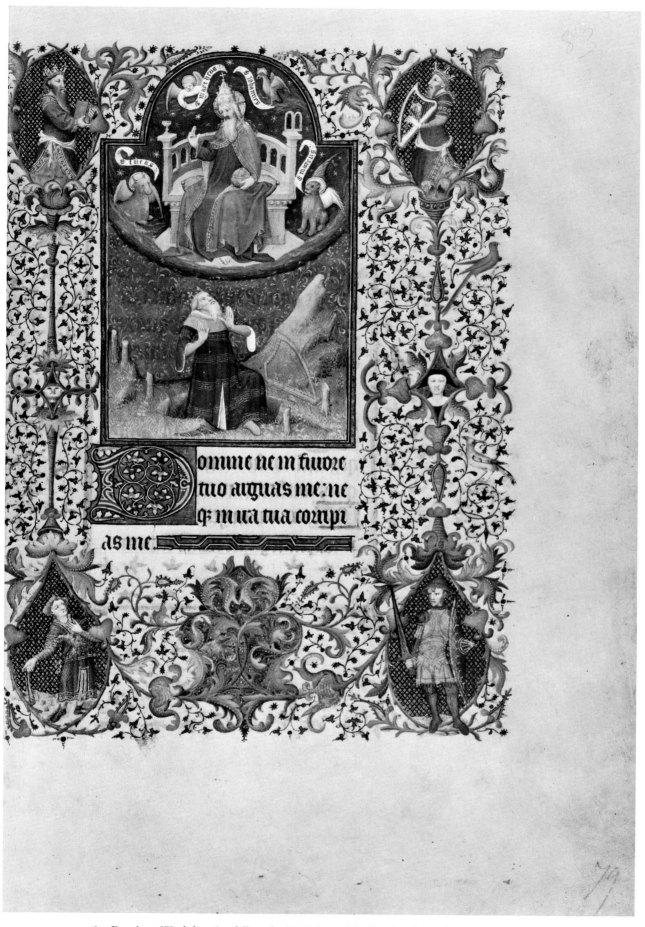

269. Boucicaut Workshop (medallions by Workshop of the Breviary Master): *David before the Lord.*
Paris, Bibl. Mazarine, ms. 469, fol. 83.

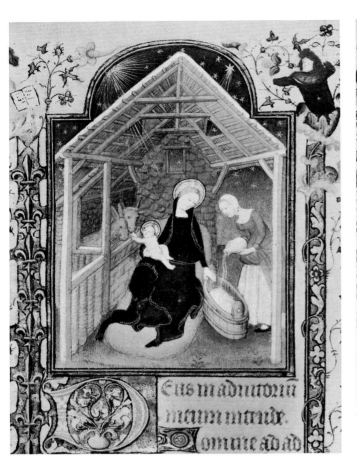
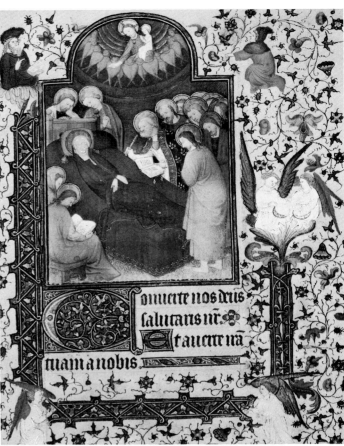

270 and 271. Boucicaut Follower: *Preparing the bath after the Nativity. Death of the Virgin.*
Baltimore, Walters Art Gallery, ms. 260, fols. 63v and 92.

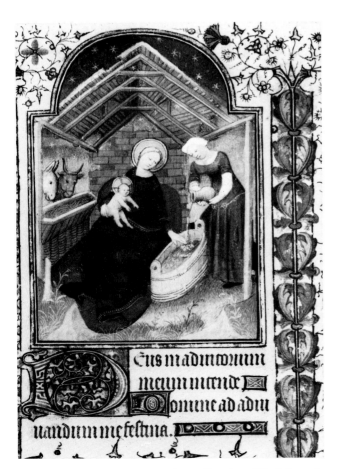
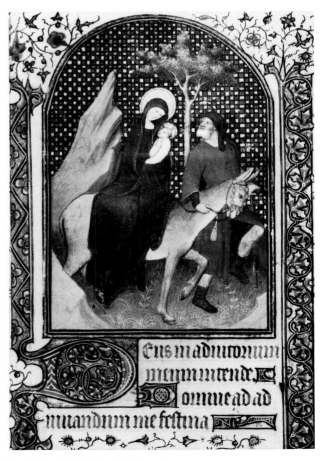

272 and 273. Boucicaut Workshop: *Preparing the bath after the Nativity. Flight into Egypt.*
Paris, Coll. Charnacé, Book of Hours.

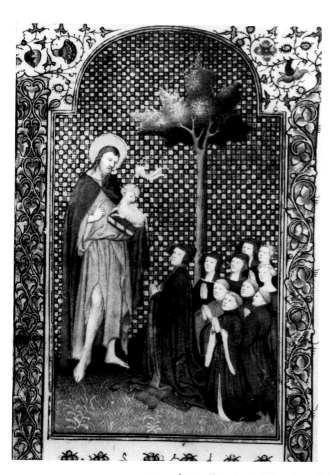

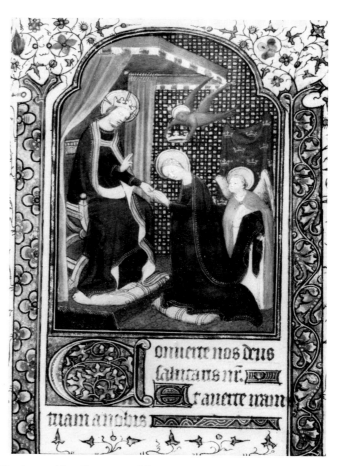

274 and 275. Boucicaut Workshop: *John the Baptist preaching. Coronation of the Virgin.*
Paris, Coll. Charnacé, Book of Hours.

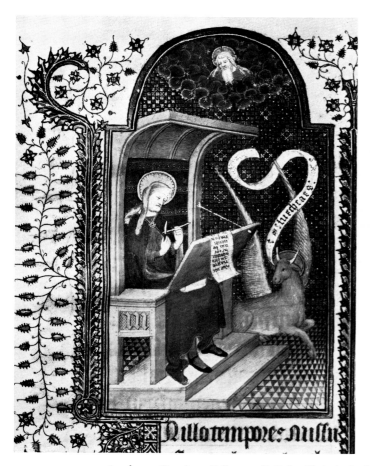

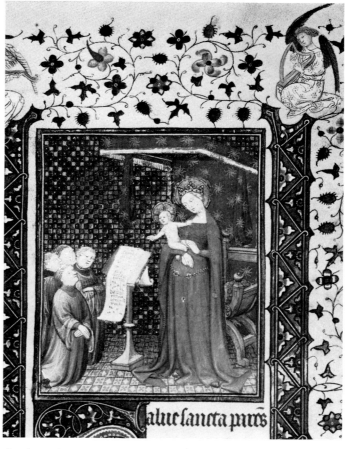

276 and 277. Boucicaut Follower: *St. Luke. Choir singing before the Madonna.* London, Victoria and Albert Museum,
ms. A.L. 1646–1902, fols. 15 and 172.

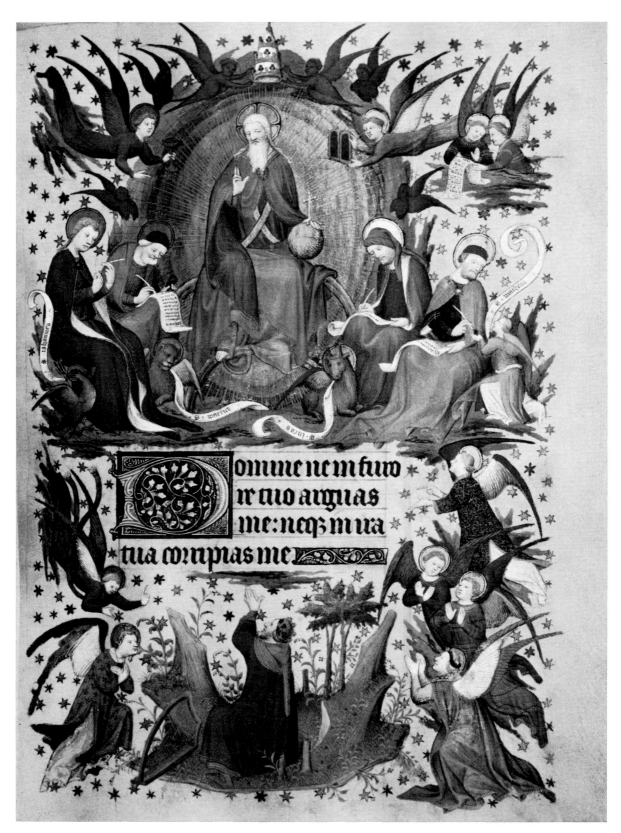

278. Boucicaut Master and Workshop: *God, the Evangelists, and David in prayer*. Florence, Corsini Coll., Book of Hours.

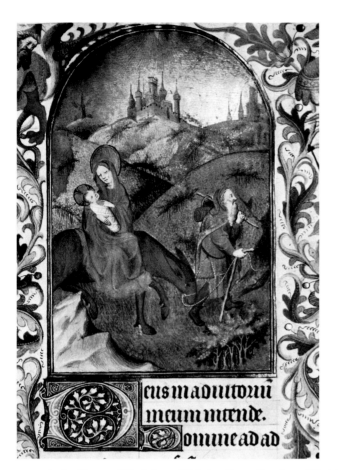

279 and 280. Egerton Workshop: *Flight into Egypt*. Boucicaut Workshop: *Elevation of the Host*. Florence, Corsini Coll., Book of Hours.

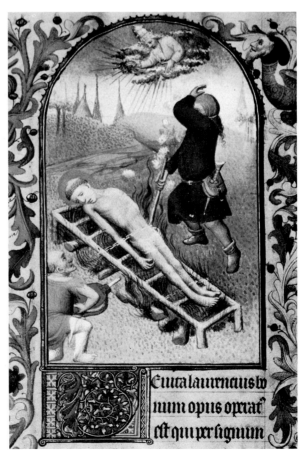

281 and 282. Netherlandish (?) Illuminators: *SS. Peter and Paul*. *Martyrdom of St. Lawrence*.
Florence, Corsini Coll., Book of Hours.

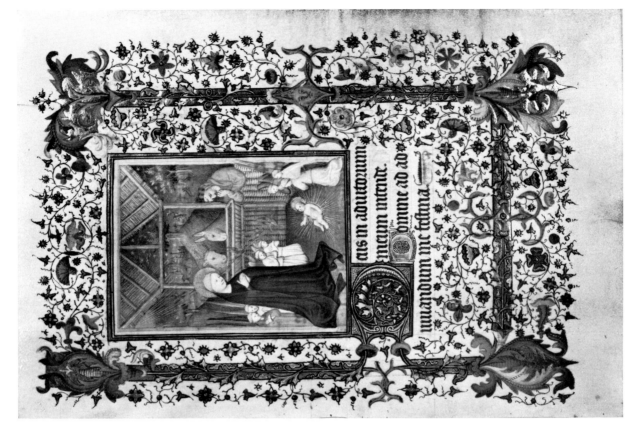

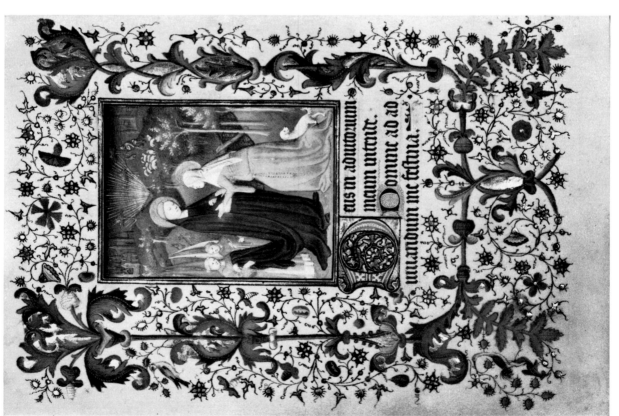

283 and 284. Boucicaut Master and Workshop: *Visitation. Adoration of the Child.* London, Brit. Mus., Add. 16997, fols. 45v and 57.

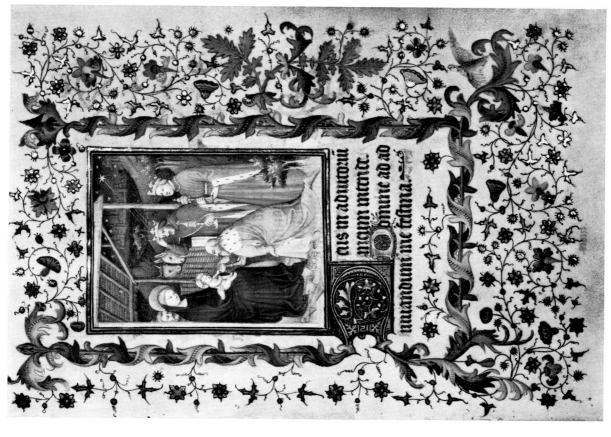

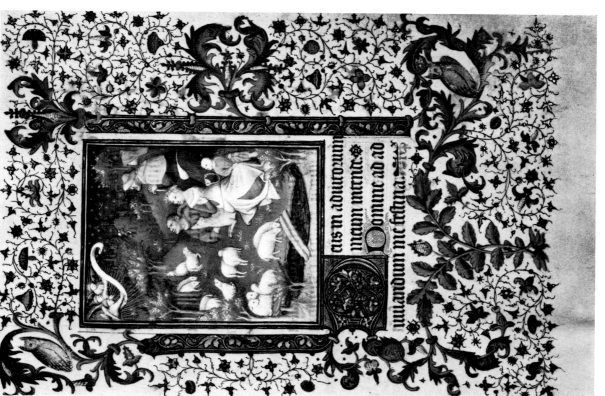

285 and 286. Boucicaut Master and Workshop: *Annunciation to the Shepherds. Adoration of the Magi.* London, Brit. Mus., Add. 16997, fols. 63 and 68.

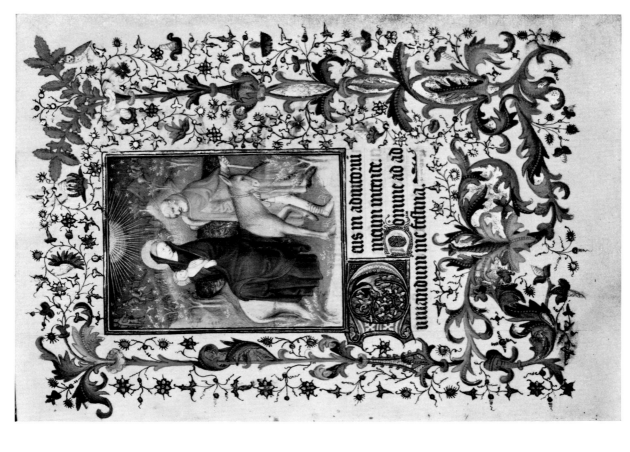

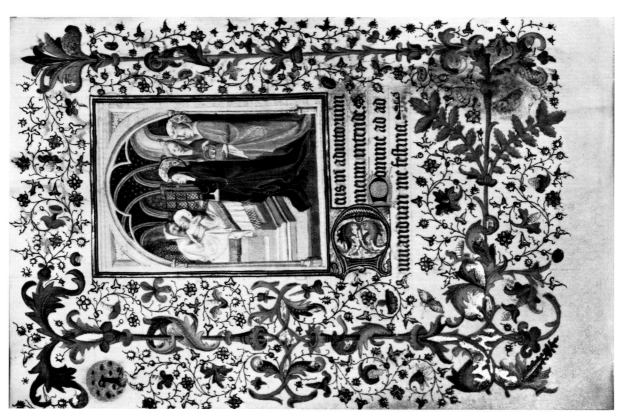

287 and 288. Bedford Master: *Presentation of Christ in the Temple.* Boucicaut Master and Workshop: *Flight into Egypt.* London, Brit. Mus., Add. 16997, fols. 72v and 77.

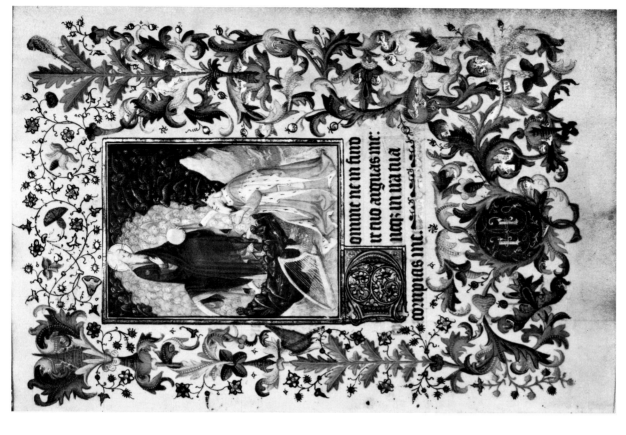

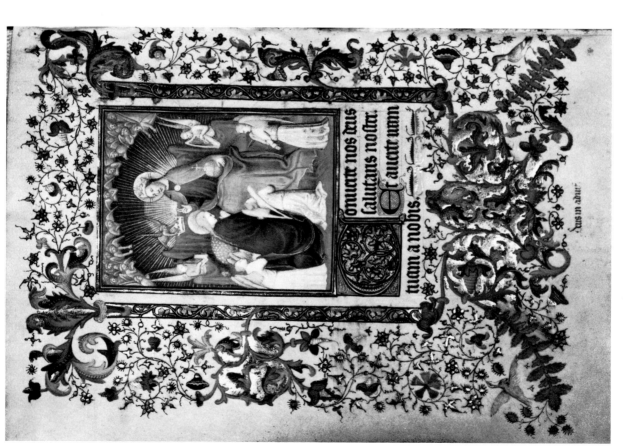

289 and 290. Boucicaut Master and Workshop: *Coronation of the Virgin. David before the Lord.* London, Brit. Mus., Add. 16997, fols. 84v and 90.

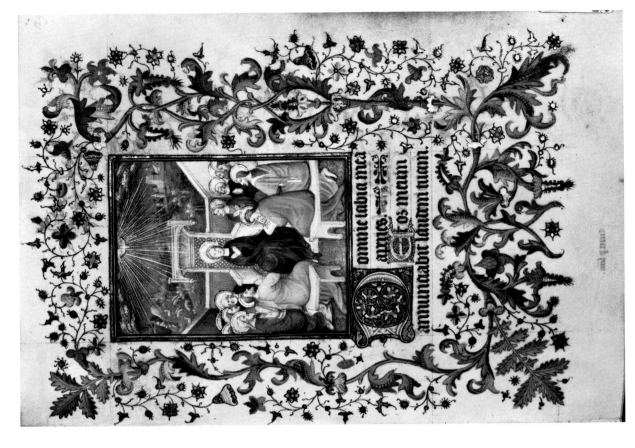

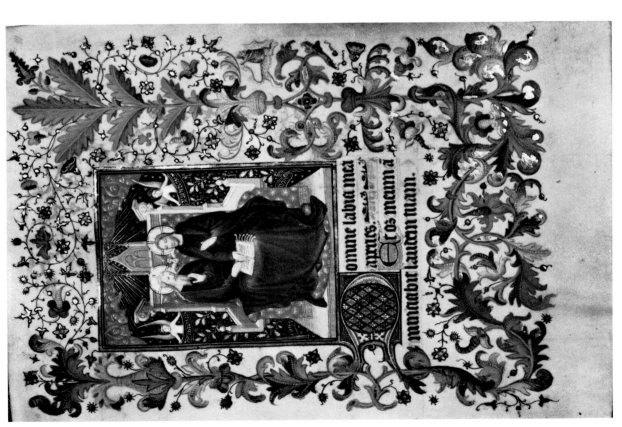

291 and 292. Boucicaut Master and Workshop: *Trinity*. Boucicaut Master: *Pentecost*. London, Brit. Mus., Add. 16997, fols. 111 and 129.

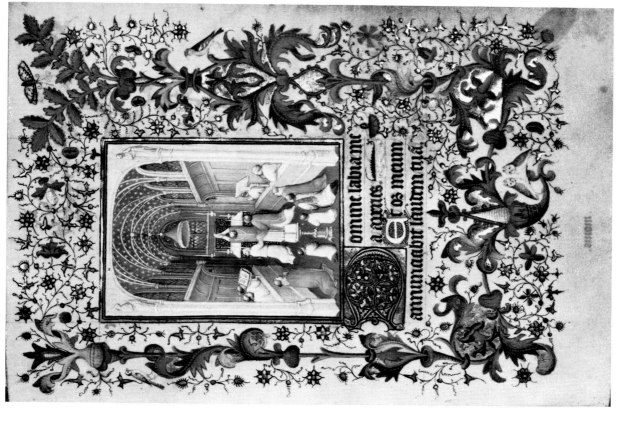

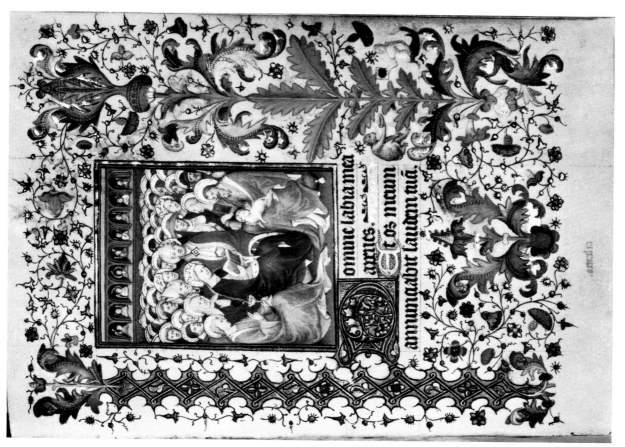

293 and 294. Boucicaut Master and Workshop: *All Saints. Celebration of Mass.* London, Brit. Mus., Add. 16997, fols. 137 and 145.

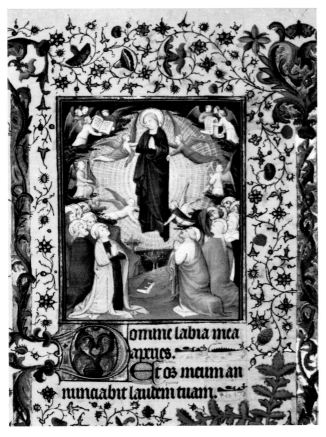

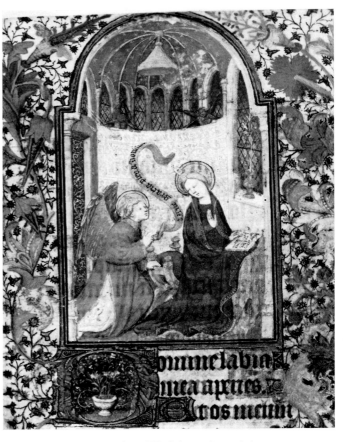

295. Boucicaut Master and Workshop: *Assumption of the Virgin*.
London, Brit. Mus., Add. 16997, fol. 163.

296. Boucicaut Workshop: *Annunciation*.
Washington, Library of Congress, ms. acc. 4560 (7), fol. 21.

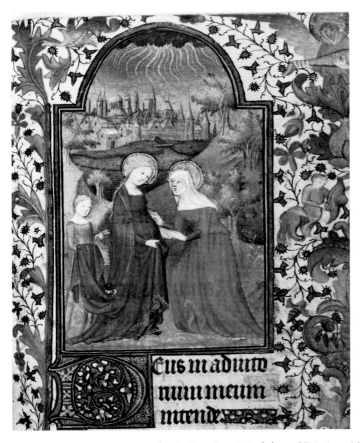

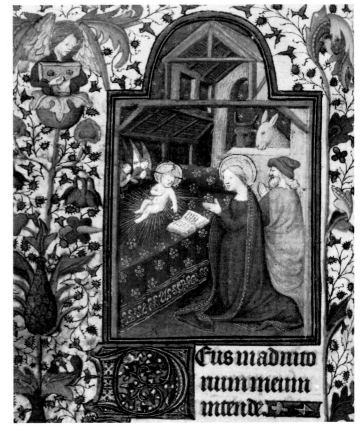

297 and 298. Boucicaut Workshop: *Visitation. Adoration of the Child.* Washington, Library of Congress,
ms. acc. 4560 (7), fols. 33 and 45v.

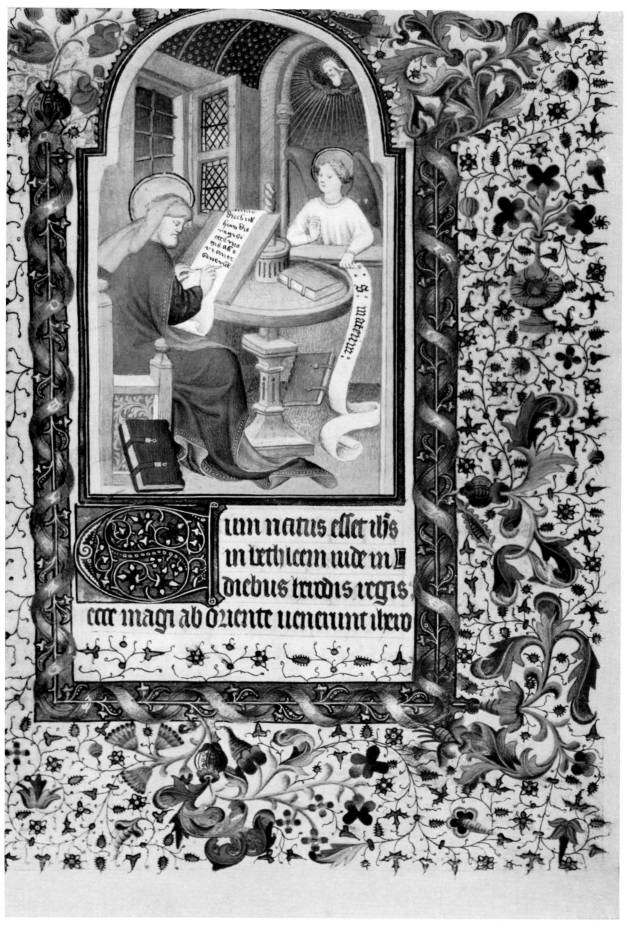

301. Boucicaut Master and Workshop: *St. Matthew*. New York, Private Collection, Book of Hours., fol. 17.

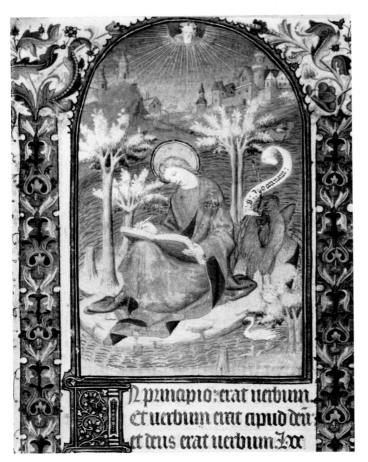

302 and 303. Boucicaut Workshop: *St. John on Patmos*. Boucicaut Follower: *Christ before Pilate*.
New York, Private Collection, Book of Hours, fols. 13 and 20v.

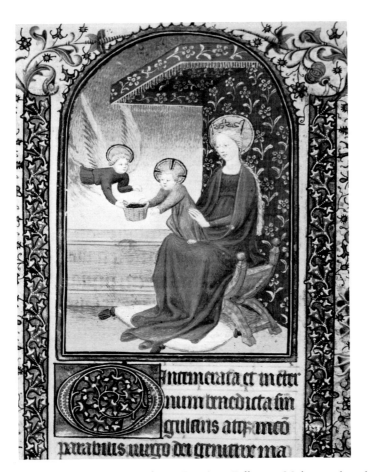

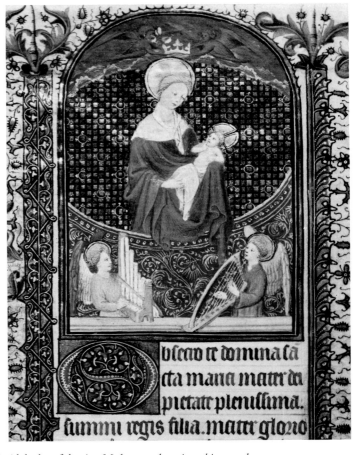

304 and 305. Boucicaut Follower: *Madonna and angel with basket of cherries. Madonna and music-making angels.*
New York, Private Collection, Book of Hours, fols. 23 and 27v.

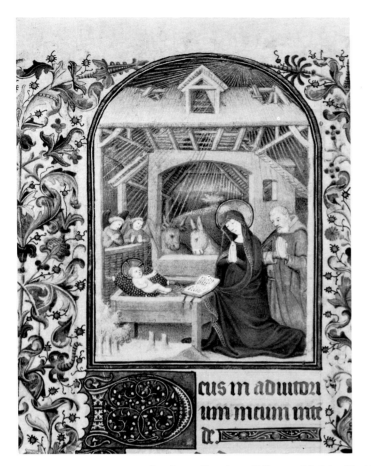
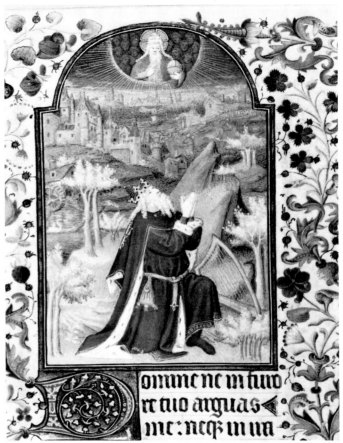

306 and 307. Boucicaut Follower: *Nativity. David before the Lord*. New York, Private Collection,
Book of Hours, fols. 72v and 109.

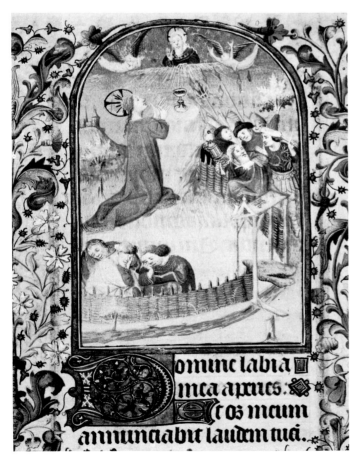
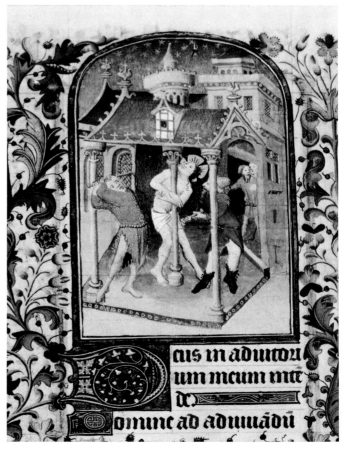

308 and 309. Netherlandish (?) Illuminator: *Agony in the Garden. Flagellation*. New York, Private Collection,
Book of Hours, fols. 132v and 136v.

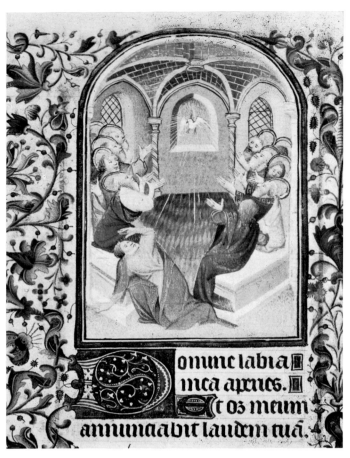

310 and 311. Netherlandish (?) Illuminator: *Deposition. Pentecost*. New York, Private Collection,
Book of Hours, fols. 142v and 146v.

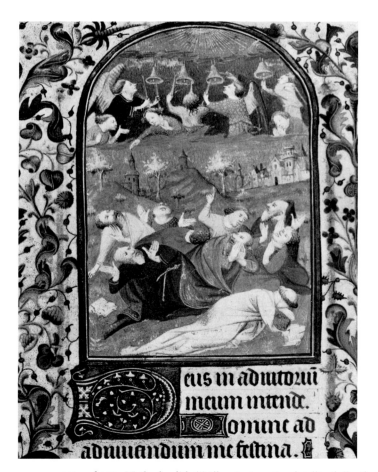

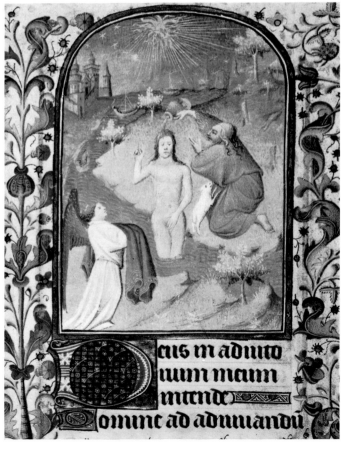

312 and 313. Netherlandish (?) Illuminator: *Angels tolling bells; the Unbelievers confounded. Baptism*. New York, Private Collection,
Book of Hours, fols. 148v and 150.

314 and 315. Boucicaut Follower: *Assumption of the Virgin. St. Anne and the Virgin*. New York, Private Collection, Book of Hours, fols. 210v and 224v.

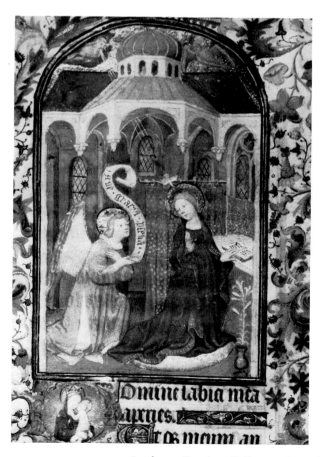
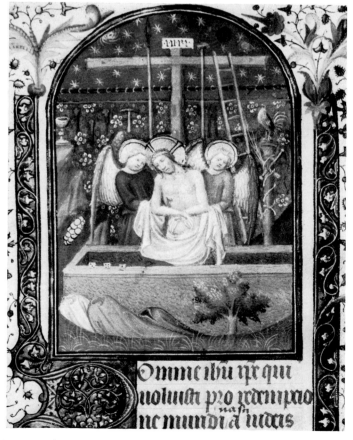

316 and 317. Boucicaut Follower: *Annunciation. Man of Sorrows*. Cracow, Muzeum Narodowe, ms. Czart. 2032, pp. 49 and 449.

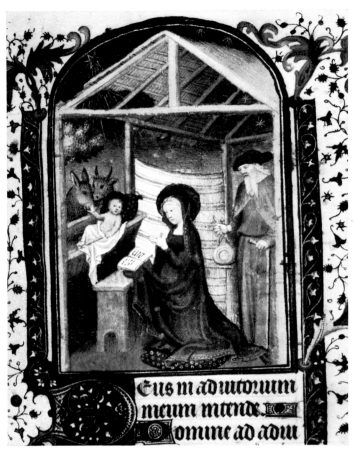

318 and 319. Boucicaut Follower: *Presentation of Christ in the Temple. Adoration of the Child.* Cracow, Muzeum Narodowe, ms. Czart. 2032, pp. 129 and 99.

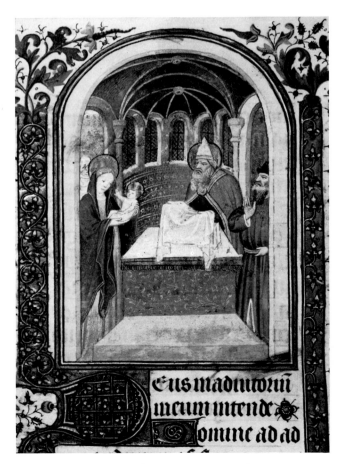
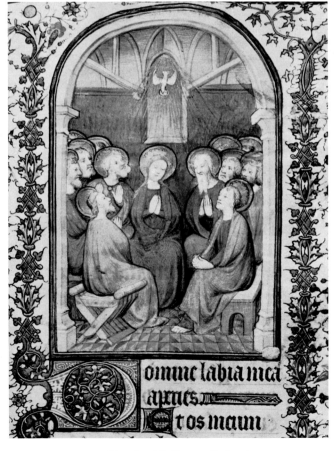

320. Boucicaut Follower: *Presentation in the Temple.*
Cleveland, Museum of Art, Book of Hours (acq. no. 42.169), fol. 93v.

321. Boucicaut Follower: *Pentecost.*
Peterborough, Museum and Art Gallery, Book of Hours, fol. 123.

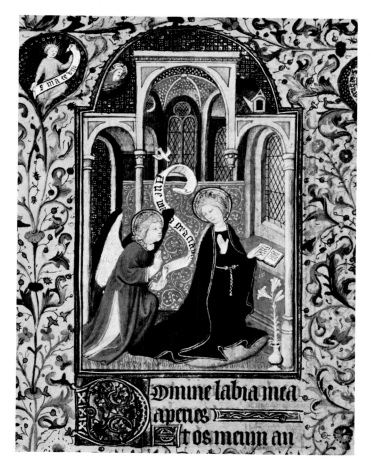

322 and 323. Boucicaut Follower: *Annunciation*. Rohan Workshop: *Madonna enthroned and angels*.
London, Brit. Mus., Harley 2940, fols. 38 and 175.

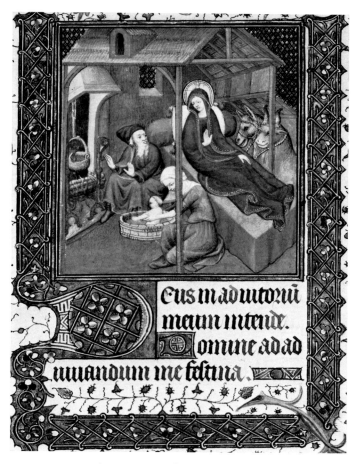

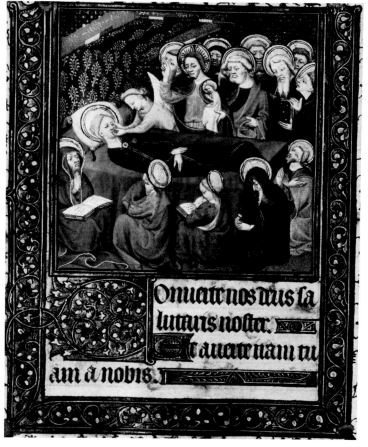

324 and 325. Master of Harvard Hannibal: *Nativity. Death of the Virgin*. New York, Morgan Library, ms. 455, fols. 59 and 84v.

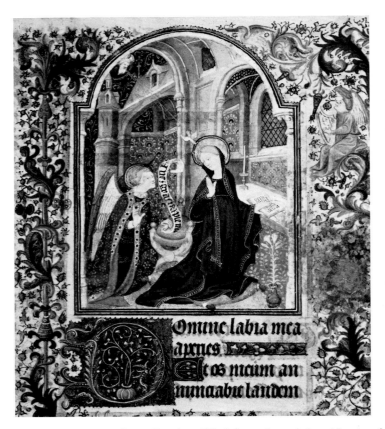
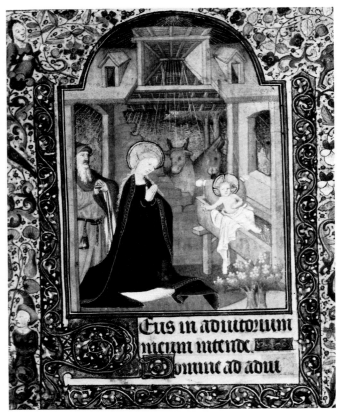

326 and 327. Boucicaut Workshop: *Annunciation*. *Adoration of the Child*. Oxford, Bodl. Lib., Douce 80, fols. 36 and 72.

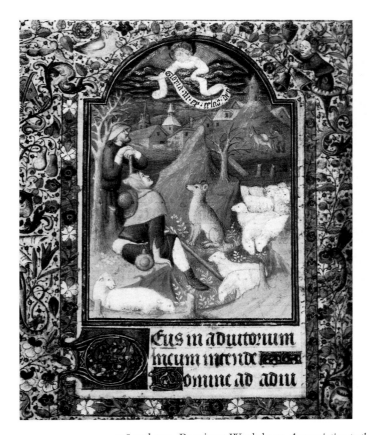
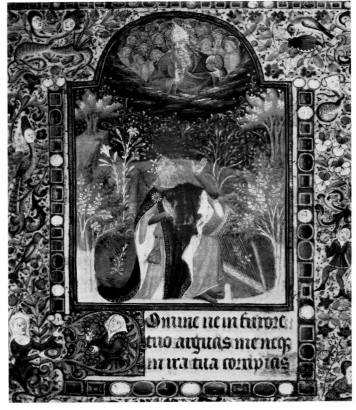

328 and 329. Boucicaut Workshop: *Annunciation to the Shepherds*. Boucicaut Follower: *David before the Lord*.
Oxford, Bodl. Lib., Douce 80, fols. 78v and 101.

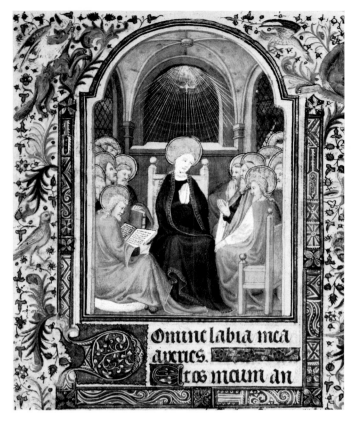

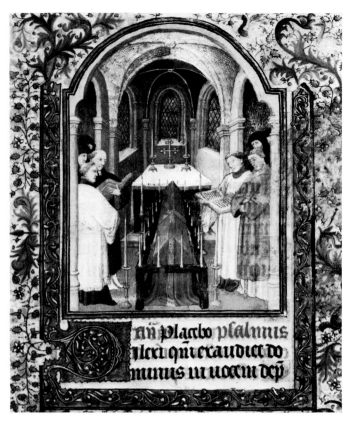

330 and 331. Boucicaut Workshop: *Pentecost. Funeral Service.* Oxford, Bodl. Lib., Douce 80, fols. 127 and 134.

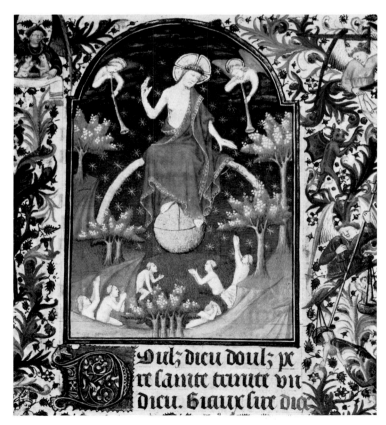

332. Boucicaut Workshop: *Last Judgment.*
Oxford, Bodl. Lib., Douce 80, fol. 192.

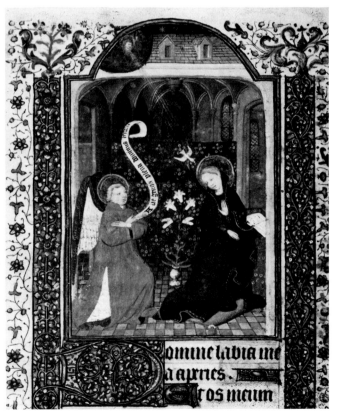

333. Boucicaut Follower: *Annunciation.*
Oxford, Bodl. Lib., Rawl. Liturg. e 24, fol. 19.

334 and 335. Boucicaut Master and Workshop: *The Lord, good and bad angels. Cain and Abel.*
Baltimore, Walters Art Gallery, ms. 770, fols. 16v and 60.

336 and 337. Boucicaut Master and Workshop: *Abraham with three angels and Noah in the Ark. David composing.*
Baltimore, Walters Art Gallery, ms. 770, fols. 87 and 117.

promettent pardon. non
ns a ceulz qui sont baptis
oliques combien que aps
uks crimes et erreurs, se
determinent que ceulz se
tiennent la foy catholiq̄
nent tresmauuaisement
t desseru a ardoir et q̄ cest
ent de la foy. xxj.

endent que les pechies mor
s entre les ocuurs de misen
pas estre appelles au juge
racion. xxj.

nion de ceulz qui mainten
mens qui sont a auenir
des homes ne seront pas p
xxiij.

qui maintiennent que
ement espargnera les mau
eres des iustes xxiiij.

on se ceulz qui sont bapti
rites. et en apres demeuret
maunaise uie. ou ceulz
ez entre les catholiques.
nt a heresies ou salmes.
ion. ou ceulz qui combie
baptisez entre les catholi
nt departis de la foy. ma
s ont uescu en estat de pe
ussent esperer remission du
ment par les preuileges des
xxv.

est. auoir ihesucrist en son
uck homes est promis sau

De lordre de la desputoison par la quelle il
est premierement a determiner du pardu
rable tourment des dampnes auec le dya
ble. que il nest de la pardurable beneurte
pour ce que le des sains. J.
deux cites dont lune est du
dyable et lautre de dieu
sont paruenues a leurs
leurs fins dehues par ihu
crist nre seigneur nous
auons a desputer diligennent en ce liure
tant comme nous pourrons par laaide de
dieu de quelle condicion soit le tourment
auenir au dyable. et de touceulz qui a li
aptiennent. Et ay unex ame a tenir cel
te ordre. a fin que apres ie traitte de la be

338. Boucicaut Master and Workshop: *Hell*. Baltimore, Walters Art Gallery, ms. 770, fol. 227v.

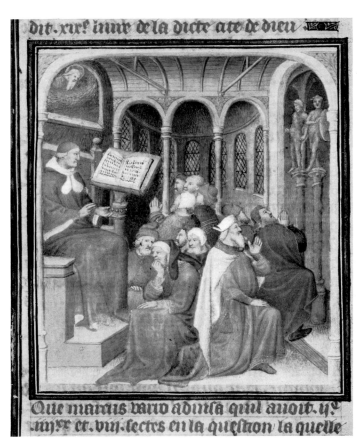

339 and 340. Boucicaut Master and Workshop: *Adoration of the new-born Child. Varro teaching.*
Baltimore, Walters Art Gallery, ms. 770, fols. 139v and 179v.

341 and 342. Boucicaut Master and Workshop: *Last Judgment. Christ and the Virgin in glory.*
Baltimore, Walters Art Gallery, ms. 770, fols. 203 and 252.

Cy commencent les paraboles salemon .j.

es paraboles Calemon fils dauid roy de ysrael a sauoir sapience. et de sapline. a entendre parabo les et pruden ce. et recepuon enseignemet de doctrine. et nisice. et iugement. et loyaulte. et droi ture. que sens soit donnez aux petis. Cest adire aux humbles ignorans. et que saience soit donnee aux iounes et

entendement a ceulx qui en ont mesti er. les sages seront plus sages a oir. Et celui qui entent bien en sauen nu eulx gouuerner soy. et aultres. et apir eueurs parabolles. et interpretacions. et les figures. et les paroles des sages. la paour nre seigneur est comencemet de sapience. li sotz despisent sapience. et doctrine. mon filz oyes la discipline de ton pere. et ne laisse mie la loy de ta mere. que grace soit aioustee et mise seur ton chief. et fermail dor a ton col. mon filz se li pecheurz te lescheut ne les croyes mie. Cest adire se losengiers te losengent ne les croys mie. quilz ne te decoiuent. Silz te dient viens o no

343. Boucicaut Workshop: *Judgment of Solomon, meeting of Solomon and the Queen of Sheba, the two before idols and Solomon teaching.* Paris, Bibl. nat., fr. 10, fol. 318.

344 and 345. Boucicaut Workshop: *Building the Ark. Constructing the Tower of Babel.*
London, Brit. Mus., Royal 15 D III, fols. 12 and 15v.

346 and 347. Boucicaut Workshop: *Jacob's Dream. Joseph put into the well.*
London, Brit. Mus., Royal 15 D III, fols. 27 and 31v.

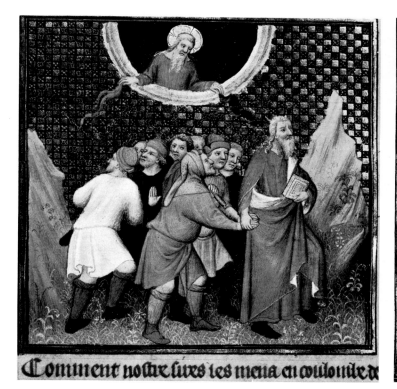

348 and 349. Boucicaut Workshop: *The Jews led by Moses leave Egypt under the Lord's protection. Nehemiah inquires of the Jews.*
London, Brit. Mus., Royal 15 D III, fols. 48 and 197.

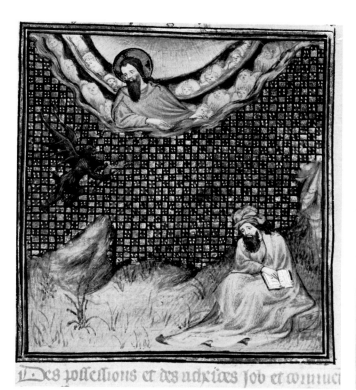

350 and 351. Virgil Master: *God, Satan, and Job.* Boucicaut Workshop: *Job and his friends.*
London, Brit. Mus., Royal 15 D III, fols. 209 and 219v.

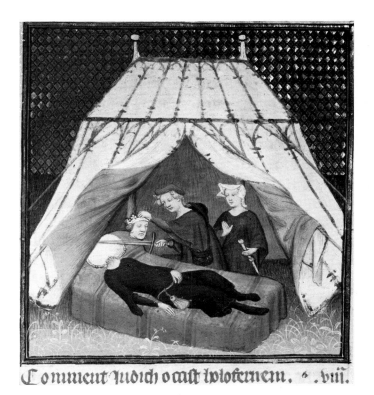

352 and 353. Boucicaut Workshop: *Judith decapitating Holofernes*. Boucicaut Master and Workshop: *The fool mocked*.
London, Brit. Mus., Royal 15 D III, fols. 239 and 262.

354. Egerton Workshop: *St. John on Patmos*.
London, Brit. Mus., Royal 15 D III, fol. 526.

355. Boucicaut Follower: *God in Majesty and the Evangelists*.
Paris, Musée de Cluny, no. 11316.

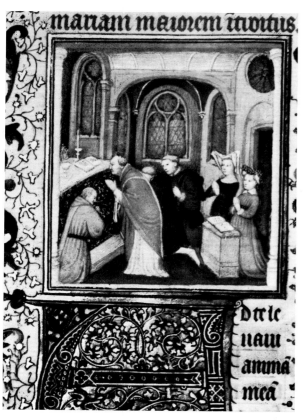

357. Boucicaut Workshop: *Angels holding the Trenta Shield.*
Lucca, Bibl. Governativa, ms. 3122, fol. 7.

356. Boucicaut Workshop: *Celebration of the Mass.*
Lucca, Bibl. Governativa, ms. 3122, fol. 7.

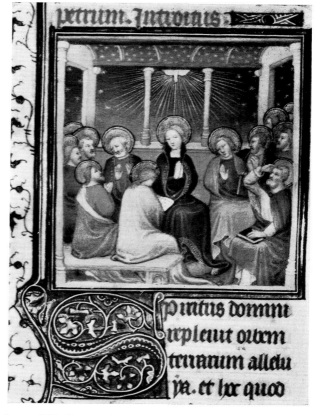

358 and 359. Boucicaut Workshop: *Birth of the Baptist. Pentecost.* Lucca, Bibl. Governativa, ms. 3122, fols. 246v and 178.

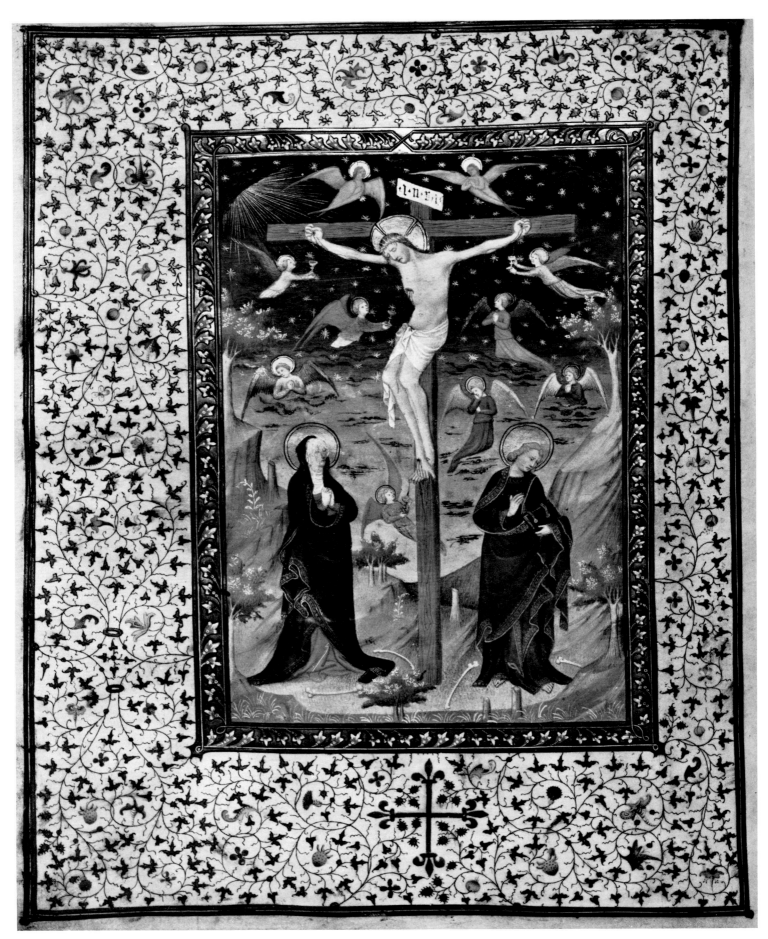

360. Boucicaut Workshop: *Crucifixion*. Lucca, Bibl. Governativa, ms. 3122, fol. 151v.

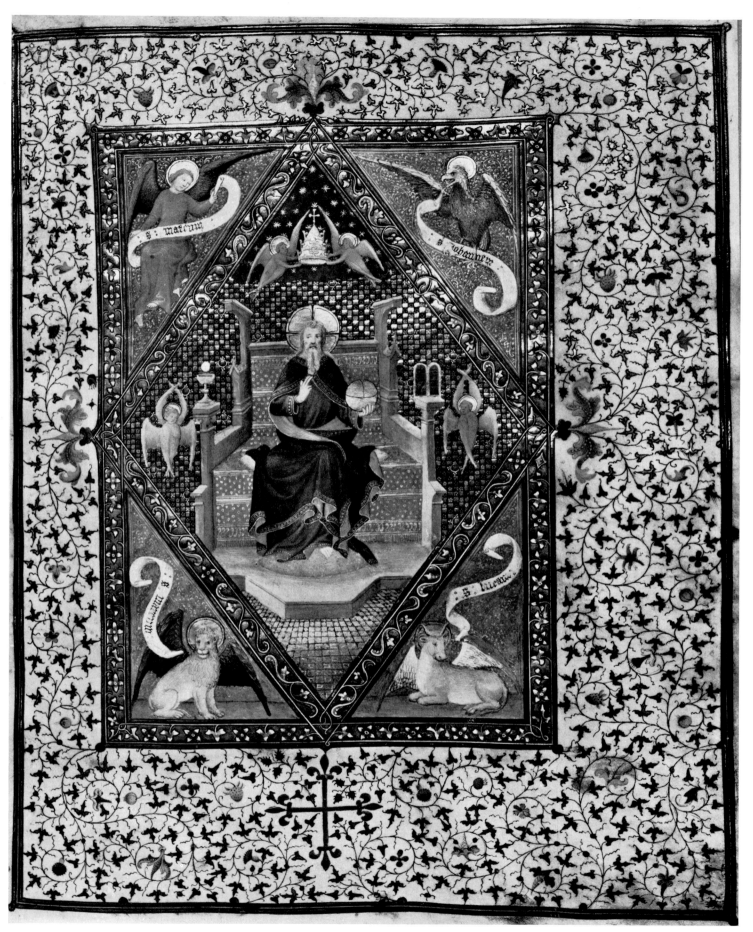

361. Boucicaut Workshop: *God in Majesty*. Lucca, Bibl. Governativa, ms. 3122, fol. 152.

362 and 363. Boucicaut Workshop: *Entry into Jerusalem. Resurrection.*
Lucca, Bibl. Governativa, ms. 3122, fols. 95 and 160.

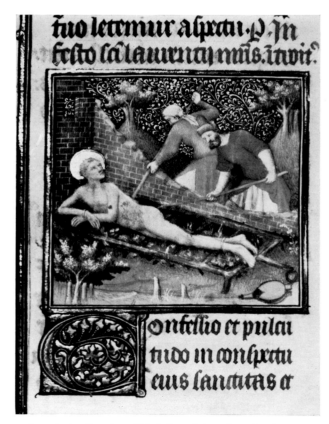

364 and 365. Boucicaut Workshop: *Martyrdom of St. Lawrence. All Saints.* Lucca, Bibl. Governativa, ms. 3122, fols. 261 and 281v.

Cy apres sensuit histoire de ceres qui fut lancienne et tres planturuse deesse des bles. La . vii. Rubriche . ⁊

Eres comme auons dient et affermement quelle fust royne tres anciene des siciliens et de tant grant engin resplendissant fut dee que comme elle eust trouue et pourprise la cultiuere de la terre. Elle premiere ensei

Cy apres sensuit histoire de la tres anciene isis deesse et royne des egyptiens. La . xi. Rubriche.

Sis qui par auant estoit nommee jo fut non seulement tresnoble et tres excellent royne des egyptiens. ains finablement fut leur tres si mere et tres reuerend deesse. Mais toute uoies en quelz temps elle ait este. ou

366 and 367. Boucicaut Workshop: *Ceres. Isis in Egypt pointing to ship that brought her.*
Lisbon, Gulbenkian Foundation, ms. L. A. 143, fols. 13v and 17.

Cy sensuit histoire de de ceres

368. Workshop of Master of the Coronation: *Ceres.*
Paris, Bibl. nat., fr. 12420, fol. 12.

Cy apres sensuit de la tres an

369. Master of Berry's Cleres Femmes: *Iris arriving in Egypt.*
Paris, Bibl. nat., fr. 598, fol. 16v.

370. Boucicaut Workshop: *Athena striking Arachne.*
Lisbon, Gulbenkian Foundation, ms. L.A. 143, fol. 31v.

371. Cité des Dames Workshop: *Manto and the construction of Mantua by Ocnus.* Lisbon, Gulbenkian Foundation, ms. L.A. 143, fol. 47.

372. Workshop of Master of the Coronation:
Suicide of Arachne. Paris, Bibl. nat., fr. 12420, fol. 28.

373. Workshop of Master of Berry's Cleres Femmes:
Manto. Paris, Bibl. nat., fr. 598, fol. 43.

374 and 375. Boucicaut Workshop: *Pyramis and Thisbe*. Master of the Harvard Hannibal: *Sulpicia dedicating the temple of Venus Verticordia.*
Lisbon, Gulbenkian Foundation, ms. L. A. 143, fols. 21v and 113.

376 and 377. Cité des Dames Workshop: *Hippo drowning herself, body retrieved by Erythraeans.*
Wives of the Minyae striving to save their condemned husbands. Lisbon, Gulbenkian Foundation, ms. L. A. 143, fols. 86 and 48v.

378. The Limbourgs: *The Fall and the Expulsion from the Garden*. Chantilly, *Très Riches Heures*, fol. 25.

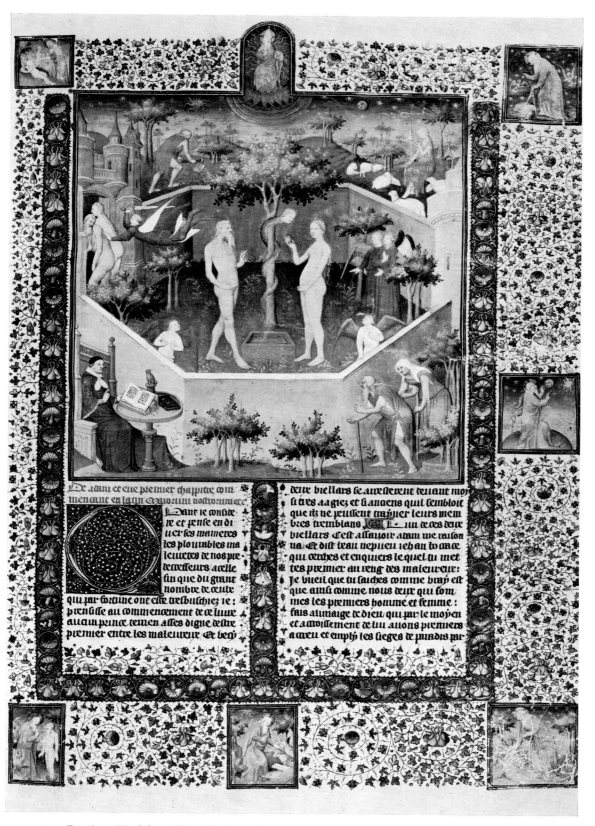

379. Boucicaut Workshop: *The Fall, Adam and Eve working and later appearing to Boccaccio, scenes of creation.*
New York, Coll. Kettaneh.

380. Luçon Workshop, before 1411: *Adam and Eve*.
Geneva, Bibl. publique et universitaire, fr. 190, I, fol. 7v.

381. Cité des Dames Workshop: *Adam and Eve*.
Paris, Bibl. de l'Arsenal, ms. 5193, fol. 8v.

382 and 383. Boucicaut Workshop: *Hercules poisoned by the shirt of Nessus. Laurent presents his translation to a king.* New York, Coll. Kettaneh.

384. Luçon Master: *A Jewess eating her child.*
Geneva, Bibl. publique et universitaire, fr. 190, II, fol. 101.

385. Cité des Dames Workshop: *A Jewess eating her child.*
Paris, Bibl. de l'Arsenal, ms. 5193, fol. 309v.

386. Boucicaut Workshop: *A Jewess eating her child.*
New York, Coll. Kettaneh.

387. French Illuminator:
A Jewess cooking her child.
New York, Coll. Kettaneh.

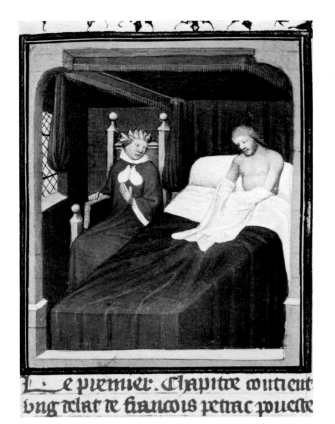

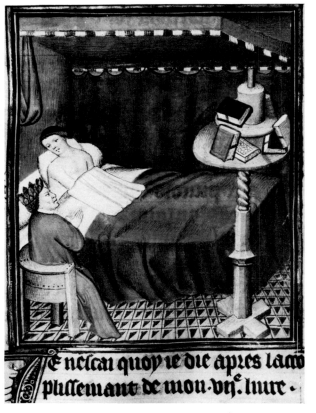

388. Boucicaut Workshop: *Boccaccio's Vision of Petrarch.*
New York, Coll. Kettaneh.

389. Luçon Workshop: *Boccaccio's Vision of Petrarch.*
Geneva, Bibl. publique et universitaire, fr. 190, II, fol. 102v.

390 and 391. Boucicaut Workshop: *Cleopatra's husband has the head and limbs of her child brought to her table. Hieronymus and Demaratha.*
New York, Coll. Kettaneh.

Fe nauoie pas encores afles rel

397. Luçon Workshop: *Darius in the stocks.*
Geneva, Bibl. publique et universitaire, fr. 190, I, fol. 139.

Le dziefme Chapitre conttient le

398. Boucicaut Workshop: *Darius and companions in the stocks.*
New York, Coll. Kettaneh.

Il eft afles certain par les vieilz hi

399. Luçon Workshop: *Jugurtha thrown from prison into the Tiber.*
Geneva, Bibl. publique et universitaire, fr. 190, II, fol. 27v.

L eft afles certain par les vick

400. Boucicaut Master and Workshop: *Jugurtha thrown
from prison into the Tiber.* New York, Coll. Kettaneh.

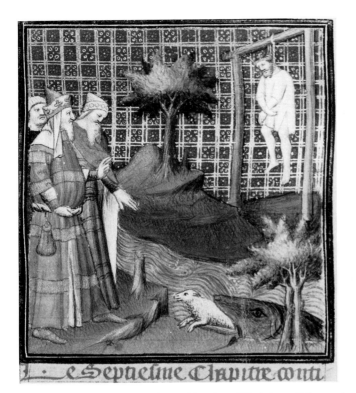

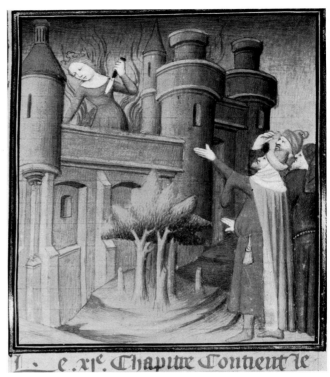

401 and 402. Boucicaut Workshop: *Polycrates hanged and receiving a lamb from a fish. Suicide of Dido.*
New York, Coll. Kettaneh.

403 and 404. Boucicaut Workshop: *Samson conquering the lion. The dying and ill-smelling Emperor Galerius.*
New York, Coll. Kettaneh.

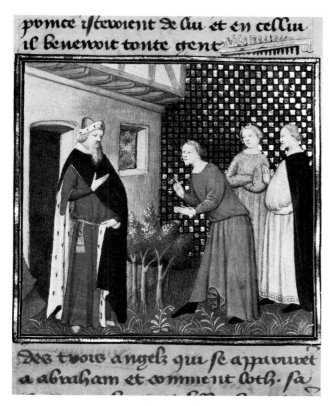

des twis angelz qui se appviwet
a abraham et coment loth. sa

filles auc cananiene ; mouth et
balsama ; ysaac en fu moult dolent
mais il ne luy osa blasmer

Comment Jacob filz de ysaac
twmpa son fewe. Esau

405 and 406. Boucicaut Master and Workshop: *Abraham and the three angels. Isaac blessing Jacob.*
Paris, Bibl. de l'Arsenal, ms. 5077, fols. 20v and 22.

ment

Comment le Roy Layus
boult sauoir la destinee de

Comment hector fu mis en tre
et palamedes fu fait empereur

407 and 408. Boucicaut Master and Workshop: *Hunters discovering Oedipus. Priam and Hecuba mourning at Hector's tomb.*
Paris, Bibl. de l'Arsenal, ms. 5077, fols. 34v and 49.

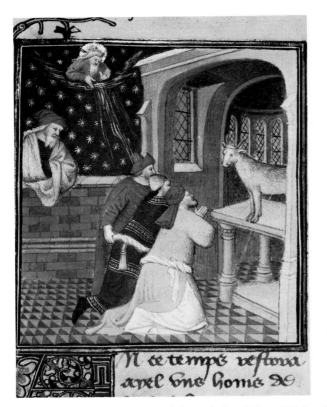

409 and 410. Boucicaut Workshop: *God sends fire as Elijah makes a sacrifice*. A would-be illuminator: *Scipio Africanus riding in triumph*.
Paris, Bibl. de l'Arsenal, ms. 5077, fols. 76v and 152.

411 and 412. Boucicaut Master and Workshop: *The sons of Jugurtha divide the realm. Adherbal falls from castle of Cirta*.
Paris, Bibl. de l'Arsenal, ms. 5077, fols. 168v and 170.

413 and 414. Boucicaut Master and Workshop: *Followers of Jugurtha murder Roman officers. Pompey borne in triumph.*
Paris, Bibl. de l'Arsenal, ms. 5077, fols. 172v and 183.

415 and 416. Boucicaut Master and Workshop: *Herod pays homage to Augustus. Diocletian destroys a Christian church.*
Paris, Bibl. de l'Arsenal, ms. 5077, fols. 252v and 278v.

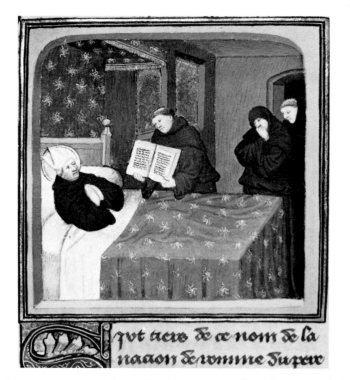

417 and 418. Boucicaut Master and Workshop: *Death of St. Augustine. Arthur of Brittany battling a Roman consul.*
Paris, Bibl. de l'Arsenal, ms. 5077, fols. 295v and 298.

419 and 420. Boucicaut Workshop: *Brunhilde punished by King Clothaire. Charlemagne crowned Emperor in St. Peter's, Rome.*
London, Brit. Mus., Cotton Nero E. II, I, fols. 64v and 103.

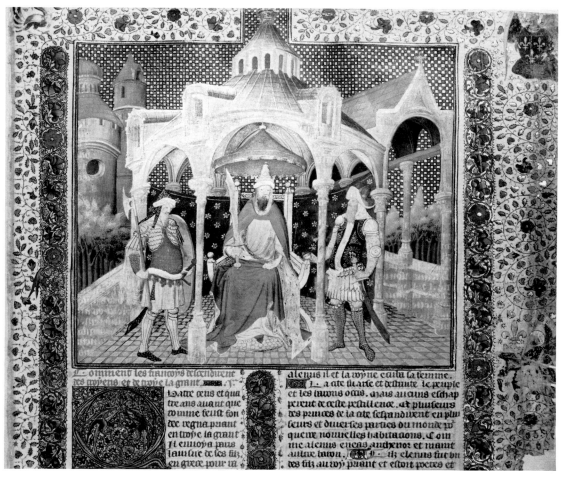

421. Boucicaut Workshop: *King Priam of Troy*. London, Brit. Mus., Cotton Nero E. II, I, fol. 2.

422 and 423. Boucicaut Master and Workshop: *St. James and an angel show Charlemagne the celestial sign. The obsequies of Roland.*
London, Brit. Mus., Cotton Nero E. II, I, fols. 118 and 131.

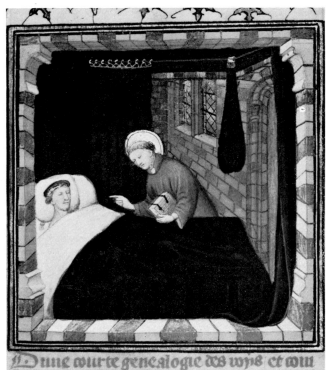

424 and 425. Boucicaut Master and Workshop: *Veneration of the supposed St. Denis. St. Valéry appearing to King Hugh Capet.*
London, Brit. Mus., Cotton Nero E. II, I, fol. 188, and II, fol. 29.

426 and 427. Egerton Workshop: *Dissolution of marriage of Charles IV and of Blanche.* Boucicaut Workshop: *The Battle of Crécy.*
London, Brit. Mus., Cotton Nero E. II, II, fols. 115 and 152v.

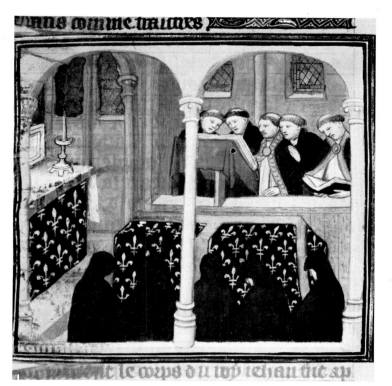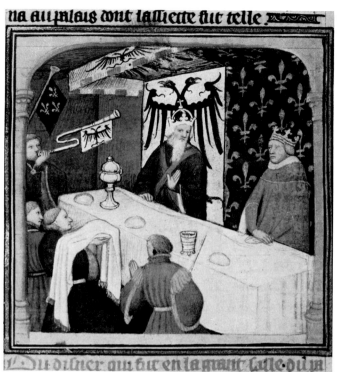

428 and 429. Boucicaut Master and Workshop: *Obsequies of Jean le Bon in the abbey of St. Anthony. Charles V entertains the Emperor Charles IV.* London, Brit. Mus., Cotton Nero E. II, II, fols. 200v and 229v.

430. Ambrogio Lorenzetti: *Boniface VIII receiving Louis of Anjou.* Siena, S. Francesco.

The illuminated manuscript page contains two columns of Gothic text below the miniature. The text is in medieval French and largely illegible in reproduction.

431. Boucicaut Workshop: *Bersuire presents his translation of Livy to Jean le Bon; a shepherd discovers Romulus and Remus; Rome in the background.*
Paris, Bibl. nat., fr. 259, fol. 15.

432. Boucicaut Workshop: *Coronation of Hannibal as leader of the Carthaginians.* Paris, Bibl. nat., fr. 259, fol. 253.

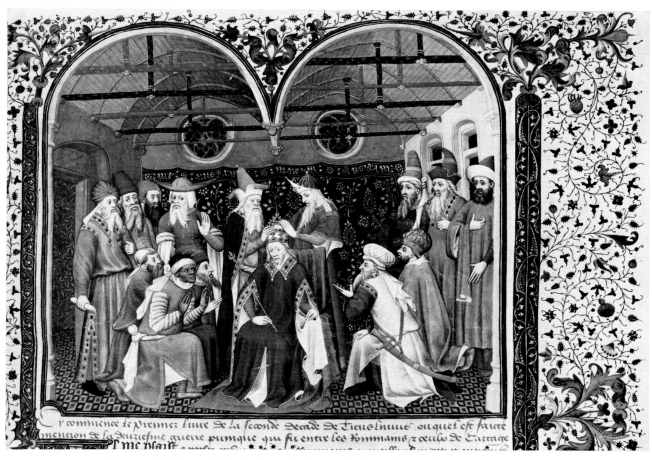

433. Master of the Harvard Hannibal: *Hannibal crowned as leader of the Carthaginians.* Cambridge (Mass.),
Harvard College Library, Richardson 32, II, fol. 263.

434 and 435. French Illuminator: *Lucus Cornelius Merula discovers an ambush of the Boi*. Boucicaut Workshop: *Rebuilding of Rome after Gallic invasion*.
Paris, Bibl. nat., fr. 259, fols. 523v and 150v.

436. Boucicaut Master and Workshop: *Scipio Africanus conquers the Lusitani*.
Aachen, Coll. Ludwig, *Tite-Live*, fol. 72v.

437. Boucicaut Workshop: *Romans worshipping foreign gods*.
Cambridge (Mass.), Harvard College Library, Richardson 32, II, fol. 332v.

438. Master of Berry's Cleres Femmes: *Romans worshipping.*
Geneva, Bibl. publique et universitaire, fr. 77, fol. 343.

439. Boucicaut Master and Workshop: *Consuls chosen for the provinces.*
Aachen, Coll. Ludwig, *Tite-Live*, fol. 25.

440. Master of Berry's Cleres Femmes: *Romans creating a pontiff.*
Geneva, Bibl. publique et universitaire, fr. 77, fol. 238v.

441. Boucicaut Follower: *Lucius Valerius, supported by Roman women,*
proposes to Cato the revocation of the sumptuary law. Paris, Bibl. nat., fr. 259, fol. 501v.

442 and 443. Boucicaut Master and Workshop: *Porcius Cato speaks for the maintenance of the sumptuary law. The Romans sacrificing animals.*
Aachen, Coll. Ludwig, *Tite-Live*, fols. 44v and 96v.

444 and 445. Boucicaut Master and Workshop: *Aetolian ambassadors seeking peace in Rome. Amynander welcomed by his partisans in Athanania.*
Aachen, Coll. Ludwig, *Tite-Live*, fols. 116 and 141v.

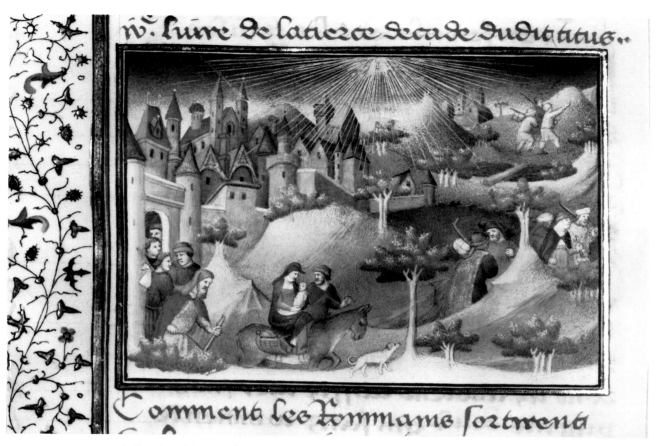

446. Boucicaut Master and Workshop: *Macedonians forced by Philip from their ancestral homes.*
Aachen, Coll. Ludwig, *Tite-Live*, fol. 201v.

447. Boucicaut Workshop: *Scenes of creation.* Paris, Bibl. nat., fr. 9141, fol. 9.

Ci commance le tiers livre qi traitte qlle chose est hôme · et ql chose e lame selô vite omme ainsi soit felône ce que dit ysidore que home soit vne befte selon autre de sa nature suster

448. Boucicaut Master and Workshop: *God giving Adam a soul.*
Paris, Bibl. nat., fr. 9141, fol. 29v.

Er comace le · iiii· livre qi traitte des qua

449. Boucicaut Workshop: *A scholar speaks to noblemen about the elements and the four humors.* Paris, Bibl. nat., fr. 9141, fol. 43.

Ci commance le · xve· livre des proprietez qui traitte des prouinces e des pais plotique l'aide de dieu Il fault dire aucue chose des parties de la teure et des

Ci comance le trefieme livre qui traite De leaue et des poiffons et de fes differance eftriptes les prop etez du feu et de leau Il est temps que nous parliez

450 and 451. Boucicaut Master and Workshop: *Scholar addressing nobleman about the regions of the world. Scholar discoursing on water and fish.*
Paris, Bibl. nat., fr. 9141, fols. 217v and 197.

Ty commence le iiij. liure qui deuise
des qualitez des elemes et des .iiij.
humeurs desqueles pont compo sez
les corps tant de hommes comme
de bestes Prologue

Le premier chapitre parle de l'eau
en general..

estriptes les proprie
tes du feu et de l'eau Je
est temps que nous
disons maintenant

452 and 453. Boucicaut Workshop: *A physician speaking about the elements and the four humors. Professor speaking about the properties of water.*
Cambridge, Fitzwilliam Mus., ms. 251, fols. 45 and 190v.

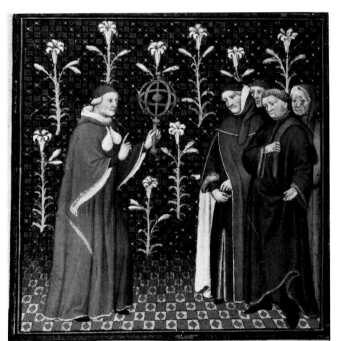

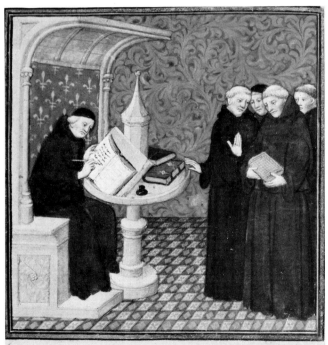

Ty commence le vnj.e liure des pro
prietez qui parle et truicte du monde
et des corps celesticulz Et ne vueil
pas que le prologue du truinstateur

Ty commence le v.e liure des proprie
tez qui truicte de la matiere de quoy
toutes choses materuelles pont fautes

454 and 455. Boucicaut Workshop: *Professor with sphere speaking about the world and the heavenly bodies. Cleric writing and others talking*
about the nature of matter. Cambridge, Fitzwilliam Mus., fols. 135 and 166.

puet estre consideree en autant de manie
res comme le labour que il est un
repos espirituel et lautre corporel et
lun et lautre sont prouffitables a grant
de la sante de lame et du corps se
ilz sont attrempez et deuement pro
porcionnez a nature et se non ilz cor
rompent le corps et lame quant aces
cuites ☙ Quant le repos est trop
grant il engendre les mauuaises
humeurs et les nourrist et multi
plie et est cause de corrupcion Et
ce appert en eaue qui est nette de sa
nature mais quant elle se repose
trop elle se pourrist et corrompt Le
feu aussi et les autres mettaulx se
enrouillent quant ilz se reposent
trop longuement ☙ Derechief le
repos est aucunesfois trop petit et
cestui ne retrait point a nature ne
ne recueure pas la perte de natu
re et ne enforce point la persone
☙ Le repos moien fait a loer car
il conforte la chaleur de nature
et retrait le sang et amende la di
gestion et si porte le corps moie
ment ☙ Derechief il est un repos
qui est bref et cestui cy fait a loer
mais quil ne soit pas trop long Et
si est un repos de la fieure et cestui
cy est moins a loer Si comme nous
dirons cy apres ou septiesme liure
se dieu plaist ▪

Cy fine le sixe liure Et se commence
le septiesme liure des proprie
tez qui parle des maladies qui
aduiennent en corps domme Et
ne veuil pas que le prologue de
cestui liure soit compte pour
chapitre ▪

...me que a laude de di
eu nous auons aco
plir le traitie des
proprietez qui sont en
homme selon sa na
ture il reste a dire
des choses qui lui aduiennent
contre sa nature et qui la destruisent
et corrompent ☙ Il est vne chose
qui blecent lomme et sa nature cest
assauoir la cause la maladie et les
accidens qui ensuiuent la maladie
☙ La cause de la maladie est ce dot
vient la mauuaise disposicion du
corps si comme est mauuaise com
plexion et trop grant vuidange de
faulte de certi et mutacion de qua
litez toutes ces choses sont cause
de maladie ☙ La maladie aussi est
vne chose dont il vient mal au corps
si comme est fieure et apostume
et leur semblables Laccident qui
sensuit est la foiblesse qui demeure
apres la maladie si comme la doule
du chief et ses semblables ☙ La
bonne disposicion du corps est ap
pellee sante par la quele le corps
de la persone est de tele comple
xion que il fait franchement
toutes les eunres de sa nature
et si est hors de toute attrempance
elle chiet de necessite en maladie
car par la desattrempance et lin...

456. Boucicaut Workshop: *Physician addressing the ill*. Cambridge, Fitzwilliam Mus., ms. 251, fol. 106.

457. Boucicaut Workshop: *God presenting Eve to Adam*. Cambridge, Fitzwilliam Mus., ms. 251, fol. 16.

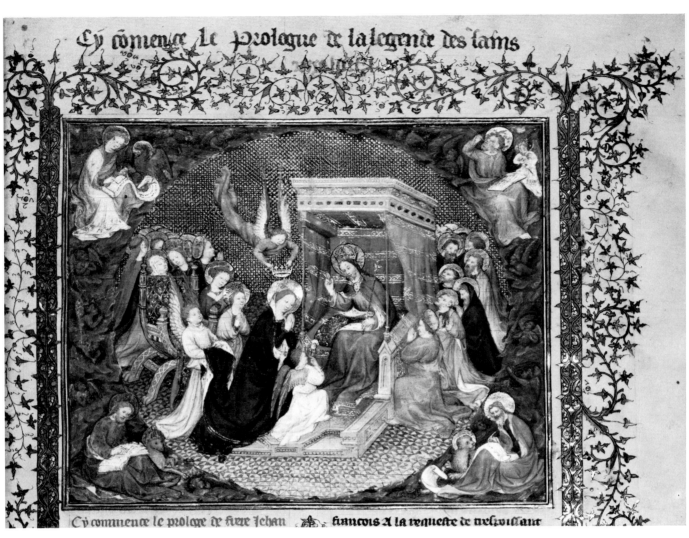

458. Master of the Coronation: *Coronation of the Virgin*. Paris, Bibl. nat., fr. 242, fol. 1.

459 and 460. Workshop of Master of the Coronation: *Noah and family entering Ark. David in the water before the Lord.*
Paris, Bibl. nat., fr. 159, fols. 13 and 271v.

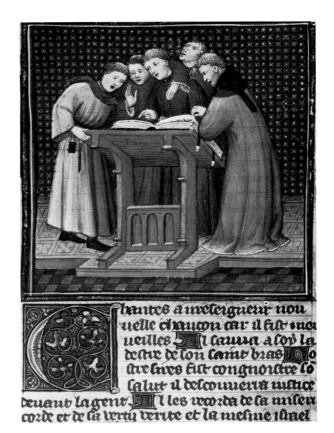

461 and 462. Master of the Coronation: *David playing on bells. Clerics singing.* Paris, Bibl. nat., fr. 159, fols. 274v and 277v.

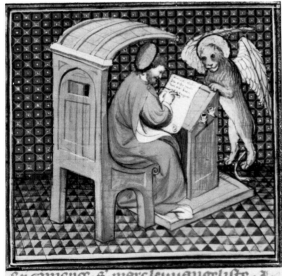

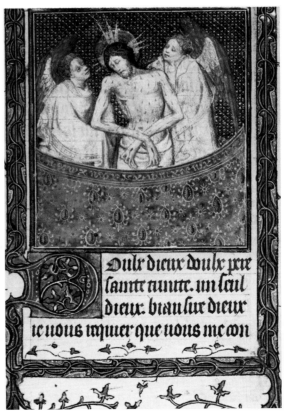

463. Master of the Coronation and Workshop: *St. Mark.* Paris, Bibl. nat., fr. 159, fol. 440.

464. Master of the Coronation: *Man of Sorrows.* Whereabouts unknown, Book of Hours, fol. 162 (damaged).

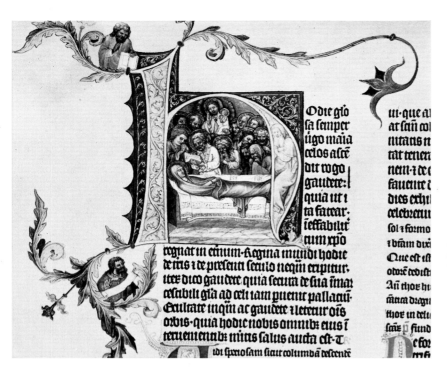

465. Bohemian, before 1364: *Death of the Virgin*.
Prague, National Museum, *Viaticum of Johann von Neumarkt*.

466. Tapestry showing arms of Guillaume Rogier,
Count of Beaufort. New York, Metropolitan Museum.

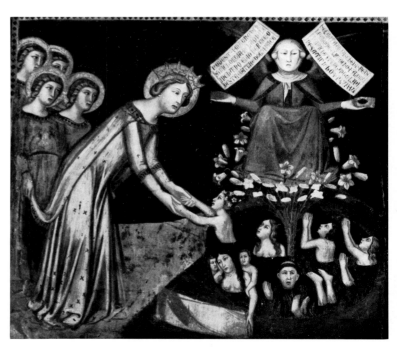

467. Brussels Initials Master: Detail of border.
Cleveland, Museum of Art,
Heures de Charles le Noble, p. 379.

468. Follower of Ambrogio Lorenzetti, 1368: *Madonna and angels welcoming the blessed*. Paganico, S. Michele.

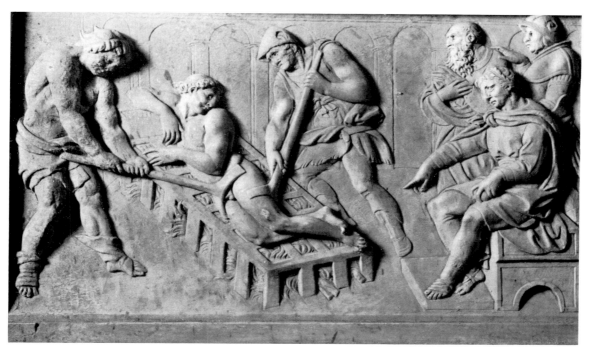

469. Jacopo della Quercia: *Martyrdom of St. Lawrence*. Lucca, S. Frediano.

470. French, *ca.* 1410: *Coronation of the Virgin*. La Ferté-Milon.

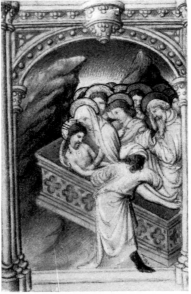

471 and 472. The Limbourgs: *Ascension of Christ. Entombment.*
Paris, Bibl. nat., fr. 166, fols. 14 and 17v.

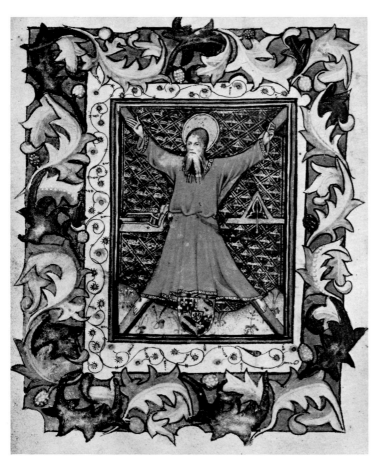

473 and 474. Flemish, before 1419: *St. Andrew with arms and emblems of Jean sans Peur. St. Leonard.* Paris, Bibl. nat., nouv. acq. lat. 3055, fols. 172v and 164v.

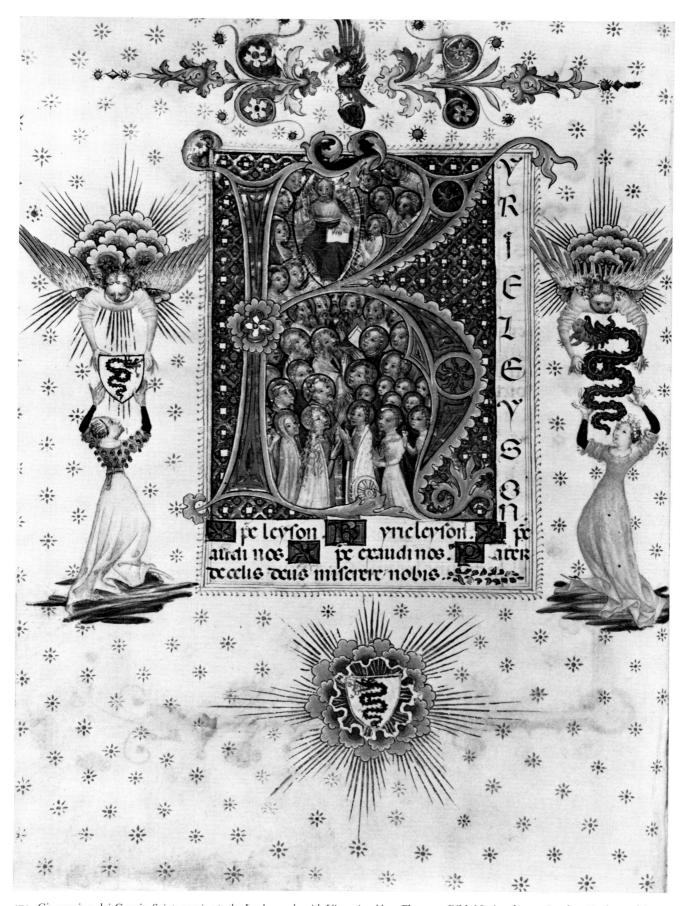

475. Giovannino dei Grassi: *Saints praying to the Lord; angels with Visconti emblem.* Florence, Bibl. Nazionale, ms. Landau-Finaly 22, fol. 4v.

476. Jacquemart de Hesdin: Landscape (detail of *Flight into Egypt*). Brussels, Bibl. Royale, ms. 11060–61, p. 106.

477. The Limbourgs: Landscape (detail of *Meeting of the Magi*). Chantilly, Musée Condé, *Très Riches Heures*, fol. 51v.

478. Associate of Epître Master: *Aurora*.
Paris, Bibl. nat., fr. 606, fol. 21v.

479. Master of Walters 219: *Crucifixion*.
Baltimore, Walters Art Gallery, ms. 219, fol. 147.

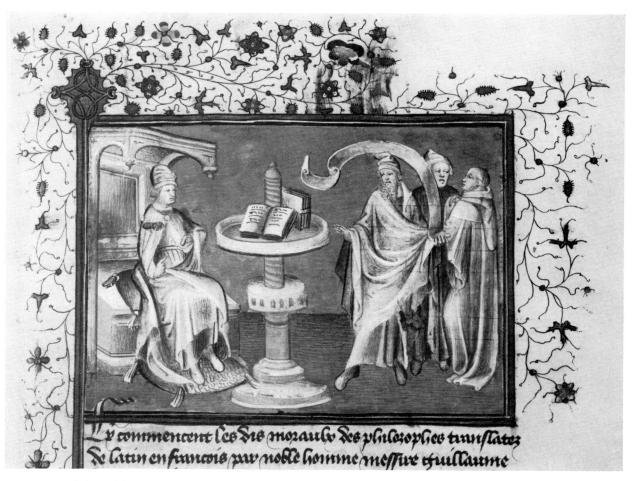

480. Workshop of the Apocalypse Master: Frontispiece of *Les dis moraulx*. Leningrad, State Library, Fr. Q. v. III 4, fol. 2.

481. Bedford trend, *ca.* 1412: *Crucifixion.* Paris, Bibl. de l'Arsenal, ms. 623, fol. 213 A. – 482. Bedford Workshop: *Crucifixion and Passion scenes.* London, Brit. Mus., Add. 18850, fol. 144.

483. Rohan Workshop: *Annunciation, with scenes of the Life of the Virgin and her parents.* Cambridge, Fitzwilliam Mus., ms. 62, fol. 29. – 484. Jean Fouquet: *Annunciation.* Chantilly, Musée Condé, ms. 71.

485. Rohan Master: *Miracle at Bethesda*. Braunschweig, Museum Herzog Anton Ulrich.

486. Simone Martini: *St. Martin and the beggar.*
Assisi, S. Francesco.

487. The Limbourgs: *St. Martin and the beggar.*
New York, Metropolitan Museum, Cloisters, *Belles Heures*, fol. 169.

488. Orosius Workshop: *The Pagans and the Christians*. Philadelphia, Museum of Art, ms. 45–65–1, fol. 64.

489. Workshop of Master of the Angevin Bible: *The Magi with Herod in Jerusalem*. Paris, Bibl. nat., fr. 9561, fol. 135v.

490. French, 1317: *Preaching of St. Denis with view of Paris*. Paris, Bibl. nat., fr. 2091, fol. 99.

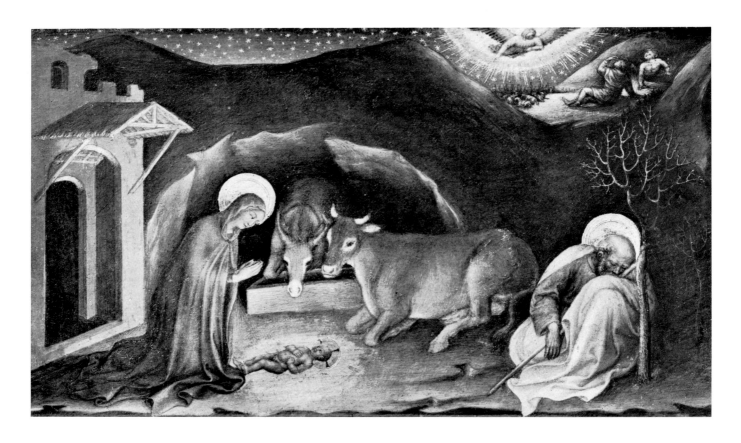

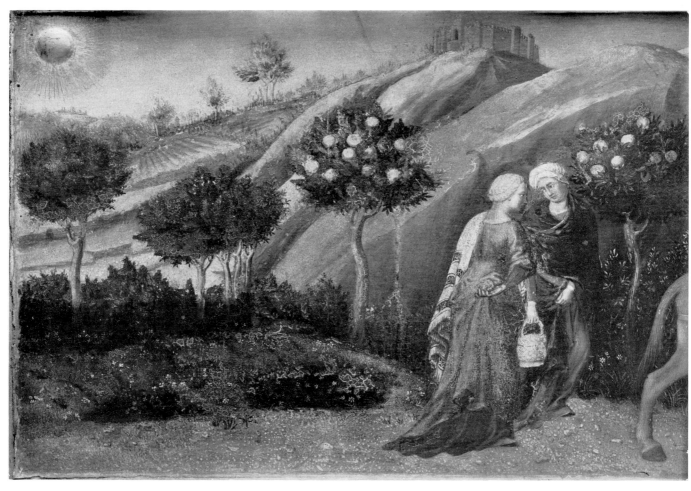

491 and 492. Gentile da Fabriano, 1423: *Nativity. Flight into Egypt* (details). Florence, Uffizi.

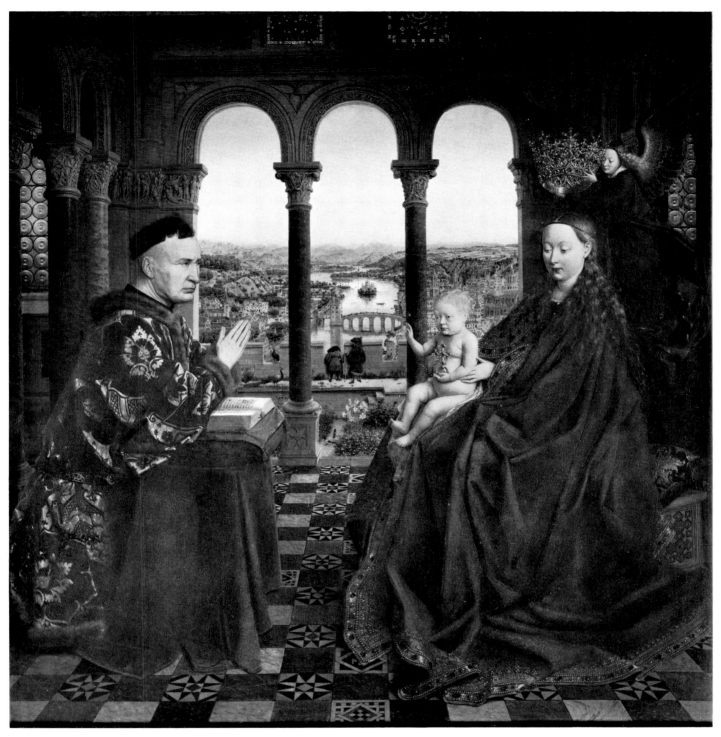

493. Jan van Eyck: *Chancellor Rolin before the Madonna*. Paris, Louvre.

494. Jan van Eyck: *Madonna of Canon van der Paele*. Bruges, Musée communal. 1436.

496. Jan van Eyck: *Madonna*. Frankfurt, Städel Institut.

495. Flemish copy of Master of Flémalle: *Madonna with two angels*. New York, Metropolitan Museum.

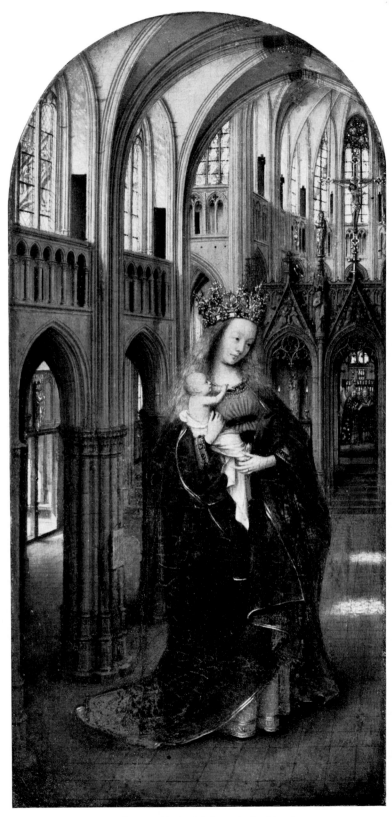

497. Jan van Eyck: *Madonna in the Church*.
Berlin-Dahlem, Staatliche Museen.

LIST OF ILLUSTRATIONS

The author and the publishers are grateful to all institutions, collectors and photographers who have supplied photographs for reproduction in this volume. The negatives of those photographs supplied by the author himself will be given to the Archive of the Bibliothèque nationale in Paris.

ORANGE (TEXAS)

OXFORD

PAGANICO

PARIS, Museums and Libraries

INDEX

References to reproductions are indexed only topographically.
All saints indexed are from the *Boucicaut Hours*.
Subjects in secular manuscripts which are discussed in the text have been indexed. The subjects
of hundreds of other representations can be found only in the lists of miniatures in the Catalogue.